Dawn of the Belle Epoque

Dawn of the Belle Epoque

The Paris of Monet, Zola, Bernhardt, Eiffel, Debussy, Clemenceau, and Their Friends

Mary McAuliffe

ROWMAN & LITTLEFIELD PUBLISHERS, INC.
Lanham • Boulder • New York • Toronto • Plymouth, UK

Published by Rowman & Littlefield Publishers, Inc.
A wholly owned subsidiary of The Rowman & Littlefield Publishing Group, Inc.
4501 Forbes Boulevard, Suite 200, Lanham, Maryland 20706
http://www.rowmanlittlefield.com

Estover Road, Plymouth PL6 7PY, United Kingdom

Distributed by National Book Network

British Library Cataloguing in Publication Information Available

Library of Congress Cataloging-in-Publication Data

McAuliffe, Mary Sperling, 1943–
 Dawn of the Belle époque : the Paris of Monet, Zola, Bernhardt, Eiffel, Debussy,
Clemenceau, and their friends / Mary McAuliffe.
 p. cm.
 Includes bibliographical references and index.
 ISBN 978-1-4422-0927-5 (cloth : alk. paper) — ISBN 978-1-4422-0929-9
(electronic)
 1. Paris (France)—History—19th century. 2. Paris (France)—History—20th
century. 3. Paris (France)—Intellectual life—19th century. 4. Paris (France)—
Intellectual life—20th century. 5. Arts, French—France—Paris—19th century.
6. Arts, French—France—Paris—20th century. 7. French literature—19th century.
8. French literature—20th century. I. Title.
DC735.M43 2011
944'.361081—dc22

 2011003611

∞™ The paper used in this publication meets the minimum requirements of
American National Standard for Information Sciences—Permanence of Paper
for Printed Library Materials, ANSI/NISO Z39.48-1992.

Printed in the United States of America

For Jack

Contents

Illustrations

~

Acknowledgments

This book is about Paris, and so it is fitting that I pay tribute here to the City of Light—to the streets and quarters where the people I have written about worked and lived, and to the many museums that provided me with invaluable resources and inspiration. These include the Musée Carnavalet (Musée de l'Histoire de Paris), the Musée d'Orsay, the Musée Marmottan-Monet, the Musée Rodin, the Petit Palais—Musée des Beaux-Arts de la Ville de Paris, the Maison de Victor Hugo, the Musée Clemenceau, the Musée de l'Orangerie des Tuileries, the Musée de Montmartre, the Musée Cognacq-Jay, the Musée Bourdelle, the Musée des Arts et Métiers, the Musée des Arts Décoratifs, the Musée Fournaise (Chatou), and the Musée de la Grenouillère (Croissy-sur-Seine).

In New York, the Metropolitan Museum of Art has been an important resource, and I am especially indebted to the outstanding research division of the New York Public Library, including its Art and Architecture collection and its Library for the Performing Arts, where I have spent countless hours. I am also indebted to the many specialized studies and published letters, diaries, and memoirs to which I have given specific credit in my notes and bibliography.

Along the way, numerous friends and associates have provided valuable help and assistance. I am especially grateful to Susan McEachern, editorial director at Rowman & Littlefield, for her vision, guidance, and support. My thanks as well to assistant editor Carrie Broadwell-Tkach and senior production editor Jehanne Schweitzer for their professionalism and skill in making

this book a reality. I am also greatly indebted to Mark Eversman, my long-time editor at *Paris Notes*.

From start to finish this book has been a labor of love, an adventure that I have undertaken and completed with the steadfast and enthusiastic assistance of my husband, Jack McAuliffe. It has been a team effort, and it is in this spirit that, with thanks and love, I dedicate it to him.

~

Introduction: The Terrible Year

(1870–1871)

The phrase "Paris Commune" may mean little or nothing to most Americans, but it still resonates with meaning for many French, especially Parisians, for whom it conjures up either fearful images of bloodshed and destruction or memories of a noble cause brutally suppressed. The viewpoint of course varies, depending upon one's politics and, still to some extent, one's class. But nonetheless, it resonates. Unlike Americans, the French remember their history—perhaps because they live so closely with tangible vestiges of their past. And if Belleville and Montmartre no longer summon up the images of danger and despair that they once did, then the simmering *banlieues* just beyond certainly do.

So return a century and a quarter to the year 1871. Louis Napoleon, Bonaparte's nephew and ruler over the Second Empire, had been captured the previous autumn by the Prussians, after unwisely starting a war with them and their magnificent army. Parisians promptly overthrew his imperial government and established a republic, which attempted to carry on the fight. But by this time, Paris was surrounded by the Prussian army, which was intent on starving the city into submission. After four months of deprivation, during which almost all the horses of Paris (as well as, most famously, the rats) turned up on dinner plates, the French government capitulated. A new government, far more conservative than the old, agreed to peace terms that the belligerently patriotic working class of Paris found humiliating and unacceptable.[1] In March 1871, the workers of Paris rose up in revolt.

1

The opening shots of this bloodbath took place on the Butte of Montmartre, in a now-obscure spot presently commemorated only by a historic marker. The current address of this site—located just behind Sacré-Coeur—is 36 Rue du Chevalier-de-la-Barre, but in 1871 it was 6 Rue des Rosiers. Here, all hell broke loose after the government sent troops to recover some two hundred cannons that the citizens of Montmartre had dragged all the way from the Place de Wagram to the top of the Butte. Having subsidized these cannons through public subscription, the men, women, and children who participated in this dramatic transfer believed them to be theirs and were determined to keep them safely out of Prussian hands. The government strongly disagreed on the question of the cannons' ownership and certainly did not want to see such weapons in the hands of Paris's volatile poor. A confrontation ensued, during which two generals were captured and dragged to 6 Rue des Rosiers, where they were shot.

The spot looks quite different now, as you can readily see from contemporary paintings of Montmartre's Tour Solférino, a popular *guinguette*, or tavern and dance hall, then located on the present site of Sacré-Coeur. The dazzling white Sacré-Coeur, which went up in the Commune's aftermath, was erected in expiation for the sins of France, but its conservative Catholic promoters had little sympathy with the Communards. Not coincidentally, the basilica completely hides the ground where the cannons were parked and the uprising first broke out.

Following Montmartre's opening shots, Paris's workers quickly established their own government, the highly contentious but socially conscious Commune, which took over the Hôtel de Ville. Members of the official French government, under Adolphe Thiers, raced for the safety of Versailles, well beyond Paris's massive walls. Ironically, these walls (and the sixteen muscular forts just outside them) had been built during the 1840s at the instigation of none other than Thiers himself, who well knew their strengths and weaknesses. Their only soft spot was in their southwestern sector, at Auteuil's Point-du-Jour. Thiers proceeded deliberately, but finally, on the night of May 21—after a lengthy cannon bombardment of western Paris and the capture of Fort d'Issy and other nearby fortresses—government troops poured into Paris.

Much has been made of the rebuilding of Paris under the direction of Louis Napoleon's prefect of the Seine, Baron Georges Haussmann, whose broad boulevards not only cleaned up some of the most insalubrious slums of central Paris but also provided wide and straight thoroughfares on which troops could march. Unquestionably, the Communards found it difficult to build and defend their barricades in the new Paris, but one unforeseen consequence of Haussmann's slum clearance was the removal of Paris's poor from

the center of town to its outskirts—to Montmartre, Belleville, and all those impoverished communities in the eleventh, eighteenth, nineteenth, and twentieth arrondissements. Here, in their home territory, the Communards put up a fierce fight.

Withdrawing from the Hôtel de Ville to the *mairie* (town hall) of the eleventh and then of the twentieth arrondissement, the Commune's headquarters was pushed into a corner, even while its supporters continued to fight tenaciously in Belleville and Ménilmontant. During this terrible May week, since known as "Bloody Week," reprisals triggered reprisals as fury and despair escalated. Seething at the brutality of Thiers' troops, Communards destroyed Thiers' stunning mansion on Place St-Georges at Rue Notre-Dame-de-Lorette (9th).[2] They then set to work on other monuments linked with the Ancien Régime and both empires, destroying Bonaparte's massive Victory Column and statue in the Place Vendôme, and setting the torch to the Palais des Tuileries, the Palais Royal, the Palais de Justice, and the Hôtel de Ville.

Soon it seemed as if all Paris was burning, and the killing still went on. Maddened by the news that Communards had murdered the Archbishop of Paris, Thiers' troops stepped up their relentless executions. In return, a group of Belleville Communards removed fifty prisoners, including ten Jesuit priests, from the grim Roquette prison in the eleventh arrondissement where they had been held hostage. After dragging these hostages uphill to what now is 81–83 Rue Haxo, in the heart of Belleville, the Communards brutally executed them. The Jesuits have since built a church, the Eglise de Notre-Dame des Otages, on the site.

By the week's end, only a few pockets of resistance remained—the largest being the famed cemetery of Père-Lachaise, in the twentieth arrondissement. Here, a macabre nighttime gun battle took place among the tombstones, until by morning the remaining Communards had been driven into the cemetery's far southeastern corner. Lined up against the wall, all 147 were summarily shot and buried in a communal grave. The site, now a place of pilgrimage, is marked only by a plaque dedicated "Aux Morts de la Commune, 21–28 Mai 1871."

At least twenty thousand Communards and their supporters died—a figure that dwarfs not only the Communards' own well-publicized executions, but even the grisly body count of the Reign of Terror. This, and a Paris filled with smoking ruins, was the legacy of these terrible weeks and months.

How, people wondered, could Paris possibly survive?

CHAPTER ONE

~

Ashes

(1871)

W hat blood and ashes! What women in mourning! What ruins!"[1]
Sarah Bernhardt, like so many of her fellow Parisians, had left Paris during the height of the siege, and now that the "abominable and shameful peace" was signed and the "wretched Commune" crushed, she ventured back. But the Paris she found was not what she expected. Everywhere, she wrote in her memoirs, one could smell the "bitter odor of smoke."[2] Even in her own home, everything she touched left an unpleasant residue on her fingers.

Emile Zola, who had holed up in his small house on Rue La Condamine (17th), in the heart of the fighting between government and Communards, had an entirely different reaction. For two months he had tried to keep up his writing as cannon boomed night and day and as shells hissed over his head, but at last—warned that he was about to be seized and possibly shot by the Communards—he fled Paris. At the time, it seemed the end of the world. But he quickly forgot this once the Commune was over. Writing in July to his boyhood friend, Paul Cézanne, he told him that now that he was back in his home in Paris, it all seemed as if it had been a bad dream. When he saw that "my house is the same, my garden has not budged, not a piece of furniture, not a plant has suffered," he concluded that it almost seemed as if it all had been a "nasty farce invented to frighten children."[3]

Yet if Zola's little world remained blessedly untouched, the larger world around him had suffered enormous damage. Not only had the Tuileries Palace and a swath of historic public buildings gone up in flames, from the Palais

de Justice to the Hôtel de Ville, but countless private houses and businesses had been damaged or reduced to rubble. Many of these, like Thiers' mansion, had been the target of angry mobs, while countless others were the random victims of Communard fire-bombers. But many more, primarily in the western sectors of Paris, had suffered from the lengthy cannon bombardment by government troops prior to their forced entry into the Commune-controlled city. Ironically, this western sector was the part of Paris most likely to contain government supporters, but western Paris took its hit not only from the mob its residents feared, but also from the government troops that these Parisians regarded as their saviors.

Pummeled in turn by the Prussians, by French government forces, and by the Commune, Paris in late spring of 1871 was a shambles. Not even the trees along its avenues and quays remained standing, having been used for fuel during the siege's long winter months.[4] All suffered, but not equally, for the greatest damage was borne by the poor, whose despair and anger had fueled the Commune. The death toll from Bloody Week was enormous by any standards, and for years there was a noticeable dearth of men of a certain age in the working-class areas of Montmartre and Belleville.

Georges Clemenceau was acutely aware of this when he returned to Paris in the summer of 1871. Although his career in politics would eventually take him to the pinnacle of power, he began life as a doctor, with a deep abhorrence of all forms of political and social injustice. Born and raised in the remote reaches of the Vendée, near Nantes, Clemenceau had followed in his well-born father's footsteps, both in his medical studies and in his ardent republicanism. Paris made its imprint on him at an impressionable age, as a young medical student—one who enthusiastically participated in left-wing protests against Napoleon III's repressive empire. America made a deep impression on him as well, where he traveled widely, served as a foreign correspondent for a Paris newspaper, and (strapped for cash) taught at a girls' finishing school. After that, life as a country doctor in the Vendée must have seemed extraordinarily dull—especially once it became evident that Napoleon III's war on Prussia was turning into a disaster for the French. As the Second Empire tottered, Paris beckoned ever more strongly, and at last Clemenceau left his young American wife and child in the Vendée and headed for the City of Light. Here he settled in Montmartre and promptly dived into the turbulent politics of the time.

French military defeat and the end of the Second Empire soon vaulted him into public life as mayor of the eighteenth arrondissement (essentially, the mayor of Montmartre), where his left-wing politics and devotion to his constituents won him widespread support during the long difficult months of Prussia's siege of Paris. Elected to the National Assembly, he voted against

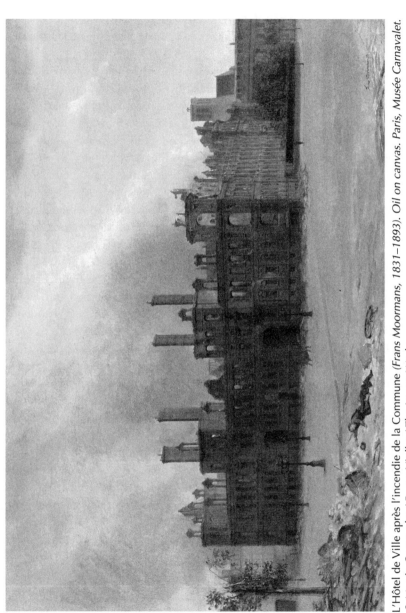

L'Hôtel de Ville après l'incendie de la Commune (Frans Moormans, 1831–1893). Oil on canvas. Paris, Musée Carnavalet. © Musée Carnavalet / Roger-Viollet / The Image Works.

Prussia's terms for peace but was outvoted by a conservative majority, which formed a new government. Soon after, during the opening days of the bloody Commune uprising of 1871, Clemenceau's attempts to broker a peaceful resolution between government and workers came to naught, ironically earning him the enmity of both sides.

Significantly, he did not join the Commune. Although sympathetic with its poverty-stricken followers and their hostility to the newly formed government, he firmly believed that such a government could only be legitimately opposed—and modified—through peaceful means, not through violence. At last, just before the height of the bloodshed, he returned to the Vendée and his family, a decision that may have saved his life.

But Paris still beckoned, and he returned after the Commune's bloody demise, opening a dispensary in the heights of Montmartre, at 23 Rue des Trois-Frères (the small building in which it was housed is still there). Here, for two days a week, Clemenceau cared for the poor of Montmartre, free of charge. And here, driven by the appalling conditions he saw around him, he reentered politics.

He had seen too many women like Gervaise Lantier, the tragic heroine of Zola's still-to-be-written great novel, *L'assommoir* (Zola had just begun the serial publication of the first of his twenty-volume series on the Rougon-Macquart family, including *L'assommoir*, which would be published in 1877). Indeed, Clemenceau and Zola did not yet know one another, although their paths had briefly crossed several years earlier, when both had written for the same left-wing student newspaper in Paris. Now they lived only a few blocks from one another, but while Clemenceau was avidly pursuing his path in politics, Zola was torn between the life of tranquility and the life of action. Both were ardent republicans of a left-wing but nonextremist cast, yet it would be many years before their paths would memorably cross, with Zola at last taking the path of action. In the meantime, Zola wrote with driving power and a journalist's eye for detail about the heredity-driven lives of his fictional family, including Gervaise Lantier, who found herself mired in poverty on the slopes of Montmartre.

Zola certainly was not sentimental. In his preface to *L'assommoir*, Zola wrote that this was "the first novel about the common people which does not tell lies but has the authentic smell of the people." From this, he added, "it must not be concluded that the masses as a whole are bad, for my characters are not bad, but only ignorant and spoilt by the environment of grinding toil and poverty in which they live."[5]

By contrast, Zola's childhood hero, Victor Hugo—whose blockbuster novels *Notre-Dame de Paris* (*The Hunchback of Notre-Dame*) and *Les misérables* seethed with righteous indignation over the plight of the common

people—served up large quantities of heart-wrenching sentiment. But while Zola (along with Flaubert and other leading intellectuals of the time) now regarded Hugo as a man of the past—a giant, perhaps, but an outmoded one—the common people regarded Hugo in an almost messianic light. Returning to Paris the day after the empire's fall, Hugo was greeted by a huge crowd at the Gare du Nord. Never one to shy from an audience, he pushed his way through the mob and into a café, where he spoke from a balcony: "Citizens," he told them, "I have come to do my duty." He had come, he added, "to defend Paris, to protect Paris"—a sacred trust, given Paris's position as the "center of humanity."[6] After that, he climbed aboard an open carriage, from where he spoke again to the fervent crowd before making his way to the house of a friend, near Place Pigalle. There the young Montmartre mayor, Georges Clemenceau, warmly welcomed him. Altogether, it must have been a most gratifying occasion for the old man, who had left Paris almost twenty years before in what had amounted to a self-imposed exile.[7]

Hugo arrived just as the siege set in, and on October 22, he reported in his diary, "We are eating horse in every form." A month later, he noted: "People are making rat pâté," adding (with a bit of ghoulish delight), "It is said to be quite good."[8] Several days later, he was one of the lucky ones still to have meat, only this time it was antelope, bear, and stag, in that order—courtesy of the zoo in the Jardin des Plantes. (During these same desperate days and weeks, young César Ritz, who was working at the elegant—but similarly food-deprived—Restaurant Voisin, served up *épagneul*, or spaniel, and a dish of elephant trunk with *sauce chasseur*.)

Deprivation was not the only difference in the Paris that greeted the returning Hugo. Paris's physical appearance had undergone an enormous transformation, and much of the city he had known so well no longer existed. Baron Haussmann, Napoleon III's prefect of the Seine, had cut a swath through some of the oldest and most poverty-ridden quarters of Paris, in the process eradicating whole sections of the city that had provided the setting—indeed, had served as a major character—in *Notre-Dame de Paris* and *Les misérables*. Haussmann had destroyed history, but he had not been able to destroy memory. *Les misérables*—which Hugo had written in large part while on the Isle of Guernsey—summoned up the Paris that he had known so well before his departure in 1851.

But when Hugo returned to Paris in triumph in 1870, he found a city he no longer recognized, set out along broad boulevards that served a distinctly military as well as aesthetic purpose. The churches still existed—Saint-Merri, Saint-Médard, Saint-Jacques du Haut Pas, and of course Hugo's beloved Notre-Dame, which he had almost single-handedly saved from irreversible decay and ruin. But so much else did not.

Not surprisingly, such changes dismayed Hugo, an ardent lover of the Gothic—one who proclaimed that Paris had reached architectural perfection in the fifteenth century, only to come downhill ever since. Touring the city on the Petite Ceinture, the circular railway that since 1852 had run along the inner wall of the Thiers fortification, he commented with considerable irony, "Fascinating. Paris demolishing itself in order to defend itself—a magnificent sight."[9]

⌐∿

Paris had of course undergone considerable demolition and change throughout the centuries, although nothing quite as far-reaching as what Haussmann and the Second Empire undertook. Philippe-Auguste's twelfth-century wall—a hulking physical presence for several centuries—had long since been bypassed by an expanding population and fallen into ruin. The wider-circling fourteenth-century wall that sheltered *Notre-Dame de Paris*'s thieves and gypsies had been destroyed by none other than Louis XIV, who loftily pronounced the irrelevance of such a fortification in light of his proven prowess as a military commander. Louis then had this wall replaced with today's Grands Boulevards, a demolition scheme that seems to have pleased everyone.

The eighteenth century brought an even wider-circling tax wall, which its proponents mistakenly thought would charm Parisians with its sublime architecture, especially its neoclassical tollhouses, which were designed by one of the foremost architects of the day. Instead, these tollgates were among the first targets of the irate Paris populace during the opening days of the 1789 revolution.[10] Still, the wall itself remained in place for decades longer, as two emperors and a sequence of returning monarchs agreed that the customs it collected were unquestionably useful. Only in 1860 did it come down, thanks to Baron Haussmann, who perceived that the Thiers fortifications (which encompassed Paris in an even larger circle) could serve the same purpose, and to much better effect.

A fortification rather than a mere tax wall, the massive Thiers structure—built in the 1840s and named after the same Adolphe Thiers who in 1871 was once again head of government—turned out to be especially useful as a tax barrier. Of course its original purpose was defensive, with an eye toward the northeast and a reunited Germany. That it failed miserably during the Franco-Prussian War—and just as miserably during the Commune uprising—did not persuade the government of the Third Republic to tear it down. Not until after World War I did it finally disappear, ultimately to be replaced by Paris's unloved ring road, the Périphérique.

In the meantime, the removal of the older tax wall in 1860 meant a new look for Paris. Villages such as Montmartre, Belleville, and Grenelle

now were incorporated into Paris proper, with the city's original twelve arrondissements, or administrative units, expanded into twenty, completing the number of arrondissments and establishing Paris's administrative limits as they exist today.[11] This meant that the barrier that once divided the city from such outlying areas as the Butte of Montmartre had now disappeared, its path marked only by a series of boulevards, such as the Boulevard de Clichy, that once ran alongside it. Soon Parisians in search of a good time flocked northward to the cabarets that began to open in Montmartre.

Unlike these well-to-do pleasure seekers, the residents of those regions once beyond the wall, much like Zola's Gervaise Lantier, found it almost impossible to leave their particular hellholes once industrialization and its accompanying poverty set in. Those who did manage to cross the great divide, leaving their poverty and former addresses behind, typically did so in much the same fashion as Gervaise's daughter, Nana—as common street prostitutes or, if especially ruthless and fortunate, as high-society courtesans, living in the shadows of upright society. It seems hardly surprising that Nana and others like her treated the world with as much contempt as the world had treated them.

～

"What terrible events, and how shall we come out of this?" wrote Edouard Manet to his young artist friend, Berthe Morisot. "Each one lays the blame on his neighbour, but to tell the truth all of us are responsible for what has happened."[12]

Morisot's response is not recorded, but her parents certainly would not have agreed with Manet. For years, Madame Morisot had chaperoned young Berthe and her sister on their regular outings to the Louvre, where they studied and painted. For years, Madame Morisot had disapproved of the young men they had met there, but Edouard Manet and his two brothers, Gustave and Eugène, were a different matter. The Manet brothers came from exactly the sort of social milieu that would recommend them to the family of a sheltered young woman of the Parisian *haute bourgeoisie* such as Berthe Morisot.

Still, there was an element of danger to the brothers, especially Edouard, that Madame Morisot found worrisome, even if her daughter did not. Elegant and sophisticated, Edouard was a ladies' man. He was also a painter of provocative pictures. His *Le Déjeuner sur l'Herbe* (*Luncheon on the Grass*), with its startling juxtaposition of clothed men and a nude woman, as well as his *Olympia*, with its brazenly sexual courtesan, created a hullabaloo in the art world before eventually being acknowledged as masterpieces. And then there was the matter of his politics. Madame Morisot, who along with her husband was a firm supporter of Thiers, thought Manet's sympathy for the Communards was

totally incomprehensible. By contrast, she and her husband took considerable pride in their son, Tiburce, and his decision to join the Versailles government's general staff. Yet neither of the senior Morisots was enamored with the full-fledged monarchists in the Versailles government. The Morisots were—like Thiers—constitutional monarchists, and they were just as wholeheartedly anti-Communard.

For his part, Manet was appalled by the suffering he saw in Paris during Bloody Week. He had left Paris toward the end of the siege, not returning until late May. His response to what he saw was based on sympathy with human suffering as well as revulsion at the brutality of the Versailles troops. But Manet, like Clemenceau and Zola, was no Communard. He was instead an ardent supporter of a liberal republic, a patriot who had—along with Edgar Degas—joined the National Guard to defend Paris from the Prussians.[13] He was appalled by the violence and repression practiced by the government troops, but he was equally unnerved by the Commune. For every story of a friend or acquaintance who had experienced a close brush with death at the hands of a government firing squad, there were stories of mistaken identities and narrow escapes from death at the hands of the Communards.

Among the latter, one of the most striking stories is that of Pierre-Auguste Renoir, who was quietly painting along the Seine when several passing Communards took note of the "mysterious signs" with which he covered his canvas. Anyone who painted like this, they concluded, could not be a real painter; he must be a spy, hard at work at creating a plan of the quays of the Seine in preparation for the landing of enemy troops. Ignoring his protests, they brought him back to the *mairie* of the sixth arrondissement to be shot. Here, Renoir most fortunately spotted a familiar face—Raoul Rigault, who now was the Commune's police chief but who in the days of the Second Empire had once found refuge with Renoir while on the run from the police. Rigault embraced Renoir, presented him with accolades to the crowd ("La Marseillaise for Citizen Renoir!") and promptly released him—now equipped with a pass to leave Paris.

In addition to his artistic daring and liberal political persuasions, Edouard Manet had yet another problem—at least, from the senior Morisots' point of view. Not only was he a womanizer, he also was a married man. To make matters worse, his marriage was hardly a conventional one. His wife, Suzanne Leenhoff, came from a respectable-enough Dutch family and had been the piano teacher to the Manet brothers before attracting Edouard's attentions. She may also have attracted the attentions of Edouard's father, and the son she bore out of wedlock could have been the child of either—although the boy, who was treated kindly by the family, was never acknowledged by either man. In any case, Suzanne was Edouard's mistress for many years before he

most surprisingly married her, shortly after his father's death. Shielded by the entire Manet family, she escaped the kind of social ostracism one might expect, and eventually she was accepted even by Edouard's formidable mother, Madame Manet.

Still, Edouard Manet seems to have remained a problem for the senior Morisots—especially since, by 1871, Berthe Morisot was still unmarried and approaching the age of thirty. Worried about her daughter's future, Madame Morisot found Berthe's determination to paint quite incomprehensible. Originally, when the teen-aged Berthe and her sister Edma first showed a flair for art, the Morisot parents had unhesitatingly provided their daughters with teachers. After all, it was considered appropriate for a young woman in their circle to paint or to play a musical instrument competently. But while Monsieur and Madame Morisot were embarked on burnishing their daughters' social graces, Berthe soon realized that she possessed ability and need for expression that far outstripped the conventional amateurism that her social standing and gender permitted. Even more dismaying, she was developing an entirely unconventional way of painting. Having rejected the static stage sets of the studio for the more revolutionary out-of-doors, she was already striving to capture the fleeting moments of everyday life—the style that derisive critics would soon call Impressionism.

Monet, Renoir, and Pissarro, painting in tandem, were simultaneously pressing for this same goal. "I have a dream," Claude Monet wrote in 1869, envisioning the magic glow of light on water that enveloped the Grenouillère, the famed floating café on the banks of the Seine in Croissy-sur-Seine, near Paris.[14] Renoir shared this dream, and the two artists agreed to paint the scene together. Shortly after, Camille Pissarro made his own artistic breakthrough with Monet, painting in the nearby hills above Bougival. What is especially remarkable about Berthe Morisot, though, is that although she was unable—because of gender and background—to join her fellow artists at local cafés, she developed her vision and techniques on her own.

Driven by an increasingly clear and radical vision of what to paint and how, Berthe Morisot was plagued with constraints. Although the Salon (the official exhibition of the Académie des Beaux-Arts) opened its prestigious doors to her most conservative paintings, her artistic integrity recoiled from this acclaimed but stodgy venue. At the same time, her parents urged her to marry. Appalled by the fate of her sister, who reluctantly set aside her paintbrushes when she wed, Berthe held marriage at arm's length, enduring chaperones for every outing and remaining resignedly in her parents' home. Men unquestionably found her dark beauty attractive, but with the single exception of the painter Puvis de Chavannes, whom she found stuffy, her talent and intelligence kept most suitors at bay.

And then there was Edouard Manet. Manet seemed fascinated by Berthe Morisot, painting her almost a dozen times, including his famous *The Balcony*, where she appears—dark and ravishing—as the painting's focus. In another of his paintings, *Berthe Morisot with a Fan*, she seems flirtatious, showing a pink-slippered foot and ankle while coyly hiding her face behind a fan. Although political differences certainly had an impact on Madame Morisot's increasing disapproval of Edouard Manet, his friendship with her daughter, along with its dangers, may well have exacerbated her alarm.

Still, Berthe seems to have resisted Edouard, maintaining the quiet decorum that her milieu demanded. After all, affairs were not on the approved list for an unmarried woman of Paris's *haute bourgeoisie*. As it turned out, Madame Morisot need not have worried.

∼

While Berthe Morisot remained in Cherbourg with her married sister, others—including Edouard Manet—were returning to Paris. Still others had never left, sticking it out through the worst of the siege and the Commune uprising. Among these, Edmond de Goncourt claims a special place, thanks to the journal that he kept during these and subsequent events, right up until his death in 1896.

Originally the journal was the joint production of Edmond and his brother Jules, both of whom had taken great pleasure in the enterprise, ever since starting it in 1851. When Jules died in 1870, Edmond was sufficiently distraught that he considered stopping the journal, but fortunately—given the enormity of events—he changed his mind. Nobly born, financially independent, and notoriously temperamental, Edmond had an arrogance, egocentricity, and extreme sensitivity that made him a difficult friend. Yet his taste, sensibilities, and wit managed to win him a circle of friends that included some of the most interesting literary figures in Paris.

In addition to the journal, Edmond and his brother had written a good deal of art criticism (successful), some plays (less successful), and a series of novels featuring pathological cases in starkly realistic settings. Their masterpiece, *Germinie Lacerteux* (published in 1865), had a great influence on young Emile Zola and the emerging Naturalist movement. But although Zola was counted among Edmond de Goncourt's closest friends, Goncourt scarcely bothered to hide his envy over Zola's success. Much to Goncourt's dismay, his affected and elaborate style turned off readers, whereas Zola's hard-hitting and straightforward prose appealed to an ever-larger following. But this, too, served to reinforce Goncourt's disdain for a world that did not sufficiently appreciate him.

Not surprisingly, Edmond de Goncourt's opinion of the Commune was less than flattering. "What is happening," he wrote on March 28, "is nothing less than the conquest of France by the worker and the reduction to slavery under his rule of the noble, the bourgeois, and the peasant." Yet he could find a kind of beauty in the horror. "Against the night sky," he wrote during the height of the confrontation, Paris "looked like one of those Neapolitan gouaches of an eruption of Vesuvius on a sheet of black paper."[15]

Upon closer inspection, of course, this macabre beauty disappeared. Within the city, Goncourt noted the ever-present smoke, along with chilling reminders of the fighting: "here a dead horse; there, beside the paving-stones from a half-demolished barricade, a peaked cap swimming in a pool of blood." Touring the ruins, he listed the Palais Royal as burned, but its two wings intact; the Tuileries burned and in need of rebuilding; the Palais de Justice "decapitated," with "nothing left of the new buildings but the iron skeleton of the roof"; the Prefecture of Police "a smouldering ruin"; and the burned-out Hôtel de Ville "all pink and ash-green and the colour of white-hot steel, or turned to shining agate where the stonework has been burnt by paraffin."[16]

He was witness to a Paris in ruins, with ashes and destruction everywhere. But despite the terrible damage and the enormous amount of suffering, the shattered city was already showing surprising signs of life. The day after the Commune had been annihilated, Goncourt sanguinely wrote: "This evening one can hear the movement of Parisian life starting up again, and its murmur like a distant tide." Two days later, he added: "Across the paving-stones which are being replaced, the people of Paris, dressed in their travelling-clothes, are swarming in to take possession of their city once more."[17]

Zola, writing to Cézanne soon after his return, put it more succinctly: "Paris is coming to life again."[18]

Sarah Bernhardt agreed. One morning soon after her own return, she received a notice of rehearsal from the Odéon theater. "I shook out my hair," she wrote, "stamped my feet, and sniffed the air like a young horse snorting." She had realized, with typical exuberance, that "life was commencing again."[19]

But perhaps Edouard Manet put it best of all. Writing to Berthe Morisot on June 10, he told her, "I hope, Mademoiselle, that you will not stay a long time in Cherbourg. Everybody is returning to Paris; besides, it's impossible to live anywhere else."[20]

CHAPTER TWO

~

Recovery

(1871)

In addition to the sting of defeat and the extensive devastation suffered during the siege and Commune, Paris—indeed, all of France—now faced the necessity of paying a huge war indemnity to Germany. Five billion francs! It was an unprecedented sum, equaling the national budget for two and half years, but the French bent themselves to the task. Within a month after the Commune's demise, two billion francs were sent to Germany, the product of a remarkable response to a national loan that the French government floated. Opened on the morning of June 27, it closed—fully subscribed—that same evening.

Zola's biographer, Henri Troyat, notes that by subscribing to this loan, the French had successfully seized upon a way to forget the humiliating foreign war and terrible civil carnage from which they had just emerged: "Patriotism of the wallet followed on the heels of patriotism of blood."[1] Perhaps it was so. Life was still difficult, as Madame Morisot acknowledged in a letter to her daughter Edma. She was apprehensive about the future for a France "split between madmen" (those she termed the "Manet clique," who "railed against Monsieur Thiers") and the monarchists, who "flaunt all their old prejudices." "Poor France!" she exclaimed. "And yet," she added, "the success of the loan made me proud and happy. I invested a thousand of our savings; their value had shrunk to seven hundred."[2]

Following the loan's extraordinary success, a kind of euphoria swept France. Patriotism and a healthy rate of return[3] combined to create a nationwide response that Germany had scarcely anticipated. Bismarck had

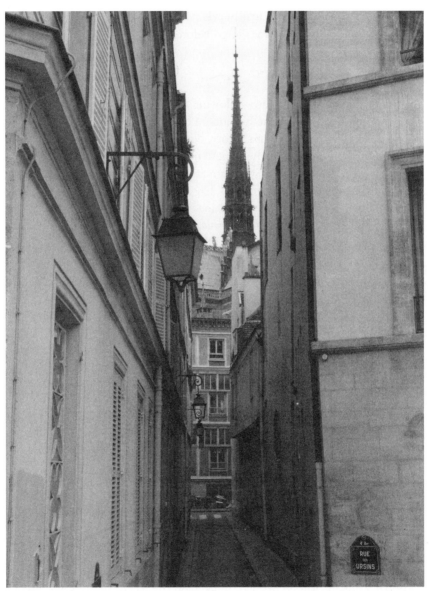

Notre-Dame from the Rue des Chantres, Paris. © J. McAuliffe.

expected that the reparation would drain France's coffers, further weaken its military, and allow the German army to remain on French soil for years. Instead, the French passed this first hurdle with all flags flying. But there were still another three billion francs to go before France would see the backs of its German conquerors.

⁓

Victor Hugo left Paris in a hurry following the funeral of his son, which took place on March 18, just as the Commune burst into being. Heartily approving of the Commune, at least in theory, but leery of its extremism, he hastily departed for Brussels. There he experienced a frightening encounter with the other end of the political spectrum and fled to Luxembourg. He did not return to Paris until September.

The months away had been agonizing, and the return even more so. An entire people, he wrote in *L'année terrible*, had been martyred. Both sides in the uprising had relentlessly shattered the Paris that he adored. And he had adored Paris for a long time. The youngest son of an officer in Bonaparte's army, Hugo was born in 1802 near the Swiss border, in Besançon. Two years later, his mother, a confirmed royalist, gave up on her marriage, leaving Major Hugo to his mistress and his wars. Settling in Paris with her three sons, Madame Hugo acquired a lover of her own, who plotted against Napoleon and ended up facing a firing squad.

In the midst of this festering family life, Victor found refuge in the luxuriously overgrown garden behind his home on the Left Bank. But this was only a temporary refuge. Back and forth young Victor went, between mother and father (now a general); between royalist and Napoleonic sympathies; between Paris, Italy, and Spain. Even Paris at first offered little stability, as one home followed another in depressing secession, leaving the lovely garden well behind.

Surrounded by turmoil, young Hugo began to write and found that he was good at it, winning a major prize from the Académie Française when he was fifteen. Along with his older brothers (who shared his literary ambitions, if not his talent), he founded a literary review, which he filled with an avalanche of poetry and prose. Yet even these triumphs could not entirely distract from his family's ongoing troubles, including the dismal evidence that his brother Eugène was going mad. Indeed, on the day of Victor's wedding to Adèle Foucher, Eugène permanently slipped over the boundary into insanity and spent the rest of his brief life in a padded cell.

Life for young Victor Hugo was beginning to look a lot like a Victor Hugo novel. Still, there were sunny moments, and by his mid-twenties Hugo had achieved an enviable literary reputation and the income to go with it.

He now began to write plays, making his triumphal debut at the Comédie-Française with *Hernani*, where he achieved a memorable coup for the daring new Romantic style.

It was the 1831 publication of Hugo's astonishing novel *Notre-Dame de Paris* that really sent up the fireworks, announcing the arrival of a major literary star. Huge, rambling, and fairly dripping with emotion, this dark Romantic tale quickly became a blockbuster, translated into countless foreign languages, including English, retitled *The Hunchback of Notre-Dame*. Passionately drawn to the medieval architecture and poverty-mired denizens of this ancient quarter, Hugo turned his novel into a not-so-subtle demand for social justice as well as an ode to the past. After centuries of decay, Notre-Dame now vaulted to the forefront of public attention. Saving this neglected twelfth-century masterpiece suddenly became the most popular of causes, and Hugo did not hesitate to ride the wave he had created, prodding restoration efforts that eventually preserved the cathedral.

Soon after publication of *Notre-Dame de Paris*, Hugo moved his family to 6 Place des Vosges, now the Maison de Victor Hugo and the most well-known of his many Paris residences. Here, in this extraordinary seventeenth-century square—which he shrugged off as architecturally uninteresting—he lived for sixteen years in the height of Gothic comfort. During this time he struck up a liaison with actress Juliette Drouet that would last the rest of his life, while wife Adèle turned to Hugo's friend, the writer and critic Charles Augustin Sainte-Beuve. This could not have been the happiest of households, but Hugo continued to pour out torrents of words, including an initial sketch of *Les misérables*. He did not complete it until his long years of exile on the isles of Jersey and Guernsey, where he sought refuge from the repressive government of Napoleon III.

Two decades later, Napoleon (like his uncle before him) had departed into exile, and Victor Hugo had returned to Paris—for the second time in the space of a year. It was not a happy occasion. Unlike his return the previous September, Hugo was not greeted by adoring crowds. His beloved Paris was a shambles, filled with blackened ruins and the forlorn shells of what had once been government buildings, imperial abodes, and comfortable bourgeois dwellings. Tree stumps lined the once-shaded boulevards, while troops still patrolled the streets (martial law would remain in force until 1876). Hugo's family was a shambles as well. In addition to the devastating death of his beloved oldest daughter in a tragic boating accident several years earlier, he had recently lost one of his two sons. In the meantime, his other daughter had slipped into madness.

He consoled himself with beauty where he found it (his womanizing would become increasingly notorious) and dived into the task of recording

his response to the remarkable events of the previous year—*Actes et paroles* (*Deeds and Words*) and *L'année terrible* (*The Terrible Year*). He also did what he could to foster an eventual healing for the nation, focusing in particular on winning amnesty for those Communards who had survived. With this in mind, he tackled the new Republic's president, Adolphe Thiers, who was pleasant but not inclined to budge on the question of amnesty. Hugo had to satisfy himself with a vague promise that his friend the radical journalist Henri Rochefort would not be deported.

⌣

Despite Hugo's efforts, Henri Rochefort (Marquis de Rochefort-Luçay) was in fact deported to New Caledonia, along with several thousand Communards, including Louise Michel, a vehemently radical defender of the underdog and leader of the Commune.

Much like Rochefort, she came from a background that was a far cry from the slums of Montmartre, where she most memorably took to the ramparts. Born in 1830 at the Château of Vroncourt in the Haute-Marne, she was the illegitimate daughter of one of the château's maids and, most probably, the landowner's son. We hear little about the father, but Michel grew up regarding the landowner and his wife as her grandparents, and they in turn took it upon themselves to educate this precocious child by providing her with the writings of Voltaire and Rousseau and by encouraging her to question. Such a liberal education was uncommon during these years, especially for a female, and Michel blossomed under it, growing into a sensitive, observant, and caring young woman.

Like Rochefort, she, too, became a friend of Victor Hugo. At first convinced that she wanted to become a writer, she established a correspondence and friendship with him that lasted the rest of his life. Each admired the other, and it would be Hugo who would write a dramatic tribute to her, the poem "Viro Major," following her defiance of the court in late 1871.

She had come to Paris in 1865, where she used a small bequest from her grandparents to open a day school in Montmartre. Since childhood she had ardently sympathized with the downtrodden, whether people or animals, but until this time she had not been actively involved in politics. Paris soon changed all that. The poverty-stricken residents of Montmartre wrenched her heart and roused her anger. She now embarked wholeheartedly into a life of charity coupled with radical political activity.

The events of March 18, 1871, finally lit the fuse. Michel, who had been active for months in anti-government activity, rallied the women of Montmartre to defend the cannons on the Butte from the government troops who had marched in to seize them. This, and the bloodshed that followed,

precipitated the formation of the Commune. During the frantic two months that followed, Michel threw herself into revolutionary activity, mobilizing women in support of the Commune, serving as an ambulance worker, and organizing day care for children in the besieged areas. But most memorably, she fought on the barricades as a member of the National Guard, in the Montmartre Sixty-first Battalion, fighting in battles from Issy and Neuilly to Les Batignolles and Place Blanche, from Montmartre cemetery to the barricades at Clignancourt. Hardly sleeping, she practically lived on adrenaline. "Barbarian that I am," she later wrote in her memoirs, "I love cannon, the smell of powder, machine-gun bullets in the air."[4]

After the last of the Communard resistance was shot down along the eastern wall of Père-Lachaise, Michel was arrested and brought to trial. There she defiantly dared the court to kill her. "Since it seems that any heart which beats for liberty has the right only to a small lump of lead," she told the court, "I demand my share"—a dramatic plea for death undoubtedly prompted by the massacres she had witnessed as well as by the execution of her dear friend (and possibly lover), Théophile Ferré.[5]

Instead of granting her wish, the court sentenced her to what it probably believed was a slower form of death—deportation to the harsh penal colony in France's South Pacific islands of New Caledonia. There she remained, defiantly surviving. Paris, it turned out, had not seen the last of the woman whom her antagonists derisively called the "Red Virgin."

Georges Clemenceau's father idolized Victor Hugo and detested the political right wing and the Church. The son wholeheartedly embraced these views, which would influence him through his long political career. Moreover, friends of the father, such as the long-time republican Etienne Arago, would influence young Clemenceau as well, helping at crucial points along the way. Indeed, Arago, as mayor of Paris after the fall of the Second Empire, was the reason behind Georges Clemenceau's sudden elevation to mayor of the eighteenth arrondissement, having selected him (along with the mayors of the other nineteen arrondissements) for the position.[6]

When Clemenceau returned to Paris after the Commune's annihilation, he opened his neighborhood clinic in the heart of Montmartre and once more dived into politics. But he discovered a Paris that not only had been shattered by siege and war but also had been stripped of its political preeminence. In the aftermath of the Commune, there no longer was a mayor of Paris, and indeed—thanks to the precautions of the Thiers government and those that followed—there would not be one for more than a century. But even though Clemenceau was defeated in the July national elections to the

Assembly (the winners were of a far more conservative stripe), he was not discouraged. After all, the great Victor Hugo had also been denied a victory in this election, although Hugo had attracted an impressive number of votes considering that he had refused to officially enter his name.

On the other end of the political spectrum, Bonapartism had gone down in flames with the Second Empire, and for the moment, the threat from the royalist right was blocked by its own standard-bearer, the Comte de Chambord, who stubbornly insisted on replacing the tricolor with the Bourbon white. In fact, the clear winner of the July elections was Thiers, who now—despite his long history of support for the Orléanist monarch Louis-Philippe—favored a republic, albeit a conservative one. It was the only course, Thiers concluded, reading into the July vote that France did not want to return to a monarchy or an empire, but just as firmly did not want a government that reminded it in any way of the Commune.

Yet a conservative republic was not the sort of republic that Clemenceau had in mind. Much like Hugo, whom he vastly admired, or Manet, who in time would become a good friend, Clemenceau was leery of revolution but heartily embraced reform. His only course at present was to enter local politics, which he did with characteristic energy. Paris had been left with only a municipal council, which served merely as an advisory body under the prefect of the Seine. But it was better than nothing. In late July, Clemenceau stood for election and won a seat on the council, where he soon began to play a leading role in the matters that concerned him most—public health, education, and assistance to the poor, especially to impoverished and abandoned children.

He also was concerned about friends such as Louise Michel, with whom he had worked during the height of the siege to help the most destitute of Montmartre's residents. With her help he had organized distribution centers for food and medicine. With her help he also had started up free schools for the children. He worried about her fate, as well as that of her sick mother. Eventually, after Michel reached New Caledonia, he sent her money, and in time he would push for amnesty for the Communards. But not now. Not in 1871, and not from his lowly perch on Paris's municipal council.

～

Frédéric Auguste Bartholdi first had the idea of a gigantic statue in the late 1860s, following a memorable trip to Egypt. The Suez Canal was then nearing completion, and he proposed a lighthouse for its entrance, consisting of an enormous female figure holding a lighted lamp.

Bartholdi always protested that this Egyptian project, which never came to anything, had little influence on his Statue of Liberty. We will never

know. But what we do know is that when the prominent French historian and liberal politician Edouard de Laboulaye approached Bartholdi in June 1871 with the idea of a huge monument to liberty from the French to the American people, Bartholdi enthusiastically signed on. Commissions had dried up in the aftermath of Commune, siege, and war—and in any case, Bartholdi was enthralled with the idea of creating a huge sculpture on the scale of the ancient Colossus of Rhodes.

The idea of a monument to liberty was not entirely new in 1871. In fact, Laboulaye—a great admirer of the United States—had brought it up in a dinner table discussion in 1865, during the Second Empire. At that time, Laboulaye and his republican friends had conceived of the idea as a commemoration of the centennial of American independence. By 1871, it no longer was possible to construct such a colossus in time for the 1876 celebration. But that seems not to have mattered, for the date probably had never been more than a good hook from which to hang a political statement. Looking at Paris and at France in the wake of the multiple disasters of 1870–1871, Laboulaye and his colleagues concluded that now, more than ever, was the time to make a statement about liberty. Yes, it would be a gesture of friendship to the American people, but more importantly, it would be an attention-getting reminder for the French—this at a time when Laboulaye, looking at the French political landscape, believed that liberty in France was once again in jeopardy. He deeply feared that his nation, having been whiplashed between revolution and reaction for almost a century, faced infinite dangers. The French people would have to choose, and a powerful image such as a statue dedicated to Liberty would help point the way.

Bartholdi shared similar sentiments and, thoroughly committed to Laboulaye's cause, conceived of his gargantuan statue as Liberty Enlightening the World. By June 1871, he had embarked for the United States, where Laboulaye had arranged for him to meet numerous American luminaries, including President Ulysses S. Grant, to do what he could to drum up enthusiasm for a national fund-raising movement. After traveling from coast to coast, Bartholdi returned to France, convinced that Americans would support this magnificent project. He was ready to begin.

~

As it turned out, a man by the name of Gustave Eiffel would prove essential to the success of Bartholdi's vision. But in June 1871, as Bartholdi was about to sail for the United States, Eiffel was far more interested in his company's financial prospects than in any republican projects on behalf of liberty, no matter how enlightening. Eiffel was an eminently practical man and, at the

age of thirty-nine, already a successful one, on the brink of what would become a breathtaking career.

Oddly, he had almost ended up spending his life running his uncle's vinegar factory. Preparing for this sensible but undramatic career, he passed up the fields of metallurgy, mechanics, and civil engineering in favor of chemistry—a rather astonishing choice, given his eventual triumphs as an engineer. But a family feud put an end to young Eiffel's vinegar prospects, leaving him free to pick another profession.

Not that the young man at first had any idea of what he wanted to do. But luck and family connections eventually brought him to the office of Charles Nepveu, near the Gare Saint-Lazare. The year was 1856, and Nepveu's iron-working firm was located right in the center of the booming new railroad business. If Eiffel was nervous at his interview, he had every reason to be. Although he had briefly worked for his brother-in-law at an iron foundry near Paris, his academic record was dismal. Like so many gifted youngsters, Eiffel had been bored in school and rarely excelled. Even when he somehow managed to pass his *baccalauréats* and enroll in Paris's Collège Sainte-Barbe, he wasn't able to pull off the grades necessary to get him into the prestigious Ecole Polytechnique. Instead, he went to the Ecole Centrale des Arts et Manufactures, the school of civil engineering, which was then located in the Hôtel Salé on Rue de Thorigny, 3rd (now the home of the Musée Picasso). Unquestionably, this gave him a valuable practical education. Still, when Nepveu decided to hire Eiffel as his private secretary, the older man was going pretty much on instinct. Little else pointed to the brilliant career that lay ahead.

Little else, perhaps, except for a strain of remarkably successful craftsmanship and entrepreneurship that ran through the family. Eiffel's father's forebears had moved from the Eifel region of Westphalia to Paris and prospered there (under the name of Eiffel) as master weavers and tapestry makers. But it was Eiffel's mother who was the real dynamo in the family. The daughter of a successful Dijon timber merchant, she took over her family's charcoal business and became a major regional distributor of coal. Neither marriage nor motherhood derailed her career, which she pursued single-mindedly. When the family became wealthy, it was entirely due to Eiffel's mother, not to his father, who had abandoned an unpromising military career to become a local government administrator.

Young Eiffel was raised by his grandmother in Dijon until he moved to Paris to complete his education. He enjoyed Paris, but his career there was lackluster until that chance encounter, at age twenty-three, with Charles Nepveu. And then, as if something inside him suddenly ignited, the young

phenomenon rapidly emerged. Eiffel took it upon himself to become familiar with the company's widespread enterprises and even studied economics on the side. He continued to soak up experience, learning all he could about iron. Soon after, when Nepveu sold his business to a large Belgian firm, Eiffel received a good position there.

It was now that Eiffel the master engineer began to emerge. Bordeaux needed a railroad bridge to cross its river, the wide and turbulent Garonne. Nepveu made Eiffel his assistant in the project, but soon the older man resigned, leaving Eiffel with a bear of a project and a two-year deadline. The twenty-five-year-old engineer rose magnificently to the challenge, introducing new techniques and demonstrating remarkable management abilities. He completed the project on time and without incident—an extraordinary accomplishment.

Eiffel brought many talents to the table, but one of his greatest was the recognition that iron as a building material required radically new design and construction methods. Wood and stone could accommodate an ad hoc approach to building operations, and throughout the centuries, cathedrals and castles alike had been argued and reevaluated as they went up, sometimes surprisingly well into the process. But Eiffel completely rejected this trial-and-error approach, insisting that every component of his projects come ready for assembly, without any on-site adjustment or alteration. This revolutionary method, founded on exact mathematical calculations, may have caused many at the time to scratch their heads, but Eiffel's iron bridges and buildings soon became renowned for their precision and reliability, even as they won admirers for their astonishing lightness and grace.

After Eiffel's marriage (to the granddaughter of a Dijon brewer), he and his bride moved to a large house in northwest Paris—an area where he would live, at several addresses, for the rest of his life. Soon after, he went into business for himself, establishing workshops just over the city line in what now is Levallois-Perret. His business expanded rapidly, and soon he was building bridges and buildings all over the world.

Yet in June of 1871, he could not foresee the future, and the fragility of the French economy concerned him. Responding to the unpredictable domestic economic situation, Eiffel vigorously sought out contracts abroad, sending one of his company's directors to Latin America to wrap up large contracts in Chile, Bolivia, and Peru. Other foreign jobs followed, in locations that spanned the globe—from Romania to Cairo, and from Russia to the Philippines.

It was an ever-more-lucrative and rewarding career. And if Eiffel had but known, this was only the beginning.

⌒

The year 1870 brought not only the defeat of France and the fall of the Second Empire, but the capture of Rome—the final event in the long march toward Italian unification. The two stories were intertwined, for Napoleon III had for several years used French troops to defend the pope, who was determined to retain temporal power in Rome, the last remaining vestige of the once-mighty Papal States.

Napoleon was a Catholic sovereign who ruled with the support of conservatives and the Catholic clergy. Although believing that it was his duty to support the pope, he had proven willing to let Italian unification proceed in exchange for rounding out France's boundaries with the acquisition of Nice and Savoy—a policy that alarmed France's most stalwart Catholics, who cared little for what went on outside of Italy and feared for the pope. Their worst anxieties were realized when, after a series of Prussian victories, Napoleon pulled his garrison back from Rome. Italian troops now poured into the Holy City, marking the end of an era not only for the history of Italy, but for Christendom.

Significantly, it was while the final act of Italian unification was drawing closer that the First Vatican Council (on July 18, 1870) declared the doctrine of papal infallibility—increasing the pope's power in the spiritual realm at the very moment when his temporal powers were appreciably waning. Napoleon, who had celebrated the event by declaring war on Prussia, had a far different ending in mind, one in which France and the pope would emerge triumphant. Instead, a year later, as Paris and Parisians began to pick up the pieces of their lives, the once-powerful Papal States and the empire of Napoleon III had both disappeared. The towering column in the Place Vendôme, symbol of the first Napoleon's magnificent victories, had been pulled down, while the Tuileries Palace, the official Paris residence of Napoleon I and III, was now a burned-out shell.

But the Concordat of 1801—the agreement between Church and state in France—remained. According to this agreement, worked out by Bonaparte and the then-current pope in the wake of the Revolution, Roman Catholicism was defined as the religion of the majority of the French. The Concordat also stated that the clergy would henceforth be paid by the state. In turn, the Church renounced its claims to the (extensive) property it had lost during the Revolution, and, in a concession that put an end to centuries of acrimony between Church and monarchy, agreed that the nomination of bishops would henceforth be the prerogative of the state, with the pope retaining the canonical portions of the investiture process.

When the Concordat was signed, France was almost irreparably divided between deeply religious Catholics and out-and-out secularists—those who had ardently opposed and those who had just as ardently supported the Revolution. Not surprisingly, during the years that followed, the Catholic Church became the refuge and the rigorous defender of the royalist and imperial right, while reformers and radicals of all varieties became the opponents of the Church and its entrenched conservatism.

While there were various degrees of belief among Catholics throughout France, Paris had for years been a center for those alienated from and opposed to the Church, as well as being opposed to organized religion in general. This alienation stretched from Paris's reforming politicians and intellectuals to its workers. When young Georges Clemenceau wed an American bride in the United States, he refused to be married in a church, any church—an insistence that so offended his intended's guardian that young Georges almost sank his matrimonial chances.[7] Louise Michel, despite her youthful attraction to mystical Catholicism, had become strenuously anti-clerical, and she typified the thousands of Parisian workers who had risen up during the Commune against a broad spectrum of injustice. For her and for the workers she so ardently defended, the Church and the clergy were as despised as the emperor and his minions.

After the Commune's violent demise, royalists and the bishops alike demanded French support for the pope, pleading that Rome should be restored to the papacy. Thiers astutely managed to avoid these treacherous waters, but the issue remained, ready to be fanned into flames. In the meantime, religious fervor spread among the devout, who responded to the chaotic events of 1870–1871 with a massive outpouring of piety, expressed in numerous visions as well as in mass pilgrimages to holy sites throughout France. For years, when difficulties arose, devout (and politically conservative) French Catholics had believed that France was being punished as a nation for its sins—most especially for its sins of anticlericalism and secularism, which the pious viewed as the evil offspring of republicanism and the Revolution. Now, surrounded by catastrophe on all sides, devout Catholics were quick to conclude that such sins—including the irreligion and decadence of the Second Empire, and especially France's failure to go to the aid of the pope—lay at the root of the otherwise unaccountable disasters that had befallen their beloved country. Unquestionably, God had sent these disasters to scourge the entire nation of its deep-seated moral rot.

It was at the height of the siege of Paris that a certain Alexandre Legentil proposed that the French take a vow to build a great church in Paris if God saved their nation and the pope. A Jesuit by the name of Père de Boylesve

had already suggested the idea of a French basilica dedicated to the Sacred Heart. His sermon was widely distributed, and by 1871 the two ideas had come together.

Although the outcome for neither Paris nor the pope was exactly what Legentil had in mind, both at least survived, even if by the skin of their teeth, and the new Archbishop of Paris, Cardinal Guibert, approved the vow as an unconditional promise, which the pope endorsed. This meant that the faithful were now committed to building a basilica dedicated to the Sacred Heart—a cult whose adherents had once included the doomed monarchs Louis XVI and Marie Antoinette and whose emblem had become the emotion-laden symbol for counterrevolutionaries, royalists, and conservative Catholics throughout France.

More than this, the site that beckoned above all others for the proposed basilica was the equivalent of sacred ground for the workers of Paris—the very spot where the Commune had begun its daring and ultimately fatal quest.

CHAPTER THREE

~

Scaling the Heights

(1871–1872)

Although I am very Republican," Sarah Bernhardt confessed in her memoirs, "I liked the Emperor, Napoleon III." She had also harbored a secret prejudice against Victor Hugo, whom she had heard spoken of, ever since her childhood, as "a rebel and a renegade."[1]

This may seem curious, given Bernhardt's own reputation, for although she smoothed over the rougher edges of her biography for her adoring public, she had been schooled for scandal from the start. Born in 1844 on the Left Bank of Paris (probably in the attractive residence at 5 Rue de l'Ecole-de-Médecine, 6th), she was the eldest daughter of a pretty Dutch courtesan who had clawed her way out of poverty and into the arms of a series of wealthy protectors, one of whom (we do not know which) was Sarah's father. Expected to earn a living, Bernhardt first turned to acting—a likely enough profession at a time when actresses were expected to have dubious morals and the casting couch was an assumed part of the job. Fresh out of the Conservatoire, she made her debut at the Comédie-Française—starting at the top. But she was young and inexperienced, and she did herself no favors with her volcanic temper, more suited to a diva. Discouraged by cold treatment and bad reviews, she left the theater for a series of adventures, one of which left her pregnant with her beloved son, Maurice.

Unquestionably, she could have been successful at her mother's profession, but fortunately she decided to give the theater another try. The director of the Left Bank Théâtre de l'Odéon gave her a chance, and she persuaded him to keep her on until, after two long years, she at last had a hit. The

Franco-Prussian War and the Commune interrupted her career, but as soon as Paris got itself back together, she returned to the Théâtre de l'Odéon.

It was only a few months after her return that she learned that her company was going to perform Victor Hugo's historic melodrama, *Ruy Blas*. Despite her prejudice against Hugo, she badly wanted to play the role of the queen, and she communicated this via friendly channels to "the illustrious master." She won the part, but the subsequent reading was to be at Hugo's residence, and Bernhardt—flattered by her sycophants—was miffed. The theater was much closer. How dare he ask her to inconvenience herself! In a snit, she begged off, claiming illness, and only met Hugo a few days afterward, when she was astonished to find him so "charming, so witty and refined" that he won her over completely. The culmination of her delight in Hugo came on opening night when, after the performance, he went down on bended knee to thank her. "Ah, how small I felt," she wrote, "how ashamed and yet how happy!" "I had become so rich in hopes [of the] future," she added, "that I was afraid of thieves."[2]

Soon after, she received an invitation to return to the Comédie-Française. Soon after, as well, Victor Hugo published *L'année terrible*, his powerful book of poems on the terrors that Paris had so recently suffered. Throughout, he expressed his outrage at the censorship that still existed in post-Empire France by provocatively omitting certain passages, whose absence he indicated by conspicuous lines of dots.

The entire first printing sold out before noon on the day it was published.

~

Claude Monet returned from England and Holland during the autumn of 1871, renting a house for his family in Argenteuil, northwest of Paris. He had escaped to London just as the Second Empire collapsed and the Germans were marching in. There he was joined by fellow artist Camille Pissarro, who left behind scores of his own paintings as well as many that Monet had entrusted to him for safekeeping.

It was true that few people yet understood or appreciated exactly what Pissarro and Monet were trying to accomplish with their bold new techniques, but ignorance seems no excuse for the tragedy that took place when the German troops moved into Pissarro's abandoned dwelling in Louveciennes. With no regard for what they were destroying, the soldiers tore pictures from their frames and used them as floor mats and aprons (the house had been turned into a regimental butcher shop). Although Monet was eventually able to recover many of his paintings, almost all of Pissarro's prewar output was irreparably damaged or destroyed.

La Butte Montmartre en 1866 (*Alfred-Eloi Auteroche, 1831–1906). Paris, Musée Carnavalet. © Musée Carnavalet / Roger-Viollet / The Image Works.*

Even before this disheartening reversal, Pissarro had suffered years of poverty while trying to establish himself. Monet, too, had experienced the financial insecurity and rejection that so often accompany attempts to push the boundaries of tradition. Born in Paris and raised in Le Havre, where his father was a well-to-do grocer, young Monet returned to Paris after deciding to become an artist. (It was at this time, in one of the studios, that he met Pissarro.) Rejecting his father's offer to buy out his discharge from military conscription in return for joining the family business, Monet instead opted for conscription and was promptly sent to Algeria. After two years in Africa and a severe case of typhoid, his aunt came up with the money to have him released from his remaining years of service. At this time his father, who was facing unexpected financial demands, promised to continue Monet's allowance only if he would agree to enroll in an official studio. It was upon entering the studio of Charles Gleyre that Monet met Renoir, Alfred Sisley, and Frédéric Bazille.

Gleyre pretty much left his pupils to do as they wanted, but even an indulgent teacher such as Gleyre was far too restrictive for Monet, who longed to be free and out-of-doors. When Gleyre's studio closed in 1864 for lack of funds, Monet left all studios for good, painting nature in spots ranging from Fontainebleau to Normandy with an evolving technique influenced by the work of Corot, Courbet, and Manet. Eventually Renoir, Sisley, and Bazille joined him on his rambles, and it was under Monet's tutelage that they learned how to paint en plein air, acquiring totally new techniques to capture the fleeting moment.

There were scattered portents of success, such as when the Salon accepted two of Monet's seascapes for exhibit—much to the irritation of Edouard Manet, whose Olympia had just been pummeled by critics and whose name was so similar to Monet's that a number of people confused the two and congratulated Manet on Monet's paintings. "Who is this urchin with his despicable pastiches of my painting?" Manet is supposed to have demanded, leading those who wanted to introduce the two to reconsider, at least for the time being.[3]

Manet had already shocked Paris critics—and inspired Monet—with his startling Le Déjeuner sur l'Herbe, shown at the 1863 Salon des Refusés, the venue for avant-garde works that were not accepted by that year's Salon. Whatever Manet's critics thought, Le Déjeuner sur l'Herbe inspired Monet and his own subsequent Luncheon on the Grass, a huge painting that he never was able to complete. Still, although depicting a more conventional scene than the one that Manet had daringly portrayed, Monet nevertheless undertook a bold departure by embracing open-air painting, complete with a soft light filtered through the trees.

Despite the reputation for "prettiness" that Monet's paintings would in time receive in some quarters, his goal was always to portray everyday reality rather than the accepted and stilted subjects of history and antiquity—in much the same spirit as Zola, who was also finding his way during these same years. Monet's approach was entirely different from Zola's, of course, for in breaking away from the conventional modes of representation, he focused on light and beauty rather than grittiness and sordidness—on attractive land- scapes and ordinary people enjoying themselves in the out-of-doors. Even Monet's cityscapes from the 1860s show Paris at its best, not its worst. But whether or not Zola truly understood art or Monet (as he probably did not), he recognized a rebel when he saw one and, from his journalistic perch in the mid-1860s, encouraged Monet to continue what he was doing. "There is more than a realist here," he wrote in 1866, wearing his art critic's hat. "There is an able, delicate interpreter who knows how to register every detail without lapsing into dryness."[4]

Claude Monet, of course, was still the new kid on the block in comparison with Edouard Manet, who by then was the established leader of the Parisian avant-garde. While encouraging Monet, Zola at the same time paid tribute to Manet as the foremost painter of his day. "I do not think it is possible to obtain a more powerful effect with less elaborate methods," he wrote. "The place of M. Manet is decidedly at the Louvre."[5]

It would be many years before a painting by Edouard Manet would hang in the Louvre, and when it did, Claude Monet would have everything to do with it. But in the meantime, Parisian cognoscenti amused themselves with the similarity of the two names. "Monet or Manet?" the caricaturist André Gill asked, in a caption to his sketch of Monet's *Woman in a Green Dress*. The painting was "Monet all right," Gill informed his readers, "but we owe this Monet to Manet. Bravo, Monet! Thanks, Manet!"[6]

It was not until 1869 that Claude Monet became a friend of Edouard Ma- net, joining Manet's circle, which by now included Zola, Cézanne, and De- gas. Monet in turn introduced Sisley, Bazille, and Renoir to the group, which met evenings at the Café Guerbois in the Batignolles district, at the edge of Montmartre. "Nothing was more interesting than the talks we had," Monet would later write, "with their perpetual clashes of opinion. . . . You always went home afterwards . . . with a new sense of purpose and a clearer head."[7]

Accepted by the avant-garde but rejected by the all-powerful Salon (after a promising beginning, when it accepted several early works), Monet faced financial failure and critical ridicule. These difficult years were made all the worse by a break with Monet *père* over Monet's liaison with his model Camille Doncieux, who in 1867 gave birth to his son, Jean. (Monet would marry Camille three years later, just before the Franco-Prussian War and his

dash for safety in London.) As the 1860s drew to a close, Monet found himself hounded by creditors even as he was convinced that he was on the brink of an artistic breakthrough—the breakthrough that began while painting with Renoir at the Grenouillère, on the Seine, and was reinforced the following winter by painting snow-covered landscapes with Pissarro in nearby Louveciennes.

And then the Prussians poured in, turning many of his and virtually all of Pissarro's paintings to dust. It could have been worse: Monet's friend and artistic collaborator Frédéric Bazille had joined a line regiment and was killed in action. Monet and Pissarro were still alive, but they also were still struggling to make ends meet. Their sojourn in London had luckily brought them into contact with art dealer Paul Durand-Ruel, who bought canvases from them and, in Monet's words, kept both from starving to death. But Monet was still having a tough time financially when he returned to the Paris area late in 1871, to rejoin Camille and Jean. Edouard Manet helped find him a home with an affordable rent in Argenteuil, but plenty of hard times still lay ahead.

⌒

César Ritz returned to Paris in 1872 and to a new job at the luxurious Hôtel Splendid, on the Place de l'Opéra (2nd). It was now, at the age of twenty-two, that he made contacts—especially among rich Americans such as Jay Gould, J. P. Morgan, and Cornelius Vanderbilt—that would serve him well throughout his career. These Americans, newly minted millionaires, had thrived across the Atlantic during France's time of troubles, and soon after the rubble was swept away they began to return to Paris.

"Work hard—and live an upright life," John Wanamaker told Ritz, encouraging him to keep fit and keep to the moral high road. Cornelius Vanderbilt preferred to ramble on about his early struggles and his self-made success, while Jay Gould confidentially told Ritz to avoid letting the new machine age govern him. "Take off your coat now and again and work in a garden," he recommended—advice that Ritz probably found completely unappealing.[8]

He had, in fact, been born the thirteenth and last child of a hardworking farm family in the remote Alpine village of Niederwald, where—like other Swiss farm boys—he learned the necessity of discipline and hard work. But he also concluded that he didn't want to stay in Niederwald. This meant having to learn a trade, so his parents sent him to the cantonal capital of Sion, where he learned French but not much else. They then arranged for him to apprentice at a hotel in nearby Brig, where he worked hard but was dismissed—ironically because his employer thought he didn't have much aptitude for the hotel business.

Still, young Ritz retained his resiliency and optimism, and when word reached him that Paris was about to open its 1867 Universal Exposition and needed workers, he decided to give Paris a try. Starting out modestly enough in a hotel on what now is the Boulevard Voltaire (11th), he did everything from cleaning floors and shining shoes to carrying bags. From there he went on to work in an inexpensive restaurant, and then to a better restaurant on the corner of Rue Royale and Rue St-Honoré (8th). Here he started as an assistant waiter, worked up to headwaiter, and ended up as restaurant manager. He then decided to get a job at the elegant Restaurant Voisin (located at the corner of Rue Cambon and the Rue du Faubourg St-Honoré, 1st). After much pleading, Ritz convinced the director to hire him, but only on the condition that he start all over again, from the bottom. But it was worth it, for at the Restaurant Voisin, César Ritz now entered the world of the rich and famous, where he learned how to move easily among them and how best to serve them.

After leaving France during the height of the Commune, when he escaped to Switzerland, this ambitious young man returned the following year to Paris and to a job as floor waiter at the prestigious Hôtel Splendid. There he served and chatted up a number of self-made men who appreciated young Ritz's newly acquired sophistication, his willingness to guide and serve them, and his commitment to hard work.

Soon Ritz would depart for Vienna and its world exposition, but he would not forget the lessons he had learned in Paris. He knew what he wanted, and he already was on his way.

⌒

There were other ambitious young men in Paris as the city began its recovery. One of these, Ernest Cognacq, had arrived in Paris as an impoverished fifteen-year-old during the Second Empire. After unsuccessfully trying his hand at numerous jobs, he at last set up shop in one of the arches of the Pont Neuf, across from the site of the great water pump known as the Samaritaine. (Once a dominant feature on the Pont Neuf, this pump acquired its name from the bas-relief of Jesus and the Samaritan woman that adorned its façade.) Although the city demolished the pump in 1813, memories of it still lingered when Cognacq began his sales pitch on the bridge, which was a popular place to saunter. It turned out that he was a gifted salesman, and by 1870, his small venture had turned enough profit that he took the next big step and rented a shop on the quay by the Pont Neuf. He named his store La Samaritaine.

Cognacq's store was not the first department store in Paris. In fact, the young woman who became his wife had worked at Bon Marché, which began

its illustrious career in 1869, the year before Cognacq's Samaritaine.[9] The entire point of such an enterprise was to sell large quantities of merchandise to large numbers of buyers, at lower prices (and a lower profit margin) than ever before. Consumers flocked to Bon Marché and Samaritaine, drawn by the lower (and fixed) prices as well as by the delightful ambiance that these stores offered. Rather than stuffy and uninteresting destinations, shoppers (usually women) found themselves in huge and utterly tantalizing emporiums, where goods one didn't really need suddenly became irresistible.

Zola—who wrote of "the feminine character of success, Paris yielding herself with a kiss to the boldest"[10]—understood the attractions that such places offered and described them in infinite detail in the eleventh novel of his Rougon-Macquart series, *Au bonheur des dames* (*The Ladies' Paradise*). Having spent several hours a day for a month at the Bon Marché and the Louvre department stores, and having consulted with the architect Frantz Jourdain, who provided him with an imaginary layout for a fictional store, Zola went to work on his novel. In it he described the tempting displays at his store's entrance, the ingenious and glamorous presentation of goods behind its large and attractive windows, and above all, the theatricality of the store itself, which exuded the enticement of an exotic temple or an Oriental bazaar. He knew that women could lose themselves, and their money, in such places, and many did. That was, of course, the idea.

Although Zola set his story during the Second Empire, he really was writing about the Paris of the Third Republic, with its dizzying rush into mass consumption. The architecture of Zola's fictional store—complete with electrification—looked a lot like the new Printemps, which was under construction even as Zola wrote (the first Printemps had been destroyed in a fire). It also looked a lot like the Samaritaine that Frantz Jourdain would soon build for Ernest Cognacq.

After countless interviews with store employees, Zola also came to understand the mindset of the entrepreneurs behind these enterprises. Whether or not his depiction of Octave Mouret, the upwardly mobile owner in *Au bonheur des dames*, was a specific profile or a composite of all the hard-driving owners of these new *grands magasins*, he certainly captured their determination to win customers and their corresponding willingness to crush any and all of the small tradespeople in their way.

Despite the new department stores' encouragement of their bourgeois customers to overspend on needless "necessities" and luxuries, Cognacq recognized that the bulk of his customers were not wealthy and knew the value of a sou. He strove to give them their money's worth and soon was famous for his motto, "The customer is always right!" As for his own personal life, he was remarkably frugal. He regularly worked fifteen-hour days and never

took a vacation. His wife, Marie-Louise Jay—a hard-working and thrifty young woman of peasant stock—was equally sensible and frugal, agreeing to put off marriage for more than eight years until Cognacq's financial situation was more stable. During this time she worked at Bon Marché, where she learned the business and was promoted to head salesperson in the clothing department. Finally, in 1872, she wed Cognacq. But even now they continued their grueling work routine, with Marie-Louise advising Cognacq on a wide range of business matters while running the clothing department at Samaritaine. All the while, she practiced the most rigid personal economy, on which she outdid even her parsimonious husband. Indignant at one of his few luxuries—cigars costing fifty centimes apiece—she reprimanded him for behaving "as if he were Rothschild!"[11]

Already, Samaritaine was expanding rapidly, with sales increasing threefold from 1872 to 1874. Already, as well, numerous small shopkeepers were feeling the competition and being trampled underfoot. This certainly did not contribute to the Cognacqs' popularity, but popularity was beside the point so far as they were concerned. "I do not aim at being loved," Marie-Louise Cognacq snapped on one occasion. "What I love above all and before all is La Samaritaine."[12]

She and her husband unequivocally held this view and expected their employees to share it with them. As her husband put it, while hiring a new employee (Ernest Cognacq personally interviewed all his prospective employees): "Don't concern yourself with what you are earning; tell yourself only that here you are not wasting your time, for you are learning how to work."[13]

It was a curiously old-fashioned way of approaching what amounted to a revolution in retailing.

～

Emile Zola was born in Paris (1840), died in Paris (1902), and made a career of delving beneath the glittering surface of Emperor Napoleon III's Paris. Yet Zola spent his formative years in the southern climes of Aix-en-Provence, where he and young Paul Cézanne palled around together—an idyllic boyhood spent exploring the sun-washed Provençal countryside.

Zola's Parisian birthplace, at 10 Rue St-Joseph—a narrow back street in the second arrondissement—is marked with a plaque, but none of the addresses upon his return to Paris (at age 18) have received this distinction, and with good reason. After the death of his engineer father (an imaginative but impractical man of Italian and Greek descent), Zola's mother, the daughter of a poor Parisian tradesman, returned to Paris. Here she, her father, and her son lived in grinding poverty in a series of decrepit Left Bank apartments.

Some friends tried to help. A lawyer friend of Zola's father even wangled a scholarship for the boy at the prestigious Lycée St-Louis, but there he was totally out of his depth—a country bumpkin, and a poor one at that. He had never particularly enjoyed school, and now he liked it even less, cutting classes and doing little work. Lonely and bored, he turned away from his classical studies and submerged himself in the romantic literature of the period—Victor Hugo, George Sand, and Alfred de Musset. Not surprisingly, he failed his baccalaureate exams.

What to do now? No decent job would be available to him without a degree. At length, the family's lawyer friend found him work as a clerk at the docks on the Canal St-Martin, but Zola hated it and quit. Since his mother (now working as a cleaning woman) was no longer able to support him, he drifted, destitute, in the slums of the Latin Quarter. Reduced to setting traps on the roof for sparrows and broiling them on the end of a curtain rod, he lived for days with little else but his writing and his dreams.

Cézanne provided temporary rescue, arriving in Paris to study art equipped with a small but regular allowance from his worried parents, who wanted him to become a banker. The two lived together for several months on the seventh floor of a dilapidated building, from where they could look out on Paris and dream. Both would eventually reach their own summits of achievement, although Zola would get there far sooner than Cézanne.

But first, Zola's childhood infatuation with romanticism had to go. Beaten down as he was by poverty, this particular attachment proved fairly easy to leave behind. Prose replaced poetry in his repertoire, and Balzac and (eventually) Flaubert replaced Hugo and Musset as his idols. Most fortunately, Zola's attitude toward work underwent a similar sea change. When a friend of his father recommended him for a job with the publishing house of Hachette and Company, he leaped at the chance. "Saved from Bohemia!" he cried, and never looked back.[14]

Promotion followed promotion, along with regular meals, an expanding waistline, and an increasingly comfortable life. Most importantly, he learned his way around the publishing business—no small achievement for an aspiring writer. His short stories sold first, bringing a heady taste of success. He married, provided for his mother, and found that life was looking better and better. His first book was a collection of his earliest short stories, which Zola came to regard as overly sentimental. Another soon followed, accompanied by some self-promotion that did not amuse his employers, who requested his resignation.

But by now literary fame beckoned, and Zola felt that he had all the tools he needed to acquire it. He wrote a massive amount (much of it as a journalist and critic), with increasing power. He also began to socialize, and

although his long friendship with Cézanne was by now cooling, he replaced it with companions among a circle of like-minded writers and painters, including Monet, Manet, and Renoir.

But the best of his work was about to come. From the outset, he conceived of this masterwork as a whole—as a series of books (there would ultimately be twenty) about several generations of a fictional family, the Rougon-Macquarts. Setting his stories in France's Second Empire, he set out to portray this extended family (both its legitimate and illegitimate branches) in vividly realistic detail. Whether successful businessmen or down-and-out workers and prostitutes, Zola portrayed his Rougons and Macquarts as the products of heredity and environment, a family propelled by raw appetites and ambition. It was powerful stuff, and it would eventually make Zola a wealthy man.

~

In 1871, as Paris was trying to recover from its many calamities, Zola was hard at work gathering material for the second of his Rougon-Macquart novels, *La curée* (*The Quarry*), documenting every detail through the sharp eye—and methods—of a journalist. Paris itself is the quarry in this story, set during Louis Napoleon's 1851 coup d'état, and the scenes of Parisian life that Zola depicted were sufficiently raw that he offended countless readers. He responded in high dudgeon, citing the huge amount of documentation he had collected. "What dominated," he wrote (in a blistering November 1871 letter to the newspaper that was publishing the novel in serial form), "was the foul reality, the incredible adventures of shame and folly, money stolen and women sold. . . . Must I give the names, tear off the masks, to prove that I am an historian, and not a purveyor of filth?"[15]

Although the story was set during the Second Empire, this was not enough to protect Zola from the censors of the new republic. Much to his anger, it was a prosecutor of the Republic who warned him of the danger of printing *La curée*. This, to Zola, smacked of exactly the sort of repression characteristic of the Second Empire that he despised, and he was not reluctant to point this out to his readers. "Alas," he wrote, "they cannot accept the idea that real virtue should know how to guard itself without compulsion and has no need of gendarmes. A society is only strong," he pointedly added, "when it throws the light of day upon the truth."[16]

As Zola had discovered, all was not well in Paris, despite its rapid recovery from the disasters of the previous year. Clemenceau, now on the municipal council, knew this for a certainty. His work with the poor of Montmartre was a constant reminder of the vast underside of Paris life, and he was especially alarmed by the plight of children in Paris's poorest quarters. From everything

he saw, even the most minimal level of state protection of these children, especially those who were illegitimate, was completely ineffective.

Yet those Parisians who were prospering under the new regime had little time for the unfortunates in their midst. Paris was awash in opportunity for those who could seize it, and a second loan, floated in July 1872—this time for three billion francs—attracted an unprecedented public response.[17] With the loan so amply subscribed, France was now on track to repay its war reparations even before the required date in 1874. This meant that German troops would soon be departing from French soil.

Paris—and all of France—rejoiced at the prospect.

～

One October morning in 1872, Cardinal Guibert, then Archbishop of Paris, climbed the slopes of Montmartre with a colleague to look at the proposed site for the basilica of the Sacred Heart, on the very top of the Butte. It was a misty morning, and they could see little. And then, as Monseigneur Guibert meditated on the reason for choosing this particular site, a beam of sunlight suddenly broke through the clouds, revealing all of Paris below them. "It is here," he cried, "it is here, the place of the martyrs . . . where the Sacred Heart should reign."[18]

Which martyrs did Guibert have in mind? Montmartre had throughout history suffered its share of martyrs, the most famous being St. Denis, who according to legend was beheaded there. But as everyone knew, other names held in reverence by the political right were also linked to this particular spot on the top of the Butte: the two generals of the National Guard who had been executed there at the Commune's outbreak, and Guibert's predecessor as Archbishop of Paris, who died at Communard hands.

This highlighted the fact that the site chosen for the basilica of Sacré-Coeur was the very place where the first confrontation between government troops and the people of Montmartre had occurred—the place, in fact, where the Commune was born. Not surprisingly, many Parisians, especially residents of Montmartre and Belleville, were angered by what they viewed as a blatant attempt to wipe out all memory of the Commune by building over and obliterating this site. Worse yet, the offending edifice would be dedicated to the Sacred Heart, a potent symbol of royalist and counterrevolutionary sympathies.

Not only had the Commune suffered a bloody defeat, but its most stalwart supporters would henceforth live their lives in the shadow of a huge monument built to assert, in solid stone, the convictions of the counterrevolution.

~

The Moral Order

(1873–1874)

By 1873, Paris was on its way to becoming the city it had once been, before the Année Terrible took its toll. From one end to the other, structures that had been bombarded or burned were being rebuilt, while in a corresponding Herculean effort, thousands of trees were being planted to replace those that had been chopped down for fuel during the siege.

To the north, near the Louis XIV gateway of Saint-Martin, the grand old Théâtre de la Porte-Saint-Martin—the scene of many triumphs for Victor Hugo's plays before its incineration during a Commune gun battle—was already restored and back in business. In the center of town, all two thousand tons of Napoleon Bonaparte's impressive Vendôme column—destroyed by Communards as a detested symbol of Empire—had been pieced back together, topped by a statue of Bonaparte looking like Caesar (an interesting choice for the Republic, which could have opted for a more contemporary rendition of the statue, as it had been during the monarchy of Louis-Philippe, or no statue at all).

And then there was the Hôtel de Ville, torched by the Communards in a fire so intense that it took more than a week to extinguish. Reduced to rubble, with only its stone shell remaining, the ruin presented a mammoth challenge to the architects who now undertook to rebuild it. The process would take more than a decade. Along the way, the young Auguste Rodin—still supporting himself with work as an ornamental craftsman—carved one of the 110 statues of eminent Parisians that embellish its exterior. Rodin's contribution was the sculpture of d'Alembert.[1]

During the restoration of Paris, the government made some thought-provoking choices, including the statue of Bonaparte atop the Vendôme column, where it chose the version favored by Napoleon III and the Second Empire. Yet the new government hesitated at restoring the Tuileries Palace. As with the Hôtel de Ville, a stone shell of the palace remained, making restoration possible, albeit exorbitant. Still, the palace—the royal and imperial residence ever since Napoleon Bonaparte—was such a vivid symbol of monarchy and empire that the Thiers government hesitated. Torn between whether to demolish the ruins or restore them, it procrastinated. In the end, the blackened shell remained an eyesore for years.

Thiers was similarly undecided about the basilica of Sacré-Coeur, whose proposed site on the Butte of Montmartre would be, at the very least, controversial. Archbishop Guibert was looking for government backing for the proposed basilica, including the right to expropriate the desired properties on top of Montmartre. Thiers procrastinated. After all, the basilica's most fervent supporters were those who just as fervently supported the restoration of the Bourbon monarchy—an aspiration with which he had little sympathy. But by the time favorable legislation reached the National Assembly, Thiers had been ousted from power and replaced by the arch-conservative royalist Marshal MacMahon. By this time as well, a quarter of the members of the National Assembly had taken the vow to build, in Paris, a basilica dedicated to the Sacred Heart. Although there was some debate in the Assembly, it was no surprise when a law passed, 382 to 138, authorizing the Archbishop of Paris to purchase (by requisition) the desired property for the proposed basilica of Sacré-Coeur.

The blood of martyrs, including (and especially) those martyred by the Commune, was about to be expiated by the royalist right.

⌒

Edmond de Goncourt could be nasty. Witty, yes, but nasty. His friends, including Emile Zola, were frequent targets, but those he did not count among his friends drew his worst barbs. Adolphe Thiers was among the latter group. Goncourt avidly listened to his good friend Edouard de Béhaine's account of a dinner with Thiers and then ripped off the following in his journal: "Béhaine came away appalled by the senile, sententious ramblings of our great statesman."[2]

This unfortunate dinner occurred in January 1873. Thiers was, of course, notoriously ambitious, vain, self-opinionated, and cantankerous, but few, including Thiers himself, could have predicted his fall from power in May. After all, it was he who had negotiated successfully with Bismarck for the progressive withdrawal of German troops from France, in tandem with

L'Hôtel de Ville en reconstruction *(Victor Dargaud, 1850–after 1913). Oil on canvas, 1880. Paris, Musée Carnavalet. © Musée Carnavalet / Roger-Viollet / The Image Works.*

France's reparations payments (Bismarck's original position had been to insist on keeping the entire contingent of German troops on French soil until the last payment was received). Better yet, following the success of the second loan, in 1872, Thiers was able to promise that the final reparations payment would be made in 1873—a dramatic accomplishment, since this meant that it would be paid ahead of the 1874 deadline, even if only by a few months. The French were overjoyed at this news, which signaled the imminent departure of their detested German occupiers. Basking in public acclaim, Thiers was judged to be politically invulnerable.

But his very success proved to be his undoing. After the loan was on course for repayment, and negotiations with the Germans virtually complete, Thiers did not seem quite as necessary as before. On May 24, those who detested Thiers for his commitment to a republic, however conservative, stage-managed his fall from power. In his place, the Assembly elected Marshal MacMahon, a staunch supporter of the monarchy, the ruling classes, and the Church. The following day MacMahon announced that "with the help of God, the devotion of our army, which will always be the slave of the Law, and the support of all loyal citizens, we shall continue the work of liberating our territory and of re-establishing moral order in our country."[3]

In the words of Thiers' biographers, this was "the first round of a struggle that would last for the next six years."[4] In fact this struggle, which involved monarchy versus republic, Catholic Church versus secular state, and the role of the army, would last for many years to come.

⌒

"Moral Order" became the defining phrase for the new government, and counterrevolution was in the air. It was now forbidden to commemorate the revolutionary date of July 14. Busts of Marianne, the symbol of the Republic, disappeared. And in August 1873, Louise Michel was taken from prison and, with other condemned Communards, herded onto a train to New Rochelle. From there they were shipped to the French colony of New Caledonia, on the other side of the world.

The voyage lasted four difficult months, with more misery to come. Still, on looking back on the experience, Michel wrote that she "wasn't bitter about deportation, because it was better to be somewhere else and so not see the collapse of our dreams."[5]

⌒

A succession of twelve theaters had housed the Paris Opera, all of which proved unsatisfactory or simply burned. But in 1858, Napoleon III decided to build a truly palatial opera house, one in keeping with his vision for a re-

vitalized and opulent Paris. Of the 171 architects who vied for the prize, the young and virtually unknown Charles Garnier emerged as the winner, based on his frank recognition of this structure's basic purpose. His Opera, now called the Opéra Garnier or Palais Garnier, would showcase the audience by providing a glittering backdrop for the social encounters that constituted the true heart of a night at the Paris opera.

Construction began in 1862 and continued for years, hindered by the discovery of a water table directly beneath the building as well as by war and the Commune uprising. But after the worst was over and Paris had begun to rebuild, Garnier's opera house remained an unfinished hulk. The new republic squirmed at the implications of pouring yet more money into this embarrassing reminder of the Second Empire, and made no move to complete it. There even were those who proposed tearing the place down and using the site for Sacré-Coeur.

Then, in the autumn of 1873, a devastating fire destroyed the opera house on Rue Le Peletier. By this time, the government was in the hands of the royalist right, which was less sensitive to the political implications of this paean to wealth and grandeur. And in any case, Paris demanded an opera house. In response, Garnier gathered an enormous workforce and set to work. Once again, as 1873 rolled into 1874, his great opera house was the site of feverish activity.

～

"Here's the letter I've had from Monet," Edouard Manet wrote his friend, the collector and art critic Théodore Duret, in the spring of 1874. "My rent has cleaned me out and I can't do anything to help him. Can you give the hundred francs to the bearer of the picture?"[6]

As 1874 opened, Edouard Manet had gone through much of his inheritance and was experiencing significant financial difficulties, but Claude Monet's financial situation was far worse. Although 1873 had been a reasonably good year for him, his primary client remained his dealer, Durand-Ruel, who was unable to sell most of Monet's paintings. In addition, expected inheritances from Camille's and Monet's fathers had amounted to little. By 1874, Monet's work had yet to find a receptive audience, and Durand-Ruel had reached the brink of bankruptcy and could afford no more lifesaving purchases. In desperation, the artist now turned to an idea that he and some of his cohorts had floated as early as 1867—that of entirely bypassing the official Salon, which had treated them shabbily, and giving their own private exhibition. Pissarro, Cézanne, Renoir, Sisley, Degas, and Berthe Morisot agreed to join.

Only Edouard Manet refused to go in with them. After years of ridicule and rejection he had at last tasted success at the 1873 Salon with a painting

called *Le Bon Bock* (*The Good Pint*), featuring a large, cheerful-looking fellow nursing a pipe and a tankard of beer. The public immediately identified the subject as French Alsatian, and the painting quickly gained appeal as a symbol of France's recent loss of Alsace-Lorraine to Germany. But Manet failed to understand the cause for this particular success, and although sympathetic with his fellow painters, he insisted on maintaining his ties with the Salon, regardless of the way it had treated him in the past.

The prominent photographer Felix Tournachon, known as Nadar, agreed to let the group use his studio free of charge, and they went forward with high hopes. These were quickly blasted by a hostile reception bordering on hysteria, including warnings that this art form was so inherently vile that it threatened pregnant women and the moral order. Most of the painters in the group were by now hardened to this sort of response, although never before at quite so high a pitch, but the sheer nastiness of the experience must have been especially difficult for Berthe Morisot, whose former art teacher took it upon himself to write a warning to her mother. "One does not associate with madmen except at some peril," he informed her. "All of these people," he added, "are more or less touched in the head," and "if Mlle Berthe must do something violent, she should . . . pour some petrol on the new tendencies."[7]

It must have been a challenging situation for Morisot, who had always been hesitant about marketing her artwork. "I did not dare to ask him whether he would buy some of my work," she had earlier written her sister Edma, after a prominent Paris dealer complimented her on one of her watercolors. The thought of undertaking a commission recommended by Manet made her tremble. "I know my nerves," she wrote Edma, "and the trouble I should have if I undertook such a thing." Somewhat later, she wrote that she had sent a seascape to the dealer Durand-Ruel but had not yet heard from him. "I am eager to earn a little money," she added, "and I am beginning to lose all hope." Being a woman made her goals even more elusive. "What I see most clearly," she told Edma, "is that my situation is impossible from every point of view."[8] And yet she was driven to create—and to succeed.

Morisot's mother did not make matters any easier. "Yesterday," Morisot told Edma, "my mother told me politely that she has no faith in my talent, and that she thinks me incapable of ever doing anything worthwhile." Madame Morisot corroborated this in a subsequent letter to Edma: Berthe, she wrote, "has perhaps the necessary talent . . . but she has not the kind of talent that has commercial value or wins public recognition." More than this, "when a few artists compliment her, it goes to her head."[9]

Manet was one of these artists, while Edgar Degas was another. Neither was a fool, and Degas in particular was constitutionally unable to pay a false

compliment to a woman—an act that would have been quite beneath him. A member of the *haute bourgeoisie*,[10] much like Manet and Morisot, Degas came from a wealthy banking family whose wealth had quite suddenly evaporated, thanks in large part to enormous business debts run up by Degas' brother in New Orleans. This devastating news had only recently surfaced, forcing Degas to realize that he would henceforth be dependent on sales of his own artwork to support himself.

Conservative by upbringing and cynical by nature, with as witty and biting a tongue as Edmond de Goncourt, Degas was not a natural colleague for the little group that now took the name "Impressionist" (a name that originated with one of the group's detractors, who had howled in derision at Monet's painting, *Impression, Sunrise*, and thus inadvertently labeled these artists for the ages). Degas did not like either the Impressionist name or the scandal associated with the exhibit. Closer to Manet than to those who had dared to exhibit, Degas did not even like some of the artists who were his colleagues-in-arms. In particular, he did not care for Monet's landscape painting or his penchant for painting out-of-doors.[11] Yet despite Degas' surprisingly traditional tastes and his decidedly prickly nature, he joined forces with this group of rebels, taking a leading role in organizing this and subsequent exhibitions.

Still, notoriety and publicity do not by themselves pay the bills, and the Impressionists' first exhibit was a financial bust. Soon Monet was evicted by his landlord, with no place to go until Manet found him another house in Argenteuil.[12] The two men then painted together for most of the summer—out-of-doors, with Renoir frequently joining them. Much to Manet's amusement, Monet fitted up a boat for a studio, with a canvas awning stretching from cabin to stern, under which he set up his easel. Manet painted him there as he worked, developing his use of small, separate brushstrokes to capture the fleeting effects of light on water.

Manet, in fact, was overwhelmed with admiration. "There is not one . . . who can set down a landscape like [Monet]," he enthused. "And when it comes to water, he's the Raphael of water." Claude Monet had, at least for the moment, brought Edouard Manet out of the studio, and it was during these bright summer months that Manet came closest to the vision of his younger colleague. "That's what people don't understand yet," Manet explained to his good friend Antonin Proust, a journalist and associate of the prominent republican politician Léon Gambetta. "That one doesn't paint a landscape, a seascape, a figure; one paints the effect of a time of day on a landscape, a seascape, or a figure." That winter in Venice, he told another friend, "They're so boring, these Italians, with their allegories. . . . An artist can say everything with fruit or flowers, or simply with clouds.[13]

～

Water had always been a central feature of life in Paris. The Seine courses through its center, cradling (in Victor Hugo's words) the Ile de la Cité and dividing Left Bank from Right. Until dams and other man-made devices controlled its flow, the Seine was a broad and shallow river that flooded regularly, leaving wide bogs and marshes along its lowland banks. But it was also a river whose level lowered significantly during the dry summer months, leaving behind a muddy detritus of shallow pools and ooze. It was to avoid the Seine's floods that Paris's Roman conquerors built their homes and forum on the Left Bank hill now called Montagne Sainte-Geneviève. To supplement their undependable and inconveniently located water supply, they built a lengthy aqueduct that brought in water from the south.

This aqueduct subsequently deteriorated and disappeared as the Roman Empire crumbled. Parisians had to fall back on Seine water, although by this time a growing number were digging wells—especially on the Right Bank, where the water table was close to the surface. This water seemed clean but unfortunately was not. The very fact that it lay near the surface meant that it received the run-off from Paris's notoriously muddy and filthy streets, as well as seepage from its open sewers.

Not until well into the nineteenth century did anyone draw a connection between the quality of the water they drank and the epidemics that regularly swept the city. Instead, for centuries, they merely drank up, with the more finicky either filtering the liquid or simply allowing it to settle before quaffing.

Before that, Paris had employed an extraordinary number of devices to step up its water supply, including aqueducts that tapped the springs of Belleville and Ménilmontant (never very productive) and the huge Samaritaine water pump on the Pont Neuf (dismantled in 1813) and its sister Notre-Dame pump on Pont Notre-Dame (removed in 1858). Along the way, steam pumps had their day, as well as Napoleon Bonaparte's grand Canal de l'Ourcq, which served as a navigation system as well as a supplier of drinking water.

By the 1830s, several entrepreneurs had decided to take a new approach. With sublime optimism and an unfettered can-do spirit, they proposed to tap into the pristine aquifer that lay deep below the city's surface. The idea was that this aquifer, caught between layers of impermeable rock and clay, could be reached by drilling. Unlike a regular well, an aquifer—if tapped in just the right place—spurts upward. Fortunately, Paris was sitting at the center of a huge geological basin containing an aquifer of formidable proportions. Prodded by the inspector general of mines and the city's mayor, the municipal

council approved a large sum to tap this underground reservoir by drilling a series of artesian wells within city limits.

The first of these, the *puits de Grenelle* (at what is now the intersection of Rues Valentin-Haüy and Bouchut, 15th), encountered innumerable hardships until, after eight years and a depth of 538 meters, a sudden whistling sound pierced the air and a column of water dramatically shot up. Work then began on a well in Passy (at present-day Square Lamartine, 16th), one at Place Hébert (in the Chapelle quarter, 18th), and another on the Butte-aux-Cailles (13th). The one in Passy reached water after six years, but the one at Place Hébert suffered a serious cave-in and did not become operational until 1888. The well on the Butte-aux-Cailles (interrupted by the Franco-Prussian War as well as by internal squabbles) did not become operational until 1904.

By this time it had become obvious that the Paris aquifer was not inexhaustible, as each additional well had noticeably depleted the force and flow of the others. But any disappointment over the artesian wells was significantly lessened by success elsewhere. By the 1870s, Paris had become the beneficiary of one of Baron Haussmann's most daring—and successful—ideas.

Even before becoming the most powerful man in Paris, next to the Emperor himself, Haussmann had taken a great interest in the problems associated with public water. By the time he became prefect of the Seine, water in Paris not only was in short supply, but also was notoriously foul and smelly. Although water's role in spreading epidemics was not yet widely known, Haussmann nevertheless became convinced that something had to be done. With his intrepid engineer Eugène Belgrand, he set to work to create a vast system of covered aqueducts and reservoirs to convey and store vast quantities of pure spring water from afar.

The work began during the 1860s, while Haussmann was still in office, and then was suspended during the war. But once Paris was free of hostilities, the huge job of bringing water to Paris continued, even without Haussmann to prod it forward. By 1874, water from the Vanne began to reach the city (water from the Dhuis had already arrived by the late 1860s, but was disrupted during the war). Scarcely more than a decade later, the entire system was completed. Certainly one of Haussmann's finest achievements, this is the water system that, with modifications and updates, still supplies Paris today.

∽

The building and rebuilding of Paris continued. The Right Bank arm of the Pont de Sully, on the eastern tip of the Ile Saint-Louis, went up between 1873 and 1876 (its Left Bank arm was completed in 1878). Further to the west, a cast-iron Pont de Grenelle replaced a wooden roadway in 1874.

And both the opera house and Sacré-Coeur continued to go forward, in odd juxtaposition with one another. To begin with, the design for Sacré-Coeur—much as with the opera house—was to be decided by competition. But far more significantly, Archbishop Guibert had made the decision that Sacré-Coeur would be magnificent—an aspiration certainly shared by its far-worldlier rival. No modest structure for Guibert. He had chosen the highest elevation in Paris for this visible assertion of the Church's power and presence, and he had no question but that the basilica should draw eyes from every point throughout the city—a visual manifestation of the new Moral Order.

Here is where the two structures dramatically parted company, with Guibert emphatic that there should be no element of "vice or impiety" in the design. Unlike the Opéra, which epitomized everything that he and his colleagues detested, the basilica of Sacré-Coeur should radiate grandeur but not flamboyance. Above all, it should be a monument to white-robed purity.

The public competition for best design took place between February and June 1874, with seventy-eight architects exhibiting their plans in the Palais de l'Industrie on the Champs-Elysées. Here, for five months, Parisians crowded one another to glimpse and discuss the proposed designs. Few of these plans embraced an outright Gothic vision—the site itself was inhospitable to the traditional cross shape, with its requisite lengthy nave. Also, unlike the traditional east-west axis, this structure would clearly maximize its site to best advantage if it faced south.

In the end, the judges awarded the prize to Paul Abadie, who had acquired a reputation in the Périgord for restoring churches in an idealized and fantasy-infused fashion. His design, a multidomed concoction in which Romanesque and Byzantine mixed and merged, offended architectural purists but in general won the hearts of the basilica's supporters. Most winning, as far as the latter were concerned, was Abadie's intention of building the basilica from a kind of stone (travertine) that would remain pristine forever, actually becoming whiter with age.

It was exactly what Archbishop Guibert had in mind.

⌒

It would be several more years before Clemenceau would be able to express his profound opposition to Sacré-Coeur in any politically meaningful fashion. In the meantime, he was hard at work on behalf of Paris's poor from his seat on the city council, where he proposed urgently needed reforms for the city's impoverished children. Infant mortality in Paris was on the rise, he pointed out, and he made good use of his medical credentials to argue that

sick children should be sent to the country rather than to overcrowded city hospitals, where the danger of infection was especially high.

He also urged that everything be done to help indigent or unwed mothers keep their children, including subsidizing them rather than wet nurses (as was the custom) to nurse their children. Together, he believed, such changes would not only help prevent the abandonment of children, but it would reverse the upward trend in infant mortality—a particular concern what with France's loss of population during the war and, especially, the Commune.

Meanwhile, in a part of town that had little occasion to think about poverty, Edouard Manet's younger brother, Eugène, was courting Berthe Morisot. Eugène, who was a far quieter and less dandified version of his brother, was not an artist but certainly was gifted with artistic sensibilities. He also was quite taken with Berthe, and during a seaside visit in 1874, took the opportunity to tell her so.

What did Berthe Morisot think about this? Was she in love with Eugène's brother, Edouard? Was Edouard in love with her? Edouard certainly seems to have been attracted to her, but then again, he was attracted to many women—though few could have aspired to the combination of beauty, intelligence, and artistic ability that Berthe Morisot possessed. With typical reserve and propriety, Morisot kept her feelings to herself. Yet a whiff of almost school-girlish pleasure emerges from an 1871 letter to her sister Edma, in which she writes that Manet "thinks me not too unattractive, and wants to take me back as his model." But she immediately retreats into her private shell. "Out of sheer boredom," she adds, "I shall end by proposing this very thing myself." And then she changes the subject.[14]

But Eugène did not seem to regard his older brother as a rival, insurmountable or otherwise. After his return to Paris in the summer of 1874, Eugène wrote tender letters to Berthe, who remained at the seaside. "I wandered through every street in Paris today," he told her, "but nowhere did I catch a glimpse of the little shoe with a bow that I know so well." And then he added, "When shall I be permitted to see you again? Here I am on very short rations after having been spoiled." Berthe's reply must have satisfied him, because he wrote, "*Thonjoun*, you overwhelm me. A letter bearing compliments, without periods or commas—that is indeed enough to cause even a stronger man than I to lose his breath." *Thonjoun*, he added, is a Turkish endearment meaning "my lamb."[15]

Apparently Eugène was not without competitors, although he did not seem especially daunted by them. "Your letter has relieved me," he went on. "I had begun to fear that X, Y, and Z had gained some ground." And then he charmingly dismissed these rivals (certainly none of whom could have

been his brother): "X, Y, and Z may pay you compliments," he told her, "but they will never pay homage to you with the delicate praise that is due to goddesses."[16]

This sweet courtship led to marriage in December 1874, in the appealing neighborhood church of Notre-Dame de Grâce de Passy. It was a quiet family affair, with the bride wearing simple street dress in deference to her father's death only a few months before. The couple then settled down in the apartment that Madame Morisot gave them, on Rue Guichard—in the same privileged Passy neighborhood in which Berthe Morisot had been raised, and in which she would spend the rest of her life.

Curiously, Morisot described herself on her marriage certificate as having "no profession." Perhaps this was a product of the modesty and reticence of her upbringing, because she never abandoned her commitment to her career. Unlike her sister, who reluctantly left off painting when she wed, Berthe Morisot—with the assistance of her devoted Eugène—would continue to expand her professional horizons after marriage. And in what was perhaps an unexpected sign of modernity, she would continue to sign her paintings with her maiden, or professional, name.

CHAPTER FIVE

◯

"This will kill that."

(1875)

This will kill that."[1] The words are Victor Hugo's, and he had in mind the impact of the printing press—whether on ecclesiastical power or architectural expression. But essentially his observation pithily summed up the mounting challenge that the new presented to the old, as his own century hurtled toward its close.

Berthe Morisot's mother, Madame Morisot, clearly illustrated how disconcerting the new could be. Following an unhappy bout with Zola's novel *Le ventre de Paris* (*The Belly of Paris*), she wrote her new son-in-law: "Reading the book by your Monsieur Zola had for me the frustrating effect of obstructing my intelligence and putting a big stone on my stomach." As far as she was concerned, neither Zola's subject nor his style could be tolerated. "His accumulations of objects, his colourful descriptions of all varieties of foods, in which he indulges with so much love, give one an indigestion," she remarked tartly.[2]

Le ventre de Paris was not, indeed, an easy book to digest—especially for those accustomed to the old ways of observing and writing. Its setting and subject was Les Halles, that central district of Paris where, from the Middle Ages until well into the twentieth century, the great food markets of Paris were located. When Zola prowled its tumultuous precincts, notebook in hand, he was searching for a slice of real life—naturalism, as he put it. But not everyone was prepared to be assaulted by his painstakingly rendered account of the sounds and smells as well as the everyday jostling and conflict that permeated the latest of his novels. The book was rude, and intentionally

so. No wonder that the elegant and cosseted Madame Morisot was offended by it.

She was reading the book at the suggestion of Eugène Manet, who had told her that "there is a parallel between this literature and the painting of the new school,"[3] of which his brother Edouard was the leader and Berthe Morisot a by-now established member. Zola was a friend of Edouard's and had been so ever since he vigorously came to Edouard's defense in a series of hard-hitting reviews he wrote during the late 1860s.

Whether Zola truly understood what Edouard Manet was about was questionable, but there were few supporters of the artistic avant-garde during these difficult years, and Manet evidently was grateful for what he could get. He painted Zola's portrait, maintained a friendly (although somewhat formal) relationship with the prickly author, and seems to have genuinely admired his writing—at least, apart from Zola's art criticism. During the 1870s, Manet praised Zola for the latter's preface to the dramatic version of *Thérèse Raquin* and the latest installment of *L'assommoir* (first released in serial version). Although we do not have Manet's specific response to *Le ventre de Paris*, we do know that he later proposed a series of paintings representing the "Belly of Paris" for the Municipal Council chamber in the rebuilt Hôtel de Ville, depicting "the public and commercial life of our times." Not unexpectedly, Manet's proposal did not meet with enthusiasm, and he reported that he was treated "as if I were a dog about to lift his leg against a municipal wall!" [4]

Manet was not alone. Others among his colleagues continued to encounter the same sort of thing. Yet despite this, the Impressionists were willing to take another stab at success. In March 1875, this group (minus Manet, who continued to hold himself apart) decided to hold an auction sale at the Hôtel Drouot. Most—especially Monet, who was "absolutely broke"—were hoping for some much-needed income from the sale. But the event turned out badly, and those few pictures that sold went for dismal prices, with many being repurchased by the artists themselves or their families. Worst of all was the public response, which was brutal. "Much entertainment was provided," wrote one scathing reviewer, "by the violet countrysides, red rivers, black streams, green and yellow women and blue children which the pundits of the new school held up to the public admiration."[5]

One would have expected Edmond de Goncourt, unlike the crass and unperceptive hoi polloi, to have responded favorably to Impressionism, at least in its earliest stages. After all, he and Zola were hunting in the same literary forest—and more than once tripped over one another in choice of subject and even descriptive passages.[6] But surprisingly, Goncourt did not join Zola in his admiration for the new style of painting, although he was capable of

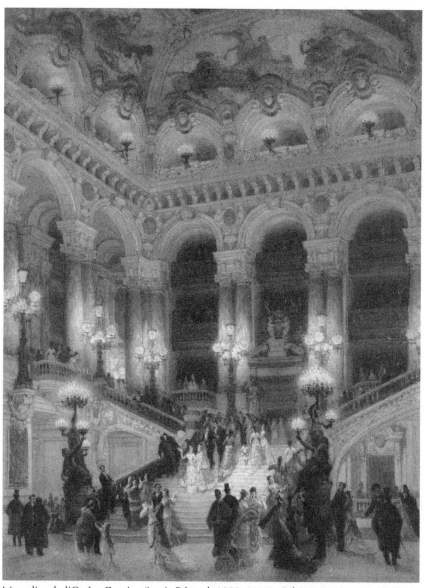

L'escalier de l'Opéra Garnier *(Louis Béroud, 1852–1930). Oil painting on canvas, 1877. Paris, Musée Carnavalet. © Musée Carnavalet / Roger-Viollet / The Image Works.*

recognizing what at least one of the Impressionists—Degas—was attempting to do. Visiting the studio of Degas, Goncourt concluded that among all the artists he had so far met, this was the one who best captured the spirit of modern life.

This seemed to intrigue Goncourt, who remarked with considerable interest that of all the subjects he could have chosen, Degas had honed in on washerwomen and ballet dancers. "When you think of it," he added, "it is not a bad choice."[7]

～

It was during these months of 1875, while the Impressionists were incurring renewed public ridicule, that Auguste Rodin, at the age of thirty-five, first cracked open the gates of the hidebound Salon. After having been flatly rejected by the Salon several years earlier, he submitted the same bust, this time in marble, and was accepted. His sculpture was not a classical subject, but it unquestionably possessed a certain classical dignity, despite the fact that its model had been a local drifter with a broken nose. The bust was titled simply that—*The Man with the Broken Nose*.

It was a major breakthrough in a life that to date had been a struggle. Born in the Mouffetard quarter of Paris in 1840, Auguste Rodin was the third child and only son of a lowly office worker at the Prefecture—a distinctly unglamorous position that kept bread on the table, but little more. Young Auguste showed no particular aptitude for anything and may have suffered from a learning disability. Perhaps, though, his inability to read, write, or do sums was simply a sign of his complete indifference to those subjects. From an early age, the only thing that genuinely interested him was drawing.

He wanted to draw, and he wanted to become an artist. At a loss for any other alternative, his despairing father at last agreed to send him to the Ecole Gratuite de Dessin (Free School of Design), then located in the former School of Surgery on Rue de l'Ecole-de-Médecine. There, this unpromising-looking lad with carrot-colored hair and ungainly build labored to make his mark. He quickly learned that the school's goal was to produce crafts-men—highly skilled young men who would join the ranks of the Parisian artisans specializing in one or another of the decorative arts, whether textile manufacturing, woodworking, stone carving, jewelry engraving, or a welter of other demanding crafts.

For those in training to become ornamental carvers there were classes in sculpturing, and it was here, after mastering the basic drawing classes, that Rodin first encountered modeling clay. "I felt as if I were ascending into heaven," he later wrote, describing how he "grasped the whole thing in a flash."[8] It was more than a revelation, it was a calling. He would be a

sculptor. But there would be many years between this epiphany and the first measure of success that his Salon acceptance represented.

At first he immersed himself in the Louvre, filled his sketchbook with drawings, and took life classes. Encouraged by his progress, he then applied for admission to the Ecole des Beaux-Arts, which rejected him—not once, but three times. Already, Rodin was showing far too much independence for the classically entrenched academics at the Ecole, who must have found his emerging naturalism completely out of step with their traditions. It was enough to crush a less determined spirit, but—refusing to give up—Rodin spent the next twenty years barely supporting himself in the decorating end of the building trades, where he concentrated on adding to his impressively growing technique. One wonders how many public monuments and buildings were repaired by or given standardized ornaments from Rodin during these hard-scrabble years.

It was during this period that Rodin began to fill in the sizable gaps in his education, learning to read with comprehension and gravitating toward the passionate poetry of Hugo and Lamartine. It was during these years, as well, that he encountered a young woman named Rose Beuret, with whom he began to live. One year later, she gave birth to Rodin's son, Auguste, who took his mother's last name, since Rodin refused to legitimize him. It was only the first of many hardships and indignities that Rose would suffer during her fifty-two years as the sculptor's faithful helpmeet.

Rose stayed in Paris during the siege of Paris and the Commune uprising, caring for Rodin's parents as well as her son and maintaining Rodin's studio (dutifully keeping his "clays" covered with damp cloths), while Rodin found work in Brussels. He remained there for several years, at length summoning Rose to join him (a hard-working aunt now took in Rodin's son and widowed father).

By 1875, Rodin was at last ready to return to Paris. But first, after entering *The Man with the Broken Nose* in the Salon, he embarked on a long-desired trip to Italy, walking a good portion of the way. Although he had many goals in mind, both in Florence and in Rome, it was Michelangelo in particular who was pulling him southward. Rodin wanted to see Michelangelo's work in real life, not simply in pictures, and once in Florence, he wrote Rose that he was hard at work studying Michelangelo, trying to understand him.

Auguste Rodin was on the brink of blasting traditional ideas about sculpture into the stratosphere, but en route, he needed to consult with the greatest sculptor of all. Past and future now melded in the shadows of the Sacristy of San Lorenzo. "I believe," he told Rose, "that the great magician is revealing a few of his secrets to me."[9]

～

It never occurred to Sarah Bernhardt that the magician might not have spoken to her and that she might not have the talent to become a sculptor. Prompted by pique over real or imagined slights endured during the course of her rapidly rising theatrical career, and armed with resolve as well as sufficient funds, she found herself a teacher, an atelier, and some fetching work clothes. What she accomplished was actually far better than most expected, and her sculptures were immediately accepted by the Salon, where they sold for impressive prices. Unquestionably, she was trading on her name, but her work pleased a number of people, including critics.

Unhesitating when it came to self-promotion (or anything else), she next approached Charles Garnier, of opera house fame, who was embarking on a new venture, a casino and theater in Monte Carlo. Bernhardt's current lover was the well-known artist Gustave Doré, and Bernhardt seems to have dangled the promise that she would persuade Doré to sculpt a figure for the Monte Carlo façade if Garnier would in turn give her the commission to sculpt its companion figure.

Doré was not at first pleased by the prospect of sharing the honors with an amateur, no matter how enticing this amateur might be, but at length he succumbed to Bernhardt's barrage of flattery and protestations of love, as well as to her well-timed disclosure to the press. As it turned out, Bernhardt's contribution to Garnier's enterprise, a graceful figure titled Le Chant, held its own with Doré's. Buoyed by her success, she went to work on an emotion-laden sculpture of a grieving peasant holding her dead grandson. Once again the Salon opened its doors, and this time the venerable institution conferred an honorable mention as well. Moved by the sculpture's pathos, the public oohed and aahed.

Henry James was not so moved. Reporting for the New York Tribune, he took note of the large sculpture whose subject was holding, "in a frenzied posture," her drowned grandchild. Damning with faint praise, he commented wickedly, "The thing is extremely amateurish, but it is surprisingly good for a young lady whom the public knows to draw upon her artistic ingenuity for so many other purposes."[10]

Rodin put it more bluntly. Bernhardt's sculpture was, in his words, "old-fashioned garbage."[11]

～

Fortunately for theater lovers, Bernhardt had by now reembraced her theatrical career, including the classic role of Racine's Phèdre, which she would make her trademark for the rest of her long career. Shortly after this theatri-

cal milestone, although in no way connected to it, Adolphe Thiers returned to his residence on Place St-Georges (9th), now completely rebuilt after its destruction by the Commune.[12]

Despite these disparate links with the past, the new continued to challenge and change the old. Not far from the Thiers residence, at the Paris Conservatoire, young Claude Debussy—who had entered the Conservatoire in 1872, at the age of ten—was already challenging the rigid teachings and conventional harmonies of the day. In his workshops in Levallois-Perret, Gustave Eiffel was continuing on his path-breaking career, this time with a plan for a railway station in Pest (now Budapest), a bold structure of iron and glass.

Drinking fountains were sprouting up all over Paris, thanks to the benevolence of the English philanthropist Richard Wallace, even as more of Haussmann's water system was being completed. And earthmovers were beginning to shift the landscape deep in the thirteenth arrondissement, where the viaduct of Rue de Tolbiac would cross the valley of the river Bièvre—a stream that still meandered through the Left Bank of Paris, although its days were numbered.

Indeed, although we forget, in 1875 there still were two rivers in Paris—the Seine and the Bièvre. The Seine bisected Paris from east to west, while the little Bièvre entered Paris from the south, winding its way through the Left Bank before depositing its waters in the Seine.

Originating in Guyancourt, near Versailles, the Bièvre had once been a bucolic stream where, according to legend, beaver thrived (possibly giving the watercourse its name). For centuries it meandered through a countryside dotted with ancient watermills and rustic villages. Within Paris, its waters flowed past mills and gardens, its tree-lined banks providing shade and beauty.

And then a series of ecological disasters struck. Jean Gobelin, a dyer, may not have been the first to sully the Bièvre's pristine waters, but he surely was the most influential. Attracted to the Bièvre by its minerals, suitable for fixing dyes, Gobelin set up shop in what is now the thirteenth arrondissement. By the seventeenth century, this foray had blossomed into the renowned Gobelin tapestry workshops, attracting a plethora of tanners and dyers to the neighborhood. By the eighteenth century, Paris's Bièvre had grown dark and polluted, and even its upstream waters suffered from considerable contamination after Christophe-Philippe Oberkampf began to manufacture his famed toile print fabrics in the little riverside village of Jouy-en-Josas.

Industrialization completed what the early polluters began, and by the nineteenth century the Bièvre had become little more than a fetid sewer that coursed its way through the most poverty-stricken reaches of Paris. It was

hardly surprising that the City of Paris was about to deal with this horror by gradually relegating it underground.

⁓

On January 5, 1875, the French president, Marshal MacMahon, formally inaugurated Charles Garnier's new opera house, which opened with a grand gala that included excerpts from several operas and a popular scene from the ballet *Le Corsaire*. But few were interested in the event's artistic offering. Instead, audience members eagerly anticipated the visual splendors that awaited them in the sumptuous building that would become known as the Opéra Garnier.

Early on the morning of the opera's opening night, hundreds of people gathered outside its doors, and by evening at least seven or eight thousand spectators were eagerly jammed together in the Place de l'Opéra, awaiting the glittering crowd that was about to arrive. It had been touch and go until the very last minute as to whether the building would be finished in time, and the magnificent red curtain with its gold fringe was fully installed only an hour before it was scheduled to rise. The guest list included luminaries from throughout France as well as Europe, including the Lord Mayor of London, who arrived in his gilt coach complete with sword bearer and footmen.

Without question, Paris was looking back at the Second Empire with this new opera house, but no one seemed to care. Napoleon III was long gone, and Paris was ready to be dazzled by Garnier's creation. How could it not be dazzled? Garnier used marble of every hue, as well as acres of gilt-encrusted carvings. He then covered any remaining surfaces with paintings, glittering mosaics, and mirrors, lighting the whole fantasy with a city's worth of flickering chandeliers.

Vast and richly decorated foyers allowed audience members to stroll and mingle, but it was the Grand Staircase that was—and remains—the Opéra Garnier's special glory. Its opulent branching stairway led upward and outward to the golden foyers and the velvet-lined auditorium, but its very design was intended to serve as a stage in its own right, where lavishly dressed patrons could sweep up the broad stairs or lean on the balconies, posing to their hearts' content. Henry James was suitably impressed, even though he thought the staircase "a trifle vulgar." "If the world were ever reduced to the dominion of a single potentate," he added, "the foyer would do for his throne room."[13]

Few on opening night probably remembered that without Baron Haussmann, there would have been no Avenue de l'Opéra, slicing its way through the business district to the opera's very door. And fewer yet probably remembered, or even cared, that the Avenue de l'Opéra was originally intended as

a fast and direct route from the emperor's residence in the Tuileries Palace to the new Opéra—as a security measure following Napoleon III's narrow escape from assassination while en route to the old opera house on Rue Le Peletier.

Garnier had even designed his opera house with a private entrance built specifically for the emperor, to allow him to enter directly, without fear of dangerous encounters. But although Napoleon III never set foot here, Garnier's opera house would forever be linked with Napoleon III's golden and decadent empire. After all, when the Empress Eugénie complained to Garnier that his proposed edifice was "neither Greek nor Louis XIV nor even Louis XVI," Garnier is supposed to have replied, "Those styles have had their day. This is in the style of Napoleon III, Madame!"

The story may be apocryphal, but Garnier's answer, even if he never said it, was certainly the truth.

～

Although both Sacré-Coeur and the Opéra Garnier definitely and even defiantly embraced the old rather than the new, they were not comrades-in-arms. Far from it. Indeed, from the outset, the basilica's promoters regarded Garnier's opera house with hostility, as a clear symbol of the Babylon that they wished to overshadow with Sacré-Coeur's pristine purity.

The basilica's grand ceremonial stone-laying was to take place in June 1875, but as the date approached, rumors circulated that there was more to Sacré-Coeur than simply moral and spiritual rejuvenation. One speaker at a conservative Catholic event put this hidden agenda in terms that sent shock waves throughout the republican population of Paris. The beginning of Sacré-Coeur, he promised, would mark "the burial of the principles of 1789."[14]

Archbishop Guibert hastened to assure one and all that Sacré-Coeur was the outcome of profound faith and piety, not politics, and used the occasion to issue a sideswipe at "the enemies of religion." But the controversy was enough to force him to scale back the ceremony, which—although still suitably grand—passed without incident.

Yet Sacré-Coeur's troubles were not over, and indeed, were just beginning. It quickly became apparent that the site that Guibert had chosen, at the top of Montmartre, was a disaster waiting to happen—at least, from a structural point of view. The Butte, composed of lime and clay, was riddled with plaster quarries. It certainly could not support a structure of Sacré-Coeur's bulk and weight.

What to do? Guibert was loath to move the basilica to another site, but the alternatives seemed daunting. Among these, the most promising was a

proposal to sink more than eighty stone pillars down to bedrock, nearly one hundred feet below. According to this plan, Sacré-Coeur would in effect be erected on stilts.

It was in many ways a brilliant idea. But at what a cost!

⁓

While the Opéra Garnier and Sacré-Coeur were the architectural embodiments of a longing for the past, whether linked directly to the vanished empire or to the Ancien Régime, another mammoth structure was about to go up in Paris that was the very epitome of forward-looking republicanism.

Frédéric Bartholdi had returned from his tour of the United States with good news. Equipped with letters of introduction from Edouard de Laboulaye, he had tirelessly traveled the young nation from east to west, via Chicago, Salt Lake City, San Francisco, Denver, Saint Louis, Cincinnati, and Pittsburgh, talking with influential citizens all along the way. Although he was not able to stir up enough interest to form a national movement, he did find considerable enthusiasm for the idea of a huge statue of Liberty Enlightening the World. The poet Henry Wadsworth Longfellow, for instance, pledged that he would do everything he could to make this undertaking a success.

Bartholdi had also spotted a perfect site for the proposed monument, on Bedloe's Island in New York Harbor. He returned to Paris, ready to begin. But by this time Laboulaye had been elected to the National Assembly and was thoroughly engrossed in political affairs in his own nation. The new government still did not have a constitution, and under the aegis of President MacMahon and the new Moral Order, the royalists were pushing harder than ever for the restoration of the monarchy. Some in the Assembly were willing to join them, but only if the restored monarch was of the constitutional sort, presiding over a parliamentary government. Minus these assurances from the Bourbon contender for the crown, the dismally obtuse Comte de Chambord, the royalists' hopes foundered.

But what sort of agreement could be reached between the passionate components of the badly divided Assembly? In early 1875, with the monarchists in disarray, Laboulaye and his republican allies proposed and won acceptance (by a narrow margin) for a constitution for a republic—the Third Republic. Yet this hardly represented a return to Revolutionary times. Bowing to political realities, this republic would be a conservative one, much as Thiers had advocated, with an indirectly elected president and a bicameral legislature structured to balance its potentially left-leaning Chamber of Deputies (directly elected by universal suffrage) with a solidly traditionalist Senate. Unquestionably, most of those who voted for this compromise had

something else in mind, at least down the road, but were willing to settle for this arrangement in the meantime.[15]

Having played a pivotal role in creating the new republic, Laboulaye was rewarded with a seat for life (one of seventy-five) in the three-hundred-member Senate. It was now that he turned his attention once again to the Statue of Liberty, creating the Franco-American Union as a fund-raising mechanism for the enormous project. In the meantime, Bartholdi had been producing maquettes, or small-scale clay models, for Laboulaye's consideration. Soon after making his contribution to the creation of the Third Republic, Laboulaye and the Franco-American Union approved Bartholdi's final model, which was unveiled to great acclaim at the Union's opening fund-raiser in November 1875 at the Hôtel du Louvre—a luxury hotel dating from the Second Empire.

Interestingly, Bartholdi now turned to Eugène Viollet-le-Duc to help him in the construction process. Viollet-le-Duc was perhaps the foremost French architect of his day, but his specialty was in restoring crumbling Gothic structures such as Notre-Dame de Paris to their former glory. Indeed, many then and since have complained that in his enthusiasm to restore these relics, Viollet-le-Duc may have overdone it, using a more-than-generous helping of imagination to reach what he considered to be these structures' "ideal" forms. For us today, Viollet-le-Duc may seem an odd choice for the construction of the Statue of Liberty, but he had been one of Bartholdi's former instructors, and—as Bartholdi knew—he was well versed in modern building materials such as cast iron, as well as in the more traditional materials of wood and stone. Also, and probably just as importantly, Viollet-le-Duc now embraced political opinions compatible with Bartholdi's. In any case, it was Viollet-le-Duc who decided that Lady Liberty would be made of copper sheets shaped by hammering against a wooden framework, in a method known as repoussé. Viollet-le-Duc also selected the foundry that would be responsible for the final construction, a well-respected firm that he had used for many of his own projects.

It was Viollet-le-Duc as well who recognized that the monument's internal structure could not be made of stone. Instead, he proposed filling it about halfway with sand-filled metal containers (to give it needed heft), from which the sand could be released in case the statue needed repair. It was an innovative solution to the problem, perhaps surprisingly so coming as it did from an architect who had spent much of his career focusing on the past.

But, much as could be asked about the new Third Republic itself—would it work?

CHAPTER SIX

~

Pressure Builds

(1876–1877)

T he aim which we set ourselves is to complete the great renewal of 1789,"
Georges Clemenceau announced, while running for office in early 1876.
This meant, he told voters, the lofty goal of reestablishing "social peace
through the development of justice and liberty."[1]

Clemenceau had reentered national politics on behalf of the poor and the
downtrodden, and he won his seat in the new Chamber of Deputies by an
overwhelming margin, representing his home base in Montmartre. Here, as
an emerging leader of the political Left, he tangled with moderates and arch-
conservatives alike, winning for himself a reputation for tiger-like ferocity on
behalf of the causes in which he believed, and emerging as one of the leading
orators of the Chamber.

Clemenceau stumped tirelessly for freedom of speech, freedom of the
press, and freedom of assembly, as well as for expulsion of the Jesuits and the
promulgation of free, secular, and compulsory primary education—the latter
two items being key components in the ongoing battle over the separation
of Church and state. Yet at this point in his fledgling career, Clemenceau's
particular concern was for those (like Louise Michel) who had been con-
demned for taking part in the Commune. Without a general amnesty, he told
his fellow deputies, there could be no basis for a lasting social peace. Without
such an amnesty, justice and liberty would be a sham. "Mere repression," he
argued, "will not prevent the recurrence of these crises which grow out of
. . . the sufferings of the workers."[2]

Not surprisingly, the radical republicans' proposal for amnesty was re-
jected—despite the fact that Victor Hugo, now an elected member of the

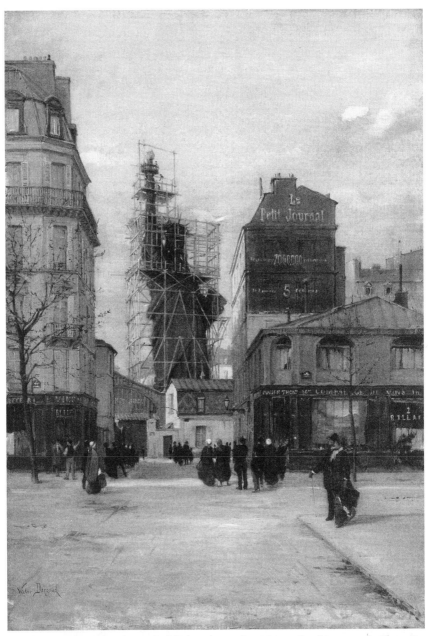

La Statue de la Liberté de Bartholdi dans les ateliers Gaget-Gauthier, rue de Chazelles *(Victor Dargaud). Oil on canvas. Paris, Musée Carnavalet. © Musée Carnavalet / Roger-Viollet / The Image Works.*

Senate, became its passionate advocate. The republic that conservative republicans had brokered with constitutional monarchists was not yet ready to accept such a radical idea. Moreover, the most extreme royalists were not yet even close to throwing in the towel. Their hope and expectation was that the Republic was only a temporary entity, and that MacMahon, as head of state for seven years, would be able to prepare the way for the eventual restoration of the monarchy—if not the clueless Comte de Chambord, who seemed to have delusions of absolute monarchy, then (in case of Chambord's death) the Comte de Paris. They had lost one round, over the constitution, but they were quite prepared to go another, especially as the republican ranks were still fluid and shifting factions rather than parties, grouped around a number of individuals such as Jules Ferry, Léon Gambetta, or—at the left wing of the spectrum—Louis Blanc.

It was here, on the far left, that Clemenceau easily positioned himself, and it was from this vantage point that he was about to take part in the drama surrounding the monarchists' last bid for power.[3]

～

In spite of Victor Hugo's efforts, the journalist Henri Rochefort (a very public Commune sympathizer) had been deported, his fate decisively sealed once MacMahon came to power. In words recalling those he had used in *Les misérables* to describe Jean Valjean's plight, Hugo now dramatically wrote, "Rochefort has gone. He is no longer called Rochefort. His name is Number 116."[4]

Hugo need not have worried, for in actuality, Rochefort did not suffer very long in New Caledonia. Soon after his arrival, the resourceful journalist managed to hop aboard a ship bound for San Francisco. Eventually working his way back to Europe, he lived in and continued to publish broadsides from London and Geneva until he was eventually allowed back in France.

Louise Michel, on the other hand, proudly accepted her exile. With head high, she stood firm for her principles—even (and perhaps especially) when these propelled her directly into trouble. Upon arriving in New Caledonia, she immediately protested the separate quarters (and possibly better treatment) arranged for the women prisoners in the group. After winning that battle, she became a staunch supporter of the indigenous Kanak population, which had been pushed off its land to make way for French immigrants. With her usual energy, she learned enough of the language to appreciate Kanak culture and proceeded to collect Kanak legends, chants, and songs, which she dreamed of setting to native instruments. "I wanted to shake palm branches, create a horn from shells, and use the tones produced by a leaf pressed against the lips," she later wrote. "In short, I wanted a Kanak orches-

tra, complete with quarter tones." And as always she taught, both adults and children, filling the Kanaks' heads, as one prison administrator acidly put it, with "pernicious doctrines" such as "humanity, justice, freedom, and other useless things."[5]

When not engaged in political activism or cultural discovery, Michel found plenty else to occupy her, whether making extensive records of New Caledonia's exotic flora and fauna or conducting scientific experiments, including an attempt to inoculate the native papaya trees.[6] Despite the privations she undoubtedly suffered, she seems to have made her exile into a reasonably tolerable experience.

In the meantime, while Louise Michel was creatively coping with the rigors of life in New Caledonia, back in Europe César Ritz was entering on a dizzying succession of positions at luxury hotels, from Vienna to Lucerne, where he juggled the job of summer manager of the Hotel National (still in existence) with winter positions at several prestigious destinations on the Riviera, including the Grand Hotel in Monte Carlo. Quite unlike the Communard exiles at the end of the world, his pampered guests quickly learned that wherever Ritz went, they would be assured of luxury, comfort, and scrupulous attention to their wants and needs, making a stay at one of "his" hotels truly a home away from home.

⌣

"I've seen Monet recently," Edouard Manet wrote his brother during the summer of 1875, "and he's absolutely broke." Monet, in fact, was at the point where he was offering ten of his pictures "of one's choice" for a pitiful thousand francs. "Not a penny left since the day before yesterday," he wrote Manet, "and no more credit at the butcher's or the baker's." Edouard, who was by no means flush at this time, was willing to put up five hundred francs if Eugène could match him, but he warned that Monet must not know that the money came from them. He added sadly, "I've tried other people and no one dares take the risk—it's just absurd."[7]

Unfortunately for Claude Monet and his cash-strapped colleagues, the Impressionists' second exhibition, in April 1876, went no better than the first. Once again, Edouard Manet declined to participate, opting for his chances with the respectable venue of the Salon—which repaid his confidence by rejecting both of his submissions. Berthe Morisot, who continued to show her works with the group (while maintaining a highly proper and somewhat formal relationship with its members), wrote her aunt that Manet was taking his current setback with reasonably good humor. She then described the fracas the Impressionist exhibit stirred up.

Morisot's husband, Eugène, had in fact been so livid over a malicious review by Albert Wolff in *Le Figaro* that he almost challenged the critic to a duel. Wolff (Morisot informed her aunt) characterized the artists as "five or six lunatics, one of whom is a woman," although he singled out Morisot for her "feminine grace . . . amidst the frenzy of a mind in delirium." This seemed to amuse Morisot, who appears to have been more exhilarated than disturbed by the experience. "Anyway," she concluded, "we are being discussed, and we are so proud of it that we are all very happy."[8]

Edouard Manet, in the meanwhile, had responded to the Salon's turndown by deciding to exhibit these paintings in his studio and issue invitations to the press. This resulted in widespread coverage, including a scathing review by the same Albert Wolff that described Manet as "a delightful and amusing young man" who nevertheless had "the eye but not the soul of an artist." Stung, Manet told his good friend Antonin Proust that "it would have been so easy to add to those two pictures the little touches so dear to M. Wolff's heart! People fight each other for the things that critics like, as if they were pieces of the true Cross. In ten years' time they won't fetch tuppence."[9]

Fortunately for Manet, his private showing brought him an enthusiastic new customer (and eventually model and lover), the beautiful Méry Laurent. It also brought him into contact with Wolff. Despite his distaste for the critic ("That creature gives me the creeps"), Manet recognized the importance of cultivating him and proposed to paint his portrait. Wolff agreed, but after the first few sittings was displeased by what he saw and refused to return. Nonetheless, Manet sent him an invitation to the Impressionists' subsequent exhibit, telling him that "you may not care for this kind of painting yet, but some day you will." In the meantime, Manet gracefully added, "It would be nice of you to say something about it in *Le Figaro*."[10]

But as Manet's brother, Eugène, wrote that autumn to his wife, Berthe Morisot, the art dealers were currently overstocked and "the entire tribe of painters is in distress."[11] Claude Monet had managed to sell only one of the eighteen canvases he showed at the April exhibit, but fortunately for a good price. Subsequently he spent an idyllic summer at the country home of a wealthy collector, Ernest Hoschedé, who admired his work. But others in the group were still facing financial difficulties. Edouard Manet had run through much of his inheritance several years earlier, having set up his own independent pavilion to display his paintings at the 1867 Universal Exposition, after being excluded from the exposition. Now, with financial success still elusive, he was cutting back on expenses and talking of giving up his studio. Most of his colleagues—with the exception of Berthe Morisot—were looking at similarly depleted coffers, and even Berthe Morisot's husband was counseling prudence under the current "money situation."

Following its postwar boom, France by the mid-1870s was beginning to experience an economic downturn, partially due to the huge strain that the war indemnity put on its economy, but also in response to worldwide financial instability. Throughout France, a long economic slowdown had begun. But despite the worrisome concern that the economy presented, the issue that continued to absorb the nation was the question of the Church, and its role in the new Republic.

~

While still in office, Thiers had prudently sidestepped the issue of whether or not to support the pope's territorial claims. But soon after Thiers' departure, Archbishop Guibert published a pastoral letter warning of divine retribution on those governments that allowed Rome's occupation by a secular Italian government. It stirred up a hornets' nest, not only at home but abroad, where it created significant dangers for France by uniting Germany and Italy on the question. The pope only exacerbated the problem by promoting Guibert to Cardinal.

During the years following the Commune, the French government—although dominated by conservative Catholics—had refrained from directly going to the pope's aid. But while steering clear of this inflammatory issue, the government continued to be a willing partner with the Church on a wide range of other subjects, such as nominations for French bishoprics and exemptions for ecclesiastics from conscription, as well as provisions allowing Catholics to establish their own universities.

This troubled a good many Frenchmen. But what especially aroused the ire of secular republicans, and more than a few Catholics, was the prospect of the basilica of Sacré-Coeur hovering over Paris, with its symbolic rebuke of the nation's sins, paid in blood with the defeat of 1870 and the subsequent Commune uprising. Cardinal Guibert was not deterred by this opposition nor by the daunting physical obstacles that now faced his mammoth undertaking. In the spring of 1876, he consented to allow Sacré-Coeur to be built on its Montmartre site and gave the go-ahead for construction to begin on its necessary stilt-like underpinnings. Work commenced, despite the huge financial outlays that would be required. Not only would the basilica now take far longer than expected to construct, but the accompanying fund-raising would continue for decades.

~

While Sacré-Coeur was beginning to go up (or at least starting to put down its roots), work was beginning in another part of Paris on a very different sort of structure—one that embodied a range of meaning more in keeping with republican sympathies.

Originally, Bartholdi's statue of *Liberty Enlightening the World* (his monument's formal title) was intended to be presented to the United States in 1876, on the occasion of its centennial. But with the final model not even approved until late 1875, this now was impossible. Instead, with only six months to go, Bartholdi and Viollet-le-Duc decided to send the statue's colossal arm and torch for display at the upcoming Philadelphia Centennial Exhibition. Strained to meet even this deadline, twenty skilled artisans went to work on the project, laboring ten-hour days for seven days a week. Yet despite the pressure, they did not finish until June. It was July before this enormous segment (some thirty-seven feet in length) was crated up and sent to Philadelphia, where it arrived in August. There, Bartholdi supervised its assembly and installation, and watched with considerable pride as it was unveiled before crowds of properly impressed Americans, who eagerly paid to climb to the top of the torch for the view.

Following its successful Philadelphia debut, the huge arm then went to New York City, where it continued to attract crowds in Madison Square Park. Eventually (in 1882), it would be crated up and returned to Paris, to be incorporated into the rest of the statue. But in the meantime, its purpose was to drum up interest and stimulate fund-raising—for, as Laboulaye had planned from the outset, this entire effort was to be funded privately. The French were to raise the funds for the statue, while Americans would pay for the pedestal and installation expenses.

Consequently, although Bartholdi did not travel throughout the length and breadth of America on this visit as he had in 1871, he managed to take in much of the East Coast, wooing potential donors every step of the way. He even talked up potential New York contributors while in town for the unveiling of his statue of Lafayette, which the French government had commissioned. Somehow, in the midst of all this activity, he found time to wed a young Frenchwoman, Jeanne-Emilie Baheux du Puysieux, whom he had met on his first visit to the States in 1871.

In February 1877, Congress and the president warmly accepted *Liberty Enlightening the World* as a gift from the French people, guaranteeing the New York Harbor site as well as funds for the statue's maintenance. Bartholdi quickly moved on to the next step—getting *Liberty's* head finished in time for Paris's Universal Exposition, scheduled for 1878. This, too, would be an enormous task, but Bartholdi was already demonstrating his stellar publicity skills, creating a diorama of the statue standing in New York Harbor for visitors to the Tuileries gardens. Today, this diorama awaits visitors to Paris's Musée des Arts et Métiers, in the pedestal of a scale replica of *Liberty*.

⌣

Zola's masterpiece L'assommoir began to appear in serialized form in 1876 and in book form in early 1877, accompanied by scandalized gasps from the reading public, which was shocked by the crudity of its language and the wretchedness of its characters' lives. Manet, however, was enthralled; he proceeded to give the title Nana to his painting of the courtesan Henriette Hauser, naming it after the daughter of the alcoholic laundress Gervaise Lantier in L'assommoir. Zola had not yet even begun to write his novel Nana, but the references in Manet's painting were clear. When the Salon (presumably scandalized) rejected it, he brashly showed it in the window of a shop on the Boulevard des Capucines, virtually on the doorstep of the Opéra Garnier, where it created a succès de scandale.

Zola, of course, appreciated the value of scandal in promoting his novels and was adept at creating it. "First of all," he told a group that included Gustave Flaubert and Edmond de Goncourt, "I took a nail and with a blow of the hammer I drove it one inch into the public's brain; then with a second blow I drove it two inches in." That hammer, he acknowledged, consisted of the many self-serving articles that he wrote, "which are just so much charlatanism to puff my books."[12]

Yet Zola, who could be so brutally honest about himself and the world around him, was also susceptible to great bouts of mawkish self-pity, whether about his poverty-stricken youth or the suspicion with which he felt he was now regarded. "It is strange," noted Goncourt, who was bitterly envious of Zola's success, "what a whiner that fat, pot-bellied young fellow is." When Goncourt, Flaubert, and Ivan Turgenev told Zola point-blank that he had no reason to complain, Zola burst out that the trouble was that he would never receive any kind of honor in recognition of his talent, and that "for the public, I shall always be a pariah, yes a pariah!"[13]

Although this embarrassing confession would turn out to contain something of the truth, at the time it left his colleagues feeling both bemused and irritated.

⌣

Once again, in the spring of 1877, the group of avant-garde painters now known derisively as the Impressionists launched another exhibit—their third. As before, the male members of the group corresponded formally with Berthe Morisot about the exhibit's preparations, and as usual, the event stirred up considerable hostility. Edouard Manet, who did not participate, had asked the critic Albert Wolff to approach the exhibit with an open

mind—but Wolff, not surprisingly, had responded with his usual scathing criticism.

But the Impressionists were not the only artists in town that spring who were creating a stir, for at the age of thirty-seven, Auguste Rodin was about to make a splash in the Parisian art scene.

Of course, Rodin had no intention of creating a scandal when he submitted his sculpture *The Bronze Age* to the Salon in 1877. He had begun work on the statue several years earlier, while in Belgium, and used a Belgian soldier as his model. Following his trip to Italy, he finished the work and proceeded to show it at a Belgian exhibition. Here it aroused admiration as well as a disturbing undercurrent of suspicion. How could anyone, his critics asked, create such a sculpture without casting it from life—that is, without creating a statue from plaster casts taken of the model? Rodin was deeply disturbed by this charge, which called his artistic integrity as well as his ability into question. He offered to bring his model before experts to show "how far removed an artistic interpretation must be from a slavish copy,"[14] but the issue continued to dog him when, in 1877, he submitted the slightly altered statue to the Salon under the title of *The Bronze Age*.

The Salon's jury accepted Rodin's creation, although many of its members found it disturbingly different from the static sculptures they were more accustomed to seeing. As this vibrant sculpture from an unknown sculptor started to attract attention, the rumors once more started to circulate that Rodin had not actually sculpted the work but had cast it "from life." The scandal blazed throughout artistic circles, with talk of withdrawing the sculpture from the Salon, and one prominent member of the Institut even claimed that the statue had been cast from a corpse. Appalled, Rodin offered to bring his Belgian model before the jury, stripped to the buff if need be, but Belgian military authorities refused to grant the soldier permission to leave the country. Next, Rodin decided to produce photographs of his model. But at this point, fortunately, several prominent artists came to his defense, including some Belgian artists who had watched him create the controversial sculpture.

Rodin won the battle, and having won, benefited from the ugly controversy that had at first threatened his career. Whether or not Oscar Wilde was right in observing that the only thing worse than being talked about was not being talked about, Rodin now found a public that was aware of him and his prodigious talents. Although his years of hardship were not over, he had passed a critical divide in his career. Three years after the controversy, the French state extended the equivalent of its blessing and purchased a bronze cast of *The Bronze Age* for the Luxembourg gardens. It now stands in Paris's Musée Rodin.

~

"Clericalism!" thundered Léon Gambetta to the assembled members of the Chamber of Deputies. "That is the enemy."[15]

The date was May 4, 1877, and Gambetta—the son of a Genoese father and a French mother—had been the flag-bearer for secular republicanism ever since the Second Empire, which he had heartily opposed. With the fall of that empire, he emerged as a leading member of the new Government of National Defense, strenuously opposing capitulation to the Germans and daringly escaping Paris by balloon in order to organize an army to come to the city's aid. Following Thiers' peace treaty with the Germans, Gambetta left France in disgust, thus missing the entire Commune uprising, but upon his return to France and to French politics, he made it clear that he now embraced a more moderate form of republicanism. Naming this the policy of "opportunism," he became the leading figure of the so-called Opportunist republicans, playing an influential role in the passage of the Constitution. According to Gambetta's plan, he and his followers would bide their time, waiting for a more propitious moment to press their case.

But it soon looked as though this moment might never arrive—at least if MacMahon and his royalist followers had their way. As MacMahon's government moved further and further to the right, the clerical issue became the rallying point for the government's opponents. In what probably was a bid to divide the opposition, MacMahon appointed a moderate republican, Jules Simon, as his prime minister, but Simon did not perform to MacMahon's satisfaction, failing to crack down on anticlericalism and allowing what the right wing regarded as an unconscionable degree of freedom of the press. On May 16, 1877, MacMahon sacked Simon (who technically resigned).

The coup d'état, or violent overthrow of an existing government, had hardly been unknown in France during the previous century. Indeed, Napoleon III had come to power scarcely twenty-five years before in just such a raw display of power, and the fear now grew that MacMahon and his supporters were preparing to follow in his footsteps. *Le seize mai*—the sixteenth of May, the date on which MacMahon sacked Simon—quickly became a rallying cry for those who opposed the MacMahon government and, with considerable justification, feared the worst.

Instead of a coup d'état, MacMahon's associates risked a general election—a daunting prospect given the amount of opposition that they now faced. With little appreciation for the nature of that opposition, they put off the elections for many months, during which they embarked on a series of actions that amounted to mass arm-twisting—prosecuting newspapers, threatening

owners of republican meeting places, dismissing "unreliable" local officials, and forbidding circulation of opposition circulars and propaganda while conducting their own massive propaganda campaign. Their actions, which betrayed more than a whiff of desperation, merely united the previously fragmented opposition, of which Gambetta now took command.

Confronting the aristocrats and clerics who made up the bulk of MacMahon's supporters, Gambetta's republicans for the first time were able to face down the right wing's politics of fear, which since 1789 had associated republicanism with disorder and crisis. Staying remarkably on message, Gambetta's followers turned the tables on their attackers, arguing that the republicans were the real conservatives, the preservers of peace and the protectors of prosperity.

Even Adolphe Thiers, who well remembered his ouster at MacMahon's hands, joined with Gambetta to oppose the monarchist right. Thiers' death at the campaign's height removed a key figure from the fray, but Victor Hugo, who had damned le seize mai as a "semi-coup d'état," now joined the political battle by publishing the first volume of his account of the coup d'état of 1851, which he pungently titled the Histoire d'un crime (History of a Crime). "This book is more than topical," Hugo told his public. "It is urgent. I publish it."[16]

He shrugged off rumors that the book would be banned, and, indeed, MacMahon's associates did not have the nerve to take on this aged man with the almost godlike reputation. The book was therefore free to make its mark, reminding even those voters who did not read it of the dangers that MacMahon's candidates represented.

Voters turned out in overwhelming numbers for this impassioned election of October 1877 and gave a ringing endorsement to the republican candidates. Even then, MacMahon clung to his office (to which he was legally entitled), but the Chamber of Deputies refused to deal with him without significant concessions on his part. Putting the situation succinctly, Gambetta famously warned MacMahon to "se soumettre ou se démettre" ("submit or resign"). In the end, MacMahon reluctantly accepted the conditions and limitations that allowed him to stay on, while the republicans under Gambetta pressed to consolidate their victory.

After all, they did not yet have control of the Senate. But elections for one-third of the Senate's members were coming up in early 1879. And despite the Senate's reputation as a bastion of conservative power, the republicans intended to win.

CHAPTER SEVEN

~

A Splendid Diversion

(1878)

The buildings are to stand on the Champ de Mars, as before, but there is now to be a great structure thrown across the Seine, with the Pont d'Iéna for its foundation, and the opposite hill of the Trocadéro is to be covered with the dependencies of the show."[1]

Henry James was writing home, via a May 1876 letter to the *New York Tribune*, about the latest excitement in Paris—its upcoming Universal Exposition of 1878. Since Britain opened the era of world expositions with its famed 1851 extravaganza featuring the Crystal Palace, Paris had responded with two expositions of its own, in 1855 and 1867. This spacing of little more than a decade between French expositions had not been lost on anyone, and as a result, the year 1878 rose before France as both an invitation and a challenge. Could France, so recently defeated in war and reduced to ashes, actually manage to mount such an extravaganza?

Indeed it could. National pride demanded a fitting celebration of France's recovery. In addition, an event of this magnitude would provide a useful diversion during a touchy time in the nation's political life. The voting public had overwhelmingly embraced the Third Republic. Yet MacMahon continued to cling to office, and the Senate's fate remained to be determined. What better way to divert a potentially volatile populace than with a huge party?

Still, after viewing architectural drawings of projects proposed for the exhibition, James observed, "The architects and economists wish greatly, I believe, that the Exhibition were to take place three or four years later, and so,

75

from the bottom of their hearts, do all quiet Parisians." The only people "in a hurry," he trenchantly added, were "the restaurateurs and the cab drivers."[2]

⟶

With the republicans in the ascendancy, suddenly the symbols that had offended the monarchist and clerical right returned to front-and-center of national life. Voltaire was rehabilitated, his memory honored by the centennial commemoration of his death. Reviving an even more potent symbol, the government made July 14 a national holiday, starting in 1880. This great day was still two years off, but as everyone knew, the French did not have to wait until 1880 to celebrate. The Universal Exposition was about to open, showing the world how splendidly France had recovered from its days of ignominy and defeat.

The government had set aside half a million francs to embellish Paris, and Claude Monet captured (twice) the Rue Montorgueil, festooned with flags for the holiday celebrating the exposition's opening. Edouard Manet looked out his studio window on Rue de Saint-Pétersbourg and painted the preparations in *Street Pavers, Rue Mosnier*, a street—now called the Rue de Berne (8th)—that his studio overlooked. He painted three pictures of Rue Mosnier at this time, including two of the street adorned with flags for the holiday celebrating the exposition's opening. One of these, *The Rue Mosnier Decked Out in Flags*, much like Monet's *The Rue Montorgueil*, captures the occasion's festivity, but the other, *The Rue Mosnier Decorated with Flags*, captures something more—rubble hid behind a fence, and a one-legged man hobbling on crutches in the foreground. Manet's politics may or may not have been showing here, but the painting certainly revealed (at least, for anyone who cared to look) a Paris that contained ugliness and suffering behind its glittering façade.

Still, Paris after the republican victories was a far different place than it had been before. In early May, Jean-Baptiste Auguste Clésinger's statue *La République* was inaugurated at the entrance to the exposition, accompanied by a rousing rendition of the Marseillaise—the first time this fervent national anthem had been played in public since 1870. MacMahon and his followers were appalled. After all, the Marseillaise summoned up images of the Revolution and of the more recent Commune. But there was little that he or they could do about it, and so from then on, Frenchmen could sing this stirring anthem to their hearts' content.

The exhibition itself opened to the accompaniment of a national holiday, replete with appropriate festivities, including outdoor music and dancing throughout Paris. Although not completely finished by opening day, the exposition was sufficiently grand that no one seemed to mind. As national

Entrance to the Cité Fleurie, Paris, constructed from remnants of the Universal Exposition of 1878. © J. McAuliffe.

pride demanded, it was the largest that had been held anywhere to date, stretching from the Champ de Mars to a Moorish-style palace constructed on the Place du Trocadéro, across the Seine. It was here, in the palace garden, that Bartholdi displayed *Liberty*'s colossal head, which had been transported through the streets of Paris in a celebrational parade of its own. Just as in Philadelphia, crowds lined up to climb the steps to the top of this enormous sculpture—in this case, not to the torch but to the crown.

Gustave Eiffel had entered the competition to design and build the bridge linking the Champ de Mars with the Trocadéro; although he failed to win this contract, he was sufficiently involved in several of the exhibition's other structures that he could chalk up the entire episode as a success. By this time he had also completed the startlingly modern Nyugati (West) Railway Station in Budapest, with its clearly visible iron structure and daring use of glass. With an eye to future sales, Eiffel made good use of the exposition to display the station's photographs and plans.[3]

Like its predecessor world exhibitions, this one starred the newest inventions of the industrial age, including Alexander Graham Bell's telephone and Thomas Edison's phonograph. It also featured a dazzling display of electric lighting that illuminated the exhibition's two main concourses. And if that was not enough to keep the crowds enthralled, there was a hot-air balloon safely tethered in the Tuileries gardens, for those who dared to make the ascent.

Here, Sarah Bernhardt came again and again, to ride the rocking wicker gondola high into the sky.

∼

By her own account, Sarah Bernhardt—who craved adventure as well as attention—was soon making two or three moored balloon trips daily from the Tuileries gardens. Eventually, though, a moored balloon wasn't enough for her. Determined to have her way, she put to work her considerable powers of persuasion to cajole the balloon's owner, Henry Giffard, into outfitting a balloon to take her on a free-floating journey. Giffard, who was no match for Sarah, at last agreed. And so, at five-thirty one evening, Bernhardt, accompanied by her artist friend Georges Clairin and the experienced balloonist Louis Godard (nephew of the famed balloonist Eugène Godard), began her adventure.

In this age before airplanes, a balloon was a high-risk activity, but it was still the only viable way to make a journey through the air. The French had begun to develop ballooning in the previous century, with the discovery that smoke from a fire of wool and straw would fill a huge bag and lift it high in the air. During the years that followed, other Frenchmen, including Giffard,

continued to improve these primitive airships—Giffard's contribution being to invent and build the first balloon with a steam engine, which allowed the balloon to change direction independent of the wind.

Bernhardt later recorded her daring journey in typically creative fashion, from the point of view of a chair in the gondola. One can smile now at the quaintness of many aspects of her adventure, but what is remarkable is that during the long hours of her ascent, sometimes to a height of eight thousand feet, it never seems to have occurred to her to be afraid. Dazzled, yes—by the view of "the city spread below us, a blur of gray," and by the "huge, orange hangings fringed with purple [that] streamed from the sun to lose themselves in a froth of white lace."[4] Melancholy, too, as when they passed over Père-Lachaise cemetery and Bernhardt plucked at the flowers pinned to her jacket, sending a rain of white petals down onto the graves below. But there was also exuberance—as when the trio polished off their foie gras sandwiches with champagne, sending the cork flying through the air, and later pelted a wedding party below with sand from their ballast bags.

Melancholy, of course, was in its own way as welcome to Bernhardt as joy. Denizens of the intensely romantic years that closed the nineteenth century reveled in a manageable sense of poetic emotion, and Bernhardt made it her stock-in-trade, on stage or off. With the approach of twilight, she wrote, "the air became charged with poetry" and "a delightful feeling of melancholy suffused us."[5] But this sense of melancholy was hardly in the same category as depression. Bernhardt may have milked every tear in her audience and worked up a frenzy of interest in her public by what Henry James caustically viewed as an excessively histrionic personality, but she knew what she was doing every minute—and enjoyed herself thoroughly in the process.

Not only had she brought a fresh perspective on acting to the staid old Comédie-Française, refusing to perform in the old-fashioned declamatory manner, but she had introduced Paris (and was about to introduce the world) to a legend-in-the-making, much of which was created especially for public consumption. She had already revealed that she studied her roles while reclining in a satin-lined coffin, and she even had herself photographed sleeping there. She also had herself photographed in a wide variety of other activities, including sculpting, for which she dramatically posed in white silk pants. Theatergoing Parisians were already accustomed to seeing Sarah Bernhardt's legs—she had, after all, achieved her first major success at the Théâtre de l'Odéon in a trouser role. Still, the nineteenth century was generally unaccustomed to such exposure, and these photos sold widely, adding to her notoriety.

Legends require furs and jewels, with which Bernhardt regally swathed herself. Legends also require suitably sumptuous surroundings, and soon

after her triumphant return to the Comédie-Française, she built herself an opulent palace in the fashionable area just north of Parc Monceau. Here she decorated with abandon, inviting her artist friends and hangers-on to indulge their ornate fancies.

It was to these rooms, filled with carpets, potted palms, and bric-a-brac—as well as Bernhardt's growing menagerie of animals—that she returned following the peaceful conclusion of her balloon adventure. It was here as well that she wrote the whole thing up in a delightful story, *Dans les nuages* (*In the Clouds*)—telling it from the point of view of the chair brought along for the ride.

The nerve, some fumed. First an actress, then a sculptor, next a painter, and now a writer. Unfortunately, at least for her detractors, Bernhardt managed to succeed in all of these roles. She was good—very good—at many things.

And, of course, she knew it.

⌒

The exposition lasted until early November and was a great success, surpassing its predecessor in every measurable way, including attendance and revenue.

In its aftermath, materials from the site were put to creative use, including a former wasteland on the city's outskirts. Here the builder constructed a series of rustic half-timbered artist studios in two long rows, divided by a long, woodsy garden. The bucolic results, at what now is 65 Boulevard Arago, became known as the Cité Fleurie, and soon drew a clientele of impoverished artists, including Rodin and Aristide Maillol, both of whom had studios there.

Claude Monet was not among them. Still broke and now burdened with a second child and an invalid wife, he left Argenteuil in the spring of 1878 for the country village of Vétheuil on the Seine, located between Paris and his future home at Giverny. Here he could live more cheaply than before but was still within range of Paris, where he regularly returned to maintain contacts and try to sell his paintings. But, despite all his efforts, he was not having much luck.

Adding to Monet's woes, his recently acquired patron, Ernest Hoschedé, had gone bankrupt. Hoschedé, a Parisian businessman who inherited his father's textile business, was accustomed to extravagance. He and his wife, Alice, had for years lived and entertained lavishly in their Paris apartment on Boulevard Haussmann, near Parc Monceau. Summers, Hoschedé was accustomed to inviting a bevy of guests to his (in actuality, his wife's) nearby château, including artists whose paintings interested him. Among these

fortunate guests was Monet, who in the summer of 1876 had accepted Ho-schedé's commission to paint four decorative panels for the château's grand salon.[6]

There the story might have ended, except for the fact that during this idyllic summer—which extended into the autumn—Monet met the elegant Madame Hoschedé. Alice's sixth and last child, Jean-Pierre, was born nine months after Monet was left alone with her in the château, giving rise to speculation that Jean-Pierre was Monet's son (speculation that, in later years, Jean-Pierre himself encouraged). Complicating matters, Monet also became fast friends with Madame Hoschedé's husband, and when Ernest Hoschedé declared his bankruptcy, Monet—despite his own financial difficulties—was quick to offer help. This amounted to a proposal to let the Hoschedé family, including their six children, live at the Monets' far less luxurious abode.[7]

It seems difficult to believe that the *famille* Hoschedé had no other alter-natives, but move in with the Monets they did. This cramped arrangement led to another move, to a somewhat larger house down the road, but even when Ernest Hoschedé began to spend more and more of his time in Paris, this still left a household of eleven persons, including Monet's sickly wife, Camille, and their two sons, the younger of whom was still only a few months old.

By this time, Camille required almost constant care, and Alice Hoschedé seems to have supervised this as well as the entire household, freeing up Monet to continue his painting. By this time as well, Alice may have re-placed Camille in Monet's bed, although it was still possible to explain the newcomer's continued presence as the result of extreme need on the part of both families.

But even this fig leaf of respectability was about to drop.

⁓

In the meanwhile, Zola was still going strong. In the autumn, as the expo-sition was winding down, Edouard Manet reported that he had met some people who had been to see Zola at his new country house in Médan. Zola had read them the first two chapters of *Nana*, Manet told a friend, "which sounds wonderful and way ahead of everything else in its realism—another triumph, no doubt."[8]

If Manet was possibly feeling a little less than enthusiastic about Zola's continuing success, Edmond de Goncourt was positively acidic. In 1874, Goncourt had written in his diary of a dinner at the Café Richie with Flau-bert, Zola, Turgenev, and Alphonse Daudet, which he described as "a dinner of men of talent who have a high opinion of each other's work." A similar dinner in the spring of 1877, at the Restaurant Trapp, now included the

young Octave Mirbeau and Guy de Maupassant, who used the occasion to acclaim Flaubert, Zola, and Goncourt as "the three masters of modern literature."[9] This dinner has gone down in literary history as marking the true beginning of the Naturalist movement, and Goncourt was pleased by the tribute. Still, the focus of the evening was on Zola, and Goncourt's bitterness about the public's apathy toward his own works continued to gnaw at him.

Zola's continued triumphs only made matters worse. Goncourt consoled himself with his rival's occasional missteps, such as the play *Le bouton de rose*, but found Zola's successes increasingly difficult to bear. "I have never known a man so hard to please, so dissatisfied with the enormity of his good fortune as Zola," he complained to his journal the spring of 1878. "Here is a man whose name echoes round the world," he added later, "[a man] who sells a hundred thousand copies of every book he writes, who has perhaps caused a greater stir in his lifetime than any other author, and yet . . . he is unhappier than the most abject of failures."[10]

Goncourt did not yet know, of course, that his own fame would come largely from the journal he was writing, rather than from the novels and plays that he and his recently deceased brother had so tirelessly created throughout the years. It probably would not have cheered him. He had greater literary goals in mind than his gossipy journal, to which he confided evidence of the critics' abuse and the public's neglect. Yes, he confessed, it all was difficult to bear. Yet "the critics may say what they like about Zola, they cannot prevent us, my brother and myself, from being the John-the-Baptists of modern neurosis."[11]

～

Zola, a shy and reserved man, was no match for Goncourt in wit or social graces, nor did he care to be. He had his work to do—the famous thousand words a day, written without fail after breakfast. With the exception of his dinners or occasional outings with fellow writers, he retired early and rarely socialized. His research was notorious for what he called his "scientific method," which involved carefully studying whatever environment he had chosen for his latest novel, talking with its inhabitants, watching them and conducting interviews—all accompanied by assiduous note taking. This, along with a great deal of background reading, largely in press clippings, was the basis for the careful layering of description that gave Zola's novels the unmistakable element of reality that he sought. Readers such as Madame Morisot sometimes complained of feeling inundated with descriptive detail, but in general, his public was suitably awed by his preparatory spadework. Still there were always those who found it somewhat amusing. A cartoon of

the time shows him being run over by a carriage "in order to describe faith-fully the sensations of such an accident in his forthcoming novel."[12]

Zola did not comprehend the humor. In fact, he was a determined writer, even a grim one, who suffered from many maladies— some or perhaps all of them imaginary. A straight-laced fellow, with a wife to whom he was faithful, he neither kept a mistress nor was interested in doing so, despite his by-now intimate acquaintance with the demimonde through his well-known researches for *Nana*. His primary indulgence, in fact, was eating, and he ate well. "Zola alone eats as much as three ordinary novelists!" Maupassant wrote after a visit to Zola's newly acquired country house in Médan.[13] Goncourt even brought himself to report favorably on the dinner that Zola gave on the occasion of his Médan housewarming, in the spring of 1878. "He gave us a very choice, very tasty dinner, a real gourmet's dinner," Goncourt observed in a rare compliment, although he felt compelled to add that the dinner included "some grouse whose scented flesh Daudet compared to an old courtesan's flesh marinaded in a bidet."[14]

Zola's expanding waistline was due to food, not drink. Alcohol and drunk-enness may have played a major role in his novel *L'assommoir* (*The Dive*), but he himself drank in moderation. *L'assommoir* certainly was not a celebration of alcohol, but it was not a temperance tract, either. It was "a work of truth," Zola explained forcefully.[15]

L'assommoir, a slang word little used before Zola made it famous, can mean either "bludgeon" or "low-level pub"—the sort of place where one could receive a knock-out blow, not so much from the clientele as from the liquor one drank. And during the 1870s, the favored way to get cheaply ham-mered was through the lethal brew absinthe.

Absinthe is a highly alcoholic beverage infused with anise-flavored worm-wood, which entered French culture at mid-century after being introduced to French troops as a treatment for malaria. It arrived at a propitious mo-ment, when the disease called phylloxera was starting to decimate France's vineyards. With wine in short supply, the stage was set for another form of alcohol, which absinthe readily provided.

Sarah Bernhardt and her companions were indulging in an especially rare luxury when they popped a bottle of champagne during their balloon ascent, but Bernhardt was known to favor absinthe as well. Called *la fée verte* (the green fairy) for its color as well as for its impact, absinthe was enthusi-astically embraced by Parisian artists and bohemians, who praised it for its extraordinary impact on their perceptions. Enthusing over the mind-altering hallucinations it induced, daring members of the artistic set participated in the ritual that consisted of a special spoon, a cube of sugar, and a glass into

which water was poured, drop by drop, over the sugar and into the thick green liquor below.

Even when diluted in this manner by three to five times its volume, absinthe still packed a wallop, and its legendary effects were probably due to its high concentration of alcohol rather than to any mysterious drug in its makeup. Eventually it was banned, first in the United States and then throughout Europe,[16] but until France's vineyards began to recover, this powerful drink was popular not only among Parisian artists and writers but also among the poor, for whom it was a cheap blast into forgetfulness. Degas' devastating picture *L'Absinthe*, painted in 1876, shows a down-and-out woman staring with alcohol-numbed eyes over a glass of absinthe, her hopelessness evident in every dejected line of her body.

The subject of alcoholism among the working class horrified many conservatives such as Goncourt and his brother, who in their novel *Germinie Lacerteux* had depicted the degeneration of a Paris maid into alcoholism. Goncourt and others were only too ready to believe that the entire Commune uprising could be blamed on an epidemic of drunkenness among Paris's workers, whom they labeled "apostles of absinthe." This infuriated Zola, who pointed out the hypocrisy of conservatives' attempts to control working-class drinking while ignoring the drinking that went on in ritzier cafés. A friend of Goncourt, for example, passed along the tidbit that during the 1850s, he had often seen Alfred de Musset taking his absinthe (one that "looked like a thick soup") at the trendy Café de la Régence—after which the waiter would half-carry the famous writer to his waiting carriage.[17]

If there was anything Zola could not bear it was the "scented and graceful vice" of the upper classes. As for alcoholism among the poor, there had been no one who had dramatized the problem more graphically than he, but he saw alcoholism as a result, not simply a cause, of the social evils that the poor suffered. "Educate the worker," he cried. "Take him out of the misery in which he lives, combat the crowding and the promiscuity of the workers' quarters where the air thickens and stinks; above all prevent drunkenness which decimates the people and kills mind and body."[18]

~

Louise Michel had been there and seen it all, far more intimately and graphically than Zola ever had, but her cries of outrage were now banished to the other side of the world. There she worked to instill the "hope for liberty and bread" among the native Kanaks, who in 1878 rose up in a rebellion that took many months for the French army to suppress. During this bloody time, most of the exiled Communards sided with their own compatriots, but Mi-

chel strongly supported the Kanaks, who (as she later wrote) "were seeking the same liberty we had sought in the Commune."[19]

She nevertheless was cautious in her memoirs about her exact role in the uprising. "Let me say only," she tells the reader, "that my red scarf, the red scarf of the Commune that I had hidden from every search, was divided in two pieces one night."[20] She strongly hints that these pieces accompanied two Kanaks who, before joining the insurgency, came to say good-bye to her. She never saw either of them again.

CHAPTER EIGHT

~

Victory

(1879–1880)

In January 1879, elections for one-third of the Senate produced a solid victory for the republicans, giving them a clear majority in both houses. Somehow, the monarchists had missed all the signals. As the Vicomte de Meaux later put it, "We were monarchists and the country was not."[1]

It was a moment to savor, especially since MacMahon, who fundamentally disapproved of the new state of things, now resigned. Even the Bonaparte threat evaporated. Former Emperor Napoleon III died in England in 1873 but left a son, the Prince Imperial, a gallant young soldier around whom dreams and plans had swirled. Now, in 1879, the Prince Imperial unexpectedly died in Africa at the hands of Zulu tribesmen (he had been serving in the British army). Bonapartists everywhere mourned the young man's untimely passing, but for those who dreaded the continued specter of Bonapartism, the Prince Imperial's disappearance from the political stage was welcome news.

Having established control of the government, the republicans promptly placed their stamp on the nation by making the Marseillaise the national anthem, as well as by moving the government from the unmistakably royalist site of Versailles back to Paris.

In addition to such powerful symbolic actions, the republicans took care to protect their political majority by a series of moves that abolished life senators, banished monarchist pretenders to the throne, and loosened controls on the press and on public houses (these being the places where republicans often held their political meetings). Wading into deeper political waters,

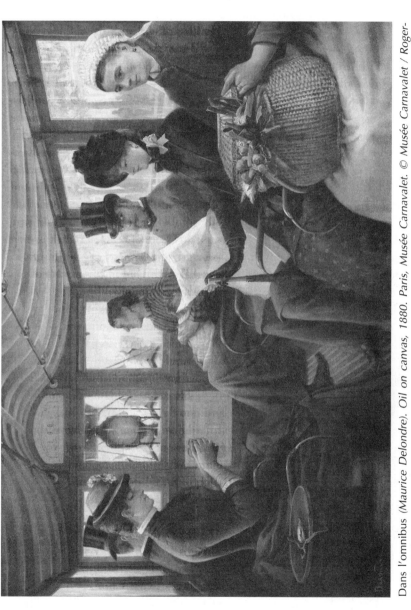

Dans l'omnibus (Maurice Delondre). Oil on canvas, 1880. Paris, Musée Carnavalet. © Musée Carnavalet / Roger-Viollet / The Image Works.

they proceeded to take on the Church by permitting divorce, legalizing Sunday work, and secularizing cemeteries, hospitals, and even law courts, from which the crucifix was now removed.

But by far the most radical measure taken by the new republican government was its legislation secularizing the entire school system and removing priests and nuns from their positions as teachers and administrators. In support of this policy, the republicans now took the radical step of expelling the Jesuits, the religious order responsible for teaching at the country's leading preparatory schools, or *collèges*, and—not coincidentally—the most feared and hated religious order in France.

～

The Society of Jesus, the formal name of the Jesuit Order, had its origins in Paris, when seven students studying at the University of Paris met in 1534 in the crypt of the Chapel of Saint-Denis, about halfway up the steep slopes of Montmartre. On this spot, as legend had it, Roman soldiers long ago beheaded St. Denis, the first bishop of Paris.

Here on this site (the current chapel, at 11 Rue Yvonne-Le-Tac, is a nineteenth-century reproduction) those seven students—including Ignatius Loyola and Francis Xavier—formed a group of companions bound by a vow of poverty and chastity, with the goal of serving God. After the order received the pope's approval, Loyola (formerly a knight) became its first superior-general, sending Jesuit teachers and missionaries as soldiers of God throughout Europe and eventually around the world.

The Jesuits' missionary role in the New World is well known, as is their role as confessors and political advisers to kings, where their privileged positions (and the power that accompanied it) earned them suspicion, hatred, and eventual suppression in several nations, including France. In the wake of this international crackdown, the pope in 1773 formally dissolved the order, but in 1814—as Revolution waned and monarchy revived—another pope reestablished it. The Jesuits now staged a sturdy comeback, returning to their centuries-old role as the "schoolmasters of Europe."

In France, the Jesuits focused on secondary education, or *collèges*. Although their schools encountered opposition and were closed for a time, by mid-century Catholics had obtained the legal right to open their own secondary schools, and by 1879 there were twenty-nine Jesuit *collèges* in France, teaching more than ten thousand students. Of these, perhaps the best known was Paris's Collège de l'Immaculée-Conception on Rue de Vaugirard, which young Charles de Gaulle would eventually attend.[2]

In addition to their secondary schools, the Jesuits operated special preparatory schools aimed at winning admission into the elite *grandes écoles*,

especially into the military academy of Saint-Cyr. Among these preparatory institutions, probably the most prestigious was the Ecole Sainte-Geneviève, located on the former Rue des Postes (now Rue Lhomond, 5th) and known informally as the Ecole de la Rue des Postes, or simply the Rue des Postes. By the late 1870s, the Rue des Postes was getting enough ardent young Catholics into Saint-Cyr to give the military academy a decidedly religious tilt.

And that was exactly the sort of thing that alarmed republicans. "He who controls the school, controls the world," warned republican educator Jean Macé,[3] and both republicans and Catholics agreed. But who would do the controlling? It was a problem that struck at the heart of the entire struggle between right and left, monarchists and republicans, clergy and secularists that had preoccupied France since the Enlightenment and had dominated French political life for the previous decade. Young Abbé Frémont, who held republican sympathies and thus was a rare bird among the clergy, succinctly summed up the situation: "Because it has bound up its cause with that of Royalism, the clergy of France has finally convinced everyone who believes in things popular and democratic that between the Church . . . and progress, the Republic and the future . . . there is no relationship possible but the most deadly hatred."[4]

The republicans, who remained divided despite their recent electoral victories, found common cause in their desire to secularize French society. Yet all but members of the far left were wary of attacking the Church and religion head-on. As minister of education and then prime minister, Jules Ferry was well aware that republicans owed their victories to Catholics who would vote for them so long as they did not attack religion itself. As Ferry put it, he was "the elected representative of a people that makes wayside altars, that is fond of the Republic but is just as fond of its processions."[5]

Accordingly, the new republican government did not strike directly at the Church, but chipped away in areas that would be most likely to receive public support. It was in this spirit that the government annulled the law forbidding Sunday work, secularized hospitals and cemeteries, removed crucifixes from courtrooms, and allowed divorce. And it was in this spirit as well that, in its most important bid at secularization, it removed the clergy from the schools—taking care at the same time to dissolve the Jesuit Order in France.

The republicans were aiming at bringing France closer to the republican ideal—not only in secondary and higher education, but at the level of primary education, which was now to become compulsory and free as well as secular. Young women were singled out for special attention with the creation of a system of girls' secondary schools, which were expected to provide "republican companions for republican men." In what amounted to a significant breakthrough, the teachers at these all-female secondary schools would

be women, but not nuns—an innovation that in turn required an entirely new establishment of teacher training schools.

It was an innovation billed as a benefit to women, by leading them "towards the light, towards knowledge." But unquestionably, its unstated aim was to decrease the Church's influence over women, who traditionally constituted the most devout portion of France's population.

～

The pope's response to all of this was surprisingly moderate. After all, despite the fireworks over secularization, the Concordat remained. Even the clergy's salaries continued to be paid by the state, and after all was said and done, only about one-third of the Church's teaching orders in France were dissolved. Having decided to leave well enough alone, the pope advised French Catholics to practice moderation in their own response to the changes at hand. Despite these republican thrusts, France remained far less hostile to the Church than Bismarck's Germany or the newly unified and secularized Italy.

But the very elements of compromise that appeased the Church gave apoplexy to left-wing republicans, most especially Georges Clemenceau, who was emerging as their most effective spokesman. He had already established his credentials as a duelist, and he was proving as brutal with words as he was with pistols.

The men who had put the unremarkable Jules Grévy in power as the first republican president of the Third Republic had counted on Grévy's commitment to moderation, as well as his opposition to the highly popular Léon Gambetta. Despite Gambetta's own conversion to moderation, and despite the fact that it was his strategies and leadership that had fostered the victories that brought the republicans into power, many of Grévy's crowd feared and distrusted him. In their eyes, Gambetta's popularity, as well as his charismatic personality, made him dangerous and unpredictable.

Yet Clemenceau and his colleagues viewed Gambetta's creed of Opportunism as a betrayal of their goals for the Republic. These included a wide range of issues, from amnesty for the Communards and abolition of the Senate to a progressive income tax and—most emphatically—the separation of Church and state, including the nullification of the Concordat. From the radical republicans' viewpoint, Gambetta had failed them. Still, from their perspective, Grévy and his ministers were unquestionably worse. It was this conviction that led Clemenceau in early 1879 to take on Grévy's minister of the interior, Emile de Marcère, who had prosecuted the editors of a Paris newspaper for a series of articles targeting abuses by the Paris police.

After Clemenceau got wind of charges that de Marcère was protecting officials who had been prepared to carry out a coup d'état following the events of le seize mai in 1877, he went into attack mode. In the Chamber of Deputies, he blasted de Marcère, accusing him of refusing to investigate the charges of police abuse and of protecting the officers who were responsible, most of whom had held office since the Empire. It was a devastatingly effective speech, and shortly thereafter, de Marcère resigned—the first of many ministers and ministries that would be toppled by the formidable Clemenceau.

Digging in on the amnesty issue, Clemenceau now turned to the printed word. After starting up his own newspaper, La Justice, with money provided by his father (who enthusiastically supported his son's politics), Clemenceau focused on the issues he held dear, in particular his demand for amnesty for the Communards. So long as Communards remained unpardoned, he insisted, the nation would suffer from the wounds of la semaine sanglante. Only complete and total amnesty for the remaining eight hundred unpardoned Communards would bring healing to the nation.

La Justice never had an impressive circulation, but its influence among republicans was enormous. By the spring of 1880, a number of these republicans were coming around to Clemenceau's point of view, which was reinforced by an incident on May 23, when the socialists held a demonstration in Père-Lachaise cemetery to commemorate the bloody events of exactly nine years before. It was a small crowd, but the police overreacted, brutally dispersing it. Challenged by Clemenceau, the new minister of the interior claimed that the rally had posed a danger to order and that the police had used moderation.

Clemenceau was unable to win a motion of censure against the minister, but the incident galvanized Gambetta, who became convinced that the time for amnesty had come. In a dramatic speech to the Chamber of Deputies, he called on its members to "close the book of these ten years" and to declare that "there is only one France and only one Republic."[6] In a tide of affirmation, the deputies passed the law granting amnesty to the Communards on the very eve of the first official celebration of July 14.

For Clemenceau, and for many others, it was a moment to savor.

～

It was a moment for Louise Michel to savor as well, although she spent little time in her memoirs talking about it. As always, she was focused on the causes and the people she cared about. Knowing that her mother was ill, she requested passage to France on a fast mail carrier—a request that the French

consul in Sydney at first refused. In response, Michel told him that she would have to give lectures on the Commune in order to raise the money necessary for the trip. At that, the consul capitulated, sending her with twenty others on the mail ship *John Helder*, bound for London.

She arrived in London on November 7, 1880, and two days later returned to Paris, at the Gare Saint-Lazare, where a cheering crowd awaited her. As she later wrote, in concluding this chapter in her life, "I had come home."[7]

⌒

Cheers had also greeted Sarah Bernhardt as she landed in London a few months earlier, where she was greeted as she stepped off the boat by a young and flamboyant Oscar Wilde, who threw a carpet of lilies at her feet.

The Comédie-Française had closed during the summer months for repairs, leaving it free to have a London season—a most unusual event, and one that Bernhardt made good use of to boost her career. Upon learning that half of the advance ticket sales had been sold on the strength of her name alone, she demanded and received a promotion to the highest rank in the company.

It was appropriate. Wilde adored Bernhardt and so did London, which enthusiastically applauded her, elevating her for the first time to international stardom. But her personal success earned her a good deal of hostility from other company members, especially since she capped it with success in the gallery and the boudoir—a gallery showing of her paintings and sculpture, and a lengthy nighttime visit (a command performance, by her account) with the Prince of Wales. Treated to a barrage of uncomplimentary coverage in the French press, she publicly threatened to resign from the Comédie-Française.

Interestingly, it was Zola who most strongly came to her defense, mocking the press for its vicious attacks and its innuendoes. How absurd, he wrote, to believe that this great actress roasted monkeys and slept with skeletons. How equally absurd, he added, to believe that she had exhibited herself in London dressed as a man for "a penny a peek." The Parisians had once adored Bernhardt, he reminded them; now let her talent speak for itself.[8]

Of course, Bernhardt herself had created the basis for some of the wilder of the stories that now were circulating about her. Having herself photographed in men's clothing or sleeping in a white satin coffin was not calculated to quell the press's tabloid instincts. Still, by the time she returned from London, matters had certainly gotten out of hand. The worst of the bilge that now assaulted her were several threatening letters that reeked of anti-Semitism.[9]

Bernhardt returned to Paris and to the Comédie-Française in triumph, but not for long. Breaking her contract with the Comédie-Française, she quietly

assembled a company of her own, which she proceeded to bring to London. The Comédie-Française sued for damages, then retrenched and begged to have her back, but she had tasted the freedom she longed for and was not about to return. She had already been approached by an American theatrical agent, and America—with its promise of vast crowds and even vaster wealth—now beckoned.

～

Georges Clemenceau had never struck people as being promiscuous—indeed, over the years he had struck some as downright puritanical. And yet it was around this time that he began to be seen around town, at society dinners and galas, accompanied by a series of attractive women. He continued to live with his wife, but it was no secret that his marriage—although blessed by three children—had never been very successful. He and his wife had lived apart for much of the time, only reuniting in 1876, when he brought her and the children to live with him in Paris. But within two years after their arrival, he broke free of family ties, launched on a series of high-profile affairs, and joined the society swim.

Clemenceau was unquestionably handsome, with a reputation for danger—both of which served to allure a bevy of females. He was also emerging as a comer in politics, which garnered attention from the male side of the equation. Everything was in his favor as he began his middle-age debut into the fast lane, sought after by prominent hostesses and by some of the most interesting people in town. It was now that he began to pay attention to his appearance, dressing fastidiously and acquiring the manners to go with it. It was now as well that he began his days with fashionable horseback rides in the Bois de Boulogne, finishing them at the Opéra, at the Comédie-Française, or at one of Paris's trendiest cafés or restaurants.

It was at one of these fashionable spots that, late in 1879, he made the acquaintance of Edouard Manet, whose political opinions meshed closely with his own. Interestingly, Clemenceau managed to retain a certain aloofness and reserve with most of the world, especially with his fellow politicians. But with artists and writers he was more willing to open up, and Edouard Manet became one of his few close friends.

Claude Monet would become another.

～

In the spring of 1879, the Impressionists held their fourth group exhibition. As before, Manet did not participate, but now Renoir, Sisley, and Cézanne also abstained. Fundamentally, this was a group of rugged individualists, all of whom had been developing in uniquely different ways. One could not

expect them to march in lockstep. Nor could one expect them to enjoy being dictated to, and Degas had an unfortunate habit of dictating.

From the outset Degas had objected to the more radical painters in the group and had tried to bring in artists of whom he approved (most of whose names never became or are no longer familiar). This caused much acrimony among his colleagues, who rightly believed that they had little in common with the artists that Degas so strongly proposed. The situation dramatically worsened in 1879, with Degas' edict that no one exhibiting with the Impressionists could also submit to the Salon. None of the Impressionists held warm feelings for the Salon, which had consistently reviled and rejected them. But they also wanted to be free to exhibit where and when they liked, especially as participating in a Salon exhibit (when it actually accepted their work) still held out the prospect of significant sales.

And so in 1879, Renoir, Sisley, and Cézanne bolted.[10] Cézanne had always been something of a fringe figure in the group, but Renoir and Sisley had from the outset been at its very core. They would be sorely missed, and Degas now worked to ensure that the remaining painters of the original group stayed put. This meant a full-court press on Berthe Morisot, and Degas sent a woman to do the job. This was Mary Cassatt, the wealthy and talented Philadelphian whom Degas had met two years previously, and who (at his invitation) was on the roster to show with the Impressionists this time around—a bright and shining exception to the mediocrities that Degas more typically recruited.

Berthe Morisot expressed her support for the independents but in the end abstained from this exhibition. She had just given birth to her first and only child, Julie, and was still in ill health, although sublimely happy. She had longed for this child and adored her, painting her again and again. "She likes to laugh and play so much!" she wrote her niece. "She is like a kitten, always happy, she is round as a ball, she has little sparkling eyes, and a large grinning mouth." Characteristically unsentimental, Morisot added, "[She] is sweet as an angel, though horribly quick-tempered."[11]

Mary Cassatt now exhibited for the first time with the Impressionists, as did Paul Gauguin, whom Pissarro brought on board, much as he had originally enlisted Cézanne. And wonder of wonders, this time around the painters actually sold some paintings. More than fifteen thousand visitors viewed their work, and despite the usual diatribes from Albert Wolff and the traditionalists, there were enough sales and favorable reviews that the exhibitors gladly rated this exhibition a success.

But the rift that had begun to split them apart was to widen in the coming year.

~

Claude Monet participated in the spring 1879 exhibition, although once more he was in a state of depression. His wife's health had worsened, and he still was impoverished—or felt himself to be. As always, he was deeply in debt, but he and his family were not exactly roasting the neighborhood sparrows for dinner, as Zola had done during his early Left Bank days. Indeed, ever since Argenteuil, the Monets had maintained a thoroughly middle-class lifestyle, eating well and employing several servants, including a gardener, and even keeping a series of studios in Paris. But this comfortable lifestyle was well beyond Monet's means, especially now with so many people in his household. And so he continued to borrow and spend, writing piteous letters to anyone he knew who might have cash to spare. "My poor wife is in increasing pain," he wrote one of his patrons, Georges de Bellio, in August. "The saddest thing is that we cannot always satisfy these immediate needs for lack of money." Stepping up his appeal, he added, "For a month now I have not been able to paint because I lack the colours; but that is not important. . . . It is unbearable to see her suffering so much and not be able to provide relief."[12]

Monet may not have been entirely honest with himself or others about his financial situation, but he was not exaggerating his wife's condition. Camille Monet died that September, after a long and painful illness. In yet another bid for financial help, Monet now wrote de Bellio, asking him to retrieve Camille's locket from the Mont-de-Piété, the municipal pawnshop. "It is the only keepsake my wife had managed to hold on to," he told him, "and I would like to be able to place it around her neck before she goes."[13]

It was unquestionably a difficult time for Monet, who told Camille Pissarro that he was "devastated." Explaining that he had "no idea where to turn or how to organize my life with two children," he added, "I am much to be pitied, for I am very pitiable."[14] But what he neglected to tell Pissarro was that, despite the creditors pounding on the door, he was in fact being well cared for by Alice Hoschedé, the woman who now was (or was soon to become) his mistress.

Given Alice's prominence in the Monet household during Camille's dying days, it was fortunate that de Bellio redeemed Camille's locket, and that Monet was able to bid adieu to his devoted wife as she deserved.

⟅⟆

Zola knew all about the Mont-de-Piété—as did just about any Parisian of his time, rich or poor, but most especially the poor. Founded in Italy in the fifteenth century as a charitable alternative to usurious moneylending, the Mont-de-Piété, or Mount of Piety, spread to France, where it eventually came under government supervision. Providing low-interest loans by serving

essentially as a pawnbroker, the Mont-de-Piété became a fact of everyday Parisian life.

By the time Monet pawned Camille's locket there, the Mont-de-Piété was directed by the Assistance Publique and was headquartered at 55 Rue des Francs-Bourgeois (now the home of the Mont-de-Piété's successor, the Crédit Municipal de Paris). In addition to this principal establishment, there were two district offices and twenty-one auxiliaries throughout the city, making it possible for any Parisian in financial difficulty to find one.

By the early 1890s, the Mont-de-Piété was lending almost six million francs a year, its capital provided by bonds earning 5 percent interest. These were popular with investors, and indeed, the Comédie-Française during these years invested all of its capital in Mont-de-Piété bonds.

But although the rich and the respectable considered the Mont-de-Piété a good return on their money, and a charitable institution to boot, it was the poor who turned to it on a regular basis, using it to scrape through their days. Zola as a very young man pawned everything of the slightest value there, including his jacket and last pair of trousers—wrapping the bedsheets around him to protect himself from the bitter cold. He later incorporated his painfully personal knowledge of poverty and its degradations into his novels. In the opening scene of L'assommoir, there is a bundle of pawn tickets on the dismal mantelpiece.

Aristocrats in financial trouble pawned their jewels, the middle class pawned their gold watches, and the poor pawned anything they could get ahold of. Clothing, tools, bed linens, and as a last resort, mattresses went to the Mont. By the 1890s, the Mont-de-Piété was receiving almost twenty-five million pledges annually, and the top floor of its warehouse was filled with decrepit mattresses, mute testimony to utter poverty. Many of Paris's poor were unable to redeem their pledges, and if these were not renewed (at a fee), they were sold.

Yet some people clung to hope, even when all hope was lost. Around the time that Monet was trying to redeem Camille's locket, one of the Mont-de-Piété's directors noticed a little packet bearing a whole series of renewal tickets, all for a mere three-franc loan. Curious, he wrote to the borrower, a woman, who appeared at his office in response. "Why," he asked, "have you not redeemed this meager pledge?" She replied that she was too poor. Then why, he wanted to know, did she continue to renew her pledge, year after year? "Ah, sir," she replied. "It is all that remains to me of my mother."

At this, the director, touched by her response, gave her back her packet. He was somewhat startled to see its contents—an old-fashioned petticoat, which the woman, now in tears, carried away with joy.[15]

CHAPTER NINE

~

Saints and Sinners

(1880)

The day before yesterday," wrote Nadezhda von Meck, "there arrived from Paris a young pianist who has just won a first prize in Marmontel's class at the Conservatoire." His technique is brilliant, she added, but he certainly did not look as old as he claimed to be. "He says he's twenty, but looks sixteen."[1]

The young man in question was Claude Debussy, and Madame von Meck, Tchaikovsky's patroness, had hired him for the summer to give lessons to the children. Fresh from the Paris Conservatoire, Debussy was not twenty, as Madame von Meck suspected, but only eighteen. Nor had he quite the credentials that he had led her to believe: in actuality he had never won first prize for piano at the Conservatoire. Much to his father's disappointment, he had only garnered a second prize.

Still, the young man was unquestionably musical—a remarkable enough fact in itself, given his background. His forebears had been Burgundian peasants, who made their way to Paris by the mid-nineteenth century (and en route changed the spelling of the family name from "de Bussy" to "Debussy"). None among this large clan had ever shown any sign of musical ability, and in fact Debussy's father was not much of a success at anything, having tried his hand as a clerk, a low-level civil servant, and a china seller before marrying Debussy's mother (formerly his mistress) nine months before the child was born, in 1862.

Young Debussy, who at that age went by "Claude-Achille" or simply "Achille," received no formal education but learned to read and write from his

mother. She was a stern woman who had no love for her other children but favored Claude-Achille—whom (much to his distress) she kept firmly by her side.[2] But his aunt cajoled him into piano lessons, which opened new vistas. He appeared to have sufficient talent that his father, who had planned a career as a seaman for him, "got the idea that I should study just music," Debussy later remarked, acidly adding, "he being someone who knew nothing about it."[3]

Debussy's father was like that—prone to sudden whims and propelled by naive notions. It was one of these enthusiasms that in the spring of 1871 thrust him into the Commune uprising, where he became a captain and participated in the fighting at Fort d'Issy, just outside Paris's walls. Arrested and imprisoned, he served one year of his sentence before being released, with temporary but stringent restrictions on his civil rights. It was during this bleak period, which Debussy rarely mentioned in his later years, that the youngster made his acquaintance with the piano. Impressed with the boy's dexterity, the father immediately had visions of the concert stage, a dream that received added impetus from one of the senior Debussy's fellow prisoners, whose mother claimed to have been a pupil of Chopin. There is no evidence that this actually was true, but Debussy's father bought it wholesale and enrolled the boy with Madame Mauté, who—whatever her credentials—must have been an inspiring teacher. Debussy certainly thought so, and in later years was generous with his credit. But with all due respect to Madame Mauté, she unquestionably was working with remarkable material. Indeed, in 1872 at the age of ten, Debussy showed enough talent that he was accepted by the Paris Conservatoire on the first try.

This amounted to starting at the top, and Debussy's father was delighted. But although Debussy did not always electrify his teachers, he was surprisingly successful—especially given the Conservatoire's innate conservatism and the youngster's unhesitating willingness to challenge it ("One is suffocated by your rhythms," he once informed a startled instructor). By the time he joined the von Meck family in Interlaken, Debussy was sufficiently self-assured and talented to win a return visit the following summer. This would bring him to Moscow and to further adventures.

But in the meantime, he had given up on becoming a concert pianist and had decided to be a composer. He had also met a lovely thirty-two-year-old married woman by the name of Marie-Blanche Vasnier.

⌣

As the new decade opened, the French government not only purchased Rodin's controversial *The Bronze Age* but also commissioned him to sculpt a monumental doorway for a Museum of the Decorative Arts, planned for the

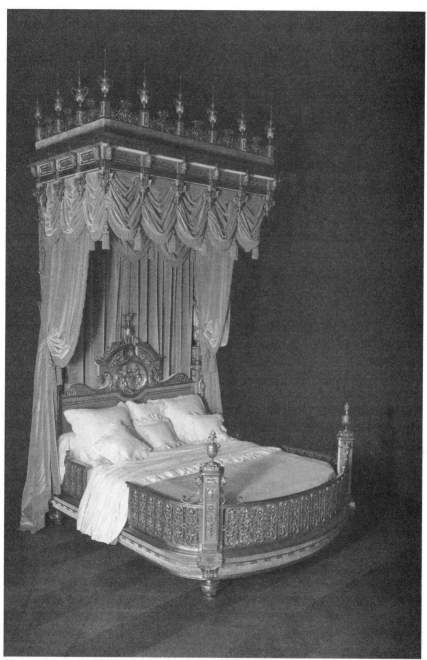

The lit de parade *(lying-in-state bed) of Valtesse de la Bigne (Edouard Lièvre, 1829–1886).
Wood frame with gilded bronze and green silk velvet, Paris, circa 1875. Paris, Musée
des Arts Décoratifs. Photo: Les Arts Décoratifs, Paris / Jean Tholance. © ADAGP, Paris.*

site of the former Palais d'Orsay—an impressive building that had spectacularly burned during the Commune. As it happened, the museum never materialized there, and eventually the Compagnie Paris-Orléans built the Gare d'Orsay on the site. In another twist to the story, Rodin would work for years on his huge and intricate vision, which he could not seem to complete. But in 1880, when he embarked on his commission, he envisioned a triumphant ending for the massive doorway, which—inspired by Dante—he called *The Gates of Hell*.

The work was to be at least twenty feet high, which was far too large for Rodin's Montparnasse studio. Well equipped to deal with this sort of problem, the government provided him with a studio in the Dépôt des Marbres, a workplace for sculptors employed in sizable public projects, located at the western end of Rue de l'Université by the Champ de Mars.

Once upon a time, this strip of land between the Rue de l'Université and the Seine had been little more than several small islets. Then, in the eighteenth century, these were merged to form the Ile des Cygnes. The king gave the island to the City of Paris, which eventually filled in the narrow channel between island and Left Bank. This created a larger land mass at the river's bend and removed the Ile des Cygnes from the map (another island, just downriver, inherited the name). In 1880, the City of Paris ceded this property to the state, in return for the adjoining exposition park at the Champ de Mars. Part of the property that the state acquired became the Dépôt des Marbres.

In the distant future, the site would house a formidable warren of government buildings, which would in time make way for the Musée du Quai Branly. But in Rodin's day, it was a vast overgrown courtyard filled with blocks of marble, hidden "in a corner so deserted and monastic that you might think yourself in the provinces."[4] The description is that of Paul Gsell, who compiled in book form the lengthy conversations he held with Rodin toward the end of the sculptor's life.

Although most of Gsell's book consisted of Rodin's thoughts and words, Gsell remained as narrator and interviewer. "Along one side of this courtyard," he wrote, "is a row of a dozen ateliers which have been granted to different sculptors." By the time Gsell was writing, Rodin occupied two of these ateliers, one to house the plaster cast of his *Gates of Hell* ("astonishing even in its unfinished state") and the other in which to work.[5]

Rodin's method of work was undoubtedly unusual. From early in his career, he paid nude models to walk about his atelier or rest, simply to observe them continuously. Thus accustomed to the human body, much as were the ancient Greeks, he "became familiar with the sight of muscles in movement"—a fundamental element of his sculpture. "He follows his models with his earnest gaze," Gsell added, "and when this one or that makes a

movement that pleases him, he instantly asks that the pose be kept." Then he quickly seized the clay.[6]

"I obey Nature in everything," Rodin told Gsell, "and I never pretend to command her." Gsell pressed him on this point. Don't your sculptures differ from your models? he asked—even if only to accentuate the power of an emotion or the essence of a truth? Rodin contemplated this possibility, and then gave a carefully qualified response. "I accentuate the lines which best express the spiritual state that I interpret," he told Gsell.[7]

It was the same answer that he would have given thirty years earlier, as he started to work on his great *Gates of Hell.*

⌒

Although Rodin differed from the Impressionists on many points, he shared their attempt to capture light. As art critic and historian Bernard Champigneulle notes, the Impressionists tried to do this by breaking light into its component colors, while Rodin broke up the surfaces of his sculptures to create "subtle projections and recesses so as to catch the vibrations of light."[8] This, plus his disregard—even contempt—for tradition, placed Rodin squarely among the artistic revolutionaries of his time.

But although a revolutionary, Rodin was in many ways a practical man. Whether or not he was aware of Renoir's comment about the current art market, he would have agreed with him that there were barely fifteen art-lovers in Paris "capable of appreciating a painter without the Salon."[9] Rodin had always believed that the same held true for sculptors and that the Salon, as narrow-minded as it was, offered the only sure road to success. The Impressionists, by bolting for their own exhibitions, had satisfyingly thumbed their noses at the art establishment, but in Rodin's view they had given up their one sure chance at persuading the public—a public that remained unpersuaded far longer than it would have, had the Impressionists not embraced their renegade status.

By 1880, the original Impressionists were already dividing on this point. Manet (who did not consider himself an Impressionist) had always opted for the Salon, however badly it treated him. In 1880—pressed by financial need as well as by bitter quarrels with Degas—both Renoir and Monet joined him. Degas, who had fanned the flames by pushing second-rate protégés into the group exhibition, was livid at what he viewed as Renoir's and Monet's desertion. "Degas has produced chaos among us," wrote Impressionist mainstay Gustave Caillebotte to Pissarro. "It's really too bad for him that he has the unfortunate character he does."[10]

But Degas, although difficult, was not the only factor pushing the original Impressionists Salon-ward. Among this group, only Morisot and Caillebotte

were independently wealthy, and Morisot could best be described as comfortably well-off rather than rich.[11] All the others—including the once well-to-do Degas and Manet—were in need of a steady income. Renoir, the son of a tailor, had grown up in poverty and longed for income and respectability. Monet, a child of the *bourgeoisie*, had chosen his renegade posture, but found it difficult to accept the deprivations that this entailed. Now, with a household of eight children, he could no longer afford the luxury of exhibiting solely with other Impressionists. By late 1879, his paintings were beginning to bring in higher prices, and he decided to stop selling them for a pittance, as he so often had in the past. As part of this positive change in his professional life, he joined Renoir in abstaining from the Impressionists' fifth exhibition (which did not do well), and then he proceeded to exhibit in a one-man show at the gallery of the fashionable magazine *La Vie Moderne*, founded by Zola's and Goncourt's publisher, Georges Charpentier, and located on the chic Boulevard des Italiens.[12]

Monet, much like Renoir and Rodin, was on his way to success.

～

Edouard Manet, too, longed for success. And yet, despite the constant drumbeat of rejection, he could not help but continue to paint as he did—primarily Parisian cityscapes and the people who inhabited them, including down-and-out subjects such as his first rejection by the Salon, *The Absinthe Drinker* (not to be confused with Degas' later work with a similar subject and title). Over the years, the Salon had accepted some of his pictures but rejected far more, finding their realism shocking and vulgar. In this, the Salon juries were fulminating not only against the blatant eroticism of Manet's courtesan *Olympia* or his unclothed woman nonchalantly seated between two properly clothed men in *Le Déjeuner sur l'Herbe*, but also against his direct assault upon artistic conventions and traditions. The Salon was as quick to dismiss his depictions of everyday life in *The Laundry* as it was to condemn these more sensational paintings. Still, among those paintings that it did accept was the picture of a woman and child in front of Gare Saint-Lazare (*The Railroad*). Oddly enough, no one on the Salon jury recognized Manet's respectable-looking model here as the same Victorine Meurent who had so readily posed for both *Olympia* and *Le Déjeuner sur l'Herbe*.

Striving to depict everyday life in all its realism and naturalness, Manet began to adopt some of the Impressionists' techniques. Yet he differed significantly from his Impressionist colleagues by remaining primarily a studio painter, one who preferred to paint the people and places of the city rather than rural landscapes. He was also a brilliant portraitist, who painted his parents (a somber work that marked his first acceptance to the Salon, in 1861)

and his friends, including the poet Stéphane Mallarmé and Zola (whose portrait the Salon accepted in 1868). Manet painted multiple portraits of Berthe Morisot, and his stunning *The Balcony*, in which she is the central figure, was accepted by the 1869 Salon. Clemenceau never liked the portrait that Manet did of him, but then again, Clemenceau did not like Rodin's portrait bust of him either.

Manet took Clemenceau's lack of enthusiasm in stride, but was annoyed by sitters who wanted their portraits changed to something more flattering. "Is it my fault," he demanded of his friend Antonin Proust, "if [the poet George] Moore looks like a squashed egg yolk?"[13] But far more discouraging was Manet's failure to win any formal commissions from the state. He had, of course, hoped that once his republican friends came into power, he would see some commissions come his way. But much to his disappointment, most of his political friends (with the exception of Proust, who in 1881 became minister of culture) were much too traditional in their tastes to appreciate what Manet was doing. Even Clemenceau's portrait had been at Manet's request. "It is strange," Manet commented to Proust, "how reactionary republicans can be when it comes to art."[14]

Manet's ongoing problem was his failure to find connoisseurs willing to buy his works. When in 1872 the dealer Paul Durand-Ruel "discovered" Manet, the dealer bought twenty-two of Manet's works—the first time the painter had ever really sold anything. Durand-Ruel became a major booster, but by 1880 Manet's primary patron was the discerning opera singer Jean-Baptiste Fauré, whose portrait Manet showed at the 1877 Salon. By the time of Manet's death, Fauré owned some sixty-seven of Manet's works, including *Le Déjeuner sur l'Herbe*, *The Fifer* (rejected by the Salon of 1866), and *The Railway*.

Fauré was a godsend, but Manet needed to sell more than this to pay the bills for his debonair lifestyle. And so, in the spring of 1880, when the editor of *La Vie Moderne* invited him to provide the first one-man exhibition in its Boulevard des Italiens galleries, Manet was quick to accept. He gathered the best of his recent works, including a portrait of Madame Zola, and put together what has been termed a "dazzling show." Perhaps just as gratifying was the Salon's acceptance of two of his works, his portrait of Antonin Proust and his depiction of a flirting couple at a garden restaurant on the Avenue de Clichy, *Chez le Père Lathuille*.

But he was ill, and his condition was deteriorating rapidly. At first he told his family that he was suffering from a snakebite that he had received long before in a Brazilian jungle. It was true that as a teenager Manet had sailed to Rio de Janeiro on a training vessel, in what proved to be an unsuccessful attempt to enter the Navy. But the snakebite may have been the product of

Manet's decidedly ironic sense of humor, for it soon became all too evident that he was suffering from syphilis. Since 1878 he had been experiencing attacks of paralysis, and by 1880 he had to be careful to conserve his strength. He apologized to Madame Zola for not coming in person to make the request to borrow her portrait for *La Vie Moderne* exhibition, "but I am not allowed to climb stairs."[15] After that, he departed for five long months to Bellevue, west of Paris, for water treatment.

There the weather was bad, and he was lonely and bored. "I'm living here like a shellfish," he wrote one friend, begging him to tell him "what's going on."[16] But worst of all, despite his vigorous protests to the contrary, he knew that he was not getting any better.

⁓

Manet was probably fortunate to be well out of Paris that summer, when the stench throughout the city, notoriously bad in summer, was worse than ever. Despite the sewer system established by Haussmann and Belgrand (which already extended some six hundred kilometers by the time of Belgrand's death in 1878), unsanitary filth continued to pile up on Paris streets. The increase in the number of horses was one source of the problem, but not the only one, and on bad days even a well-perfumed handkerchief could not mask the stench.

Protected from this unpleasantness, Manet remained in Bellevue, where he quietly celebrated France's first national commemoration of 14 July— sending up cheers for the Republic as well as for the amnesty just granted to the exiled Communards. In addition to Louise Michel, these included Henri Rochefort, the radical journalist who (despite Victor Hugo's pleading) had been sent to New Caledonia. Soon after his arrival, Rochefort dramatically escaped in a small whaleboat and eventually ended up in Geneva. This episode, followed by the amnesty and Rochefort's triumphant return to Paris, prompted Manet to consider the idea of a dramatic painting of Rochefort's escape, set against the background of the open sea. Although not a landscape painter, Manet had always enjoyed painting the sea, and this, coupled with the subject's dramatic possibilities, inspired Manet to regard it as a sure-fire submission to the 1881 Salon.

In the meantime, he anxiously awaited visitors, and on occasion even attempted some visits of his own—including one to his nearby Bellevue neighbor, the charming and notorious courtesan Valtesse de la Bigne. Red-haired and beautiful, Valtesse de la Bigne had brought several rich and titled men to financial ruin. She had also captivated some of the most sophisticated men in town, including Manet, who referred to her as "la belle Valtesse" and had painted her the year before.

Born Louise Emilie Delabigne, Valtesse de la Bigne was sufficiently intelligent and charming to draw an entourage of admiring writers and artists such as Manet. Zola also paid court to Valtesse—although in his case from a desire to get the characters and setting right for his upcoming novel *Nana*. Flattered by his journalistic interest, Valtesse even agreed to show him her bedroom—until then off-limits to all but her most highly paying patrons. Zola (who seems to have limited his visit to note taking) used her over-the-top boudoir as the model for Nana's bedroom. Even if the fictional Nana was nowhere near the sophisticated creature that Valtesse had become, the bed said it all. It was "a bed such as had never existed before," Zola wrote, "a throne, an altar, to which Paris would come in order to worship her sovereign nudity."[17]

～

Another, and completely different, fictional courtesan was Marguerite Gautier, the tragic heroine of *La dame aux camélias*. Gautier was the creation of Alexandre Dumas *fils*, son of the famed author of *The Three Musketeers* and *The Count of Monte Cristo*. Every bit as romantic as his father, although far less flamboyant and self-indulgent, Dumas *fils* wrote *La dame aux camélias* in memory of the great tragic love affair of his youth.

The woman, whose name was Marie Duplessis, was of course young and beautiful, emanating the sort of fragility that virtually demanded protection. She had taken to reckless expenditure and drinking to combat her boredom and unhappiness, which her admirers did everything to alleviate. Her demands grew in proportion to their willingness to fulfill them, yet she remained unhappy. Even their roses left her cold. Perhaps she was allergic to roses, or perhaps not, but they made her dizzy. Only camellias, which are odorless, would do.

Dumas, who was but twenty at the time, was helplessly in love with Marie and eager to provide the protection she needed. But most unfortunately, he did not possess the requisite fortune, and Marie was accustomed to going through fortunes. It was true that Dumas' father was one of the nineteenth century's most successful playwrights and novelists, with an income to match, but Dumas *père* was in his own way as irresponsible with money as was Marie. No matter how much Dumas *père* earned (and it was a lot), he always managed to outspend his income. An epic womanizer (much like his friend Victor Hugo), he spent freely, was an easy target for loans, and supported not only his current mistresses but also those who had come before.

Dumas *fils* possessed neither his father's taste for adventure nor his gargantuan appetite for life. But he did have this one love, and he desperately wanted to keep her for himself. It was not to be. Not only was Marie a devourer of fortunes, but she suffered from a disease of the lungs, which the

nineteenth century viewed with romantically infused trepidation. If pretty young girls had to die in nineteenth-century novels, this was the way to do it, and by the time Dumas met her, Marie was in an advanced state of consumption.

Tender and compassionate in his love, Dumas won her over and seems to have dreamed of reforming her. But this proved impossible. His debts began to mount, even as he realized that she was false to him. Finally, the wounded young man left the beautiful courtesan. Many months later, hearing that she was very ill, he wrote from Madrid to beg forgiveness. She never replied. A pale ghost of her former self, she continued to make the rounds of all the stylish places, but became ever more ill. After a long and difficult decline, she finally died.

Young Dumas was devastated by the news, and upon learning of her death, wrote a novel about her—*La dame aux camélias*. In it, he portrayed the Lady of the Camellias as he would have liked her to have been. Marie never would have recognized herself as a penitent who renounces her degrading life for the man she loves. But the story was heartrendingly romantic, and it was an enormous hit. It became an even bigger hit when Dumas turned it into a play.

And it became bigger yet, thirty years later, when Sarah Bernhardt made it her own.

⁓

Sarah Bernhardt had known Dumas *père* from childhood, when he was one of a coterie of distinguished men in attendance on her mother, Youle—a courtesan who had attained a comfortable place in the Parisian demimonde. It was Dumas who provided his box for Sarah's first evening at the Comédie-Française, a performance of Molière's *Amphitryon*. It was a comedy, but Sarah did not laugh. Instead, she felt so sorry for the duped wife that she burst into loud sobs. Most of the members of her party were embarrassed by this outburst, but Dumas was not. Moved by the unusual degree of empathy she had showed, he tucked her in that night with words she would always remember: "Good-night, little star."[18]

When it came time for Sarah to audition for the Conservatoire, it was Dumas who helped her practice a scene from Racine's *Phèdre*. After that, their careers continued to intersect, with Bernhardt eventually performing in two of his plays, while his son's *La dame aux camélias* would in time become one of her signature pieces. But in 1880, when Bernhardt decided to bring *La dame aux camélias* on her first American tour, she had never before played the role.

By now Alexandre Dumas *père* was dead and Alexandre Dumas *fils* was king of the French theater. He was successful, rich, and honored, culmi-

nating in his acceptance to the Académie Française (an honor that had eluded his father). He had also developed a strong moral streak, probably in reaction to his father's earthy embrace of life. Of course, moral streaks have their limits, and Dumas *fils* quietly kept a mistress, to divert him from his increasingly unstable wife. Still, by the time that Sarah Bernhardt was preparing to cross the Atlantic with *La dame aux camélias*, she and its author had little in common. They certainly encountered one another with some frequency in the world of the theater, and Bernhardt had been involved in an altercation with him during the rehearsals for *L'etranger*, the first play he had written for the Comédie-Française. The altercation ended amicably enough, but there does not seem to have been any particular friendship between them afterward.

Indeed, Dumas *fils* would have frowned on the sort of shenanigans in which Bernhardt (and his father) took such delight. Preceded by sizzling stories of her flamboyant lifestyle, Bernhardt hit New York with gale force. Her elegance and beauty seduced, while the luxury to which she was accustomed left Americans gasping. Once front and center in the public's attention, she made sure that this translated into success at the box office. Anticipating that Americans would understand little of what was being said onstage, which remained entirely in French, she made sure to entertain her audience visually, providing her productions with spectacular costumes—such as her gown for *La dame aux camélias*, which was embroidered in pearls. Treated to spectacle both on stage and off, Americans swooned with delight.

Traveling was difficult, even with a luxuriously appointed private train to provide accommodations in the remoter corners of the country. But Bernhardt gamely pressed on, playing more than 150 performances in fifty cities and towns before returning to France. She made a fortune in the process and looked forward to return engagements in the years to come.

～

Sarah Bernhardt would not be the only famous Parisian to cross the Atlantic in the upcoming years. While Bernhardt was wooing audiences in the States, work resumed on the Statue of Liberty at the foundry of Gaget, Gauthier et Companie, located at 25 Rue de Chazelles (17th), just north of Parc Monceau.[19] By 1880, individual French citizens had contributed enough to pay for designing and building the statue, as well as shipping her to New York (Americans were to pay for the pedestal). With the French end of the fundraising virtually complete, an essential milestone had been reached, but now came the problem of engineering the enormous structure. Following the unexpected death of Viollet-le-Duc in 1879, Bartholdi turned to an expert in wind resistance to do the job—the up-and-coming Gustave Eiffel.

Borrowing from his long experience with bridges and viaducts, Eiffel dramatically changed *Liberty*'s interior framework from what Viollet-le-Duc had in mind. Instead of sand-filled coffers, Eiffel devised a huge iron pylon that supported the statue's skin of shaped copper sheets. These he indirectly attached to the pylon by a skeletal framework of iron strips—an innovative and flexible construction that allowed the statue to withstand the changing temperatures and high winds of its future harbor home.

In the meantime, Bartholdi was busy creating *Liberty*'s exterior. He had nurtured his vision for many years, beginning with sketches and small study models and gradually progressing to larger models. From an approximately 4-foot-high terra cotta model he constructed one scaled at one-sixteenth the final version (about 9 feet, not including its pedestal). He then magnified this version to one that was four times as large (approximately 36 feet) and then divided this larger model into sections that he enlarged to their final dimensions (a whopping 151 feet, including the arm and torch).

The construction process itself was a remarkable undertaking, which Paris's Musée des Arts et Métiers commemorates. Near a scale model of Lady Liberty are two tiny reproductions of the Paris foundry where Bartholdi wrought his final colossus. The one depicts his workmen in the process of enlarging a replica of *Liberty*'s head, while the other illustrates the head's final assembly. The museum also has on display an impressive full-size replica of *Liberty*'s index finger.

The whole enterprise was so astonishing that Parisians paid to visit the foundry of Gaget, Gauthier et Compagnie to watch as the work progressed. And gradually the statue began to rise—a starting vision above the housetops.

～

Parisians were undoubtedly dazzled by the enormous statue of Liberty that was slowly rising in their backyard. Many, especially the workers of Montmartre and Belleville, were also furious at the basilica of Sacré-Coeur that was beginning to rise in their midst. In the summer of 1880, these two strands came together in a proposal to the city council that a colossal statue of Liberty be placed "on the summit of Montmartre, in front of the church of Sacré-Coeur, on land belonging to the city of Paris."[20]

The idea was to block any sight of Sacré-Coeur with another huge monument, one dedicated to liberal and secular ideals. By October, the city council had decided by an overwhelming majority to ask the government to build, in place of the basilica, a work of unquestionable national significance. To accomplish this, the council asked the government to revert to public ownership the land on which the basilica was being built. Arguing that unless the government did something to prevent its rise, Sacré-Coeur would forever

constitute a provocation to civil war, the council then dumped the entire proposal in the lap of the Chamber of Deputies.

There it disappeared for a time, giving Cardinal Guibert and the other fervent supporters of Sacré-Coeur a chance to catch their breath—and to pull whatever political strings were left to pull.

⁓

In late 1880, as Sacré-Coeur began to rise, thousands tried to force their way into the offices of the newly formed Compagnie Universelle du Canal Interocéanique, in the hopes of obtaining shares in this hugely promising venture. The idea of linking the Atlantic and Pacific oceans via a canal was not a new one, but Ferdinand de Lesseps—the man who had single-mindedly pushed through the Suez Canal—was behind the endeavor, which augured its success. De Lesseps's vision of a forty-five-mile canal across Panama's isthmus was a bold one, but as his many enthusiastic backers were quick to point out, to the bold go the rewards. And without question, the anticipated financial rewards of a cross-isthmus canal were enormous.

De Lesseps was not an engineer, and indeed ignored the advice of engineers, most especially that of Gustave Eiffel, who insisted that locks would be essential to this sea-level project. Eiffel also predicted that the canal would take far longer to build, and at a far greater cost (both human and monetary) than de Lesseps so confidently predicted. But at this point, no one was paying any attention to the experts. The public, sold on de Lesseps's celebrity and the chance of untold riches, barnstormed the company in the attempt to get in on a piece of the action.

The great Panama Canal affair had begun.

⁓

Flaubert dead! Edmond de Goncourt was devastated. He had visited the great novelist only a few weeks before, and Gustave Flaubert had seemed perfectly well. And now Goncourt was traveling to Rouen to bury him.

The funeral took place in the little church where Madame Bovary had gone to confession, but most of the crowd, to Goncourt's irritation, seemed more interested in the idea of a good meal and a spree following the burial, and the word "brothel" even began to circulate. Daudet, Zola, and Goncourt refused to join in the anticipated revelries. Instead, they returned to Paris "talking reverently about the dead man."[21]

Goncourt, who had truly been fond of Flaubert, was uncharacteristically subdued. "The fact is," he remarked sadly to his journal, he and Flaubert "were the two old champions of the new school, and I feel very lonely today."[22]

CHAPTER TEN

~

Shadows

(1881–1882)

As the new decade opened, the financial downturn that had begun in the mid-1870s continued to worsen, not only in France but throughout Europe. Many forces and factors were at work, but France was especially hard-hit by competition from foreign agricultural products as well as by natural disasters that decimated the country's all-important vineyards. French agricultural incomes plunged, leaving impoverished farmers and their families with little alternative but to migrate to urban centers such as Paris, where they swelled the numbers of the unemployed.

In response, France's new republican government came up with a gigantic public works program for railways, roads, and canals—a popular but hugely expensive undertaking. The government also reintroduced the tariff—an unpopular measure, as it contributed to a rise in food prices. With poverty and discontent festering, the government entered into the international race for empire—with the intent of enhancing French prestige as well as diverting discontent at home. In the spring of 1881, France began to extend its influence into North Africa (Tunis), and would soon be looking toward Southeast Asia. Georges Clemenceau, who strongly opposed colonial expansion, took the measure of the current leadership and launched an attack on his longtime political enemy Jules Ferry, who now was prime minister of France.

Their enmity dated from the siege of Paris, when Ferry—as prefect of the Seine—supported Thiers' decision to seize the cannon at Montmartre, despite Clemenceau's efforts to negotiate a peaceful resolution to the confrontation. Ferry regarded Clemenceau as a rabble-rouser, while Clemenceau

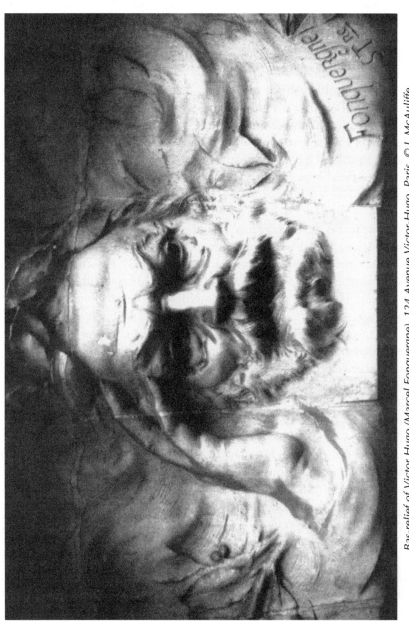

Bas-relief of Victor Hugo (Marcel Fonquergne), 124 Avenue Victor-Hugo, Paris. © J. McAuliffe.

considered Ferry a secret conservative bent on undermining the Republic. Ferry's education policies did not go far enough for Clemenceau, and his colonial policies went too far. Clemenceau was not the only one to be outraged by Ferry's tactics on the Tunis affair. The whole business had a murky look, and many members of Parliament were angered at being ill informed and then required to ratify the entire affair after the fact.

As a result, although the republicans continued to be securely in charge of the Third Republic, it remained a question as to which faction of republicans would lead the government in the months and years to come. As the elections of 1881 approached, anyone with a finger in politics could foresee that the so-called Opportunists—the current republican leaders of the Third Republic—faced some bumpy times ahead.

⌒

Several years before, Victor Hugo had unexpectedly come face-to-face with death. In actuality, it was an encounter with old age—an experience that, even at seventy-six, he had not anticipated. Mercifully, the stroke he suffered was a mild one, but for a time it looked as if it would bench him permanently. His flood of poetry stopped flowing, and his amorous adventures came to an abrupt halt.

As it turned out, the indomitable old man recovered; sheer determination and willpower did the trick. He no longer was a one-man torrent of words, but in other respects he seemed to have regained his lease on life. Still, his brush with mortality had alarmed a number of prominent people, who decided that it was time to pay him tribute before it was too late. After all, he was the Third Republic's most visible symbol.

And so, in February 1881, the Third Republic gave him a blowout party to celebrate his eightieth birthday. In actuality, February 26, 1881, marked Victor Hugo's seventy-ninth birthday, but that made no difference to those who were determined to do him honor. He was, in official parlance, "entering his eightieth year," and that was enough to justify whatever festivities the Republic could summon up.

And the festivities were indeed overwhelming. They began the day before Hugo's birthday, with presentations and honors and a triumphal arch erected at the entrance to the street (Avenue d'Eylau, 16th) where he lived. Schoolchildren were absolved of their misdeeds, and crowds began to pour into Paris for the occasion. On the morning of the great day, an enormous and well-organized procession stretched from the Avenue d'Eylau (now the Avenue Victor-Hugo) down the Champs-Elysées to the center of Paris. At noon, the procession set off in a flurry of snow, with senators and deputies leading the way. Five thousand musicians followed, playing the Marseillaise.

Clubs, schools, and whole towns marched past the old man and his two grandchildren (the remainder of his descendants, as both of Hugo's sons and his elder daughter were now dead, and the second daughter, Adèle, was insane). In all, it took six hours for the procession of half a million people to pay their respects.

It was a magnificent event, and Hugo—who had never been overburdened with modesty—rose to the occasion, presiding over the endless stream of admirers like the icon he had in fact become.

⌢

Despite opposition the previous year from Paris's city council, Sacré-Coeur continued to go up—and down. In April 1881, with the basilica's massive support system well under way, Cardinal Guibert celebrated the first Mass there, in the crypt.

In the meantime, Gustave Eiffel was completing the internal framework of Sacré-Coeur's secular rival, the Statue of Liberty, while at the same time building the great hall of the Paris office of Crédit Lyonnais. The Impressionists were busy as well, holding their sixth exhibit—with Monet and Renoir again abstaining.

This was the year that Monet moved from Vétheuil to Poissy, on the western outskirts of Paris. Despite an improvement in his finances, he had not paid the rent in Vétheuil for more than a year, and an irate landlady seems to have prompted the move. He brought Madame Hoschedé and her six children (plus his own two) with him, but he was displeased with the new location and spent the remainder of the winter on the Channel coast, reveling in the scenery and the solitude. When he finally returned, he once again was inundated with the concerns of a family with eight children—including financial responsibility for them all (Ernest Hoschedé had refused to pay for his children's and wife's share for some time, and probably was unable to do so). Monet soon bolted once again for the coast, this time taking Madame Hoschedé and the children with him.

Pissarro, with six children of his own, lived in similarly chaotic conditions. In a wintertime letter to his oldest son, Lucien, he reported that the children had taken sick, but were now almost recovered, "and the usual racket is beginning again."[1] Renoir's life was far less turbulent, as his *Luncheon of the Boating Party* so ravishingly testifies.

Despite the Impressionists' general preference for out-of-doors paintings that were, by necessity, painted quickly, Renoir began this work during the summer of 1880 and completed it many months later in his studio. (Even Monet revised and put "finishing touches" [his words] on many of his paintings in his studio, and after a visit to Renoir's studio, Berthe Morisot

commented in her notebook that "it would be interesting to show all these preparatory studies for a painting, to the public, which generally imagines that the Impressionists work in a very casual way.")[2] Still, like his fellow Impressionists, Renoir continued to reject the formalism of the reigning school of academic painting, with its careful renditions of historic tableaux. Instead, he wanted to capture real life. This meant a focus on the mundane, from country roads to domestic pleasures. It also meant a new attention to ordinary people as they went about their everyday lives.

A decade earlier, at the Grenouillère, Renoir and Monet had captured not only the effect of light on water, but also the palpable pleasure of Parisians holidaying on the Seine. Renoir again caught this relaxed and festive mood with the casual conviviality of his *Luncheon of the Boating Party*—a moment of sun-drenched bliss on the balcony of the Maison Fournaise, in Chatou.

Like the Grenouillère, the Maison Fournaise—which Renoir called "the most beautiful spot in all the environs of Paris"—owed its existence to the railroad, which since the 1830s had provided easy access to this delightful area just west of Paris. Boating on the Seine, as well as strolling along its banks, soon became a major leisure activity for Parisians of all classes, who democratically mixed and mingled there. Sensing good business possibilities, a bargeman and boat builder by the name of Alphonse Fournaise built an open-air café and small hotel on the Ile de Chatou. With the help of his daughter, Alphonsine, and his son, Alphonse, he also developed a boat rental business. Soon his enterprise, the Maison Fournaise, became a meeting place for writers, artists, and celebrities of all sorts, including Guy de Maupassant, who described it in 1881 in *La femme de Paul*, calling it the restaurant Grillon.

The summer afternoon depicted in Renoir's charmed scene at the Maison Fournaise stands in marked contrast with Manet's miserable summer of 1881, which he spent in Versailles. Unfortunately the summer was rainy and gloomy, and his health continued to deteriorate. "I don't need a chair," he remarked irritably on one occasion, upon being offered one. "I'm not a cripple."[3] But it was obvious to all around him that he was getting worse and worse.

Yet at heart he still was the same charming bon vivant who took a keen delight in his friendships. These included the American painter James McNeill Whistler, then in London, to whom Manet introduced his friend, the collector Théodore Duret. Manet also continued to adore the entire process of painting and drawing, although it was becoming more and more taxing for him. "You're not a painter unless you love painting more than anything else," he remarked to a friend during these difficult months. "And a grasp of technique is not enough, there has to be an emotional impulse."[4]

Manet, of course, was not and never had been lacking in either emotional impulse or technique, but his genius had consistently gone unrecognized during much of his career. It was only now that he began to receive some long-overdue signs of respect from the conservative art establishment. Earlier that year, in a change of plans, he had sent Henri Rochefort's portrait rather than the painting of Rochefort's sea escape to the 1881 Salon. This turned out to be a good decision, for despite the jury's antipathy to Rochefort's (and Manet's) politics, it at long last awarded Manet a medal.

Recognition came on another front as well. That autumn, after the Opportunists encountered an overwhelmingly pro-Gambetta electorate, Jules Ferry's cabinet reluctantly resigned and Gambetta at last came to power. Gambetta's tenure would be brief (lasting only from November 1881 to the following January), but long enough for Antonin Proust, Manet's friend since boyhood, to become Gambetta's minister of fine arts. Proust immediately saw to it that Manet was made a chevalier in the Legion of Honor—delighting Manet, but also leaving him a bit despondent. Earlier recognition "would have made my fortune," he wrote one well-wisher, but "now it's too late to compensate for twenty lost years."[5]

Manet was not the only artist whom Antonin Proust helped during his brief tenure as minister of fine arts. Proust also gave a significant boost to Rodin's career by acquiring for the nation Rodin's most important bronze to date, *St. John the Baptist*.

Unlike Manet, Rodin was still at a point where such official recognition could and did make a huge difference. This acquisition, together with the state's earlier purchase of *The Bronze Age*, gave him a nice push along the road to fame and fortune. Unlike Manet, Rodin had a reticent manner and an indifference to politics that made it unlikely that he would offend any of the political figures who could and did help him along the way. Indeed, as Champigneulle points out, Rodin "had the knack of spotting people who could be useful to him."[6]

This was fortunate, because Rodin shared with Manet a fierce commitment to his own artistic vision, despite the controversy that it inevitably ignited. Rodin unhesitatingly challenged conventions, especially those of the academic sculptors whose insipid creations he abhorred. But once past the controversy over *The Bronze Age*, this did him little real damage, since he increasingly circulated among and cultivated some of the most important members of Parisian society—people with money, taste, and connections. Once won over, these patrons provided invaluable support while this indomitable sculptor continued to shock the more staid members of the art world.

Quite unlike Rodin or Manet in temperament was Degas, who by this time had justifiably earned his reputation as a devastating wit. Holding forth at the Nouvelle-Athènes (at Place Pigalle), which had replaced the Café Guerbois as the most popular meeting place for artists, Degas regularly used his well-honed observations and aphorisms to demolish his colleagues. According to the writer and poet Paul Valéry, Degas was "scintillating" and "unendurable," a ruthless raconteur who "scattered wit, gaiety, terror."[7] Edmond de Goncourt agreed, but in typical Goncourt fashion seemed to relish Degas in full attack mode. In 1881, following a dinner with mutual friends, Goncourt wrote that "it was fascinating to watch that hypocrite eating his friends' dinner and at the same time . . . plunging a thousand pins into the heart of the man whose hospitality he was enjoying—all this with the most malevolent skill imaginable."[8]

It was perhaps Degas' way of striking back at a world that had so unexpectedly removed his status as a gentleman artist, forcing him to support himself. He could never adjust to this change in status, and he found it especially difficult to finish anything that had been commissioned and paid for in advance—a transaction that, in his view, lowered the work in question to the level of a commodity. The uncertainty of the economy only worsened his predicament. Although a growing number of collectors were buying from him, he complained of financial hardship. Despite his complaints, he probably was far better off than he indicated. Still, the unpredictability of the economy was an unsettling and very real presence throughout France during these years.

～

The boost that the government's public works program gave the economy was real but temporary, lasting only until early 1882, when it dramatically collapsed in the wake of the high-flying merchant bank, the Union Générale.

A recent (1878) addition to the French banking scene, the Union Générale originated as a business venture for the Catholic political right, including monarchists and members of the Catholic hierarchy. With the Catholic Church in France on the defensive and secularism on the rise, Eugène Bontoux (a practicing Catholic) had seen need and opportunity converging in such a venture, which he believed would by its very existence challenge the current banking structure. As its appeal unabashedly stated, the bank's purpose was "to unite the financial strength of Catholics, . . . which [now] is entirely in the hands of adversaries of their faith and their interests."[9] These adversaries, as another statement made clear, were Jews and Protestants.

Bontoux, a former engineer, had held responsible positions with the Rothschilds' French and Austrian railroads, ultimately as director of the Südbahn,

the major Austrian line. In these jobs he had proved himself to be a capable manager, but at the helm of the Union Générale he enthusiastically joined in the reckless speculation of the times. Thinking big, he aimed at making the Union Générale the largest financial institution in the nation, and inflated his capital accordingly.

At first, Union Générale's success was gratifyingly stratospheric, and its stock soared. But the times were more than usually volatile, and in January 1882, the stock market plunged, taking Union Générale with it. The disaster impacted nationwide, wiping out the life savings of the well-to-do as well as tradespeople, artisans, domestic servants, and farm laborers. Long lines of people waited all day outside the Union Générale offices in the hope of regaining something—but to no avail. According to *Le Figaro*, "The despair of these people who have lost everything is pitiable to contemplate. Numbers of priests were among them, and many women, weeping bitterly."[10]

The crash reverberated throughout the country, setting off a malaise that went especially deep among the working classes, who blamed the government for this and subsequent financial disasters. But this malaise contained a deeper and more malignant strain, which placed the blame on Jewish bankers, whom irate investors claimed had plotted to destroy the Union Générale. Bontoux, who was sentenced to five years in prison and fled to Spain to avoid serving his sentence, eventually returned and wrote a book in which he, too, blamed the Jews (as well as the Freemasons) for the Union Générale's demise.

In fact, the Rothschilds and other bankers had advanced funds to Bontoux during the panic, in an attempt to prevent the market crash that followed. But this was not what a significant number of people throughout France wanted to believe. Threatened by the incomprehensibility as well as the power of the financial system that had ruined them, they looked for scapegoats and found them among the people who for centuries had been relegated to handling money. It was perhaps not surprising that, especially during hard times, this malignant weed of anti-Semitism would reappear and multiply.

CHAPTER ELEVEN

~

A Golden Tortoise

(1882)

In June 1882, Edmond de Goncourt heard an interesting story about the young poet and aesthete Robert de Montesquiou. According to Goncourt's sources, Count de Montesquiou was bored with his carpet and wanted something more colorful, preferably something that moved. Struck by a brilliant idea, he hastened to the shops lining the Palais Royal, where he bought a live tortoise. This provided temporary amusement, but soon Montesquiou tired of the animal's dullness and had its shell gilded. This did the trick for a while, but a golden tortoise was not enough, and before long Montesquiou delivered up the tortoise to a jeweler, whom he directed to encrust the reptile's shell with topazes. This operation, which may have inspired the diamond-encrusted tortoise in Evelyn Waugh's *Brideshead Revisited*, was only a partial success. The bejeweled tortoise provided an interesting diversion, but soon died, probably from its ornamentation.

Montesquiou himself was no slouch when it came to ornamentation; he was clothed in Scottish tartan when he visited Goncourt. He regularly chose his outfits to match his moods, and those moods could take him in remarkably colorful directions. Upon their meeting, he struck Goncourt as an eccentric but also a complete aristocrat. Goncourt—a snob through and through—thoroughly approved of aristocrats (including himself, of course), and despite Montesquiou's extreme affectations, he and the young man became friends. In time, Montesquiou would also provide the inspiration for Marcel Proust's decadent aesthete, the Baron de Charlus.

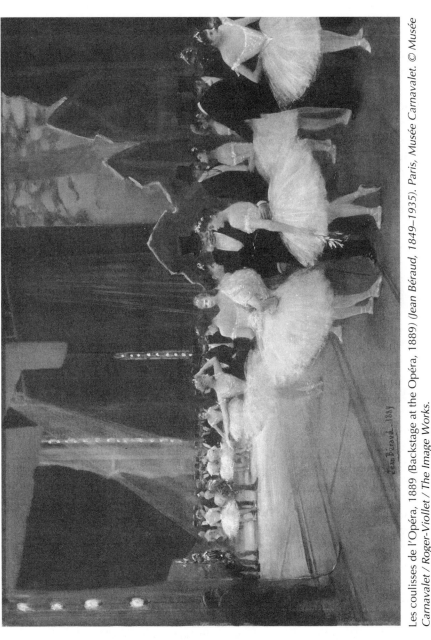

Les coulisses de l'Opéra, 1889 (Backstage at the Opéra, 1889) (Jean Béraud, 1849–1935). Paris, Musée Carnavalet. © Musée Carnavalet / Roger-Viollet / The Image Works.

~

Several months after meeting with Montesquiou, Edmond de Goncourt accompanied his dear friend the Princess Mathilde Bonaparte (Napoleon Bonaparte's niece) on a visit to Charles Frederick Worth. Worth, an Englishman who was the reigning deity of Parisian fashion during the Second Empire, had revolutionized Parisian dressmaking, turning it from a mere trade into the highly regarded art of fashion, or haute couture. He had dressed Empress Eugénie, and in the Third Republic he continued to dress the most prominent and wealthy women in Paris, including Goncourt's Princess Mathilde.

Goncourt was curious to see Worth's house, which was located in Puteaux, just across the Seine from the Bois de Boulogne. Here he was stopped in his tracks by Worth's collection of china plates, thousands of them, and the crystal drops that hung everywhere, even on the backs of chairs. The place was a nightmare, Goncourt reported in his journal, "and you come away . . . as dazed as if you had been in a monstrous fairyland palace."[1] Ironically, Worth seemed incapable of enjoying his extraordinary creation. According to Goncourt, the poor man suffered from exhaustion and from headaches brought on from the clouds of perfume enveloping the great ladies he had been dressing all day.

~

Even after the great crash of 1882, most of the well-dressed women who were Charles Frederick Worth's clients made a practice of regularly attending Paris's grand new opera house. Dandies like the Count de Montesquiou gravitated to it as well. The Opéra's architect, Charles Garnier, could also be found there on a regular basis, looking as elegant as the rest, despite his humble beginnings. The son of a Left Bank wheelwright, Garnier—much like Rodin—had embarked on his artistic career at Paris's Ecole Gratuite de Dessin. But unlike Rodin, Garnier had succeeded in getting into the Ecole des Beaux-Arts, where he carried off the Grand Prix de Rome. It was a brilliant start to a career that began to sag in the middle, until Garnier unexpectedly won the competition to design Paris's new opera house. Now, even several years after its opening, he could regularly be found at his Opéra, where his favorite spot was the second step on the right of the Grand Staircase, where he could watch the ever-evolving show.

And it was quite a show—a spectacle of sweeping skirts and flashing jewels, which continued right into the red velvet sanctuary of the auditorium itself. There, the on-stage production was of far less importance than the audience's preoccupation with itself—who was with whom, what so-and-so

was wearing, and other such engrossing subjects. Behind stage was of equal interest to the group of wealthy men who, according to art historian Robert Herbert, "treated the ballet dancers as a kind of game preserve."[2]

These men, in their top hats and opera capes, exercised their territorial rights in the stage wings and the dressing rooms as well as in the flamboyantly decorated Foyer de la Danse, located immediately behind the stage. Before and after a production, this room—with its tilted floor raked upward to the exact same degree as the stage—would be filled with pretty young ballerinas, many of them accompanied by their mothers. These girls, the daughters of workers and tradesmen, were quite prepared to display their legs (something that was a definite no-no in proper bourgeois society). They had seized on this opportunity to better themselves—not only by a job with the Opéra ballet but also by the prospect of finding a wealthy protector. Their mothers, far from being shocked, eagerly participated in the hunt for good sugar daddies (or, when fortunate, husbands) for their daughters.

Degas was fascinated by this world, drawing and painting it again and again. He was not in the slightest bit romantic about it, and his ballerinas are well-muscled, tired, and not infrequently bored. It was a hard life, and their faces and sagging bodies show it. It was also a double life, with protectors to satisfy long after the rehearsals and the performances were over. Degas, who did not seem to have taken much personal interest in any of these girls except as models for his paintings, was endlessly interested in their lives, including the older men who hovered so possessively over them. These men, termed "lions," appear again and again in his paintings, sometimes adjusting a costume or sometimes simply watching.

Degas viewed the entire backstage scene with a certain ironic detachment, but unquestionably was drawn to working people, whether jockeys (he loved to paint scenes at the races), dancers, or laundresses, all of whom he viewed as free from the bourgeois pretension that he abhorred. After visiting the Marais quarter, which by then had evolved from its aristocratic origins into a workers' enclave, he reported to a friend on the inhabitants' liveliness and grace. "Their society," he added, "is delightful."[3]

By this time Degas was withdrawing from more than bourgeois society. As he approached his fiftieth birthday, he was becoming more reclusive. Although he shared a deep friendship with Mary Cassatt (who, like him, was unmarried) and treated Berthe Morisot with great respect, there is no indication that he ever had intimate relations with anyone, male or female. Adding to his reputation as a misogynist, his witty but scathing remarks about women had been making the rounds for years. There were several families among which he felt at ease, and he served almost as an uncle to their children, to whom he was devoted. But apart from these notable exceptions, he was

drawing more and more into his shell. Perhaps, as biographers have surmised, he was growing afraid of death, signaled by his increasingly bad eyesight. Certainly he felt the pressure of producing while there was still time.

Indeed, Degas was no longer young, and he felt this keenly. "I thought I still had time," he wrote to a friend, not long after his fiftieth birthday. "I piled up all my plans in a closet and always carried the key around with me, and now I've lost that key."[4]

∽

As 1882 progressed, Edouard Manet, too, felt the sands of time running out. "This year is not ending very well for me as regards my health," he wrote Berthe Morisot in the closing days of 1881. "However, [my doctor] seems to think that there is room for hope, and I conscientiously follow his prescription."[5]

During the spring, he completed *A Bar at the Folies-Bergère* for the Salon of 1882, as well as a lovely study of the actress Jeanne Demarsy as *Spring*. While he was completing *A Bar at the Folies-Bergère* (his last great work), friends crowded into his studio, as if reluctant to let him go. By late afternoon his studio was usually so packed that it was difficult to find a seat near the artist, who no longer could join his friends at their café haunts as in the past. His manservant would serve refreshments, and then, fatigued, Manet would stretch out on the low couch and contemplate what he had just painted. "Nice, very nice!" he would say good-humoredly, and then his friends would tease, pretending to be irate members of the Salon jury rejecting his work.

But by this time, Manet no longer seemed to be disturbed by the furious opposition that he still stirred among traditionalists in the art world. He spent the summer at Rueil, just outside of Paris, and tried to rebut the rumors that were starting to circulate in the press about his illness. But soon after he returned from Rueil, ahead of schedule, he made out his will. Then he struggled over the canvases that he intended to submit for the 1883 Salon but was physically unable to complete them. His brush "disobeyed," as a friend later recalled, and this was the hardest thing of all.[6]

∽

Sometime during early 1882, Manet wrote Berthe Morisot that he had just had a visit from Pissarro, who held forth on the mess that had developed over the upcoming Impressionist exhibit, the group's seventh. Degas had been planning the exhibition since the previous November, but was stirring up the same old hostilities by his insistence upon including painters to whom Caillebotte, Monet, Renoir, and Sisley objected.

At this point the Impressionists' faithful art dealer, Durand-Ruel, interceded. Encouraged by what had appeared to be a strong economy, Durand-Ruel had once again begun to purchase paintings from Monet, Pissarro, Renoir, and Sisley. But with the crash of 1882 and especially the failure of the Union Générale (from which he had borrowed heavily), Durand-Ruel suddenly needed to sell his growing collection of Impressionist art. With the Impressionists' next exhibit scheduled for March, he told the wavering Monet and Renoir that he would display his own pictures by them, even if they did not choose to exhibit. Monet replied that he wanted to be cooperative, and that after all that Durand-Ruel had done for the Impressionists, the least they could do was to help him sell their paintings. Yet he had reservations, and was only willing to participate if Renoir agreed. For his part, Renoir wrote that he would accept such an arrangement, but only on the condition that the only other artists included in the exhibit would be Monet, Sisley, Morisot, and Pissarro.

The obvious exception to this list was Degas. With only a week to go before the exhibit, Degas withdrew. Mary Cassatt and others in Degas' camp followed, but Sisley, Monet, and Renoir returned to the fold, exhibiting as in the past. Caillebotte, Gauguin, Pissarro, and Morisot joined them, although Morisot—then in Nice with Eugène and Julie, who was ill—had to send Eugène back to Paris to arrange for her contribution.

As always, Morisot was self-effacing. Despite her husband's reassurances, as well as those from her brother-in-law, she was uncertain of herself. Reassured once more by her husband, she replied that she had read his most recent letter with great pleasure. "Everything you tell me," she told him, "reassures me about my exhibition, which I thought must be ludicrous." She also was quick to defend her colleagues from the critics, especially from *Le Figaro*'s Albert Wolff, and reported with considerable glee that a whole inkpot had been spilled over that issue of *Le Figaro*, with the result that "Wolff's prose thus got only what it deserved."[7]

⌣

"Everyone is penniless as a result of the recent financial events," Edouard Manet wrote Morisot soon after the great crash, "and painting is feeling the effect."[8]

Coming soon after the crash, the Impressionists' seventh exhibition did not do well financially, although for the first time the critics (with the exception of Wolff) seemed more favorably disposed. Yet after an initial inrush of visitors, attendance at the exhibition dropped off, leaving the exhibitors in the red.

It should have been no surprise. Following the great crash, there were upheavals that rippled throughout the entire economy. The French banking system now reorganized itself, placing a firm barrier between merchant banks and banks of deposit. It was at this time that the Crédit Lyonnais became a deposit bank, known for its conservative management.

But if banks such as the Crédit Lyonnais survived, Gambetta's ministry did not. After only sixty-seven days, he was forced to resign. Nor did Gambetta himself survive. Late in the year, he died of a gunshot wound—an accident, not a suicide, according to his mistress, who was with him at the time (although not actually in the room where he was wounded). Although quite a bit of titillating mystery surrounded the whole business, it seems clear that Gambetta, who was only forty-four at the time, could have reasonably anticipated decades of useful activity ahead. But this was not to be. His funeral procession drew enormous crowds of mourners, who lined the route all the way from the Palais Bourbon (home of the Chamber of Deputies) to Père-Lachaise cemetery. There, in accordance with his wishes, he was laid to rest without benefit of clergy, in an unblessed grave.[9]

A political lion had died, but his adamant insistence upon the separation of Church and state lived on. Legislation drafted that year (but not passed until 1887) encouraged other French citizens to follow his example by making it possible to ensure that they would receive nonreligious funerals. Noting the powerful example that Gambetta had furnished, one observer commented, "The Catholic Church yesterday lost something of its power."[10]

∿

By the summer of 1882, opposition to Sacré-Coeur had spread from the local level to the Chamber of Deputies, where Georges Clemenceau led the attack. Clemenceau, a passionate believer in the separation of Church and state, vehemently argued that the 1873 law devised on Sacré-Coeur's behalf was a travesty and an insult to the nation, a law that imposed the cult of the Sacred Heart on France because "we fought and still continue to fight for human rights." Indeed, this law allowed the cult of the Sacred Heart to be imposed on the nation in restitution for the Revolution—"for having made the French Revolution," as Clemenceau put it.[11]

The government could not afford to be far behind in these sentiments and indeed declared itself in complete agreement with Clemenceau in its opposition to the 1873 law. But there was a problem, as Archbishop Guibert was quick to point out. This was the matter of restitution. If the law of 1873 were overturned, bringing work on Sacré-Coeur to a halt, it would cost the government a huge sum in indemnities. Of course, rescinding the law would remove any obligation from Guibert and his supporters to complete what had

become an almost impossible undertaking, but no one expected Guibert to take this way out. Ignoring this aspect of the problem entirely, Clemenceau and his fellow radical republicans took the position that there was no need whatever to pay compensation. Monarchists and their arch-Catholic allies had been responsible for the mess, and (according to Clemenceau) it was time to put something more fitting in its place.

With Clemenceau's oratory clearing the way, the chamber voted by a large majority to rescind the 1873 law. Yet Sacré-Coeur was far from defeated and in fact was about to win an essential reprieve. By a quirk of timing, the law rescinding the 1873 act was passed too late in the session to take effect, and the government—motivated by the fear that a huge compensation would indeed be required—quietly scuttled the measure.

Sacré-Coeur would continue to rise. But Clemenceau and his fiercely anticlerical colleagues were not done yet.

∽

Money as well as republicanism may have been on the Chamber of Deputies' mind when it voted that year for demolition of the Palais des Tuileries, whose blackened ruins had blighted the center of Paris for more than a decade. Earlier, the monarchists had held sufficient power to hold open the possibility of rebuilding. But with the ascendancy of the republicans as well as the onset of hard times, this no longer seemed a viable option.

Yet there never had been a question about rebuilding the equally forlorn hulk of the Hôtel de Ville, which in 1882 was near enough to completion that a celebration was planned for July 13, on the eve of the great national holiday. The president of the Republic was to preside, and all the usual dignitaries (including Victor Hugo) would attend. But in the interest of making this a truly democratic occasion, thousands were invited to the buffet and dance that would follow the formal banquet.

In order to allow as much time as possible for the buffet/dance, the banquet was set for an unusually early hour, at six o'clock. Hours ahead, huge crowds began to form outside the entrance, eagerly waiting for the dignitaries (including Hugo) to arrive. After a suitable meal and requisite speeches, the diners were encouraged to disperse as rapidly as possible, to allow the wait staff to set out the two thousand glasses, four thousand plates, and five hundred napkins required for the mob that was about to descend.

At nine o'clock all was in readiness, and the doors opened for the lucky two thousand (clutching little pink tickets) who had been waiting outside. Anyone who saw or experienced this grand bash was not likely to forget it. The crowd, a democratic mixture of tradesmen and fishwives, pushed and shoved around the buffet, where bottles of champagne quickly disappeared

and pieces of sandwiches and cream cake flew through the air. Afterward, the press gleefully reported stolen silver, piles of broken glass, and two thousand cigars that had inexplicably disappeared. All this while outside on the balconies, singers from the Opéra bellowed the Marseillaise.

It was not clear from the reports whether anyone actually managed to dance, but that was beside the point. Two thousand representatives of the man on the street had gained entry to this grand event and, judging from their raucous enthusiasm, they had a wonderful time.

〰

Despite heady occasions such as this, life was tough for the working class, and getting tougher. Unemployment was on the rise, especially in Paris, where it contributed to a growing disenchantment with the Republic, which seemed to have become the plaything of venture capitalists.

Yet socialism was slow to take hold in this potentially fertile climate, even though it was rapidly developing in nearby Germany. The Commune's suppression and the subsequent deportation or exile of its leaders had much to do with this, but divisiveness among the various radical groups was an even more critical factor, fueled by personal enmities as well as profound differences over whether these groups should be aiming at reform or revolution.

Louise Michel immediately dived into this seething ferment, speaking passionately on behalf of workers and the unemployed. She also got herself thrown in jail for insulting policemen after she witnessed several policemen beating a man. "You are charged with insulting policemen," said the judge. "On the contrary, it is we who should bring charges concerning brutality and insults," she replied, "because we were very peaceful." The first witness, a police constable, testified that she said to him, "You are hoods and deadbeats." That was a lie, Michel retorted spiritedly. "I said, 'Someone is being murdered,'" she wrote in her memoirs, "not some slang phrase, and the word 'deadbeat' isn't in my vocabulary."[12] But the court was not persuaded and sentenced her to two weeks in prison—without showing any concern whatever for the man who had been beaten.

〰

In 1882, seven-year-old Maurice Ravel began to take piano lessons. Although born in the small village of Ciboure, near the Spanish border (his mother, a Basque, had wanted to have her first child in her own birthplace), he had been raised in Paris—in a series of modest dwellings in the Pigalle quarter, at the foot of Montmartre.

He adored his mother, who spoke Spanish fluently and filled her son's childhood with the stories and folk music of Spain. He was also deeply attached to his father, who was a Swiss civil engineer (a fact that would eventually prompt Stravinsky to jest that Maurice was a "perfect Swiss watchmaker"). Ravel Sr. had worked on railway projects in Spain, where he met his future bride, and by the time of Maurice's birth was employed as an engineer at an automobile factory in Levallois-Perret, just beyond Paris's northwest borders. Yet despite his industrial career, Ravel Sr. never shut his eyes to his eldest son's obvious musical talents, and in fact was himself deeply interested in music, encouraging Maurice and his younger brother, Edouard, in their musical talents. Maurice, in turn, sympathized with his father's love of machinery and from an early age was thrilled by factories, with their "wonderful symphony of traveling belts, whistles, and terrific hammerblows."[13]

Another Parisian who was thrilled by factories and deeply invested in Levallois-Perret was Gustave Eiffel, whose famed workshops were located there. Eiffel himself had for years lived in northwest Paris near his workshops, and his decision to move to the Monceau quarter kept him in much the same area, while offering the advantage of a better address as well as proximity to the workshops of Gaget, Gauthier et Compagnie, where the Statue of Liberty was now rising.[14]

Already, the quarter was rapidly gentrifying from an edgy wasteland to one where foundries such as that belonging to Gaget, Gauthier et Compagnie were being squeezed out. As the Statue of Liberty continued to rise, her head appearing over the rooftops in a startling fashion, the day of the workshop in the Monceau quarter was already ending. In its place rose neo-Renaissance palaces for financiers and equally luxurious abodes for their pampered mistresses, such as Valtesse de la Bigne, who held court at 98 Boulevard Malesherbes.

Debussy, still a student at the Conservatoire, was a frequent visitor to the Monceau quarter, paying his respects at the Rue de Constantinople home of Madame Marie-Blanche Vasnier, whom he had met while accompanying a singing class. Madame Vasnier, an elegant brunette in her early thirties, had a beautiful singing voice, for which Debussy wrote more than twenty songs—some with remarkably ardent dedications. She also had a husband, Eugène Vasnier, a successful building contractor who seems to have been either extremely tolerant or extraordinarily obtuse. Vasnier not only put up with Debussy's courtship of his wife but allowed the young musician to cultivate a father-son sort of friendship with him as well. The Vasniers even gave Debussy a fifth-floor room in their house, with a piano on which to practice and compose. Not surprisingly, Debussy made his way to Rue de Constantinople almost every day.

Eventually, when Debussy was composing *Pelléas et Mélisande*, he, too, would move to the Monceau quarter—to 58 Rue Cardinet (17th), not far from the Rue de Constantinople. But by this time he was a married man, and Madame Vasnier had faded to a memory.

⌒

In 1882, ten-year-old Misia Godebska was allowed a once-a-month visit to her family, which had moved to an imposing house on Rue de Prony, near Parc Monceau. Misia, who at ten was already a talented pianist, would in time become prominent among Parisian artistic circles as Misia Sert, one of the foremost arts patrons in Paris. But now, imprisoned in the school of the Convent of the Sacred Heart, she could only think of escape.

Years later, when Rodin became acquainted with the building that the school occupied—the Hôtel Biron, on the Rue de Varenne (7th)—he would promptly fall in love with it and acquire a magnificent studio there. Eventually, the beautiful mansion would house the Musée Rodin. But when Misia was enrolled there, the sisters of the Sacred Heart had turned the place into a tough-minded boarding school for girls, one that tolerated no signs of luxury, not even hot water or heat. Misia, who loved luxury and was by nature a free spirit, rebelled at the rigors and the discipline and longed for her monthly visit home—not because her parents were loving and welcoming, which they were not, but because she loved the magnificence and the comforts of their opulent mansion. There, she was surrounded by trompe l'oeil ceilings, antique tapestries, and an abundance of bronze gas lamps and potted palms, and she could play the piano for hours, settle in for a good read in the conservatory, or wander with her pet pony in the garden.

Although not far in distance, it was a completely different world from her prisonlike school just across the Seine.

⌒

Others, especially successful writers and artists, were by now flocking to the Monceau quarter. These included Sarah Bernhardt (at 35/37 Rue Fortuny) and Dumas *père*, whose last address was 107 Boulevard Malesherbes, just outside the park. Dumas *fils* lived nearby, at 98 Avenue de Villiers, and monuments to all three were eventually erected in Place Malesherbes (now Place du Général-Catroux), located in the midst of these addresses.

While not foreseeing his own eventual memorial, Dumas *fils* did attend the 1883 inauguration of his father's monument—a tribute to Dumas and his readers of all ages, with a student, a workman, and a young girl engrossed in *The Count of Monte Cristo*, accompanied (on the monument's other side) by

a suitably dashing d'Artagnan. At the summit, a smiling sculpture of Dumas regards the world with typical geniality. Relations between father and son had been strained at the time of Dumas' death, but on this occasion, more than a decade later, Dumas *fils* was moved to tears.

From then on, every time he passed this statue, Dumas *fils*—now a literary power in his own right—would give it a special greeting, just between the two of them. "Bonjour, Papa," he would say.

And Dumas *père* always smiled warmly back.

CHAPTER TWELVE

~

Digging Deep

(1883)

During the early 1880s, Parisians on their daily rounds would have encountered a considerable amount of construction throughout their city—signs of the continuation of Baron Haussmann's remaking of Paris as well as the general rebuilding that had been going on since the conflagration a decade before.

If they had taken the time, they might have noticed—among the workmen and the debris—a small man with a sharp face, top hat, and goatee. This fastidious-looking onlooker, a man by the name of Théodore Vacquer, was well accustomed to watching and waiting, ready to seize upon any relics of antiquity that these digs might turn up. Having begun his career during the Second Empire as foreman of city works, Vacquer had become an inspector for the city's Service Historique and now was an assistant curator of the recently opened Museum of the City (now known as the Musée Carnavalet).

Vacquer, a failed engineer and architect, was no armchair historian. He was passionate about reconstructing the history of Paris, and he believed that the only way to do this was by recovering as many concrete vestiges of the past as possible. Fortunately, he began his quest during a time when Paris, under Baron Haussmann, was undergoing a remarkable amount of excavation. Pulled by curiosity, Vacquer discovered his lifelong obsession, the archaeology of Paris.

Paris's human history actually goes back a great deal further than Vacquer ever imagined, to Neolithic times. But when Vacquer was beginning his search, few people had any accurate idea of what had happened much

Les Arènes de Lutèce, Paris. © J. McAuliffe.

before their own day. The period that fascinated Vacquer began more than two thousand years ago, with a Celtic fishing village on the banks of the Seine. The Romans replaced this with a town of their own, called Lutetia, and erected a temple and administrative buildings on what is now called the Ile de la Cité, as well as centrally heated houses on the Left Bank hill now known as Montagne Sainte-Geneviève. Lutetia also boasted a forum, an amphitheater, and several public baths, as well as an aqueduct and a grid of well-built roads.

Lutetia thrived until the last part of the third century A.D., when barbarians began to puncture the Empire's periphery. By the late fifth century, the empire's western portion had collapsed, but Lutetia, now governed by the Germanic Franks and known as Paris (after its Celtic founders), continued in a modest way to prosper—that is, until the ninth century, when the Vikings arrived, leaving devastation in their wake.

Paris began its near-miraculous recovery in the twelfth century, but by this time its Gallo-Roman history was long forgotten. When in 1711 workers digging a vault beneath Notre-Dame's choir discovered five large carved blocks of stone dedicated to the Roman god Jupiter and dating from the reign of emperor Tiberius, it created a sensation.[1]

Antiquities continued to turn up at construction sites, but the antiquarians who collected and even catalogued these did not really know what to make of them. Despite good intentions, the story of Paris's origins remained muddled. And then, around the middle of the nineteenth century, Théodore Vacquer began to visit the numerous construction sites that were emerging under the direction of Baron Haussmann. Haussmann of course envisioned a city of the future, of broad boulevards and flattened cityscapes. To achieve this, he tore out narrow winding streets, leveled the city's innumerable hills and rises, and dug deep into the accumulated dirt and rubbish of the centuries. Vacquer was there to record and save what the workmen uncovered, and since so much of Haussmann's projects took place in the center of Paris, directly above ancient Lutetia, the antiquities that the workmen uncovered were frequently Gallo-Roman. As a result, the outlines of Gallo-Roman Paris began to emerge—for the first time in fifteen hundred years.

When Haussmann's bulldozers began to uncover the ruins of the Gallo-Roman arena, the Arènes de Lutèce, Vacquer (who had already located the remains of a forum near Rue Soufflot, plus numerous other prizes) was eager to add the arena to his list. But Haussmann was not inclined to sacrifice modernity for antiquity. Despite public outcry, the city council agreed to have the ruins demolished. Compounding the travesty, the council authorized the construction of a bus depot on the site.

Then, in 1883, more work in the Rue Monge area revealed another portion of the arena. Immediately the public, stirred by Victor Hugo's impassioned prose, rallied to the beleaguered arena's defense. This time the city council responded favorably and declared the site a *monument historique*. Work began on unearthing this remnant of a now-treasured past, in the expectation of glorious results that would rival spectacular Roman arenas elsewhere, such as the one at Arles. In fact, the Arènes de Lutèce turned out to be nowhere near so exciting, in large part because so much of the structure had been dispersed and destroyed centuries before. Bogging down the restoration further was the necessity of rebuilding the demolished section—all of which took several decades.

In the end, it was completed and then dismissed with a collective shrug. Once a cause célèbre and now practically forgotten, the Arènes de Lutèce has become a public park. Those in search of unusual pieces of Paris's past can find it here, in a quiet corner of the fifth arrondissement (Rue Monge at Rue de Navarre).

∽

1883 was a year of funerals. It began, in January, with Gambetta's huge public funeral. Then in May came the death of Victor Hugo's devoted mistress, Juliette Drouet, leaving Hugo so distraught that he could not even attend the burial. In between came the death of Edouard Manet.

Unable in his last months and days to undertake anything but small pastel portraits and the occasional still life of fruit and flowers, Manet painted his last picture—a vase of flowers—on March 1. After vain attempts to save him by amputating his leg, Manet died on April 30, 1883, at the age of fifty-one. Soon after, Berthe Morisot wrote to her sister of her visits to him before he died. She had been devastated by his evident agony as well as by the imminent end of a long and close friendship. "If you add to these almost physical emotions my old bonds of friendship with Edouard," she told her sister, "an entire past of youth and work suddenly ending, you will understand that I am crushed."[2]

Manet's pallbearers included his two best friends, Antonin Proust and Théodore Duret, as well as Emile Zola and Claude Monet. Degas, who was not a pallbearer, followed the funeral procession to Passy cemetery. During Manet's lifetime, his charm, wit, and elegance had perhaps overshadowed recognition of his artistic genius, even from his closest friends. Zola, for one, had thought that Manet was "searching for something . . . that others with more talent would find." And the *Le Figaro* critic, Albert Wolff, managed a similar halfway compliment, writing that "Manet in the future will be valued

more for what he attempted than for what he achieved." But Degas, following Manet's casket to the cemetery, concluded otherwise. "He was greater than we thought," he commented.[3]

~

After the funeral, Manet's mother came to stay with Berthe and Eugène. Berthe Morisot had never found her mother-in-law easy to deal with, especially given Madame Manet's barely disguised disapproval of Morisot's career. Painting, in Madame Manet's opinion, was all right for a woman as a pastime, but it should never interfere with a woman's commitment to her family—especially to her mother-in-law. Morisot, who had neither the time nor the inclination to hover about Madame Manet and who neglected to write daily as was expected when they were apart, had during the early years of her marriage allowed this and other irritations to grow. Although Madame Manet was delighted at the birth of Julie, who was her only grandchild, there remained underlying tensions and misunderstandings between mother-in-law and daughter-in-law, largely over the time and priority that Morisot gave to her painting.

But as Morisot began to receive more and more professional recognition, she encountered difficulties with other family members as well. Her brother, Tiburce (who had never amounted to much), scolded her for neglecting Julie—an unjust charge that wounded Morisot deeply, as it probably was intended to do. Her older sister, Yves, to whom she had never been close, complained of a "wall of ice" that had grown between them. Even Edma complained of a distancing between the two formerly close sisters. In large part, this was a consequence of the increasing demands that Berthe's career made on her time and concentration. Raising a child, managing a household, and being a good wife, all the while focusing on expressing herself in ways that had never been done before, took an enormous toll on Morisot. The world never ceased to tell her that her family and her friends came first, but while she was quick to acknowledge this, she found it difficult to pack her paintbrushes away when friends and family came to call.

But in addition to the time crunch, there was another factor distancing Morisot from family and longtime friends. As she was beginning to realize, there were fewer and fewer of these old friends or even family members with whom she still had much in common. Perhaps she had always instinctively felt this lack of commonality—a factor contributing to her characteristic reserve (as a teenager, her father had found her "secretive" and asked her sister Yves to "tell him if she knew any of [Berthe's] little secrets").[4] In any case, she now was gravitating toward her Impressionist associates as well as to the Manet brothers' social circle. This had political as well as artistic im-

plications, given the political liberalism of most of these artists, politicians, and writers.[5] "I am beginning to develop close friendships with my Impressionist colleagues," she wrote Edma in early 1884.[6] And even though the youngest Manet brother, Gustave, died later that year (followed shortly by his mother), the Manet brothers' liberal politics—and friends—continued to exercise a strong influence over Morisot through Eugène. This threatened to widen the gulf between her and her siblings, whose political and religious opinions were far more conservative than her husband's and, increasingly, her own.

From the outset, Morisot had known that the course she had chosen would be a difficult one. But she had not anticipated the challenges that she now was encountering on such an unexpected front.

⌒

For those Parisians who still clung to the old ways, change was coming at a disconcerting pace. Soon after Gambetta's death, Jules Ferry once again took charge, pulling together a centrist majority that would keep him in power for more than two years. Under Ferry's leadership, the government continued to reverse the repressive measures of the Moral Order and took steps to encourage freedom of assembly and a vigorous press. It also continued to work for the secularization of French society, with a secularized universal education its particular goal. In April, a judgment of the Council of State authorized suspension or stoppage of ecclesiastical salaries, which the Church rightly viewed as a means of controlling the clergy. In addition, the president of the Republic now gained the right to appoint bishops.

All of this was certainly welcome to Clemenceau, although change did not come nearly fast enough for him. Ferry's government (much like the moderate governments that preceded him) kept its hands off the Concordat, which Clemenceau and his radical republican colleagues ardently wished to abolish. Yet it was not domestic policy but foreign affairs that now drew Clemenceau's ire, especially France's expansion into what would become Indochina—the area encompassing modern Laos, Cambodia, and Vietnam. France, under Ferry, was beginning to build an empire, and Clemenceau was adamantly opposed.

Ferry had gotten in trouble with Parliament (and Clemenceau) before, with his secretive manner of conducting France's expansion into Tunisia. This time, it was worse. China, which held feudal sway over much of this area, was not pleased to see the French asserting themselves there, and soon the French found themselves fighting the Chinese army as well as an effective group of local guerillas. In the spring of 1883, the Chamber of Deputies— jolted by news of the French commander's death in battle—unanimously

approved sending more troops. But despite the addition of twenty thousand men, four battleships, and a score of smaller ships, the fighting continued. By autumn, an incensed Clemenceau angrily denounced Ferry for dragging France into this mess, which he charged that Parliament had not properly authorized. China, Clemenceau warned, had an "inexhaustible reservoir" of men, and fighting such a power would sap France of its manpower for years to come. Just as devastating, he warned, was the economic damage that such a war would wreak, draining France's coffers at the very time the French were suffering severe economic hardship at home.

But Ferry still held a majority in the Chamber of Deputies, which approved continuation of the war. In December, he returned to request more funds. Despite fierce opposition from Clemenceau, the Chamber gave Ferry yet another vote of confidence, and the war slogged on.

⌒

Yet growing French opposition to the war in Southeast Asia did not signal a declining interest in the world beyond France's borders. Indeed, despite hard times, there still remained those with the money and the inclination to travel who were heading off to ever-more-exotic destinations. Among these adventurers, the most stylish chose the latest in luxurious transportation, the Orient Express.

Paris by now boasted six large train stations. These stood, and still stand, as the termini for tracks that radiate outward from the city like ever-extending spokes of a wheel. The first, the Gare Saint-Lazare (8th), was inaugurated in 1837 and originally served Paris's western suburbs before reaching north into Normandy. The Gare d'Austerlitz (13th) connects Paris with southwest France and Spain. Its neighbor on the Left Bank, the Gare Montparnasse (15th), is the terminus for trains to Brittany and western France. The Gare du Nord and the Gare de l'Est, near neighbors in north-central Paris (10th), were built to serve northern and eastern France as well as international destinations beyond. And the Gare de Lyon (12th), whose first station on this site opened in 1849, stands across the Seine from the Gare d'Austerlitz, where it connects Paris to southern France, Switzerland, and Italy.

Eventually, the Orient Express would depart from the Gare de Lyon under the name of the Simplon Orient Express. But when the first Orient Express left Paris for Vienna in June 1883, it was from the Gare de l'Est. Soon after, the route was extended all the way to Istanbul. During these early years, despite the Orient Express's reputation for luxury, it was not an easy trip. To begin with, the actual train that left Paris did not go beyond the Danube. Passengers had to change trains in Bulgaria and complete their journey by

rail, carriage, and ferry. These were still early days for rail travel, and most passengers, in fact, had no intention of slogging all the way to Istanbul. Instead, they chose to peel off to destinations such as Vienna, Milan, Venice, or Athens. Not until 1889 did the first nonstop Orient Express leave the Gare de l'Est for Istanbul, opening new vistas for luxury travel.

Luxury was already readily available in an elite handful of grand hotels, although César Ritz was about to take the deluxe hotel to new heights. But at the age of thirty-three, he still was on his upward climb, in a dizzying succession of positions that took him from Vienna to Lucerne. In Lucerne, he juggled the job of summer manager of the Hotel National (still in existence) with winter positions at several prestigious hotels on the Riviera, including the Grand Hotel in Monte Carlo. His guests, who summered in Lucerne and wintered in Monte Carlo, quickly learned that wherever Ritz went, they would be assured of luxury, comfort, and scrupulous attention to their wants and needs. In particular, Ritz's "following" knew that he would always remember their individual preferences and requirements, making a stay at one of "his" hotels truly a home away from home.

Luxury was filtering down to the bourgeoisie as well. In 1883, Printemps achieved the distinction of being the first department store in Paris to be lit electrically. Zola, who had foreshortened the date of this glittering achievement by two decades in *Au bonheur des dames*, had jumped the gun on the actual event as well—readily incorporating it into his book, which appeared in 1882, while the rebuilt Printemps was still under construction.

La Samaritaine and the Cognacqs were also thriving. Hard work was paying off handsomely—in 1882, Samaritaine took in some six million francs. Adding to their sense of well-being, in 1883 Ernest and Marie were able to compensate for their childlessness by adopting their grandnephew, Gabriel, whose father had just died, leaving him an orphan.

Ernest Cognacq would later turn philanthropist, establishing a foundation that administered a number of child-related institutions, such as a maternity hospital, a nursery, and an orphanage. His foundation would also underwrite a retirement home and low-cost housing. But despite his good works, Cognacq was not widely beloved. He had the reputation of being a hard man, and even his philanthropy aimed at reinforcing his rigorously patriarchal sense of family. (There was also some suspicion that he established his various foundations as a means of leaving the government—whose waste he despised—with as little as possible of his by then considerable fortune.) Cognacq enforced a strict moral code among his employees, and the failure of Gabriel's father, Fernand, to live up to this code (he had married a Samaritaine salesgirl) had gotten him thrown out of the Cognacq household. With Fernand's death, Gabriel entered this same household.

Both Ernest and Marie were reportedly delighted with the child, who was only three years old at the time. But they did not overburden themselves with tenderness. "If you do not work," Gabriel's grandaunt informed him, "we will not keep you, and we will disinherit you."[7]

She seems to have meant it.

⌣

Not surprisingly, Edmond de Goncourt had an acerbic view of children, which his rare encounters only reinforced. Young Zézé Daudet, son of the novelist Alphonse Daudet, may have been a normal, active youngster, but according to Goncourt, he was a terror. Perhaps he was. In Goncourt's words, Zézé "wanted to cut the goldfish with the pruning-shears, . . . tried to pull off all the rhododendron buds . . . , and he did his best to wreak havoc wherever his little hand could reach." Worse yet, "when he had broken or destroyed something, his face shone with happiness."[8]

Zola and his wife took a very different view of children, for much like the Cognacqs, they were deeply unhappy with their childlessness. For years, the Zolas had longed for children, and Zola himself had often said that "to make a book, to plant a tree, to have a child" constituted a good life.[9] Well, he had certainly made a book—many of them—and would have opportunities to plant trees by the score in his new country home in Médan (which Goncourt ungraciously likened to a feudal-looking building in a cabbage patch). But what about a child? Madame Zola had subjected herself to a variety of "cures," but to no avail. And then rumors began to circulate about the possibility of Zola's own impotence. Scorning mistresses, he had long claimed that happiness was only to be found in wedded bliss, and that he was happily married. After all, he protested, love without children was simply adultery.

His friends noted the awkwardness in this logic and mused a bit. "As the sun went down," Goncourt wrote after a day at Médan, "there rose from that treeless garden and that childless house a melancholy."[10] Later, when this phrase appeared in the published version of Goncourt's journals, it would infuriate Madame Zola. But by that time, she had every right to be furious.

⌣

Sarah Bernhardt certainly had never been burdened with the moral strictures so earnestly practiced and preached by Ernest Cognacq or (more privately) by that author of scandalous books Emile Zola. By the time she returned from her American tour, she had gone through a long list of lovers and borne an

illegitimate child, whom she openly raised and adored. Of course such be-
havior was only to be expected of an actress, especially one with Bernhardt's
volcanic temperament. Parisians by now were accustomed to being titillated
by Bernhardt's latest escapades. Still, it considerably startled Parisians when,
in 1882, word filtered back from England that the unconquerable Bernhardt
had stooped to marry a handsome young Greek whom scarcely anyone had
heard of.

Bernhardt, of course, liked to live dangerously. She adored the game of
love, which she played to win, but again and again her victories left her
feeling flat. Lovers who fell hopelessly in love with her enchanted her for a
brief time and then bored her. Lovers who made scenes over her faithlessness
bored her further still. And then she met Aristidis Damala. At twenty-five,
he was twelve years her junior, a handsome and arrogant young playboy who
was addicted to a fast life, beautiful women, and morphine. Bernhardt found
him absolutely irresistible.

With Damala, she upped the stakes in her games of love, selecting a lover
whose conquest was uncertain and therefore more desirable. What Bernhardt
evidently did not expect was how perfectly Damala would play her old game
against herself, refusing to pursue her and taunting her with other lovers. It
was more than she could stand, and finally, in utter capitulation, she asked
him to marry her.

It represented a full and complete triumph for Damala, who became Bern-
hardt's pampered pet. She proceeded to give him everything he wanted,
including starring roles (for which he was eminently unqualified) as well as
enormous sums of money. But in early 1883, the game abruptly ended—at
least, for the time being. Damala, jealous of his wife's stage successes, bolted
for Algeria. Bernhardt, who was left with the bills, faced financial ruin. She
sold her jewels and went on tour, recouping her losses. But soon Damala was
back, tired of the soldier's life and gallingly willing for Bernhardt to support
him, which she unaccountably continued to do.

It was during this turbulent and difficult year that Bernhardt leased the
Théâtre de la Porte-Saint-Martin, a large theater near the great gate that
Louis XIV had built to commemorate his military victories. The history of
this particular theater must have appealed to her—after all, Victor Hugo had
enjoyed some of his greatest successes here. Still, it was a huge house to fill.
And Damala was by this time in and out of clinics, a constant worry and a
distraction to Bernhardt, who finally asked for a legal separation.

In the Théâtre de la Porte-Saint-Martin, Bernhardt triumphed once again
in La dame aux camélias. But she had not seen the last of her financial difficul-
ties. Nor had she heard the last of Aristidis Damala.

～

While Bernhardt was dealing with the collapse of her marriage, Auguste Rodin was on the brink of a grand passion. But unlike Bernhardt's, his lover would become the greatest inspiration of his career. Her name was Camille Claudel, and if she was not pretty in a conventional way, she was as beautiful and alive as quicksilver. She was also an extraordinarily gifted sculptor in her own right.

Claudel was still in her teens when they met, and Rodin was forty-two. He had been asked to supervise the work of several young women who were sharing the expenses of a studio, including models. Claudel had organized the group, and he immediately took note of her. Rodin adored women and for years had been involved in one love affair after another, much to Rose Beuret's dismay. But Claudel riveted his attention as no other woman had before. Not only was she beautiful, but she was intelligent and talented, already able to model superbly in clay.

Rodin was smitten. After she came into his life, he wrote her, "nothing was the same, my dull existence broke into a fire of joy."[11]

～

Claude Monet had experienced little hesitation before bringing Alice Hoschedé and her six children to live with him, but gossip was beginning to circulate. Monet could shrug it off, but it was more difficult for Alice, who after all was no courtesan or even an aristocrat who could write her own rules, but the wife of a reasonably prominent member of the bourgeoisie. As such, she was expected at the very least to maintain the outward forms of respectability and decorum. Under her current situation, which was anything but respectable, she was beginning to learn what it meant to be a social outcast. It made her deeply unhappy, and finally, in early 1883, Monet (then painting along the coast of Normandy) urged her to have a discussion with her husband, presumably on the subject of a divorce. "As for myself," he told her, "you need have no fears." She could be sure of his love.[12]

But regardless of Monet's feelings, Alice was ready to throw in the towel, and she sent him a telegram to that effect. "Must I get used to the idea of living without you?" he frantically replied. He told her that he knew that he should say nothing to interfere with the decision she had made, and yet it devastated him. "I love you more than you imagine," he told her, "more than I thought possible."[13]

"What in heaven's name have people been saying to you," he anguished, "for you to be so resolved?"[14]

He soon returned, and Alice did not leave. But she remained deeply unhappy.

⟳

Paris, with its unrivalled sophistication and its theaters, cafés, and salons, offered artists and writers a cultural nucleus that few could do without. Manet had spent almost his entire life within the city, painting urban scenes, and there were many like him, who desired to be nowhere else but Paris.

But royalty and the aristocracy had made it a practice to bolt for the countryside during warm weather, whether to Vincennes, Saint-Cloud, Fontainebleau, or the Loire. With the rise of the bourgeoisie, country homes became possible (and even expected) for a broader portion of the population, including successful artists and writers. Dumas *père* adored his Château de Monte Cristo, the exuberant little Renaisssance folly that he built in Port-Marly and all too soon was forced to sell to avoid financial ruin. Zola had his own version of a château at Médan, which he dearly loved—despite Edmond de Goncourt's gibes. Goncourt himself rarely strayed beyond Paris city lines, but in 1868 he moved with his brother from the ninth arrondissement to the city's southwestern edge, in Auteuil. This new, countrified location represented a welcome relief from central Paris, where they had spent their entire lives, and they reveled in the greenery, the trees, and the birds.

Still, life was rarely perfect for either of these two perfectionists, and soon they had cause to complain of the noises of the country, which could be as unpleasant in their own way as those of the city. "Unfortunately," their journal reads, "for us who came here to escape from the noise of Paris, we have the noise of a horse in the house on the right, the noise of children in the house on the left, and the noise of trains going by in front."[15] In their haste to purchase their new residence, they had failed to note that it was located (on Avenue de Montmorency, 16th) within yards of the little railway, the Petite Ceinture, that then encircled Paris.

Country places could be extravagant, as with Dumas and Zola, or more modest, depending entirely upon their owner's wishes and means. The poet Stéphane Mallarmé, who never earned very much, fled Paris during the summer months to the second floor of a small house in Valvins, near Fontainebleau. There, with his wife and daughter, he delighted in his simple surroundings and in sailing his small boat on the Seine.

Others juggled their professional lives in town with permanent residences in the countryside. Rodin eventually moved to a house in nearby Meudon, but he returned to one or another of his studios in Paris almost daily, to work and to receive visitors. Still others chose to retreat permanently to

the country, limiting their contacts with Paris life to occasional city visits and country outings from their friends. Monet, who in his younger days had painted Parisian streets, buildings, and railway stations, now was fully occupied with landscape painting. He had also resumed his avid commitment to gardening. By springtime of 1883, he had found a place where he could pursue both to his satisfaction. It was a rented house in Giverny, near Vernon—a house on a small tributary of the Seine called the Epte.

Here he raised his flowers and painted as well as entertained friends such as Rodin, Georges Clemenceau, and Renoir (who had a place in nearby La Roche-Guyon). Here as well Alice Hoschedé tried to adjust to the realities of being mistress to an artist and leading an essentially bohemian life.

⌣

Monet considered himself impoverished and frequently complained about it, but it is easy to imagine any one of Paris's poor considering it a luxury to live in his house and shoes. Instead of ready access to country houses with gardens, those Parisians who could not afford such luxuries saved their sous for weekend day-trips to nearby places such as the Grenouillère or Chatou. Those men and boys who had no sous to save simply bathed in any of several spots along the Seine—much as in the large canvas that Georges Seurat painted in 1883 of the *Bathing Place, Asnières*.

Asnières, located across the Seine at the northwest edge of Paris, had a large working class, and in the distance Seurat included the smoking chimneys of the factories of Clichy. These men and boys stolidly convey the dull realities of their days and the limited prospects of their lives. Not surprisingly, the Salon did a collective shudder at this realistic slice of everyday life and rejected the painting when Seurat submitted it in 1884.

Of course, this was a pleasant scene—nothing like the dismal poverty that Louise Michel regularly encountered in Montmartre, Ménilmontant, and Belleville. Anguished and angered over these people's plight, in March 1883 she took a leading role in a mass demonstration of the unemployed at Les Invalides. Following this she led a crowd of demonstrators through the area, during which three bakeries were looted. The police promptly put out a warrant for her arrest but were unable to find her for two weeks, when she finally turned herself in to prevent harm from coming to those who were hiding her. As fiery as ever during her trial, she protested that the demonstration had been a peaceful one. "The black flag is the flag of strikes and the flag of those who are hungry," she told the court, adding, "What is being done to us here is a political proceeding. It isn't we who are being prosecuted, but the anarchist party through us."[16]

Her sentence was extraordinarily harsh: six years of solitary confinement. But despite this, she did not for one moment regret the actions she had taken. What was at stake, she concluded, was nothing less than the future of the human race, "one without exploiters and without exploited."[17]

"Please read the defense of Louise Michel," Pissarro wrote his son, who then was living in London. "It is really remarkable. This woman is extraordinary. She renders ridicule harmless by the force of her feeling and humanity."[18]

Ironically, this woman who was devoting her life to the defense of the underdog began serving her sentence on July 14.

CHAPTER THIRTEEN

~

Hard Times

(1884)

Louise Michel claimed that she didn't mind being imprisoned. Women's prisons, she wrote, were less harsh than men's, and she was not suffering from either cold or hunger. As for solitary confinement, she found it restful, especially in contrast with the frenetic pace of her former life. Given this solid block of unfilled time, she had decided to write her memoirs—even though writing or speaking about herself gave her much the same feeling as if she were "undressing in public."[1]

She needn't have worried. Her personal life was almost inseparable from her political life, and her deepest and most heartfelt thoughts were political ones, which she was accustomed to shouting from the housetops. Still, her memories helped round out her persona, leaving a searing impression of a brilliant, emotional, and deeply caring woman—one who, with a startling degree of selflessness, poured her considerable passion into helping the downtrodden.

And Paris in 1884 unquestionably held countless numbers of downtrodden. The floundering economy of the 1880s had created distress throughout a large portion of the population, and none more so than those who had been living day-to-day even in better times. Louise Michel had gone to prison for leading a crowd of demonstrators who looted several bread shops. Her prosecutors feared anarchy and mayhem, but what they did not seem to comprehend was that these people were hungry.

Yet those who warned of anarchy and mayhem held vivid memories of the Commune to support their fears. Remembering the fires and the bloodshed

Tanneries sur la Bièvre, 1892 (Jules Richomme, 1818–1903). Paris, Musée Carnavalet. © Musée Carnavalet / Roger-Viollet / The Image Works.

and ignoring or forgetting the role of the Versailles government in the massacre, conservatives and moderates alike were reluctant to do anything that might let the genie out of the bottle and trigger another uprising.

It was this fear of reprisal that led to heavy-handed police crackdowns, such as the one that resulted in Louise Michel's six-year imprisonment. It was this fear as well that had held off all possibility of amnesty for almost a decade and had left the former Communards without a monument or memorial of any kind to commemorate their dead.

The governments of Adolphe Thiers and of Marshal MacMahon's Moral Order had been especially firm on this point. While Sacré-Coeur began to rise on the heights of Montmartre, in the very spot where the Commune was born, the remains of General Clément Thomas and General Lecomte—the first victims of the uprising—were transferred with great ceremony from the cemetery of Saint-Vincent de Montmartre to an impressive memorial in Père-Lachaise. This memorial, featuring France and Justice trampling the serpents of anarchy, was erected (and paid for) by the state on land donated in perpetuity by the City of Paris. As Sacré-Coeur continued to rise, Adolphe Thiers' funerary chapel, built front and center on a promontory in Père-Lachaise, would further add to this display of homage to the Commune's most fervent enemies.

In the meantime, post-Commune Paris had been stripped of its mayor and placed under the authority of two prefects. But Paris had also been given a municipal council to handle the most mundane city affairs. This elected council, dominated by ardent left-wingers, soon found itself in possession of a rather odd responsibility, that of awarding perpetual free concessions in Paris cemeteries. Those in the national government who had previously held this responsibility were only too glad to pass it on down the line. But although shedding this burdensome responsibility, the state was careful to reserve for itself the supervision and control over epitaphs. The outcome was a veritable battle over certain epitaphs, especially in Père-Lachaise, where—following the amnesty of 1880—the municipal council gave twenty-one free perpetual concessions to various former leaders of the Commune.

Conflict over the inscriptions first arose in 1884, when the executor for one former Commune leader refused to add to the dead man's epitaph the words, "Member of the Commune." The state held firmly to its position on this and subsequent Communard epitaphs, causing a good deal of consternation in left-wing quarters. But the most difficult issue of all was the one that affected the largest number of former Communards—the absence of a suitable memorial at the mass gravesite along the wall of Père-Lachaise that had become known as the Mur des Fédérés.

One hundred and forty-seven Communards had been shot against this wall, in the last ferocious battle of Bloody Week. Many more bodies, collected from the near neighborhood, were added to what became a communal grave. Soon families and neighbors of the victims began to risk arrest by coming to pay tribute. In due course, political gatherings gravitated to the spot. Under the republican governments that replaced MacMahon's severe Moral Order, a certain amount of this was tolerated. Talking and singing was allowed, and flags were tolerated. Little by little, sheaves and wreaths of flowers were hung on the wall and not removed.

In 1883, the municipal council (prodded by Clemenceau's journal, *La Justice*) granted the land around this communal grave to the families of the dead—not in perpetuity, but for twenty-five years. This gave rise to the question of an actual monument at the wall. The prefect of the Seine opposed the project, but just as damaging was the dissent among the proponents, who differed strenuously over what sort of monument it should be. Some envisioned a dramatic portrayal of the martyrs, while others objected on the grounds that this would be "too bourgeois." Still others proposed a simple stone wall enclosing the area.

And there the matter sat—at least, for the time being.[2]

∼

Louise Michel appreciated Georges Clemenceau's "revolutionary temperament," but she had no patience for his "illusion . . . that he should wait for parliamentarianism to bring progress." And she added, "Properly, his place is in the streets."[3]

Clemenceau saw himself somewhat differently, but despite his rejection of the extremist politics that Michel embraced, he sometimes found his role in anchoring the parliamentary opposition somewhat tiresome. Years later, in response to a comment about the number of ministries he had personally brought down, he waspishly remarked, "Yes, but they were always the same ministry."[4]

Following Jules Ferry's return to power in 1883, Clemenceau was adamantly in the opposition on numerous fronts, but especially on the question of colonial expansion, as the war in Tonkin dragged on. Even after the local rulers agreed to a French protectorate, the Chinese and, most importantly, the local population continued to fight. Yet in the autumn of 1884, when Ferry appeared before Parliament to request new appropriations for the Tonkin war, he stated that French security was "total and complete" and that France's position in Tonkin had never been better. Clemenceau did not buy this (nor did Berthe Morisot, who commented, "It seems to me that

Jules Ferry who has so far been merely ridiculous is becoming insufferable").[5] But Morisot was writing to her sister, and she did not have the opportunity to confront Ferry as did Clemenceau, who proceeded to question the prime minister closely. Ferry was not amused. How could he possibly reply in detail, he demanded, given the delicate state of negotiations with China in which France was then engaged? Going on the offensive, he then attacked Clemenceau for having the temerity to attack *him*.

But Clemenceau was not about to be put off. Firmly believing that Ferry was embarked on a full-fledged military disaster, he informed the Chamber that the actual military situation in Tonkin was quite the opposite of the rosy picture that Ferry painted. Reminding the deputies that as recently as the previous spring, Ferry had stated that there were no Chinese troops in the area and that France's military operations were almost complete, Clemenceau accused Ferry of self-delusion. Indeed, he stated, the Chinese had already penetrated the interior, where French forces were on the defensive. Ferry countered that the French forces there were not quite so badly on the defensive as Clemenceau made out, but this did not help him much. On the contrary, Clemenceau now accused Ferry of "unbelievable negligence and inexcusable thoughtlessness." Wrapping up his attack, he angrily concluded that the French who had died and even then were dying in combat in Tonkin had died needlessly. "It is your work," he told Ferry, "and yours alone."[6]

Despite Clemenceau's efforts, the Chamber voted by a comfortable margin to approve the additional appropriations that Ferry had requested. But Ferry's position was growing more and more precarious, as Clemenceau and his colleagues fanned the opposition to this increasingly unpopular and never-ending war.

∽

While Clemenceau was debating Ferry over France's expansion into Southeast Asia, expansion of a different sort was going on at home. By 1884, the Gare du Nord, much like its sister Parisian railway stations, had become too small to deal with the huge increase in railway traffic going in and out of the city. The original station, dating from 1846, had been partially demolished in 1860 to provide space for a new and larger station. But soon this structure, too, failed to accommodate the growing traffic. By 1884, five supplementary tracks were necessary, and plans were under way to build an extension.

Gustave Eiffel was busy as well. In Paris alone, his firm had already provided the iron framework for numerous edifices, including the Church of Notre-Dame des Champs (Boulevard du Montparnasse, 6th), the Church of Saint-Joseph (Rue Saint-Maur, 11th), the synagogue in the Rue des Tournelles (4th), and the Lycée Carnot (Boulevard Malesherbes, 17th), as

well as the extension of the Bon Marché department store. In 1884, with the framework for the Statue of Liberty completed, his firm was working on an iron structure for the Palais Galliera, a grand edifice originally built for private use and now the Musée de la Mode de la Ville de Paris, on Avenue Pierre-1er-de-Serbie (16th).

But what especially drew Eiffel's attention in 1884 was a new and challenging project that Charles Garnier had undertaken. After funding a meteorological observatory in Paris's Parc Montsouris, a wealthy banker with an interest in astronomy had decided to build a much larger observatory in Nice. Garnier signed on as architect and turned to Eiffel to design the internal structure of the observatory's massive cupola. Garnier and Eiffel had not known each other previously, although each had taken note of the other's work. Garnier had in particular been impressed with Eiffel's proposal (never realized) for the reconstruction of the Paris Observatory dome, and of course Eiffel was well aware of Garnier's exalted position as architect of the Paris Opéra.

The Nice observatory cupola was to be huge, even larger than the one topping the Paris Panthéon. When completed, it would in fact be the largest unsupported dome in the world. Not only that, it had to rotate. Bringing a totally new perspective to this daunting task, Eiffel rejected the use of rollers, which were typically used for smaller structures of this type. Instead, he decided on a flotation system, in which the dome's weight (all 110 tons of it) was supported in a circular reservoir of nonfreezing liquid. Much to everyone's amazement, when completed, the entire dome could be fully and easily rotated in only a few minutes.

It was a triumph for Eiffel and remained one of his favorite accomplishments. But by the time the project was completed, in 1887, he and Garnier were no longer friends. It was not a question of the Nice Observatory—that had gone well enough. Instead, it was the prospect of Eiffel's extraordinary tower, which was about to rise from the Champ de Mars.

⌒

As early as 1880, the government of Jules Ferry floated the idea of another Paris universal exposition, this one timed to coincide with the centenary of the French Revolution. Paris had previously held universal expositions in 1855 and 1867, as well as the one of 1878; an exposition in 1889 would be spaced just about right from the one before, and the idea of a centennial celebration of the Revolution appealed to the new republican government.

Still, celebrating the French Revolution would not necessarily appeal to everybody, and from the outset the idea was to make this exposition as appealing to as many people and political opinions as possible. That, plus a

natural inclination to feature something truly spectacular, led to the idea of an enormous tower that at three hundred meters (one thousand feet) would be higher than anything ever before built.

Two of Eiffel's subordinates, Emile Nouguier and Maurice Koechlin, were the first to have the idea of an iron tower, which they conceived as being made of four lattice-like girders "standing apart at the base and coming together at the top."[7] Trusses would join the girders at regular intervals. Architect Stephen Sauvestre modified this design by adding the enormous arches at the base of the four uprights. A daring but workable plan, this tower bore a distinct resemblance to bridge piers, which the Eiffel team knew well. In fact, much to the consternation of traditionalists, aesthetics played little role in the tower's design. Every feature was the product of careful computations based upon in-depth knowledge of stresses, weight, gravity, and wind forces. Even the tower's attractive splayed legs were designed for wind resistance.

But perhaps surprisingly, Eiffel himself was not at first interested. Upon being shown a draft plan, he showed no enthusiasm, but he did at least give permission for Nouguier and Koechlin to pursue the idea further. They promptly showed Sauvestre's drawing to Antonin Proust, former minister of fine arts (under Gambetta), who now presided over the commission in charge of administering the exhibition. Proust was greatly excited by what he saw and insisted that the drawing be displayed publicly. At this point, Eiffel seems to have had second thoughts about his underlings' idea. Now prepared to take the lead in the proposed project, he bought the exclusive patent rights from Nouguier, Koechlin, and Sauvestre in late 1884.

It was now Eiffel's tower. And it was about to rouse a host of critics, who were still wed to the old ways.

～

While Eiffel was contemplating the possibility of building a gigantic iron tower, Rodin was beginning preparatory studies for a far smaller yet nonetheless daunting project of his own—the great group sculpture *The Burghers of Calais*.

The City of Calais, located on the Channel in northern France, had long wanted to erect a monument in commemoration of the town burghers who had saved the city centuries earlier, during the Hundred Years' War. England's King Edward III had placed Calais under siege, and the starving citizens had at last begged for terms. In response, Edward—in one of those deals reminiscent of the grimmest of fairy tales—offered to spare the city if any six of its leading citizens would surrender to him for execution. Not only that, but these six were to walk out of the city almost naked, wearing nooses around their necks and carrying the keys to the city.

Six men of varying ages and backgrounds volunteered to sacrifice themselves in this humiliating fashion, and the oldest of these, Eustache de Saint Pierre, led them through the city gates to the king. But here England's queen unexpectedly intervened, persuading her husband to show mercy. The city was saved, and the six selfless heroes were returned—but in the years since, they had never been fittingly commemorated by a memorial. Previous attempts had failed for lack of funds, but in 1884 the city launched a national subscription drive and contacted Rodin, who was immediately taken with the idea. Not only was the subject appealing, but the prospect of doing something completely original attracted him. "All towns usually have the same monument, barring a few details," he wrote to the mayor of Calais.[8] Instead, he proposed to do something quite different.

How different, the city fathers did not realize until Rodin began to send them drawings and a plaster model. Some of them were appalled. Instead of a single commemorative figure, or one supported by allegorical sculptures, Rodin proposed a group of six statues grippingly depicting each of the men as they paused at the city gates before continuing on to their own anticipated destruction. Rodin defended his concept, but his critics still objected. "This is not how we visualized our illustrious fellow-citizens," they told him. "Their dejected attitude militates against our beliefs."[9]

After vigorously rebutting this criticism, Rodin felt sufficiently assured to continue work on the individual figures and on the grouping as a whole. It was a challenging and gradual process, taking far longer than he or the city fathers had anticipated. While Rodin was grappling with his artistic challenge, Calais was experiencing its own difficulties, having been severely hit by the economic downturn that was plaguing France. This meant that, at least for the time being, the city could not pay for its monument. Unable to bring the project to completion, Rodin put the finished plaster group into storage, where—with the exception of one important showing—it would remain for several years.

In the meantime, Camille Claudel went to work in Rodin's Rue de l'Université studio as an assistant. By this time the two had embarked on a passionate love affair, which would last for several years. Yet despite their age difference and Rodin's growing reputation, she was not the dominated party. If anything, she managed to tyrannize *him*, alternately sending him into heavenly joy or deep despair. Over the coming years, their love affair would be neither an easy nor an especially happy one. Still, despite the anxiety and pain that their affair occasioned, it would inspire Rodin to create his most impassioned and deeply stirring works.

Claudel, too, was inspired—but only at first.

⌐⌐

In late 1883, Monet and Renoir had taken a painting trip to the Riviera together, during which they visited Cézanne. Early the following year Monet returned to the Riviera, this time without Renoir. "I ask you not to mention this trip to *anyone*," Monet told Durand-Ruel, "not because I want to make a secret of it, but because I insist upon *doing it alone* [Monet's italics]." The problem was Renoir. Not that he and Monet had fallen out—far from it. The two still were close friends and colleagues. But much as Monet enjoyed traveling with Renoir as a tourist, he found it difficult to work with him. "I have always worked better alone and from my own impressions," he emphasized. And of course, if Renoir knew that Monet was about to go, he "would doubtless want to join me and that would be equally disastrous for both of us." [10]

Insisting on his own vision of what and how to paint, Monet not only was retreating from his joint painting trips with Renoir but was continuing to insist on his independence from Alice, from whom he regularly spent several months away each year on painting expeditions. Placing increasing demands on himself as an artist, he was not eager to hear of her own challenges, emotionally and otherwise. "Mine is a dog's life," he told her in early January from Bordighera, listing the number of paintings on which he was working. By dusk, he assured her, he was exhausted, and after dinner and his regular letter to her, he climbed into bed, ruminated on Giverny, and dropped into a sound sleep. As for her, he was "hoping for good news tomorrow, a nice letter with no reproaches." [11]

A few days later, he wrote that he was still slaving away. But Alice's continued bouts with unhappiness no longer plunged him into despair. If anything, they had begun to annoy him. "I wish you'd love me as I love you," he told her, "while being a little more reasonable about it." Alice rallied in her next letter, and Monet responded, "That's better, I am glad to see that you're being a little braver now, it gives me heart." [12]

⌐⌐

When Georges Seurat set up his easel on the Ile de la Grande Jatte in the early 1880s, this narrow island in the Seine, just to the northwest of Paris, had become a popular pleasure-ground for working-class Parisians. Here they partied in the island's restaurants, kicked up their heels on its dance pavilion, and boated from its shores. Most of all, they promenaded or sat and relaxed beneath its trees, enjoying a respite from hard work and city life. They were far from being an elegant bunch, but Seurat was quite taken with them—although he was selective in what he painted, avoiding the bawdier and

racier aspects of the place, much as Monet and Renoir had done at the Grenouillère more than a decade before.[13] Indeed, Monet had even painted on the Ile de la Grande Jatte, in 1878.

Seurat preferred the island's northwestern shore, facing Courbevoie. It was quieter here, and he was familiar with the spot, having painted his remarkable *Bathing Place, Asnières*, from the Seine's other side. For *Bathing Place*, he had executed countless study paintings before pulling together the final composition in his own studio, much as he would do in depicting a Sunday afternoon on the Ile de la Grande Jatte. This was hardly the approach of the Impressionists and harked back to the studio painting of more traditional painters. Yet despite the fact that Seurat had received a classical art education at Paris's prestigious Ecole des Beaux-Arts, he was no stuffy academic painter. Indeed, when he embarked on his shimmering depiction of nineteenth-century Parisians caught in a sun-swept moment along the Seine, he had evolved a radical new style of his own.

Such artistic daring would not have been expected in the solidly bourgeois Parisian household into which he was born in 1859. Still, his mother had encouraged his drawing, and his father (a retired court bailiff) had uncomplainingly paid the bills. Seurat grew up in comfort on the Boulevard de Magenta (10th), within walking distance of the Parc des Buttes Chaumont—that masterpiece of lakes, rocks, and grottoes that Baron Haussmann conjured out of a former quarry—where the young boy spent many happy hours. During much of this time his father lived at a separate residence, just outside of Paris, but seemed quite willing to underwrite his son's career—a fortunate circumstance that gave Georges Seurat the financial independence to do as he chose.

His career developed with little fanfare. A quiet and intense young man, Seurat always maintained his reserve, communicating little about his private life and thoughts even to his closest family and friends. His circle of acquaintances was small, and he lived most of his life in close proximity to his family home, where he spent much time with his mother—although he frequently visited his father's suburban residence as well. But although Seurat regularly took most of his dinners at his mother's table, he characteristically never shared a word about the private life that he was simultaneously living with a mistress, even when she bore him a child.

In the meantime, he was devoting his life to his art and by 1884 had developed a unique style. Instead of embracing the Impressionists' romantic impulsiveness, he opted for a coolly scientific approach. "Divisionism," he called it, carefully placing dot after dot of complementary pigments beside one another to create a complex and ravishing whole.

This was the extraordinary technique that he so assiduously applied to his huge painting A *Sunday on La Grande Jatte—1884*, doggedly applying his extensive study of color to the luminous scene that spread so seductively before him. Dot by dot, he was creating a masterpiece.

～

Dogged persistence had characterized the mammoth Statue of Liberty project as well, and by 1884 it was at last reaping its rewards. Lady Liberty was now completed, and on July 4, 1884, was officially presented to the American minister to France. By necessity, the ceremony took place at her feet, in the foundry yard where she was created. It was a momentous occasion, marred only by the absence of the very person whose guidance had brought this daring project to its culmination. Edouard de Laboulaye had died the year before, just as his monument to Liberty Enlightening the World was nearing completion.

In Laboulaye's place, Ferdinand de Lesseps (of Suez Canal fame) made the presentation. It was, after all, an astonishing gift, and the American minister, Levi P. Morton, was duly appreciative as he accepted the gift on behalf of his countrymen. With God's grace, he told the assembled dignitaries, it would remain a lasting symbol of the "imperishable sympathy and affection" between France and the United States. De Lesseps spoke in a similar vein, expressing his heartfelt hope "that it may remain forever the pledge of the bonds which should unite France and the great American nation."[14]

Following the presentation, Bartholdi led the assembled dignitaries up the staircase inside the statue before they all returned to ground level and a celebratory feast. There, an empty chair was symbolically reserved for Laboulaye.

But this was only the beginning of yet another segment in the statue's continuing saga. For with the celebrations on the French side of the ocean now over, the long job of documenting, disassembling, and packing the mammoth figure into shipping crates began. Lady Liberty was about to make her journey across the Atlantic to her new home.

~

That Genius, That Monster

(1885)

The biggest event of 1885, and possibly of the decade, was the death and funeral of Victor Hugo. The revered literary and political giant died on Friday, May 22, after a brief but dramatic illness, during which overeager journalists falsely claimed that he had made a deathbed conversion and called for a priest. But Hugo remained true to himself to the end, rejecting the Church but welcoming prayers from individuals everywhere.

In response to this seismic event, Parliament did what it could to honor Hugo and ensure that he would forever remain the Republic's emblematic hero. Hastily passing the necessary legislation, it decreed that his final burial place would be in the Panthéon itself.

It was a decision fraught with symbolism, given that the Church and its secular enemies had been battling over this particular edifice for almost a century. The building itself occupied a location that resonated with religious significance—the hilltop site of an ancient basilica and abbey dedicated to the patron saint of Paris, Sainte-Geneviève. For more than a thousand years, Sainte-Geneviève had received the appeals of Parisians, including royalty, and when Louis XV recovered from a serious illness after praying to her, he vowed to build a grand new church in her honor. The recovered king promptly forgot his vow, but Sainte-Geneviève's abbot kept after him. At long last, in 1764, the king laid the first stone for the new basilica, a grand edifice of monumental proportions designed to occupy the hill's peak.

It was a difficult undertaking, made even more daunting by the subsoil—riddled with ancient quarries—on which the architect, Jacques-Germain

Soufflot, had to build. Distraught over the discovery of cracks in the structure, Soufflot died before the building was completed, and it took ten more years before his associate could finish the job. By this time the Revolution had begun, and religion—as well as royalty—had fallen on hard times. Mobs of angry Parisians burned Sainte-Geneviève's remains and threw her ashes into the Seine, while the Revolutionaries suppressed the abbey of Sainte-Geneviève and tore down its church.

This hostile atmosphere was scarcely the time for the completion of a monumental new church. After promptly closing the new building, the Constituent Assembly decided to turn it into the nation's Panthéon, a secular last resting place and monument to France's great men. Up went the gold letters across the front pediment declaring "Aux grands hommes la patrie reconnaissante" ("To the great men, a grateful nation"). Up, as well, went allegorical figures symbolizing the nation handing out laurel crowns to its great men. Inside, the Revolutionaries removed all Christian references and walled up the huge windows, creating the somber atmosphere of a mausoleum and eliminating anything that might remind anyone of a church. Downstairs, in the crypt, they laid to rest the bodies of Mirabeau, Voltaire, Rousseau, and Marat (these heroes encountered posthumous political riptides and were in time evicted, with Voltaire and Rousseau eventually reinstated).

The Panthéon itself encountered political riptides of its own, as changing governments tossed it back and forth, from mausoleum to church and back again. The bold inscription "Aux grands hommes la patrie reconnaissante" was alternately put up or taken down, depending on who was in charge. Under Napoleon Bonaparte, the dead heroes remained downstairs while good Catholics worshiped upstairs, but after Napoleon's downfall and the restoration of the monarchy, the entire building was reconsecrated as a church. During the reign of Louis-Philippe and the subsequent Second Republic, the edifice once more served as a mausoleum, but under Napoleon III and the Second Empire it was reconsecrated as a church.

Temporarily, the structure served as a munitions store and headquarters for the Commune, but after the Communards were evicted and order restored, the conservative governments of Thiers and MacMahon turned it once again into a church. But now, with the monarchists out and the republicans in, there was an opportunity to rethink the whole business once again, reinstating the building's function as a Panthéon, a secular temple of fame and glory for the most illustrious of France's dead.

Victor Hugo provided the occasion for this final chapter in the Panthéon's story, although his selection had its ironies. Hugo had never liked the Panthéon, which he called "a wretched copy of St. Peter's in Rome" (Edouard Manet had a similar aversion, calling it "that wretched Panthéon").[1] Hugo

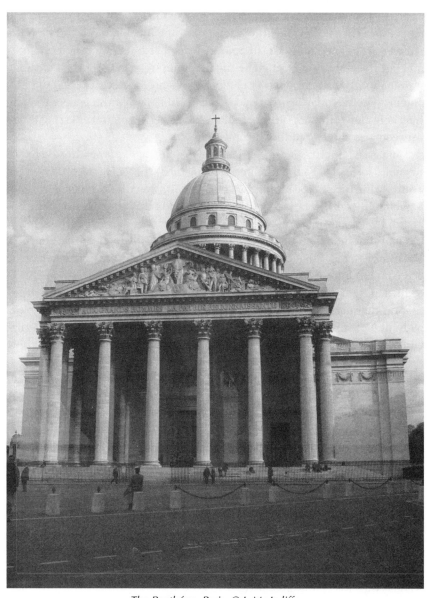

The Panthéon, Paris. © J. McAuliffe.

had anticipated burial in Père-Lachaise, and he requested that his casket be carried there in a pauper's hearse and be buried in a pauper's grave. It was not to be. Not since the interment of Napoleon Bonaparte in Les Invalides had Paris experienced such an extravaganza of a funeral. Coming as it did on the anniversary of Bloody Week, there were fears that it might prompt an uprising, but this did not happen. The night before, in an echo of the ceremony surrounding Bonaparte, Hugo's coffin lay in state beneath the Arc de Triomphe. The next day, surrounded by all possible pomp, the pauper's hearse that bore the coffin set off for the Panthéon, between crowds estimated at between one and two million people.

Dumas *fils* struck a sour note. "Had Hugo's writings . . . been hostile to the Republic instead of to the Empire," he remarked, "his poems would not have been a whit the less beautiful, but he, himself, would not have been given a public funeral." Zola (according to Goncourt) was equally disinclined to mourn Hugo's passing, and in fact seemed somewhat relieved by the event. "I thought that he was going to bury us all," he said. At which point, Goncourt acerbically noted, Zola "walked around the room . . . as if convinced that he was going to inherit the literary papacy."[2]

In a further biting commentary on the whole affair, Goncourt noted that on the night before the funeral, the prostitutes of Paris "were coupling with all and sundry on the lawns of the Champs-Elysées." But then again, Goncourt had little sympathy for the masses and had never found anything especially admirable about Victor Hugo. Hugo, in Goncourt's estimation, was a thoroughly distasteful human being, whom he once described as "that genius, that monster."[3]

What Goncourt had witnessed was Hugo's self-absorption and egocentrism, his complete obliviousness to the pain he inflicted on those who loved him. Yet as Goncourt himself recognized, Hugo was a complicated man. Much like the dramatic and emotion-fraught books he wrote, his later years had reflected a particularly Gothic stew of heights and depths, tragedy and triumph. While piling up mountains of honors, including election to the Senate, membership in the Académie Française, and worldwide literary and political acclaim, he had suffered the deaths of three of his children and the insanity of the fourth. And although praised to Olympian heights for his godlike character and contributions to society, he had constantly courted scandal with his epic womanizing.

Yet his public continued to adore him—especially the Parisians. Of course they were unaware of his personal failings, but it probably would not have mattered had they known. For he was *their* Victor Hugo. And his Paris, the Paris of Esmeralda and Jean Valjean, would live forever.

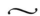

Shortly before his death, Hugo had written Frédéric Bartholdi: "To the sculptor, form is everything and nothing—nothing without the spirit, everything with the idea."[4]

Hugo had visited Lady Liberty (and Bartholdi) in late 1884, while she was being readied for her transatlantic journey. Even as the New York newspaper publisher Joseph Pulitzer was prodding reluctant Americans into contributing to the statue's pedestal (a less glamorous and far more disputatious task than funding the statue itself), the French were disassembling it and packing it into 214 numbered crates. It took a special train with seventy cars to transport these crates to Rouen, where they were slowly and carefully loaded onto a French naval ship, the *Isère*. Loading took almost three weeks, and the trip itself took almost a month, during which storms threatened to sink the boat and Lady Liberty with it. But in June 1885, she arrived safe and sound in New York Harbor, where she received a tumultuous welcome.

But she could not be unveiled, for the pedestal was not yet complete, and there was no place for her to stand. And so the heavy crates containing the disassembled statue were brought to Bedloe's Island for storage, while Bartholdi himself took another ship for New York, to consult with the American engineer in charge of the daunting job of reassembly. After a month, Bartholdi returned to Paris.

The rest of the job was up to the Americans.

As the gigantic (and wholly secular) symbol of Liberty was packed up and shipped to New York, the Blessed Sacrament was exposed for the first time in the Basilica of Sacré-Coeur, which now became a sanctuary for perpetual and uninterrupted prayer. This latter event might have offered more cheer to Paris's faithful had the budget for the Sorbonne's renowned Faculty of Theology not been abolished during these same months, leading to its closure.

The end of this renowned theological center was not unexpected, given the secularization of education in France that was already well begun. Still, it represented a breathtaking break with history—after all, the Sorbonne had been the official seat of the university's Faculty of Theology since the sixteenth century. (Before that, the Faculty of Theology was located at Notre-Dame.) By the seventeenth century, the Sorbonne had become an established power in theological circles. It had also outgrown its by now shabby facilities, and it was during these years that Cardinal Richelieu—Louis XIII's

powerful chief minister, who was also chancellor of the Sorbonne—replaced the Sorbonne's medieval structures with a far larger and grander arrangement. Its centerpiece was an impressive Baroque chapel that would eventually house Richelieu's own magnificent tomb.

Throughout the following century, the Sorbonne became a center of Gallicanism—that is, resistance to papal authority over the French Roman Catholic Church. This did not mean that its theologians became more liberal. Indeed, they did not adapt well to the increasingly secular and scientific world of the Enlightenment, and by the time of the Revolution, the Sorbonne's Faculty of Theology had earned a well-deserved reputation for flint-hard conservatism. This did not sit well with the Revolutionaries, who shut down the entire University of Paris, including the Sorbonne. They had only just begun to set up their own secular and scientifically oriented educational system when Napoleon Bonaparte came to power, bringing the university under his own imperial supervision. Bonaparte kicked out all references to the Enlightenment and restored the Faculty of Theology. But restoring the Faculty of Theology did not mean restoring the Sorbonne, which from 1801 to 1821 was occupied by a group of artists who had just been evicted from their longtime residence in the Louvre.

In 1821, the returning Bourbon monarchy evicted these painters and sculptors once again, and the Sorbonne now became the seat of the university's Faculties of Letters and Sciences as well as the Faculty of Theology. But the goal of the hidebound Bourbons was not simply to restore the Sorbonne, or even to expand its mission, but to bring the potentially wayward Faculties of Letters and Sciences under the influence of the Sorbonne's conservative Faculty of Theology.

Still, the liberal arts managed to survive within the Sorbonne, and the Faculty of Letters even displayed a spunky opposition to the Second Empire's efforts to reintroduce the Church into university affairs. The Second Empire, of course, did not survive the Franco-Prussian War, and by 1880 the Third Republic was in the hands of men who were determined to secularize education. There was, in fact, little opposition in either the Chamber or the Senate to the budgetary measure that pulled the plug on the Sorbonne's Faculty of Theology. Even the clerical right refused to come to the aid of this venerable institution, due to its long association with Gallicanism.

Not only was the Sorbonne's Faculty of Theology suppressed, but in what turned out to be a remarkably symbolic development, work now began on the Sorbonne's complete physical reconstruction. Appropriately, the first phase of this grand new enterprise—begun in 1885—was inaugurated in 1889, the centennial of the French Revolution. When the complex was finally com-

pleted in 1901, Richelieu's Sorbonne had vanished, with the sole exception of his secularized memorial chapel.

A republican and secular Sorbonne had at last emerged.

~

While Jules Ferry's government was taking aim at the Sorbonne's Faculty of Theology, Georges Clemenceau was taking equally determined aim at Ferry. Ferry wanted empire and was willing to pay for it, but Clemenceau didn't trust Ferry one inch. Demanding far more backbone from Parliament than it had hitherto shown, Clemenceau charged that it had lost control over the power to make war—all the while French troops were dying in Tonkin at the hands of a huge and well-armed foe.

Ferry continued to win votes of confidence, but by increasingly narrow margins. And then came the French defeat at Lang-Son. Although not at all on the same scale as the French devastating defeat at Sedan (in the Franco-Prussian War), as word first had it, it still was humiliating—especially in light of Ferry's repeated assurances concerning France's military strength in Tonkin, as well as lingering French sensitivities about the Franco-Prussian War. But Ferry refused to resign and instead chose to ask the Chamber for more funds to avenge the disaster. Clemenceau greeted this request with angry derision, accusing Ferry of high treason and demanding that he resign. Ferry was not brought to trial, as Clemenceau sought, but he was definitively defeated and booted out as prime minister.

Clemenceau had effectively appealed, if not to the deputies' sense of duty, then to their sense of political expediency. The war in Southeast Asia was unpopular with a growing number of French, and Clemenceau underlined the dangers of siding with Ferry during the coming elections. They must of course send reinforcements, Clemenceau told the Chamber. But it was a question of confidence in the current government. And with the Left and the Right united on this issue, where would the Opportunist center find sufficient votes?

It was a question that swirled around the autumn elections. French voters were dubious about Ferry's warnings that colonial expansion was an economic as well as a military necessity, essential for providing France with coaling stations for its navy and new markets in the face of increasing protectionism abroad. The economy was still shaky, and colonialism's opponents, from both the Left and the Right, countered that those who embraced colonialism were sacrificing the "gold and blood of France" on the altar of foreign expansionism. This, they charged, would leave France weakened by a drain of men and money in foreign adventures, and would allow Bismarck to become master of Europe.

Paris's urban population was especially irate over France's expansionist policies, which they blamed for their economic troubles, especially for the high cost of bread. Rural populations, along with the business community, were equally disenchanted with costly foreign wars. In the October elections, the radical republicans almost tripled their seats in the Chamber of Deputies, while the Right made a dramatic and unexpected comeback.

The Opportunists, or the moderate center, lost their majority, but neither the Right nor the Left had gained sufficient numbers to govern on their own. Coalition government would now be the rule, and Georges Clemenceau would benefit from this unstable situation. Excluded from government positions himself, thanks to his extremist reputation and attack-dog rhetoric, he nevertheless was about to become a significant power broker. And although he himself did not obtain a ministry, he won positions for several of his protégés, including one whose name would soon become notorious—General Georges Boulanger.

But Clemenceau was unable to bring about a French withdrawal from Tonkin. In June 1885, three months after Ferry's departure, France and China signed a treaty giving France trade access to the territory, from which China agreed to withdraw its army—in return for other concessions from France of more import to the Chinese. Late in 1885, months after Ferry had been forced to resign over the issue, the Chamber narrowly voted more funds for Tonkin, thus ensuring that France would remain. In the years that followed, France would successfully consolidate the entire area into colonial French Indochina, although deadly ambushes from the local guerrillas would continue until the end of the century.

∽

When the struggling young painter Rodolphe Salis opened Le Chat Noir in 1881, he had no idea that he was about to make history. After all, his nightspot was a scruffy place, located at the bottom of the Butte, at 84 Boulevard de Rochechouart (18th). Even in those days, this was not a good address, but Salis' collaborator, the poet Emile Goudeau, helped spread the word. Soon poets, musicians, and artists began to congregate there, in a décor that featured threadbare tapestries, stained glass, and a throne-like Louis XIII chair. Comfortably ensconced in this mock-medieval setting, the Chat Noir regulars readily discussed their work, gave readings, sang songs, and skewered the Establishment. It quickly became a kind of club, the headquarters for a talented avant-garde who enjoyed sharing ideas as well as drinks and bonhomie with one another. In this zesty atmosphere, modern cabaret was born.

Despite the cabaret's location in the heart of the Pigalle quarter and its poster image (created by Théophile Steinlen) of a lecherous-looking tomcat perched on a wall, this was not some sort of bordello experience. Le Chat Noir's clientele were looking for good times, to be sure, but their idea of a good time was a convivial (and well-lubricated) evening based on shared intellectual and cultural interests. Salis himself described the place as an "artistic cabaret," and many of Salis' regulars came from a Left Bank literary group, the Hydropathes, which Goudeau had earlier founded with the intent of making young writers and poets like himself better known through public readings in cafés. When Salis set up the Chat Noir cabaret, Goudeau simply moved his group to the new quarters.

The result was a happy combination of serious poetry and inspired flippancy, with both entertainment and publicity in mind. Le Chat Noir published its own literary newspaper, which Goudeau edited, and promoted the work of its contributors. Before long, the place was jammed with poets, painters, and musicians, including the composer Erik Satie, who briefly played the cabaret's piano, and Claude Debussy, who occasionally played as well. Other regulars included the poets Stéphane Mallarmé and Paul Verlaine.

In 1885, business was good enough that Salis could afford to move to larger quarters at a better address, at 12 Rue de Laval (now Rue Victor-Massé). He sold the old location to the rakish chansonnier Aristide Bruant, who opened his own cabaret there, calling it the Mirliton. Bruant, whom Toulouse-Lautrec immortalized in his wide-brimmed black hat and crimson scarf, specialized in social protest and the comedy of insult. He redecorated Salis' former space with old warming pans, chamber pots, and the Chat Noir's forgotten Louis XIII chair (which he irreverently suspended from the ceiling), and soon found his clientele among the bourgeoisie, out for some rough humor and a good time.

The Mirliton thrived, but the Chat Noir regulars found the atmosphere at their new location a bit stiff and formal for their liking, and they began to drift away. In response, Salis started up a pantomime shadow theater, which soon became wildly popular among the avant-garde. Henri Rivière, a young illustrator and designer, was the originator and producer of this simple but effective form of theater, which used zinc cutouts of backlit figures that appeared as silhouettes as they moved back and forth on runners positioned at different distances behind a white fabric screen. Caran d'Ache and several other artists, as well as a coterie of journalists and writers, joined Rivière in creating the many sketches and designing the figures, sets, and program covers. Together they created more than forty plays, often on Biblical, classical, and historical themes, with hundreds of cleverly designed silhouettes,

including those of current notables—such as an amusingly bear-like Zola[5] and Salis himself.

Of obvious artistic and literary merit, in addition to being good fun, this shadow theater continued to be a draw for more than a decade, until Salis' death. Look for any remains, and all you will find is a plaque on the wall telling passersby that this edifice, once the home of the famous cabaret Le Chat Noir, "was consecrated to the muses and to joy."

⌣

Young Debussy was by now in Rome, and he was anything but joyful about it. He had won the Prix de Rome, a singular honor that would elude many other worthies, including Maurice Ravel, but Debussy did not care a fig for his achievement. Although this much-coveted prize had brought him a lengthy sojourn at the Villa Médicis in Rome and represented a huge jump start to his musical career, he was unimpressed. He hated Rome, especially the Villa Médicis, and he was miserable.

The weather was terrible (too hot and steamy in summer, too cold and rainy in winter), and Debussy took an intense dislike to his teachers and colleagues. Underlying his whole attitude problem, of course, was the forcible separation from Madame Vasnier that the prize necessitated. But he was also frustrated by the uncomprehending traditionalism of those surrounding him. Debussy may have dissembled to a considerable degree to win the prize in the first place, by consciously composing an entry that would please his judges, but once in Rome he was not able to keep up the pretense. In any case, communicating with Madame Vasnier's husband, rather than with Madame herself (as propriety demanded), he regularly unloaded his irritation and resentment.

There were compensations, of course, including a memorable performance by Liszt, and other musical performances in Rome. But far more frequently, Debussy stormed about the obtuseness of the people around him and the time he was wasting. His first end-of-year composition drew from his examiners the criticism that "M. Debussy seems to be tormented these days by the desire to produce music that is bizarre, incomprehensible and unperformable." This, not unnaturally, prompted Debussy to complain that "the Institut . . . believes its own habits are the only ones that count. So much the worse for it! I'm too fond of my freedom and my own way of doing things."[6]

When it came down to it, venturing into the new and the unknown was a difficult proposition, and Debussy at times wondered whether he had the strength for what lay ahead. "There's no precedent to go on," he told Vasnier, "and I find myself compelled to invent new forms." Already he had

rejected the new directions that Wagner offered, noting that he wanted "to keep the tone lyrical without it being absorbed by the orchestra."[7] Worst of all, he feared that his time in Rome not only was a waste but had set him back. It was all that Vasnier could do to prevent Debussy from throwing in the towel and leaving at the end of his first year.

Perhaps oddly enough for such a pioneering spirit, Debussy found inspiration in the music of the sixteenth-century composers Palestrina and de Lassus. "I expect you think of counterpoint as the most forbidding article in the whole of music," he wrote Vasnier in late 1885. But in the hands of Palestrina and de Lassus, "it becomes something wonderful." These "are the only occasions," he added, "when my real musical self has given a slight stir."[8]

But Palestrina and de Lassus, although inspirational, were not enough. What Debussy truly longed for was the beautiful and seductive Madame Vasnier.

⟿

While Debussy was fighting boredom and despair in Rome, Claude Monet was fighting the ocean along the coast of Normandy. After quarreling with Durand-Ruel and exhibiting with a rival dealer, Georges Petit, he set off for Etretat, where he remained from October to December. "It's at its best now," he wrote Alice, "and I rage at my inability to express it all better." It was in the effort to express it better that, one day in late November, while stationed at the base of the monumental Manneporte, he became so absorbed in what he was doing that he didn't keep track of the tides. Mistakenly convinced that the tide was going out, he did not see a huge wave coming at him. His first thought, as the water dragged him down, was that he was "done for," but somehow he managed "to clamber out on all fours."[9]

No harm was done, he assured Alice, although he lost his painting, along with his easel, paints, and brushes. This made him furious, but he soon telegraphed his supplier to send him replacements. Despite his remote location, he anticipated that he would have another easel and everything else he needed by the next day (a fine example of the degree of service that denizens of the nineteenth century so casually expected).

Death had passed him by, but it had been a close call. "To think," he told Alice, who undoubtedly did not need to be reminded, "I might never have seen you again."[10]

These words would soon take on a new meaning, for in early 1886, while Monet was once again away painting, Ernest Hoschedé showed up in Giverny to demand that his wife and children return to him. There were furious arguments, in which the Hoschedé daughters took part. After all,

their mother's unconventional behavior was threatening their own future marriage prospects. Monet, removed from the fray in Etretat, was devastated by the prospect of losing Alice. Depressed and lonely, he told her that he was miserable and "haven't the heart to do anything; the painter in me is dead."[11]

His appeals must have found their mark, for despite this huge altercation and its threat of permanent separation, Alice remained with Monet.

~

Onward and Upward

(1886)

It may now have been Eiffel's tower, but there were other contenders for the thousand-foot behemoth at the upcoming Paris exposition. The most serious of the lot was Jules Bourdais, a prominent architect who, with Gabriel Davioud, had designed the Trocadéro Palace for the 1878 Paris exposition. Bourdais was a staunch proponent of stone, and his proposed tower was to be built entirely of granite, constructed like a huge wedding cake in five successively smaller tiers. Each layer was to be swathed with decorative sculptures and columns, with an enormous electric-powered beacon at the summit, capable of sweeping nighttime Paris with its powerful beam.

Eiffel, of course, was the proverbial "wizard of iron," who understood that metal better than anyone else on the planet. More than this, he firmly believed that the age of stone was over. According to Eiffel, the medieval cathedral builders had pushed their medium about as far as it could go. To build higher and larger, it would be necessary to rely on iron and steel.

When Bourdais called Eiffel's proposed tower "vulgar," Eiffel calmly responded with practicalities. A tower of this height could not be made of stone, he stated firmly, and certainly could not be built within the required time. After all, the Washington Monument, at half the size, had taken several decades to build. In addition, as Eiffel pointed out, Bourdais had not properly calculated wind resistance, nor had he planned any foundations for his stone monolith, whose base was to rest directly on the ground.

Fortunately, the committee making the final decision was not swayed either by Bourdais' arguments or his proposal, and in June 1886 it announced

that Eiffel's proposed tower had handily won the competition. Gustave Eiffel, master builder of some of the world's most remarkable bridges as well as the all-important internal framework of the Statue of Liberty, was going to build the highest and the most spectacular structure in the world.

It was an exciting prospect, and yet not everyone was pleased with this outcome—certainly not Charles Garnier, Eiffel's erstwhile collaborator, who was irate about the proposed tower and fully intended to put a stop to it.

◦

Reassembling the Statue of Liberty at its final destination turned out to be quite a feat in itself. With the pedestal at last completed in April 1886, workmen began to embed beams and tension bars into it and the statue's foundation, providing the anchor for Eiffel's enormous iron framework. By August, work began on the arduous process of attaching the molded copper sheets of *Liberty*'s exterior to her internal structure. This took several months, but by October 1886, Lady Liberty was virtually complete and ready for her dedication ceremony on October 28.

Bartholdi had of course returned to New York for the occasion, along with Ferdinand de Lesseps and other notables. One million people turned out for the grand parade to the waterfront, and although only two thousand guests could fit on the island itself, crowds of eager spectators swarmed onto small boats and lined the shore. Under threatening clouds, President Grover Cleveland expressed Americans' gratitude for this extraordinary symbol of liberty and friendship, promising that the United States would always treasure and care for it. Many others spoke as well, but Bartholdi was not among them, having declined the opportunity. He would leave the speechmaking to the politicians. But he had already expressed his feelings earlier that morning when he told the *New York Times* that his dream was now realized. "This thing will live to eternity when we shall have passed away," he added.[1]

The threat of rain shut down the festivities before their scheduled finale of fireworks, but on November 1, the sky over New York Harbor lit up in a grand display that wreathed the Statue of Liberty in glorious color—a forerunner of countless July 4 newspaper and postcard photos in the years to come. Lady Liberty, born in France, was now an honored resident of her new home.

◦

In early spring, a friend took Edmond de Goncourt to see Auguste Rodin, whom they found in his studio on the Boulevard de Vaugirard, in the heart of Montparnasse. Rodin showed them the life-size clay figures of his six

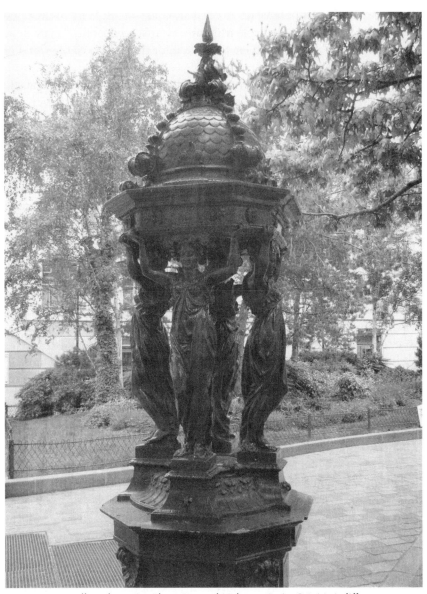

Wallace fountain, Place Bernard-Halpern, Paris. © J. McAuliffe.

burghers of Calais, along with a sketch of a nude woman. He is "a real artist in flesh," Goncourt observed, amplifying this conclusion after subsequently viewing Rodin's still-unfinished door, *The Gates of Hell*, in his Rue de l'Université studio near the Ecole Militaire. At first seeing only "a jumble, a mix-up, a tangle," Goncourt then was able to distinguish "a whole world of delightful little figures."[2]

Goncourt decided that Rodin was a creator of both poetic and realistic humanity. Noting some of the sculptures inspired by Rodin's affair with Camille Claudel (at this date, probably including *Eternal Spring* and *The Kiss*), he added that Rodin "also possesses in the highest degree an intuitive knowledge of the embraces and intertwinings of two loving bodies." One group [*I Am Beautiful*, according to Goncourt's description] "represents the idea of physical love, but without the translation of that idea being at all obscene."[3]

Goncourt saw the hand of genius here—but he feared that Rodin's mind was a clutter of Dante, Michelangelo, Hugo, and Delacroix. Indeed, Rodin struck him as a man of "a thousand ideas, a thousand creations, a thousand dreams," but also, unfortunately, a man unable to bring anything to conclusion.[4] At this point in his career, Rodin might have agreed. He seemed unable to finish his colossal *Gates of Hell*, and his *Burghers of Calais* was causing him no end of trouble. According to Goncourt, Rodin did not know whether he was going to be paid for the *Burghers of Calais*, and yet the work was so close to completion that he had to finish it, despite the cost.

Showing the "gentle, stubborn obstinacy" that Goncourt had noted,[5] Rodin simply pressed on.

⌐⌐

In 1883, the art dealer Durand-Ruel had continued to organize Impressionist exhibitions on his own, including a one-artist show featuring Monet. This was not a success, and Monet was bitter about it. Worse than being reviled, he had been ignored. Since Monet was convinced of his own worth, he therefore concluded that the low attendance was no reflection on him but on Durand-Ruel's failure to advertise the exhibition properly. Yet a year later, in early 1884, a retrospective exhibition of Manet's work, organized by Manet's brothers and Berthe Morisot, similarly flopped. With few real bidders, Manet's relatives and close friends had closed ranks to keep the prices from falling to unacceptably low levels. Instead of providing a posthumous acclamation of the recently deceased artist, the sale had been a failure.

Of course the economy remained dismal,[6] which made life all the more difficult for avant-garde artists. "Times are bad, that is certain," Berthe Morisot wrote her sister Edma, soon after the Manet auction. Two years later, the situation still had not improved. "Things must be very bad," Pissarro wrote

his son in early 1886, in a commentary on the art market. "Everything is at a standstill."[7]

Once again the Impressionists rallied, determined to hold yet another exhibition. This time Berthe Morisot played an active role in trying to bring the original group back together but acknowledged to her sister that this was difficult, due to "Degas' perversity" as well as various "conflicts of vanity."[8] Monet remained somewhat removed, partly because of his physical distance from Paris but also because of his 1885 exhibit with Georges Petit, which had widened the divide between him and his Impressionist colleagues as well as between him and Durand-Ruel. But in the autumn of 1885, Monet wrote Pissarro seeking to renew ties.

Pissarro replied with a proposition. He and Monet, plus Degas, Caillebotte, Guillaumin, Morisot, Cassatt, and "two or three others" would provide an excellent basis for an exhibition.[9] The "two or three others" included Seurat, Signac, and Redon—a new and younger generation of the avantgarde soon to be dubbed "Neo-Impressionists"— whom Pissarro was careful not to name, anticipating that Monet might not be pleased to find himself in their company. Back in the 1870s, Pissarro had nurtured Cézanne, who later mused, "We are all perhaps derived from Pissarro."[10] Pissarro had also taken the young stockbroker Paul Gauguin under his wing when Gauguin moved from collecting Impressionist art to making his own first stabs at painting.[11] Now Pissarro was nurturing a new wave of young painters—including his own son, Lucien.

"No one was kinder than Pissarro," the poet George Moore later wrote.[12] But even with Pissarro's careful diplomacy, Monet held back, as did Renoir, Sisley, and Caillebotte. Degas, as usual, was insisting that anyone exhibiting with the Impressionists could exhibit nowhere (and with no one) else, and by this time Monet was branching out and showing at the fashionable gallery of Georges Petit—a palatial hall that Zola snidely referred to as "the department store of painting."[13]

The Impressionists' eighth and last group exhibition took place in May and June of 1886, the core Impressionists in the show being Degas, Morisot, Cassatt, and Pissarro—with Pissarro now employing Seurat's pointillist technique. ("We no longer understand one another," Pissarro commented about his Impressionist colleagues, whom he now referred to as "the romantic impressionists." As for himself, he insisted "on the right to go my own way.")[14] Gauguin once again was included, and Pissarro obtained entry for Signac and Seurat. It was at this eighth and last Impressionist exhibition that Seurat's *Sunday Afternoon on the Grande Jatte* made its first appearance.

The painting aroused controversy from the outset. Eugène Manet didn't like it and got into a major argument with Pissarro about it. Degas finally

tipped the balance, damning with faint praise but allowing it into the exhibition, where it was shown in a separate room (Pissarro's latest works ended up here as well). The exhibition was poorly attended, and at first *La Grand Jatte* was ignored or treated derisively. Yet several young writers were enthralled, and the literary journals soon took note. Word began to spread about this huge painting, whose static and flat figures conveyed a stillness and an almost pagan quality completely unlike Impressionism. From London, where news of the painting had spread, George Moore wrote that it "looks like a modernized version of ancient Egypt."[15]

Not coincidentally, the young writers who championed Seurat were also championing a new form of literature, one that was moving from the Naturalism of Goncourt and Zola toward Symbolism. Paris's intellectual and cultural climate was in flux, and newly perceived forms of reality—subjective and transformative, rather than objective and imitative—were already pointing toward the fin de siècle and the coming century.

~

As if there already were not enough tension in the artistic community in early 1886, Zola added still more by publishing *L'oeuvre* (*The Masterpiece*), a novel about the struggling painters who surrounded him in his youth in Provence and Paris. In fact, *L'oeuvre* (another in Zola's lengthening Rougon-Macquart series) is transparently autobiographical, which—as Goncourt was quick to point out—may be its chief weakness. The young novelist in the story, a hard-working writer by the name of Sandoz, is engaged in writing a vast series of historical novels, not unlike the Rougon-Macquart. Zola treats Sandoz with kid gloves and grants him success but is less gentle with the artists who surround him—especially Claude Lantier, who is an artist possessed by a vision that he cannot attain. This unhappy character, whom Zola describes as an "incomplete genius," struggles with his own limitations as well as with the rejection he receives at the hands of the world around him. Clearly modeled on Zola's boyhood friend Cézanne, with some likeness to Manet as well, it represented, if not a cruel betrayal, at least a complete lack of appreciation for his best and oldest friend.

The book sent tremors through Paris's artistic community. Claude Monet, who had in years past benefited from Zola's support and never forgot it, thanked Zola for his complimentary copy and assured him of his admiration. Still, he wrote, the book left him "perplexed and somewhat anxious." In particular, he was concerned that the press and the general public will "bandy about the name of Manet, or at least our names, and equate them with failure." This was especially troubling because, as Monet reminded Zola, he and his fellow Impressionists had fought a long battle, "and my worry is that, just

as we reach our goal, this book will be used by our enemies to deal us a final blow."[16] In addition, although he did not mention it, Monet may have had some more personal reasons for anxiety: some of the most disturbing scenes involving Lantier bore an uncanny likeness to events in Monet's own life.

Cézanne's response was quieter—and more intense. A certain distancing had emerged between him and Zola in recent years, even though the two continued to correspond warmly and Cézanne frequently visited Zola at his country house in Médan. Yet Zola had noticeably failed to write on behalf of Cézanne as he had for Manet, and in general Zola had been reticent in his praise. Indeed, beneath the camaraderie, Zola had come to regard his admittedly difficult and disreputable-looking friend as a failure as well as something of an embarrassment. Cézanne, the son of a well-to-do banker, had rejected his milieu for a far simpler and more bohemian life—one that had little in common with Zola's increasing grandiosity and preoccupation with success. During Cézanne's last visit, around the time that Zola was writing *L'oeuvre*, the painter felt especially out of place among the servants and the luxury.

Still, *L'oeuvre* seems to have come as a shock to Cézanne. Its main character, Claude Lantier, is brilliant but a troubled failure, and his obvious resemblance to Cézanne showed what Zola really thought of his closest friend. Yet according to Zola, *L'oeuvre*'s ultimate target was far broader than one artist. As the novelist explained (at a dinner party given in honor of *L'oeuvre*'s publication), the book's main thesis was that "no painter working in the modern movement had achieved a result equivalent to that which had been achieved by at least three or four writers working in the same movement, inspired by the same ideas, animated by the same estheticism." When someone among the shocked and by now angry diners proposed Degas as such a man, Zola disparagingly replied that he could not accept someone "who shuts himself up all his life to draw a ballet-girl as ranking co-equal in dignity and power with Flaubert, Daudet, or Goncourt."[17]

L'oeuvre, and Zola's defense of it, thus managed to offend virtually all of Zola's painter friends, including Renoir and Pissarro as well as Degas (who was characteristically contemptuous) and Monet. But the most devastated of all was Cézanne, who replied politely but tersely to Zola in acknowledging receipt of the book and then withdrew from all contact with his former friend. This was the last letter that he ever wrote to Zola, and they never saw one another again.

⁓

It was in the midst of this ferment, in February 1886, that Vincent van Gogh arrived in Paris. At the age of thirty-three, he had already failed at several

careers, including art dealer, teacher, preacher, and theology student. But his family was filled with artists and art dealers, and van Gogh himself showed an interest in drawing. Upon the encouragement of his younger brother, Théo, he attended the Royal Academy of Art in Brussels and the Academy of Fine Arts in Antwerp. His paintings and drawings were beginning to attract attention, and it was now that Théo—who had done well as an art dealer—encouraged him to come to Paris. There, Vincent shared Théo's Montmartre quarters and briefly studied at the studio of Fernand Cormon.

Théo, who was the director of the Boussod, Valadon gallery on Boulevard Montmartre, introduced Vincent to works of the Impressionists, which Théo greatly admired. Théo would soon make his first trip to Giverny, where he purchased ten paintings and prominently displayed them in his gallery, and bought from other Impressionists as well, including Pissarro, for whom he was a lifesaver. Vincent himself was impressed by what he saw of the Impressionists: "Who will be to figure painting what Monet is to landscape?" he later wrote Théo from Arles.[18] Absorbing some of these influences, Vincent lightened his palette and loosened his brushwork. Yet it was not Monet and Renoir who had the greatest impact on him, but the younger painters—Toulouse-Lautrec and, especially, Seurat and Signac. Adopting pointillism, van Gogh experimented endlessly with the technique, while at the same time intensifying and brightening his colors.

Along with Symbolism, Japanese art and artifacts were now sweeping avant-garde Paris, and van Gogh fell in with the times, buying Japanese prints and arranging an exhibition of Japanese woodcuts at a Paris café. His intensive study of Japanese art contributed a stylized quality to his own work, which already had assimilated influences from the Impressionists and Post-Impressionists, en route to becoming entirely his own.

He would not actually meet Georges Seurat until 1888, shortly before leaving Paris. But he had already met Paul Gauguin, and the two would most memorably encounter one another again, in Arles.

～

Paris's writers and painters were not the only ones in the mid-1880s to feel the pull and tug between the new and the old—or the new and the newer. A certain amount of tension was beginning to emerge within the city's musical community as well, with the imposing figure of Camille Saint-Saëns standing firmly in the path of whatever threatened tradition.

A brilliant man and a Parisian from birth, Camille Saint-Saëns had been one of the most remarkable child prodigies of his—or any—era. He began piano lessons at the age of two and composed his first piano piece at the age of three. He learned to read and write at a dismayingly young age and then

proceeded to vanquish Latin by the age of seven. His first drawing-room recital, at age four, found him confidently playing Beethoven, while his first public concert (in the Salle Pleyel, no less) came at the age of ten.

His prodigious achievements continued through his years at the Paris Conservatory, where he wrote his first symphony. Franz Liszt became a friend and admirer, and Hector Berlioz, another friend and enthusiast, called him "one of the leading musicians of our time."[19] Disappointingly, Saint-Saëns failed on two occasions to win the Prix de Rome, but the first time it was because he was too young, and the second, because his head-spinning talents seem to have attracted professional jealousy.

One might expect some slowing down as he grew older, but as an adult, Saint-Saëns continued to dazzle. In addition to turning out symphonies, concertos, operas, chamber music, choral works, and compositions for the piano and the organ, he held down the demanding job of organist at the Church of the Madeleine, where he earned the reputation of being among the finest organ virtuosos of the time. With energy and brilliance to spare, he toured as a concert pianist, conducted, and studied geology, archaeology, botany, astronomy, and (no surprise for a musician) mathematics. Later in life he would continue to amaze by his scholarly knowledge of subjects ranging from literature and the theater to philosophy, acoustics, and ancient musical instruments. He wrote poetry and drama, mastered several languages, and by the time of the Franco-Prussian War, he was a veritable national treasure (and by 1881, one of the Academy's confirmed Immortals).

It was in the wake of the Commune, as Paris was trying to revive itself, that Saint-Saëns helped found the Société Nationale de Musique, with the goal of promoting young French composers—a goal that had a forward-sounding ring. But the vastly cultured Saint-Saëns had little patience with new ideas, at least musically speaking. As the organization's copresident, he shaped the direction of French music according to his own tastes, which were unquestionably traditional. Indeed, when Debussy's music became better known, Saint-Saëns would become a severe critic—warning his colleagues that "we must at all costs bar the door of the Institute against a man capable of such atrocities, fit to be placed beside Cubist paintings.'"[20]

Not that anyone, let alone the great Saint-Saëns, had yet heard of Debussy. But at least fate was about to deal the younger man an unexpected favor. Camille Saint-Saëns, who in 1886 debuted what would become one of his most beloved works, the *Carnival of the Animals*, ran into trouble that same year at the Société, where he was maneuvered out of his long-held leadership post. His main rival within the organization, the composer Vincent d'Indy, engineered the coup and succeeded in putting César Franck in his place (although d'Indy would hold the reins, as secretary). D'Indy was

an aristocrat and a royalist, but despite some notable right-wing proclivities managed to produce pupils such as Erik Satie, Arthur Honegger, and Darius Milhaud. And although he had little in common with Debussy, d'Indy would prove to be a reliable champion of music by young French composers, even when he didn't like what they wrote. Debussy was fortunate, for in this capacity d'Indy would become one of his first supporters.

But in 1886, Debussy did not yet know this. Early in the year, he had at last returned to Paris, having wangled a two-month leave from the Villa Médicis. Upon his return he found that he still detested the Villa, but what really bothered him was the distance between him and Madame Vasnier. In a letter to Claudius Popelin, whose son was one of Debussy's fellow students, Debussy wrote that "my wishes and ideas function only *through her* [Debussy's italics], and I'm not strong enough to break the habit." Popelin was the former lover and second husband of Goncourt's Princess Mathilde, and Debussy may have reasoned that this man of the world, who was also his friend's father, would be a good source of advice on the subject of mistresses. In any case, his letter continues a conversation that evidently began while he was in Paris. "I'm rather nervous of telling you this," he told Popelin, "as it's a long way from following your advice to try and turn this love into a steady friendship. It's mad, I know, but the madness stops me thinking."[21]

Eventually Debussy was able to find some solace while at the Villa Médicis, primarily from reading. Even before coming to Rome, he had read widely and gravitated toward the avant-garde Symbolists (among them, André Gide, Paul Valéry, and Mallarmé). He also read Rossetti, Swinburne, Baudelaire, and Poe and would later add Dickens, Dumas, Carlyle, Conrad, Nietzsche, and Schopenhauer to his extensive list. From the outset, Debussy looked for inspiration outside the world of music, and one of his guides was the bookseller Emile Baron, whose shop was located on the Rue de Rome near where Debussy's parents lived. In a letter to Baron, dated late in 1886, Debussy remarked that he found it odd that, although the most discerning part of the public was "right behind innovations in literature and the new forms introduced by the novelists," yet "when it comes to music, they want that to stay just as it was."[22]

This stick-in-the-mud traditionalism would remain Debussy's bête noire for much of the rest of his career—certainly during the early years. But right now, his main theme remained his ongoing discontent and despondency at the Villa Médicis.

⌇

César Ritz was a perfectionist. Whether it was insisting that his waiters wear white tie and apron or forbidding dust-collecting fabrics anywhere in his

hotels, he noticed—and micromanaged—every detail. It was exhausting, but fortunately his wife (whom he married when he was thirty-eight) was familiar with the hotel business and completely agreed with her husband's passionate commitment to perfection—and to success.

Of course, Ritz proceeded carefully in everything he did. It took him several years to commit to marrying Marie-Louise Beck, and although it seems to have taken him less time to decide on selecting Auguste Escoffier as his executive chef, he nevertheless was familiar with Escoffier's reputation when he hired him. It was a brilliant choice. Ritz had decided that superb cuisine was essential to a deluxe hotel, and in 1886, the memorable association between Ritz and Escoffier began.

Until Escoffier, haute cuisine in nineteenth-century France had been inspired by the celebrated chef Marie-Antoine Carême, who specialized in elaborate feasts famous for their richness, size, and astonishing appearance. This was not something that women enjoyed, but women of good reputation were not necessarily present—or at least were not listened to on the question of food. As Marie-Louise Ritz put it, "ladies were not supposed to possess palates any more than they were supposed to have legs."[23] But in a complete break with the past, Escoffier looked at deluxe restaurant meals from the woman's point of view. What woman would, or could, eat her way through such a mountain of indigestion-inducing cuisine? Lighter and simpler fare was the answer, and Escoffier began to offer it—at the same time that Ritz was making his hotel restaurants sufficiently proper and elegant that women of good reputation could safely accompany their male relations there.

Escoffier reduced the number of courses, developed the à la carte menu, introduced lighter sauces, and eliminated the most ostentatious of the food displays. He also simplified the menu and completely reorganized the professional kitchen, integrating it into a single unit. Women approved, and he approved of them, creating dishes for some of his most famous diners, including Sarah Bernhardt (Fraises Sarah Bernhardt) and the Australian singer Nellie Melba, who garnered two creations in her honor—Peach Melba and Melba Toast.

In its own way, Escoffier's shakeup of haute cuisine was as revolutionary as anything that Rodin, Seurat, Debussy, or even Gustave Eiffel was doing. And it undoubtedly had an impact on diners such as Zola, who was beginning to note with dismay his ever-expanding waistline.

Escoffier was looking for a certain kind of truth in cooking and was finding it by jettisoning the accumulation of display that had so long surrounded it. After all, as Stéphane Mallarmé is reputed to have said, "Food should look like food."[24]

~

Fat and Thin

(1887–1888)

Emile Zola was a large man, and he rapidly was getting larger. Known to friend and foe (but especially foe) as "The Bear," he had a certain bearlike, lumbering appearance that was becoming more pronounced with the years.

He had been, by his own admission, an unrepentant glutton, and once told Goncourt that food was "the only thing that matters; nothing else really exists for me."[1] And then, something happened. His forty-six-inch waistline became unbearable, and he suddenly felt that he was growing old. Old and fat. And so he went on a diet—a rather strange diet that involved drinking no liquid with meals. But it seemed to work for Zola. He lost thirty pounds in three months, and Goncourt reported that the fellow had changed so much that he did not even recognize him.

But that was not the only change that now came over Zola, for with his loss of weight came a new interest in women, especially younger women. Until then, he had regularly bored his friends with his praise for monogamy and faithfulness. "I am happy with my wife," he told them. "What more do I want?"[2] A great deal more, as it turned out. As the 1880s drew to a close, Zola was approaching fifty and feeling mortality closing in. It was now that he took note of his wife's beautiful young chambermaid, Jeanne Rozerot. Goncourt later faulted Madame Zola for employing such an attractive chambermaid, but by that time it was too late. Rozerot succumbed, and Zola promptly fell madly and giddily in love, installing her in a Paris apartment near his (on the Rue de Bruxelles, 9th) and showering her with gifts. He also gave her two children—a girl, Denise, and a boy, Jacques—thus ending any speculation about his own fertility.[3]

Shadow puppet of Emile Zola created by Henri Rivière (1864–1951) and Jules Depaquit (1872–1924) for the Théâtre du Chat Noir in 1894. Paris, Musée d'Orsay. Photo credit: Réunion des Musées Nationaux / Art Resource, NY. © 2010 Artists Rights Society (ARS), New York / ADAGP, Paris.

"Fat Zola pretended to be a chaste, austere moralist," Daudet's elder son, Léon, later wrote. "Thin Zola let himself go."[4] As a consequence, his domestic life became a standard joke in certain literary circles.

~

"Fat" and "thin" are of course relative terms, and "thin," as the late nineteenth century understood it, had nowhere near the same meaning as today. In contrast to the fulsome hourglass figures admired at the time, Sarah Bernhardt—whose portraits show a pleasingly slim and elegant woman—was considered to be thin to the point of skinny. She made fun of herself, on one occasion laughingly declining an umbrella by proclaiming, "Oh, I am so thin I cannot get wet! I pass between the drops."[5] But her detractors (of whom there were many) could be downright nasty about it. Cartoonists portrayed her as a scrawny-legged chicken, or as one acquaintance put it, a "little stick with the sponge on the top"[6]—the latter being a reference to her mop of curly red hair, which tended to frizz.

Berthe Morisot, despite her smoldering beauty, was also considered by some to be unpleasantly thin. Manet's 1873 painting of her, called *Repose*, shows an unquestionably beautiful woman reclining against a sofa, her skirts spread gracefully around her. To the twenty-first-century eye, this woman seems perfectly well padded, but a bevy of critics were quick to disparage what they called her matchstick-like arms, as well as the objectionable seductiveness of her pose.[7]

Of course, neither of the Manet brothers agreed with Morisot's critics, and Bernhardt's slenderness never seemed to bother her bevy of ardent admirers. The secret, as Bernhardt learned from a dear friend, was simply to accept and enjoy being herself. "You are original without trying to be so," a friend told her. Bernhardt's hair, her slimness, and the "natural harp" in her throat made her "a creature apart, which is a crime of high treason against all that is commonplace."[8]

Bernhardt responded characteristically, thanking her friend and profiting from her advice. "I armed myself for the struggle," she later wrote in her memoirs, making up her mind "not to weep over the base things that were said about me, and not to suffer any more injustices."[9]

Sarah Bernhardt would always be a fighter.

~

At the same time that Zola was falling head over heels in love, Edmond de Goncourt quite unexpectedly found himself in the midst of an autumnal love affair. Although there had been women in his life, he once noted that

he had never been seriously in love and therefore was under a disadvantage in attempting to describe it. And then, during the spring of 1887, a certain beautiful young woman in his circle unexpectedly reciprocated his interest, and before long he found himself tremulously on the brink of proposing marriage.

Yet he was sadly torn. On the one hand, he envisioned spending his last years surrounded by this beautiful young woman's affection. On the other hand, he remembered the devotion he had given to a life of literature, and his determination to use his fortune to found and endow a literary academy that would give recognition to the best authors of contemporary literature. This academy was no light dream for Goncourt, conceived as it was as a memorial to his brother and as a way to perpetuate the Goncourt name. There was also the sensitive matter of the official and tradition-bound Académie Française, whose rarified company Goncourt had long before given up hope of joining. *His* academy would recognize and reward the creators of modern literature that the Académie Française persisted in overlooking.

Why Goncourt believed his lady love would divert him from his literary commitment is not entirely clear. Of course he may have been rightfully concerned about her getting her delicate hands on his considerable fortune. But perhaps his dithering was simply an excuse to evade the state of marriage, which he had successfully avoided all his life. In any case, he was fierce about his commitments, as he saw them. "I must carry on to the bitter end," he wrote in April 1887. "I must keep the promise I made to my brother, I must found that Academy we thought of together." And then, in May, he wrote, "I really must have a strong will not to send my Academy packing!"[10]

He set to work convincing himself of his beloved's unsuitability, noting that her mind was "rather babyish" and her attraction "purely sensual." Worse yet, he occasionally caught glimpses of the woman she would become once her beauty faded. And then there was always the question of why such a lovely young thing would be interested in an old codger like himself. It was at moments like these that Goncourt thought he could perceive in her blue eyes the "iron determination" of a woman out to get a husband.[11]

Not put off, she came to visit. Distraught at his own vulnerability, Goncourt did not even dare to descend and greet her. Instead, he shut himself up in his room and sent a message that he had left the day before and not returned. It did not take much more of this sort of behavior to convince the young woman to look elsewhere. In great relief, Goncourt indulged in some gentle self-recrimination, but reassured himself that it was all for the best. After all, it would not be kind for someone of his age and delicate health to take a young wife. And of course, he owed it to the future of his academy.

Simultaneously with Goncourt's dramatic renunciation of late-blooming love came a literary event, his first *Journal* publication. Originally, he had decided that nothing from his journals would appear in print until twenty years after his death, and had even kept their existence a secret. But in a weak moment he shared his secret with Daudet, who encouraged him to publish. Goncourt then decided to go ahead and issue the earliest entries, those written with Jules all those years before. Extracts from the first volume (shorn of those portions that might cause undue indignation or even litigation) appeared in *Le Figaro* in late 1886 and stirred little comment except for a complaint from Princess Mathilde, who was disturbed to find anything in it that was not of the heroic mold. More disturbing was the reception to the first volume's publication, in the spring of 1887. *Le Figaro* attacked it for its egocentricity, while the Academician, philosopher, and critic Hippolyte Taine became alarmed at what the next volume might bring and wrote Goncourt begging him not to quote him on anything whatever.

"Oh, what a rabbit, what a coward, what a poltroon that fellow Taine is!" Goncourt exclaimed, making sure to include the most damaging portions of Taine's letter for future publication.[12] Yet as annoying as Taine's response was, it was better than the general disinterest that greeted publication of the *Journal*'s first volume. Goncourt resolved to expect better from future *Journal* publications, but neither the second volume (October 1887) nor the third (spring 1888) brought much in the way of sales or praise. Like so much of his literary career to date, they were yet another disappointment.

While Goncourt was suffering painful reverses in literature and love, Debussy continued to suffer from boredom and rejection at the Villa Médicis. In early 1887, he was hard at work on an orchestral piece "of special colour" that he was calling *Printemps*. This was not program music, he emphasized to his bookseller correspondent, Emile Baron: "I have nothing but contempt for music organized according to one of those leaflets they're so careful to provide you with as you come into the concert hall." Instead, Debussy "wanted to express the slow, laborious birth of beings and things in nature, then the mounting florescence and finally a burst of joy at being reborn to a new life."[13]

Unfortunately, his composition met with a chilly reception, including a warning against "this vague impressionism which is one of the most dangerous enemies of truth in the world of art."[14] This appears to be the earliest recorded use of the term "impressionism" in association with Debussy's music, a term that Debussy would in fact reject. Indeed, Debussy attributed his inspiration for *Printemps* to Botticelli's *Primavera*.

But Debussy's disgust went far deeper than a disagreement over descriptive terminology. In March 1887, he left the Villa Médicis for good. He had completed the required two years and was not about to stay for the expected third year. "Ever since I've been here I feel dead inside," he wrote Vasnier, begging him not to be too hard on him. "Your friendship's the only thing I'll have left."[15]

Despite these fervent assurances, Debussy lost interest in the Vasniers within a few months after returning to Paris. He continued for a while to come to their home for meals, advice, and loans, and his affair with Madame Vasnier may have sporadically continued during this time. One of the Vasniers' friends in fact retained a vivid memory of Debussy climbing a rope ladder to Madame's room during a family holiday that summer in Dieppe. But with Debussy's attention increasingly taken elsewhere, his affair with Madame Vasnier (and his somewhat puzzling friendship with her husband) finally ceased.

~

Berthe Morisot's circle of friends, as well as her career, was growing. In early 1887 she showed five paintings in an avant-garde salon in Brussels, followed by participation in a well-publicized exhibition with Georges Petit, where her works were displayed along with those by Monet, Renoir, Pissarro, Sisley, Rodin, and Whistler.

She sold nothing, but there were consolations. By this time she had established firm friendships with Monet, Renoir, and Degas—even though Degas himself was rarely on speaking terms with either Monet or Renoir. In so doing, she was reaching well outside her prescribed social group among the *haute bourgeoisie* to include members of the distinctly middle class (Monet) and even working class (Renoir), both of whom were especially welcome guests in her home—although Renoir did not dare introduce his longtime mistress to the Manets until 1890, after they wed. Julie was a favorite with Renoir, and in 1887 Berthe and Eugène asked Renoir to paint Julie's portrait.

Monet probably had the widest circle of friends in the group, ranging from Clemenceau, Zola, Morisot, and Rodin to James McNeill Whistler and John Singer Sargent. Before the 1887 Georges Petit exhibition, Morisot prevailed upon Monet to ask Rodin to advise her on a bust of Julie that she wanted to exhibit. She and Eugène visited Giverny, and by 1889, after many years of growing friendship, she at last felt free to write Monet and ask, "My dear Monet, may I drop the 'dear Sir,' and treat you as a friend?"[16]

The poet Stéphane Mallarmé was another close friend of the Morisot-Manet family, and during the summer of 1887, Berthe, Eugène, and Julie vacationed with the Mallarmé family in Valvins, just outside of Paris. They

would spend many other pleasant hours with him, and in time Morisot would appoint him, Degas, and Renoir as joint guardians of Julie. But her own death was far from her mind as she painted Julie, gave her lessons, and took her on strolls through Paris and—on one occasion—Amsterdam. "Although she likes painting," Morisot noted of Julie, who was seven years old at the time of the Amsterdam trip, "museums bore her; she keeps tugging at me all the time to get it over with as soon as possible, and to be taken for a walk in the country."[17]

Morisot also entertained an ever-widening circle of friends that now included a number of prominent musicians, writers, and artists. She enjoyed these regular dinners, but they were especially useful in amusing Eugène, who by the winter of 1887–1888 had become ill. In addition to her other obligations, Morisot now had a semi-invalid to care for. No, she sadly wrote Mallarmé, they would be unable to join them in Valvins again during the summer of 1888. "We make this decision after much thought," she told him, "having many reasons that are as sensible as they are dreary for remaining in Paris."[18]

～

Despite dinner parties, concerts, café life, and illicit love affairs, which continued much as usual, life was filled with uncertainty for all classes of Parisians in the late 1880s. With Jules Ferry's fall from office, France entered an unsettling era of ministerial instability, intensified by a continued weak economy and the social unrest that accompanied it. Strikes were erupting, most notably in the southwestern portion of the Massif Central, where the coal miners of Decazeville had captured national attention. Soon after this brutal strike erupted, Louise Michel—who had been freed from prison in 1885 after the death of her mother—was arrested once again after she spoke at a Paris public meeting on behalf of the striking miners. Her fellow speakers were released after appealing the court's decision, but Michel refused to appeal her four-month sentence. Embarrassed by her defiant position, the government at length simply pardoned and released her. But the social and economic turbulence continued, as did Michel's ringing speeches on behalf of the suffering poor.

"Do you take part in every demonstration that occurs?" the prosecutor had asked at her 1883 trial. Her reply still held true: "Unfortunately, yes," she had answered. "I am always on the side of the wretched!"[19]

～

Once again Zola successfully mirrored his times, having published *Germinal*—his great novel about striking miners—in 1885, when strikes were be-

ginning to break out in Belgium and northern France. Ostensibly *Germinal*, like the rest of Zola's Rougon-Macquart series, takes place during the Second Empire, with the instigator of the novel's great revolt being the son of *L'assommoir*'s wretched Gervaise Lantier. But despite Zola's intent, *Germinal* more accurately reflected the turmoil and upheaval of the Third Republic of the late 1880s. Revolutionary ideas were percolating throughout French society, from intellectuals to workers, and indeed, *Germinal*'s Etienne Lantier—a destitute workman from the slums of Montmartre—educates himself by reading the literature of class struggle, including Marx.

Germinal not only sold well (reviving Zola's waning book sales following *Nana*) but also established Zola as a leading spokesperson for the downtrodden. Indeed, his prescient depiction of the stuff of future headlines gave fodder to friend and foe alike, who claimed that *Germinal* was responsible for the rash of strikes that was sweeping France.

Of course, the rising threat of strikes and insurrection did more than buoy *Germinal*'s sales. As frequently happens during times of crisis, a hero—or supposed hero—emerges. France's hero of the moment was a military man, General Georges Boulanger, who began his dizzying rise by captivating Clemenceau into securing for him the position of minister for war. Clemenceau and his fellow radical republicans were persuaded that Boulanger was a man of their own left-wing political persuasions who could be depended upon to attack royalist influence in the army. What Boulanger in fact turned out to be was an incipient despot with the theatrical know-how to appeal to the widest possible spectrum, from monarchists to the mob.

Even before Boulanger emerged, one perceptive visitor to Paris had noted that the Republic seemed to be "at the end of its tether" and gloomily predicted that "next year we shall have revolutionary excesses and then a violent reaction," with the eventual emergence of "some kind of dictatorship."[20] But few at first perceived that Boulanger might be the personification of this threat. Indeed, Boulanger's army reforms, which had a democratic tilt, pleased a wide swath of public opinion, while his strong anti-German leanings appealed mightily to simmering French nationalism and France's desire for revenge.

Despite Boulanger's undeniable appeal, the French moderate and right-wing republicans grew alarmed over his anti-German initiatives, including a proposed ultimatum that they feared might push Bismarck into a preventive war. Although still divided on the question of religion and laicization, moderates and conservatives drew together to oust the current government, including Boulanger, from power. Unfortunately this move, although successful in depriving Boulanger of his governmental position, only fanned the flames of his popularity higher. In a May 1887 Parisian by-election, more

than thirty-eight thousand voters added Boulanger's name to their voting slips, while in July, huge crowds of Boulanger's supporters—drawn heavily from the working class—turned up to prevent his departure from Paris on military assignment.

At this point, Clemenceau suddenly saw the dangers of a military man who was too popular. "This popularity," he told the Chamber, "has come too fast for someone who likes noise too much, or, to be more just, who does not elude it enough."[21] But events continued to unfold in Boulanger's favor. The president's son-in-law was caught purchasing favors in return for Legion of Honor decorations. Responding to the scandal, Clemenceau brought down yet another government, but the extent of the corruption badly undercut the Republic's foundations. Right and Left—royalists and radicals, Bonapartists and former Communards—now joined with fervid nationalists of all stripes (including a large number of the working class who were dead set against the influx of foreign workers) to promote Boulanger and destroy what they viewed as a corrupt and opportunistic Republic. What Boulanger truly thought, no one really knew, but all parties were willing to take a chance on this man of the moment, who in turn seemed delighted with the support of anyone who came his way.

In the spring of 1888, the government at last used Boulanger's political activities as grounds to dismiss him from the army. This in turn made him eligible to run for Parliament. Winning a seat in the Chamber of Deputies (using an American-style campaign, complete with gimcracks bearing the likeness of "the brave general"), he wasted no time in calling for dissolution of the Assembly and a revision of the constitution. The idea was to provide for a new Constituent Assembly—a plan that the general's supporters quietly hoped would increase their portion of the political spoils. Virtually none but royalists supported the motion, which was handily defeated.

By this time tempers were getting hot in the Chamber, and after clashing with the prime minister, Charles Floquet—who accused Boulanger of wanting to be another Bonaparte—Boulanger met Floquet on the field of battle in what looked like a complete mismatch. Unexpectedly, the sixty-year-old Floquet managed his end of the duel well, wounding the general in the neck. Fortunately for Boulanger, the wound was not fatal, and soon he was back in action.

But now, with by-elections coming up in early 1889, Boulanger had another goal in mind—winning an electoral victory in Paris. It was a difficult time for those who feared what was coming, and Puvis de Chavannes, writing to Berthe Morisot (who was in Nice for Eugène's health), described Paris that winter as "restless and toss[ing] about like a sick man." Renoir, too, was disturbed by the prospects. His eyes were giving him trouble, he told Morisot,

but "we shall talk about General Boulanger when I can write without tears falling on my paper."[22]

〜

While General Boulanger was doing his best to undermine the Republic, work was beginning on the extraordinary structure that was intended to become the star of the 1889 Paris World Exposition—Gustave Eiffel's tower.

In January 1887, work on Eiffel's tower began, first by going downward—an essential step that Bourdais, with all his refined asceticism, had overlooked. Since two of the tower's four feet stood on unstable land near the Seine, Eiffel probed fifty feet downward until he reached solid clay. He then sent huge sealed and electrically lit caissons seventy feet downward, well below water level, with workers breathing compressed air as they excavated (a system that he had successfully tested while building bridges). When all the enormous foundation blocks were in place and the equally huge anchoring bolts were inserted, Eiffel was ready to go up. This first essential step had taken him little more than five months.

But soon after work began on the tower, a wave of opposition emerged. Eiffel's tower was about to go up on the Champ de Mars, where it would visually dominate Paris. A number of Paris's leading citizens, including Charles Garnier, were appalled at the idea of this "monstrosity" blighting their view. A Committee of Three Hundred quickly formed (one member for each meter of the tower's height), whose roster included some of the most celebrated artists, musicians, and writers in Paris. Led by Garnier, the Committee shot off a "Protestation des Artistes" to the exhibition's commissioner. As "enthusiastic lovers of beauty," they wished to warn him in the strongest possible terms against erecting this "useless and monstrous Eiffel Tower." Such an eyesore, they predicted, would dishonor and devastate Paris, dominating it like a "gigantic black factory chimney."[23]

Garnier and Eiffel had worked together in apparent harmony on the huge observatory in Nice, which had been successfully completed the year before. Eiffel had of course used sheet iron for his part of the project, but although Garnier was perfectly willing to accept iron as a structural element, he was not willing to accept it as an artistic component in its own right. Like Jules Bourdais (Eiffel's rival in the competition to build the tower), Garnier was unquestionably traditional and favored stone as the perfect building material. In addition, both he and Bourdais were architects, and they regarded an engineer like Eiffel as a "mere" technician, incapable of creating works of beauty. But ultimately, it may have been Garnier's realization that Eiffel's tower would become the highlight of the exposition that most fueled his resentment. What seems to have especially galled Garnier was the probability that this

tower would eclipse his own contribution—an interesting but comparatively unspectacular row of more than thirty buildings, from cave dwellings to a Persian mansion, illustrating the history of habitation. (Garnier was right. His "History of Habitation" was razed at the exposition's end, and virtually no one today remembers it.)

Eiffel's response to Garnier and the Committee was dignified but firm. Of course engineers have taste, he replied. Of course engineers appreciate beauty. Conversely, the aesthetic predilections of writers and artists are not infallible. Indeed, Eiffel firmly believed in the beauty of the laws of nature with which engineers work and the harmony of design that results from abiding by and respecting these laws. Did these writers and artists think that only richly decorated stone structures could embody beauty? He—and his much-maligned tower—would show them otherwise. And then he set about to prove it.

By July 1887, Eiffel's tower actually began to rise—a step for which he and his nearby Levallois-Perret firm were well prepared. As with his previous projects, Eiffel first had drawings made of each of the tower's component parts, with the impact of gravity and wind on these parts precisely calculated. Then he had each one of these parts individually produced under his workshop's controlled conditions, including carefully drilled rivet holes, drilled to a tenth of a millimeter. These in turn were preassembled in manageable sections. At Eiffel's insistence, no drilling or adaptation was allowed on-site; if a part was defective, it was sent back to the workshop. In all, some eighteen thousand prefabricated sections were eventually delivered to the tower site, forming a sort of gigantic and perfect erector set—the classic children's toy that in fact was eventually created based on Eiffel's famed methods.

Yet as Eiffel's tower went up, the criticism continued. Fearmongers predicted that the structure would inevitably collapse. After all, no one had ever attempted anything quite like this before, even if some of Eiffel's bridges had been equally daring. But if many people were uncomfortable with Eiffel's design and especially with his chosen material, Eiffel certainly was not. In fact he had, after much consideration, deliberately chosen iron rather than lighter-weight steel for this enormous structure. His decision was based in part on steel's costliness but also, and more importantly, on its greater elasticity, or "give," under high winds—an elasticity that Eiffel believed would be excessive for weather conditions on the Champ de Mars. As for the structure's weight, Eiffel's tower would prove to be surprisingly light. Its latticework design and attention to distributed weight-load (per square centimeter it amounts to something like the weight of a man sitting in a chair) make its 7,300 tons, if not exactly feather light, certainly an amazing achievement. Well-grounded, light on its feet, and perfectly calibrated for wind tolerance

and all other forms of stress and strain, this tower was not about to collapse or tip over, as its detractors warned.

Then what about the cost? The City of Paris and the French government had anted up only 1,500,000 francs, which barely covered a quarter of the projected construction costs. In response, Eiffel had set up a company to distribute shares, half of which he retained in his own name and paid for out of his personal funds. It was an enormous risk, and the City of Paris and the French government figured that Eiffel was headed for a major loss.

But even riskier was another huge endeavor, the Panama Canal project, which was about to encompass Eiffel, even as his tower was heading skyward.

By 1884, the Panama Canal venture that had begun so promisingly was running into trouble. Death (primarily yellow fever) stalked everyone on the site, including a rapid succession of directors of works. The main contracting company, which had built its reputation with the Suez Canal, wanted to get out. This left construction in the hands of a plethora of individual companies, with the not-unexpected result of inefficiency, duplication, and complete lack of coordination. In addition, there were torrential rains and a challenging terrain to contend with, leading to one disaster after another. Waste and mismanagement were rife, and funds were running out. In response, de Lesseps maneuvered to get another government-sponsored bond lottery. The government reluctantly granted its authorization (the project had already eaten up 615 million francs), but only on the condition that locks be used, as Gustave Eiffel had originally advised. Instead of a sea-level waterway, the new plan would be for a canal with locks—at triple the original estimated cost.

And so in late 1887, as the four great piers of Eiffel's tower were dramatically rising to meet at the first platform, de Lesseps sent several financiers to Eiffel to ask him to step in and rescue the Panama project. Eiffel agreed, "in the national interest," to construct ten huge hydraulically operated locks, each capable of accommodating the largest ships then in use. By now Eiffel was a recognized giant in his field, but at fifteen times the cost of his tower, this was the largest and riskiest project he had ever undertaken.

Early in 1888, as the Boulanger crisis was heating up and Gustave Eiffel had embarked on saving the Panama Canal, Vincent van Gogh left Paris for Arles, in Provence. He was exhausted by his two years in Paris, having painted more than two hundred pictures and participated in the city's vigorous artistic life. That autumn, in response to repeated invitations, Paul Gauguin

came to join him in Arles—in the barely furnished Yellow House, which van Gogh had decorated with paintings of sunflowers.

Unfortunately, this experiment in joint living and painting, begun with such eager hope and expectation, did not go well. To begin with, all the hope and expectation lay with Vincent. Gauguin had not wanted to come and only agreed to the plan after Théo van Gogh, who had been financially supporting Gauguin as well as Vincent, insisted that Gauguin join Vincent in Arles. Once there, the two artists split up the household duties readily enough, but—not surprisingly for artists of their intensity—quarreled repeatedly about art. In mid-December, Gauguin wrote Théo that "Vincent and I simply cannot live together without trouble, due to the incompatibility of our temperaments." Vincent, too, noted that their discussions of paintings left "our heads as exhausted as a used electric battery."[24]

In addition to stress from this increasingly unworkable living arrangement, Vincent had recently received word of Théo's plans to marry. "It seems quite possible," writes art historian John Rewald, "that Vincent—always extremely possessive in his affections—feared that he might thus lose some of his brother's solicitude, since Théo would soon have a family of his own."[25] Whether or not this particular piece of news contributed to Vincent's mental instability, the situation as a whole was undeniably volcanic, with an eruption imminent. The end came when, in late December, van Gogh took that infamous razor to his ear, prompting Gauguin to take to his heels.

Several years afterward, Gauguin recalled in his memoirs that he had left for a walk and heard Vincent's footsteps behind him. Turning, he saw Vincent coming after him with an open razor. Gauguin stared Vincent into backing off and then spent the night in a hotel, only to learn the next morning that Vincent had returned to the Yellow House, where he had cut off his ear (how much of the ear is subject to debate). Gauguin then telegraphed Théo and returned to Paris. But immediately after he returned to Paris, Gauguin had told a friend a significantly different version of the story, one in which no mention was made of Vincent coming after him with a razor. In this first version, the razor appeared only after Vincent returned to the Yellow House, where he had mutilated himself.

Naturally, this incident and its mysteries have attracted considerable attention over the years, and recent revision to the legend has van Gogh going after Gauguin with the razor and Gauguin, in self-defense, slicing off van Gogh's ear with a fencing sword. But whoever did what to whom, the fact remains that Gauguin immediately bolted for Paris. Van Gogh was hospitalized briefly before returning to the Yellow House and then to a mental hospital in nearby Saint-Rémy. There he would continue to paint, and Théo would continue to provide for him.

Although Vincent van Gogh and Paul Gauguin subsequently corresponded, they never saw one another again.

⌒

In a final violent ending to the year, Louise Michel barely escaped assassination while speaking in Le Havre. Her would-be assassin, a Catholic fanatic by the name of Pierre Lucas, fired a pistol at her and wounded her in the head.

Fortunately, she survived the attack, although the doctors were unable to remove the bullet—an outcome that left her in uncertain health. Yet despite Lucas' intent and her head wound, she acted quickly to protect him from the angry crowd. Later, she refused to lodge a complaint against him and instead pleaded for him at his trial, arguing that he was the victim of an evil society. The man was acquitted.

Michel lived by her principles, even in the most dire of circumstances. For her, every human being had value.

Besides, her contempt for the police was well known.

~

Centennial

(1889)

By early 1889, the Eiffel Tower was almost complete—an awe-inspiring symbol of the new and the modern rising up over the Champ de Mars. Yet this extraordinary structure, which would in time come to symbolize Paris itself, was not at first a comfortable neighbor for many Parisians, who already were finding the modern world an unsettling and even dangerous place to live.

It was this sense of uncertainty in the midst of instability and change that had contributed heavily to the rise and continued popularity of the attractive and aggressively nationalist General Boulanger. Boulanger of course constituted another and more conventional sort of danger, but this was something that, under the circumstances, his supporters proved quite willing to ignore. In January, he triumphed at the Paris polls, drawing heavy support among left-wing voters (much to Clemenceau's dismay). After this unexpected and sweeping victory, many anticipated a coup, and talk of a possible Boulangist dictatorship was rampant. But whether from aversion to illegal action or from the belief that he could get what he wanted through legal means, Boulanger held back, looking to the autumn general election to clinch his bid for power.

By this time, he had stirred up enough fear and antagonism among the leaders of the Third Republic that they at last took action. Changing the laws governing France's elections, they made it impossible for Boulanger to run in several constituencies at once—a factor that had greatly assisted his rise. Since Boulanger was planning on running in more than a hundred constituencies, this effectively put the stopper in his plans. In addition, the

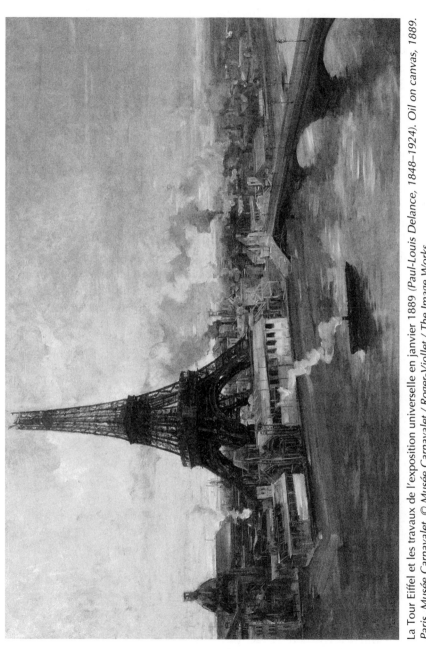

La Tour Eiffel et les travaux de l'exposition universelle en janvier 1889 (Paul-Louis Delance, 1848–1924). Oil on canvas, 1889. Paris, Musée Carnavalet. © Musée Carnavalet / Roger-Viollet / The Image Works.

minister of the interior went after the general's top aides, accusing them of subversive activity. Next in line, he hinted broadly, would be Boulanger himself. With rumors swirling that the general was about to be arrested and brought to trial in the Senate for endangering the safety of the state, Boulanger unexpectedly lost his nerve. Taking to his heels, he fled to Brussels. In August, Boulanger was sentenced in absentia to deportation for life.

Stunned by their hero's desertion, his supporters reacted quietly. That autumn, Boulanger won in Paris (where he was immediately disqualified), but rural France largely rejected him. By the following year, his party had almost disappeared. The year after, the general himself, distraught by the cataclysmic end to his ambitions as well as by the death of his beloved mistress, shot and killed himself on his mistress's grave.

It was a sudden and unexpected end to a meteoric career, one that in its prime had threatened to undo a government widely perceived as stagnant and unresponsive to its people's needs. The Third Republic survived this challenge without bloodshed—a major accomplishment, given the possibilities for violence. But as the nation celebrated its Revolution's centennial, the question now was whether the Republic's political leaders would heed the Boulangist wake-up call, or whether they would continue much as they had before.

～

The timing of the Panama Canal Company's declaration of bankruptcy, in February 1889, could not have been worse. The Boulanger crisis was still at its height, and the economy remained in the doldrums. Nonetheless the Canal Company's belly-up should not have come as a surprise, given the number of warning signs that had been readily available for those willing to pay them heed. Sadly enough, most of the canal's backers had refused to face reality, and now something like eight hundred thousand French investors, most of them people of modest means, were left high and dry.

Gustave Eiffel was deeply shocked by the news, which arrived as he was pushing his tower to completion. He had already fulfilled a large portion of his contract with the Panama Canal Company, and his first reaction— possibly on the assumption that the government would never allow a project of this importance to fail—was to press on with his part of the job. Yet even Eiffel could not soldier on in the face of a bankruptcy of this proportion (totaling one and a half billion francs), and in July, he signed an agreement by which he recovered the money due him for that portion of the work completed (not including any work done after the bankruptcy was declared).

The whole thing was a huge disappointment to him, but at least it did not ruin him financially, as it did so many others. Indeed, once the agreement was signed, Eiffel expected that the matter was over and done with.

He could not have been more wrong.

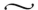

Actually, Eiffel stood in more immediate danger of financial disaster from the construction of his magnificent tower. Certainly the city and state fully expected that it would plunge him into grave financial difficulties. But in the end, his tower turned out to be every bit the success that he had expected it to be. Completing his mammoth undertaking in time for the exposition's opening in May 1889, Eiffel had the pleasure of seeing visitors surge up the steep staircases even before the elevators were working (the elevators, which posed their own unique challenges, were not completed until several weeks after the tower opened). Around two million people visited the tower during the exposition, and even some of the protesting artists were won over (although Garnier continued his sniping for years). Eiffel covered his costs during the first year of operation, and subsequent profits—including entrance fees, revenues from the tower's restaurants and other commercial enterprises, as well as the sale of those little Eiffel tower models—made him a very wealthy man.

In the end, what made Eiffel's deal especially lucrative was the twenty-year operating concession that the City of Paris and the French government had given him and his company as part of the original deal. Success must have been especially sweet for Eiffel, given the opposition that his tower had received, as well as the lackluster financial support the city and state had given him.

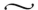

The goal of the 1889 Exposition Universelle—to educate the public to the possibilities of the new technology in the service of a republican society—was the sort of mumbo-jumbo calculated to win backers wherever necessary, especially in government. It sounded important and, better yet, linked the wonders of science and technology to the centennial of the Great Revolution, whose ancestry the Third Republic was happy to claim—without the bloodshed, of course. With thirty-seven million people traipsing through the various exhibits, including a Pavillon de l'Industrie du Gaz (featuring the latest in gas lighting, heating, and cooking), an enormous Galerie des Machines (highlighting, among other wonders, Edison's phonograph, now in actual production), and a Palais des Arts Libéraux (with displays showing

how railway, telegraph, and canal systems were linking people in the new technological age), something of the exposition's original aim must have rubbed off. But even Edouard Lockroy (minister of commerce, and prime mover and shaker behind the exposition) admitted that the attendees for the most part had not understood the exposition in the way it was intended, and the crowds who surged through the exposition grounds seemed to view the whole dazzling display as a kind of spectacular entertainment.

After all, how could the average attendee resist the Javanese dancers or the enormously popular replica of an Egyptian village, named the Rue du Caire, complete with a bazaar and belly dancers? Titillation merged with romance, especially by night, as fountains splashed and the entire exposition grounds were bathed in an effulgence of sparkling lights. And even beyond the exposition's sheer entertainment value, there was much besides technology to fuel the imaginations of those attuned to the possibilities. The Javanese gamelans caught the attention of Debussy, who years later reminded a friend of what they had heard: "Remember the music of Java," he wrote, "which contained every nuance, even the ones we no longer have names for."[1] Berthe Morisot was similarly taken with the Javanese dancers (much as Rodin, years later, would be enchanted by a troop of Cambodian dancers). The young Erik Satie heard kinds of music there that he had never encountered before, while the new Russian works conducted by Rimsky-Korsakov made a big impression on fourteen-year-old Maurice Ravel.

Morisot and many of her companions were also drawn to the exposition's retrospective exhibit of art, which included a room devoted to the works of Edouard Manet. Still, the Eiffel Tower was the undisputed star of the show, the newest wonder of the world. Rodin took time out from his studio at the nearby Dépôt des Marbres to ride the tower's elevators to the first platform, where he joined Camille Claudel and several others for lunch. Goncourt, who detested the tower, at last reluctantly agreed to join some friends, including Zola, for dinner there. Taking the elevator up, Goncourt felt seasick, but once on the platform, he was struck by the view. It was a clear July evening, and he could fully take in the enormity of Paris, with "the steep, jagged silhouette of Montmartre" on the horizon, "looking in the dusky sky like an illuminated ruin."[2]

Rather than return by elevator, Goncourt gamely chose to go by foot. It turned out to be a somewhat terrifying experience. "One feels," he carefully reported afterward, "like an ant coming down the rigging of a man-of-war, rigging which has turned to iron."[3]

Eiffel never viewed his tower this poetically, but one senses that he might have been pleased by Goncourt's response.

～

Rather than show at the 1889 exposition, Rodin and Monet had their own joint exhibition at the Georges Petit gallery. They had met several years earlier, and by the time of Georges Petit's 1887 International Exhibition, the two were friends, with Rodin visiting regularly at Giverny. Yet when Monet had first advanced the idea of a joint show, Rodin was the more highly regarded of the two and had already been made a chevalier in the Legion of Honor. Rodin was reluctant to join Monet in a joint show, as it meant that he would not be able to show at the exposition. But Monet pressed until Rodin at last capitulated. There were altercations between the two over the placement of their works, with Monet convinced that the result was a "total disaster" for him, and the usually gentle Rodin bursting out that he didn't "give a damn" about Monet or anyone, "the only thing I'm worried about is me!"[4] But in the end, the Georges Petit exhibition was a triumph for both, restoring their friendship and establishing Monet's preeminence among the Impressionists, while rocketing Rodin (whose plaster maquette of *The Burghers of Calais* caused a sensation) to the forefront of contemporary sculptors.

Even before the Petit exhibition opened, Monet spent the spring tussling with the weather in the Creuse department of west-central France, where he wrote Alice in considerable anguish that the river Creuse was rapidly shrinking and its color changing radically. None of his paintings were finished, and he had been counting on the last few days of his stay to finish a substantial group of them.

In particular, five winter landscapes needed finishing, but by May, the oak tree that figured large in all of them had quite naturally sprouted leaves. What to do? Monet decided to offer his landlord fifty francs to allow him to strip the oak of its leaves—an offer that the landlord apparently accepted, because Monet soon wrote that two men had brought long ladders into the ravine to do the job. "Isn't it the final straw," he reported to Alice, "to be finishing a winter landscape at this time of year?"[5]

By this time the Exposition Universelle had opened (on May 6), and once Monet had overseen the installation at his and Rodin's joint exhibit (which opened on June 20), he found time to visit the exposition. Here, while viewing Manet's *Olympia* in the centennial exhibition of French art, Monet had an idea. Although *Olympia* had caused a scandal among traditionalists in 1865 when first exhibited, it had quickly been accepted by the avant-garde as a kind of revolutionary standard, the painting that began it all. Yet *Olympia* still did not reside in any prominent museum or collection. Indeed, Edouard Manet's widow still owned it. Monet's idea was to highlight the painting's

importance by tapping a large number of Manet's friends and admirers to jointly purchase the painting and then donate it to the state—on condition that it hang in the Louvre.

Monet set about raising the cash, but immediately encountered strong objections, even—most surprisingly—from Zola, who in 1865 had ringingly declared Olympia to be Manet's masterpiece. Now Zola objected to sending Olympia to the Louvre as a gift, "which is bound to have an air of clique and puffery."[6] Perhaps he sensed that Monet had an additional and more self-serving objective in mind, that of publicly linking himself with Manet, as Manet's artistic heir.

Apart from Zola, the greatest opposition came from those who simply detested the painting and were determined to prevent it from ever entering the Louvre. One tack these opponents took was to remind everyone concerned that the Louvre did not accept paintings until ten years after an artist's death (Manet had died only six years before). Such a precedent did exist, although it was not iron-clad, but that never was the real issue. Those rallying to the cause knew it, and eventually raised almost twenty thousand francs for the painting's purchase. Still, the commotion over Olympia continued, to the point of involving Monet in a duel, which fortunately never came off. In the end, calmer tempers prevailed, and since the Louvre was dead set against accepting Olympia, the Musée du Luxembourg became an acceptable fall-back—at least until the Louvre opened its doors.

"We wanted to hold on to one of Edouard Manet's most characteristic paintings," Monet wrote the minister of public instruction in February 1890, offering Olympia to the state. This was a painting, Monet continued, "in which [Manet] is seen at the height of his glorious struggle, master of his vision and of his craft." Not only was it "unacceptable that such a work should not have its place in our national collections," but there was the additional concern that rising interest among American collectors would result in the departure of a painting that should remain in France.[7]

Thanks to Monet's persistence, Olympia did remain in France. But it took seventeen years in the Musée du Luxembourg before it finally was transferred to the Louvre—on the order of Georges Clemenceau, who by then was prime minister of France. Thanks to Monet and his good friend Clemenceau, Olympia now hangs, with other treasures from the Impressionist years, in the Musée d'Orsay.

～

As the crowds continued to surge into the 1889 exposition, a young man by the name of Alphonse Mucha was battling starvation on the Left Bank. Born in South Moravia into a family of modest circumstances, he had insisted,

over his family's objections, upon a career in art. But determination was one thing, and success was quite another. Setting his hand to everything from stage sets to tombstones, young Mucha worked tirelessly but without flair. And when he at last found a patron willing to sponsor his art studies in Munich, then in Paris, the young artist did little to distinguish himself.

Arriving in Paris in 1887, the young Czech artist found a city in which much was new. Baron Haussmann had wiped out great swaths of the medieval city, and siege and Commune had damaged or destroyed a good deal more. A new Paris was rising in place of the old, and Parisians reveled in the change. The new buildings still were fresh and bright, and the streets were less putrid—ever since Eugène Poubelle had become prefect of the Seine and issued strict laws governing street cleaning and garbage collection (thus giving his name to the French trash can). Electric lights now lit the Champs-Elysées and the Place de la Concorde, and although the streets were cleaner (horse manure still being a problem), traffic already clogged the roadways. Mucha later regaled his son with stories of the horse-drawn omnibuses and trams, which charged twenty centimes to cross Paris—or a reduced fare of fifteen centimes, if the rider was willing to risk the elements and ride on the top deck. The fare was cheap, but it still was beyond the reach of the average Paris worker—or of an artist such as Mucha, whose wealthy patron finally cut off all support in 1889, leaving him virtually penniless in Paris.

Mucha—whose name in Czech means "little fly" and is pronounced there with a hard "c" (unlike in France)—had earlier indulged in a top hat plus a new coat, waistcoat, black frockcoat, and trousers to go with it. All of these were considered necessary items in Paris, although the far more casual beret was starting to make inroads among Left Bank artists. But by 1889, neither top hat nor beret were relevant for Mucha, who was reduced to remaining in bed to stay warm and living on lentils, which he bought by the bag and boiled in an old pot over the fire.

It was now that a small commission and a Polish friend saved him, the latter finding him a room on the Rue de la Grande-Chaumière (6th), in the vicinity of several art schools and, most importantly, above Madame Charlotte's *crémerie*. This marked a crucial turning point, for Madame Charlotte and her *crémerie* (which has long since disappeared) played much the same role in succoring Paris's starving artists in the 1880s and 1890s as did La Ruche and the Bateau-Lavoir a decade or so later. Madame Charlotte—a buxom widow with a small pension and a heart of gold—made it her business to feed and care for her extended family of down-at-the-heels students and artists, who regularly assembled for the cheap meals, camaraderie, and maternal concern she so generously provided.

The staircase to Mucha's new quarters was so narrow that he had to dump his belongings on the sidewalk and bring everything up, piece by piece, on a rope through the window. By evening, everyone on the street was acquainted with everything he owned, including each of his pictures, but this hardly mattered. He happily joined Madame Charlotte's international family of Britons, Swedes, Finns, Russians, Bulgarians, Germans, Austrians, Italians, Spaniards, Hungarians, Americans, Frenchmen, and Poles. Each spoke his own language plus a smattering of French that he had picked up from Madame Charlotte (complete with her Alsatian accent), and they squashed together around the tables or even, when space was especially tight, around the sink and range in the kitchen.

Mucha's room was equally claustrophobic, and he took to working at the washstand, sitting on "a curious armchair bought at a pawnshop for ten francs." But "we were like one big family," Mucha later recalled, "with the good mother worrying about her children."[8] Mucha became an integral part of this family, painting one of the two signs that decorated the entrance to the *crémerie* and benefiting from the comradely sharing of tips and leads that Madame Charlotte's hard-up customers cheerfully shared with one another.

For those who did not live through it, the whole experience has a pleasant, raucous sound, but in later years, Mucha was not inclined to romanticize it. Soon he would begin to earn a reputation as an illustrator, but in 1889, the pleasures of the World Exposition seemed a world away, and life still had a desperate edge that he did not enjoy. He visited the exposition only once and never returned—he could not afford to. Later, when bare survival was no longer an issue, he would view 1889 as the worst year in his life.

～

Debussy, too, was facing financial difficulties, although these were nowhere near as dire as Mucha's. After returning to Paris from Rome, Debussy continued for another year to draw the monthly allowance accorded Prix de Rome winners. He also continued to live with his parents—a money-saving solution for him but an additional strain on the household, since his father had recently lost his job. Had Debussy been at all practical (or for that matter, responsible), he would have taken a teaching job—certainly he was well qualified for one. But he did not seem to have been in the least interested in going this route. As a stopgap, he may have continued to give piano lessons, but in large part he continued to sponge off friends and associates for meals as well as loans, which he felt no obligation to repay.

In fact, Debussy spent a good part of his days in cafés or bookshops, talking with artists and writers. He certainly had the time (and evidently the admission fee) to saunter down to the 1889 exposition, where he was fascinated

by the Javanese music as well as by the Annamite theater (from French Indochina), which, years later, still impressed him with its minimalism. In contrast with Wagner, he said, it represented "a sort of operatic embryo."[9] And he even managed two visits to Bayreuth, to see what all the fuss over Wagner was about. But he continued to compose—primarily for the salons, those elegant and intimate private gatherings that during these last years of the century offered a vibrant market for piano music and songs. Debussy composed some enchanting piano music during this period, including his *Two Arabesques* and the *Petite Suite* (the latter originally scored for piano duet). But his focus during this time was on composing songs, especially settings for the poetry of Baudelaire and Rossetti.

Indeed, spending much of his time deep in conversation at cafés or cabarets like Le Chat Noir, Debussy by the late 1880s was already in the thick of the literary avant-garde. Reflecting this, as well as his passion for reading, he answered a questionnaire in 1889 with the response that his favorite prose writers were Gustave Flaubert and Edgar Allan Poe.

∽

Poe had been a favorite among Frenchmen since Baudelaire, and he would continue to exercise his influence through the end of the century. Goncourt recognized Poe's influence, but it was Stéphane Mallarmé who became a particular admirer, to the extent of learning English so he could read Poe in the original. In 1875, Edouard Manet illustrated Mallarmé's translation of "The Raven," and a couple of years later, Mallarmé wrote Zola that he had found a copy of "The Raven" that he planned to bring him.

Indeed, Mallarmé's circle of friends was a large and an illustrious one, dating from his 1871 return to Paris after holding a series of posts in the provinces, where he had taught English. Once in Paris, he became friends with Manet, who rented a succession of studios near Mallarmé's modest residence on the Rue de Rome, near the Gare Saint-Lazare. In 1876, Mallarmé wrote an article in which he called Manet the "premier painter of light," and that same year Manet reciprocated with a portrait of Mallarmé that, as one of their contemporaries noted, radiated with their friendship. "I saw my dear Manet every day for ten years," Mallarmé wrote after Manet's death, still finding it difficult to come to grips with Manet's absence.[10]

Mallarmé quickly established himself among the literary avant-garde and began to hold literary evenings every Tuesday, to which invitations became exceptionally coveted. Mallarmé's Tuesday evenings drew the most interesting and creative minds in Paris—including Debussy, who would become a regular. These were all-male gatherings, although Berthe Morisot once teasingly told Mallarmé that she and Julie would dress as men and attend

(Mallarmé promptly invited her, and she just as promptly backed down). A quiet man, Mallarmé was a devoted friend of Berthe and Eugène Manet, whom he probably met through Edouard. But despite his simple and very bourgeois home life, with a devoted wife and daughter, Mallarmé turned out to have another side as well. In 1884, the same year in which Mallarmé's literary reputation was at last becoming firmly established, he began an affair with Méry Laurent.

He met Méry Laurent (born Marie-Rose Louviot) through Edouard Manet, whose mistress she had been during his last years. A beautiful woman and former actress, with an appreciation for luxury as well as poets and painters, Laurent had most fortunately acquired a wealthy protector by the time she met Manet, who was generally strapped for funds. Mallarmé had even less in the way of income, but Méry Laurent's protector, a wealthy dentist, was disinclined to jealousy so long as she cleared out her literary and artistic admirers before he came to call.

Living not far from Mallarmé as she did, it was easy for the two to maintain the easy friendship they had shared during Manet's lifetime. But soon friendship became something more, and a year after Manet's death, her affair with Mallarmé began. For five years Méry Laurent served as Mallarmé's mistress and muse, inspiring some of his most remarkable poetry. But finally, in the autumn of 1889, Mallarmé chose to end the relationship, begging her to remain his dearest friend. She agreed, and although no longer lovers, they remained close for the rest of his life.

～

Unquestionably, 1889 was a difficult year for lovers. Opening with the spectacular joint suicide of Austrian Crown Prince Rudolph and his mistress at Mayerling, it saw the continued decline of Berthe Morisot's dear friend and husband, Eugène Manet. It also swept Sarah Bernhardt's devastating husband, Aristidis Damala, back into her life again.

It was a difficult reunion. Bernhardt had just returned from touring Egypt and Turkey when she learned that Damala was ill and living in utter squalor in Paris. Drug-dependent and broke, he had lost his health, his looks—everything. Responding with pity to this poor broken creature, Bernhardt stepped in and tried to help him, sending him to a sanatorium. For a while this seemed to work, but not for long. Damala, as consumed as ever with self-glorification and gratification, did not have the wits or the ability to save himself.

At last realizing that there was nothing she could do to prevent the inevitable, Bernhardt gave Damala one last gift, by arranging for him to perform with her in *La dame aux camélias*. It was a generous and moving gesture, for it

was clear to everyone who saw him, on stage or off, that despite his delusions, he was not fit for the role. Indeed, Damala died soon after.

It had been an unfortunate marriage from the start, but Bernhardt had tried in her own way to live up to her responsibilities. This had proven impossible, and although in the end she was well rid of Damala, she nonetheless grieved deeply for him. She sent his body back to Greece and wept over his grave whenever she was in Athens. And for years she signed her letters, "the widow Damala."[11]

CHAPTER EIGHTEEN

~

Sacred and Profane

(1890–1891)

As the last decade of the nineteenth century began, Charles de Gaulle was born.

This future leader was a reserved child who became a notoriously taciturn man, a fact that most biographers ascribe to the fact that he was "un homme du nord," or man of the north—evoking the straight-laced, close-mouthed citizens of Lille, where he was born. True, de Gaulle was not a product of the Mediterranean lands of the South, whose vibrant inhabitants left him ill at ease, and whom he never entirely trusted. But apart from his birth—in his mother's home in Lille, as local tradition dictated—he was raised in Paris.

It may seem difficult to picture de Gaulle as a Parisian, but if one discards the Paris of Montmartre, which de Gaulle seems never to have visited, and focuses instead on the more commonplace but comfortable bourgeois quarters of the seventh and fifteenth arrondissements, one finds the area where de Gaulle grew up—and where he returned as an adult.

He was born in 1890, the third child of what would become a family of four sons and one daughter. His father, a teacher, was a fourth-generation Parisian, and both parents were devout Catholics and monarchists. Imbued with a large dose of patriotism and a respect for the military (de Gaulle *père*, although no Bonapartist, frequently took the family to the nearby Invalides for outings), young de Gaulle's life revolved around his parish church, St-François-Xavier (7th), and his schools. Given his parents' ardent Catholicism, his first school was run by the Brothers of the Christian Schools of St. Thomas Aquinas, followed by the Collège de l'Immaculée-Conception, on

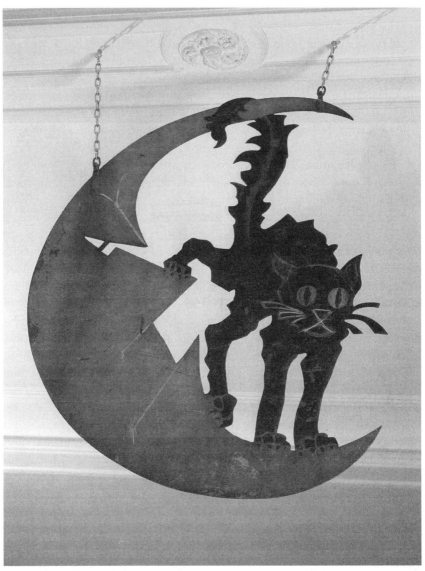

Sign from *Le Chat Noir* (Adolphe Willette), used at both addresses of the *Chat Noir* cabaret. Paris, Musée Carnavalet. © Fr. Cochennec et E. Emo / Musée Carnavalet / Roger-Viollet / The Image Works.

Rue de Vaugirard (15th). The latter, a rigorous and influential Jesuit institution where de Gaulle *père* taught, played a significant role in shaping young de Gaulle—not only his rhetoric but his values and his view of the world.

A Jesuit institution? Indeed, for by 1890, despite the efforts of the Third Republic to oust the Jesuits and secularize education, nearly all of France's former Jesuit *collèges*, or secondary schools, were back at full strength— thanks to considerable support from those who applauded them for standing firm against the forces of modernity, including secularism and socialism as well as the more liberal and socially conscious Catholicism that was beginning to emerge. Indeed, as the last decade of the century opened, right-wing Catholics and die-hard monarchists regarded the social order as increasingly precarious. Traditionalists in France, such as Charles de Gaulle's parents, insisted on the rigorous and conservative education that the Jesuits provided, with its rigid discipline and tough moral code.

Yet during these same years, Pope Leo XIII was conveying quite a different message to his French flock. Since his accession in 1878, this pope had shown a surprising degree of moderation in his relations with the French Republic, advising French Catholics to accept the current state of affairs, which included not only the secularization of French education but also continuation of the Concordat and the state subsidy of the French Catholic Church—neither of which the Church wanted to lose. Given the Vatican's unhappy recent relations with Italy and Germany, as well as with the Austro-Hungarian Empire, it was inclined to yield on the issue of educational laicization in France. After all, acceptance of the admittedly moderate Third Republic was beginning to look both necessary and inevitable—and in any case far preferable to the political and social models envisioned by the rising radical left.

And so in late 1890 and early 1891, the pope set to work to bring about a rapprochement between France's current government and the religious and monarchist right—a rallying to the Republic, or *ralliement*. As the pope's spokesman on this issue put it: When the people's will has been made clear on the form of government it wishes, and when that people's government is consistent with "those principles which alone can preserve Christian nations," then certain sacrifices to conscience must be made "in order to put an end to our divisions" and "save that nation from the abyss which yawns before it."[1]

Nevertheless, many conservative and royalist Catholics in France were not convinced.[2] In their eyes, the government of the Third Republic was anti-Christian, and that was that. Against this backdrop, the basilica of Sacré-Coeur continued to rise. Although it still lacked its great dome, the basilica's inauguration and benediction took place in June 1891. For those such as Clemenceau, who had opposed Sacré-Coeur's construction from the

outset, this constituted yet another outrage against the people of Paris. But for the faithful, the event offered reassurance that Christian piety still had a firm base in the godless city of Paris—even in that former Communard stronghold (and now bohemian center) of Montmartre.

∼

As if to underscore the seamy side of political life, the Panama Canal affair now resurfaced, creating some nasty excitement on the otherwise featureless political scene. Memory of the Boulanger crisis as well as awareness of the rising socialist threat had assured a certain amount of self-interested stability in France's government after Boulanger, but cracks in this façade now began to appear.

The allegations were of bribery, and in 1890 the minister of justice was directed to investigate. It took a year before the wheels of justice began to turn, but in 1891, the homes of several of those involved in the Canal adventure, including Gustave Eiffel, were raided. These raids yielded no incriminating evidence against Eiffel, but by this time there was no turning back.

Suddenly, not only were Ferdinand de Lesseps and his directors in grave trouble, but Gustave Eiffel was endangered as well.

∼

Meanwhile, the poor—whether working or unemployed—remained destitute, and Louise Michel continued to agitate on their behalf. This led to yet another arrest following her 1890 May Day speech in the town of Vienne, where protesting workers had set up barricades, fought with police, and looted a factory.

When offered provisional release, she refused unless all of those arrested with her were treated similarly. The town then tried to get rid of her by revoking her arrest warrant, but she refused to leave the prison until her conditions were met. Local doctors then declared her insane, and she was returned to Paris. But fearing that the government would try to get her out of the way by committing her to an asylum, she fled Paris for London, where she remained for five years.

Vienne was not the only place where oppressed workers were rising in protest, and the spring of 1891 saw a surge in demonstrations and uprisings throughout the country. When soldiers fired into a workers' procession in Fourmies, along France's northeastern border, ten people were killed and many others wounded. Angered and alarmed by the violence, in which several children died, Clemenceau spoke out. Asking for an end to the prosecution of labor leaders, he begged the badly divided republicans to do something about the crisis facing France's workers by uniting around a

much-needed program of social reform. "Look out the window," he told his fellow deputies. "See all the peaceable people who work and ask nothing of you except conditions of order and peace that will allow them to work and to prepare the regime of justice." The very future of France depended upon a just resolution of these workers' grievances. One day, he warned, France might need to call upon these very workers to defend it.[3]

One day in the not-too-distant future, Clemenceau's prophecy would prove correct.

⁓

The 1890s thus opened inauspiciously, with labor demonstrations and anarchist bomb threats amid an environment of continued economic stagnation. Property owners predictably feared the rising tide of socialism, while desperate workers just as predictably gravitated to radical political action.

Despite this austere backdrop, the beauty, creativity, and opulence that would later be called the Belle Epoque was already emerging. To some extent this reflected continuing activity or even new alignments among an older cast of characters, such as the Impressionists, where the American artist Mary Cassatt and Pissarro shared techniques as they created breakthroughs in the difficult art of color engraving, and Cassatt and Berthe Morisot drew closer over a shared interest in Japanese prints, even venturing into a brief collaboration.[4]

And then there were the emerging figures, such as Debussy, who was still a virtual unknown but would in time become an emblem of the good years to come. Debussy's *Fantaisie* had been scheduled for a spring 1890 concert by the Société Nationale de Musique—a singular honor for the young composer. But after the final rehearsal, Vincent d'Indy, who was conducting, realized that the program was too long and decided to cut all but the *Fantaisie*'s first movement. Deeply distressed by this decision, Debussy quietly took action by removing the music for *Fantaisie* from the musicians' stands. Afterward, he wrote d'Indy that he could hardly have done otherwise: "Playing just the first movement of the *Fantaisie*," he told him, "is not only dangerous but must inevitably give a false impression of the whole."[5]

It represented an amazing amount of cheek on the part of the young and unrecognized composer, but Debussy was completely sure of what he wanted—and didn't want. As he wrote Raymond Bonheur (a friend from Conservatoire days who shared literary interests with Debussy), "All I want is the approval of people like you, who find literary programmes not sufficiently solid or engaging as a basis for music and prefer the sort which can be taken on its own terms."[6]

It was not long afterward that Debussy met Erik Satie, who also preferred music that could be taken on its own and undeniably new terms. "The

moment I saw him," Satie later wrote, "I felt drawn to him"—and indeed, their friendship would last for many years, even through stormy periods in Debussy's life when other friends fell away. Despite Satie's age (four years Debussy's junior), he seems to have had a marked influence on Debussy— although the debate continues as to how much. Many years later, Satie would recall that when they first met, Debussy "was full of Mussorgsky, and very conscientiously was seeking a path which he had difficulty in finding." Certainly Debussy at that time was seeking a new path in musical expression, and Satie— who wryly noted that his own progress had not been impeded by the Prix de Rome or any other prizes—took the opportunity to emphasize "the necessity for a Frenchman to free himself from the Wagnerian adventure." And then he famously added: "We ought to have our own music—if possible without *choucroute* [sauerkraut]."[7]

According to Satie, it made little difference whether this music made use of some of the methods discovered by Monet, Cézanne, or Toulouse-Lautrec. Symbolism, Impressionism—it did not matter what one called it, so long as one went one's own way. And from the outset, Satie had been as determinedly individualistic as anyone on the planet.

Born in 1866 in Honfleur to a French father and Scottish mother (who gave a Scandinavian rather than French spelling to his Christian name), young Erik was placed in his grandparents' care following his mother's death and his father's move to Paris. Eccentricity seems to have run in the family, although it skipped over Satie's eminently respectable father and grandparents and landed squarely on his uncle, whom the young boy adored. Drawn to music (although he didn't begin piano lessons until the age of ten), Satie was also drawn to the unconventional, and he proved a rebel from the start.

At the age of twelve, Satie rejoined his father and new stepmother in Paris, and a year later was sent to the Paris Conservatoire. His father and stepmother undoubtedly wanted to encourage his musical inclinations, but Satie was bored by the music he heard there and put off by the Conservatoire's conventionalism. Not unexpectedly, the Conservatoire was equally unimpressed with him, and he passed his years there without distinction.

It was in 1887, at the age of twenty-one, that he began to publish his first works for the piano, including his three deceptively simple but seminal *Gymnopédies*, two of which Debussy later scored for orchestra. These plus *Sarabandes*, which Satie published the same year, in time earned him a reputation as a "harmonic innovator" and a "forerunner of the music to come," including the Groupe des Six and, especially, Debussy and Ravel.[8]

But in 1891, when he first met Debussy, Satie was still an unknown, making his living by playing the piano at Le Chat Noir and then (after quarreling with its owner, Rodolphe Salis) at its nearby competitor, the Auberge du

Clou. These were Satie's Montmartre years, when he lived behind Sacré-Coeur on Rue Cortot, near the beautiful old mansion that now is the Musée de Montmartre.

Like Debussy, Satie preferred the company of artists and writers, and he claimed that he learned more from painters than he ever had from musicians. He probably had one particular painter in mind, the gifted and fiery Suzanne Valadon, with whom he had a brief affair. She already had a son, Maurice, by a father whose name she refused to divulge (Maurice later took the name of Utrillo from the owner of the Auberge du Clou). Satie befriended the boy, whose artistic abilities would eventually emerge, along with severe alcoholism and mental instability. But a conventional family unit never formed from this highly unconventional grouping. Valadon went on to professional success and more personal fireworks, but without Satie, who was heartbroken.

For the time being he occupied himself with the mystical Society of Rosicrucians (Debussy at this time was also drawn to the mystical and the occult) and then founded his own church—a strange and elaborate structure of which he was the only member, and whose journal he used primarily to attack a couple of individuals he despised. He also pushed for admission into the sacrosanct Académie Française and reacted with scathing denunciations when, quite understandably, the Académie members flatly rejected him. Yet despite Satie's eccentricities, there were those who took him seriously, eventually including the eminent philosopher Jacques Maritain.

An odd bird, no doubt about it, Satie nevertheless had the ability to cut through pretense and neatly skewer sham. It was this ability that would repel those who found him strange or merely laughable. But along the way it did earn him the friendship of a few stalwarts, who appreciated him and, at least to some degree, understood.

⌐

As the decade opened, Debussy was still striving for recognition, but Claude Monet had at last achieved artistic acclaim and financial success. The emerging American market played a large role in this, even though Monet had consistently disparaged Durand-Ruel's efforts to cultivate it. And Monet had successfully played off dealer against dealer, to his own benefit.

It was now that Monet bought Giverny, which he had been renting since 1883, for the sum of twenty-two thousand francs (paid in four yearly installments). And it was now that he began his series of *Poplars* and *Haystacks*, using a single motif in each to explore the infinite gradations of change in light, shadow, and color from one day to the next, one season to another.

Choosing sites near Giverny (the line of poplars rose along the banks of the Epte, and the haystacks dotted nearby fields), Monet was able to visit and

revisit these locations with relative ease. Next would come his studies of the great cathedral of Rouen, which despite its proximity to Giverny, required him to stake out an empty apartment overlooking the cathedral from which to paint.[9] After that, his eye fell on a much closer subject, the possibilities at Giverny itself.

Monet's *Haystacks* and *Poplars* at first roused a certain amount of incomprehension and derision, such as from one of the partners in the Boussod, Valadon gallery, who informed Théo van Gogh's replacement that "you will also find [among our inventory] a certain number of paintings by a landscape artist, Claude Monet, who is beginning to sell a bit in America, but he . . . is beginning to overstock us with his landscapes, always the same subjects." And an unimpressed critic wrote: "Here we have the grey stack, the pink stack (six o'clock), the yellow stack (eleven o'clock), the blue stack (two o'clock), the violet stack (four o'clock), the red stack (eight o'clock in the evening), etc., etc."[10]

Still, praise for Monet's *Haystacks* and *Poplars* outweighed the criticism. An 1891 exhibition of Monet's paintings at the Durand-Ruel Gallery (Durand-Ruel was now back in place as Monet's primary buyer) brought critical acclaim and increased sales. Pissarro, who had yet to find an audience for his work, complained to his son that "for the moment people want nothing but Monets. . . . Worst of all they all want *Sheaves in the Setting Sun!*"[11]

Pissarro was right. That year, Monet's sales from Boussod and Durand-Ruel amounted to a hefty ninety-seven thousand francs.[12]

∼

While Monet at last prospered, life still was exceedingly difficult for two other artists of genius, Georges Seurat and Vincent van Gogh. Camille Pissarro had spent the spring painting in London, but on his return to France received a request from Théo van Gogh to take in his brother, who had been confined during the previous year in the asylum of Saint-Rémy.

Pissarro had known Vincent van Gogh during his stay in Paris, and had been generous with his time and advice, helping van Gogh move away from his dark, Dutch-inspired style and colors and toward the brighter and freer Impressionist palette and technique. Pissarro was also well acquainted with Théo van Gogh, who had come through for him when other dealers, especially Durand-Ruel, had not. With characteristic generosity, Pissarro agreed to have Vincent stay with him in Eragny, just outside of Paris, where Pissarro had settled with his wife and many children.[13]

But Pissarro's wife was afraid that Vincent might prove dangerous and was especially worried about the children. Giving way to his wife's wishes, Pissarro recommended that Théo turn to Pissarro's friend, Dr. Gachet, in

Auvers-sur-Oise. Dr. Gachet was indeed willing to care for Vincent, who came to him in May 1890. But despite Dr. Gachet's efforts, two months later Vincent van Gogh committed suicide.

Even then, the tragedy was not over, because soon after Vincent's death, his devoted brother, Théo, became seriously ill. Traumatized by Vincent's death, Théo ultimately went mad. He died in January 1891, only a few months after his beloved brother, and is buried beside him in Auvers.

The Seurat story is less dramatic but ultimately just as moving, ending as it did in the sudden loss of a young and gifted artist. In Seurat's case, death came quickly and unexpectedly, in March 1891, nine days after he had taken an active role in an exhibition of Neo-Impressionist painters. Scarcely two weeks later, his infant son died of the same illness, possibly influenza.

At the time of their deaths, van Gogh was thirty-seven and Seurat was thirty-one. Given a normal lifespan, they both could have lived well into the twentieth century. "It is a great loss for art," Pissarro commented about Seurat,[14] who had forged the radically new style that Pissarro, however temporarily, had adopted. And although Pissarro did not seem to recognize it at the time, it was a fitting tribute to van Gogh as well.

∼

There was yet another death in 1891 with reverberations in the Parisian artistic community, although it was the Monet household that was most immediately affected. Ernest Hoschedé, the abandoned husband of Alice Hoschedé and current art editor of the *Magazine Français Illustré*, had for years overindulged in food and drink, with the unhappy outcome of a severe case of gout. By 1890 the gout had grown worse, and by early 1891 it was clear that Hoschedé was dying.

During his last days on earth, Alice suddenly appeared at her husband's bedside and attended him day and night. He died wretchedly, in poverty, and Monet paid for his funeral and burial, which at the request of Hoschedé's children, was at Giverny. Apart from Hoschedé's children, there appear to have been few real mourners.

As for Alice, one simply does not know what she felt. One thing was clear, though: she now was in a position to salvage her reputation by marrying Monet.

∼

Not long after the death of Ernest Hoschedé, sixteen-year-old Maurice Ravel received first prize in the piano competition at the Paris Conservatoire. Across town, after a lengthy stay in Brittany, Paul Gauguin (who had not

attended Vincent van Gogh's funeral) showed up at Madame Charlotte's *crémerie*, where he made friends with Alphonse Mucha before embarking for Tahiti. And Auguste Rodin, who had made a real splash at his joint 1889 exhibition with Claude Monet, now received a vied-for commission from the Société des Gens de Lettres to create a monument to Honoré de Balzac—the Société's choice being heavily influenced by that year's president, Emile Zola, who thought Rodin supremely capable of conveying Balzac in the way that Zola envisioned him, as the forerunner of Naturalism.

Around this same time, Ernest Cognacq, by now a very rich man, moved into a large mansion at 65 Avenue du Bois (now Avenue Foch, 16th), which was big enough to accommodate his growing art collection—a collection that would eventually be open to the public in Paris's Musée Cognacq-Jay.[15] And a new face, that of a young woman by the name of Maria Sklodowska—soon to be known as Marie Curie—appeared in Paris.

From the outset, Maria's determination and focus were extraordinary—certainly on a par with her exceptional intellect. Born in Warsaw in 1867, she had been raised in the stifling political atmosphere of Poland under Russian domination. Although blessed with a supportive family, her father's salary as a physics teacher was insufficient to underwrite the kind of education she longed for. The University of Warsaw did not admit females, and if she was to pursue her dreams, she would have to study abroad.

Paris beckoned, but Maria's older sister had dreams as well—of becoming a doctor. These two young women, remarkable for their time, at last decided upon a plan. Bronia, the elder, would study medicine in Paris while Maria worked as a governess to support her. Then, when Bronia won her medical degree, Maria would come to Paris. For five long years Maria carried out her part of the agreement, teaching by day and studying by night, until at last Bronia sent for her.

When Maria arrived in Paris in 1891, she was twenty-four. It was not the usual age to begin an academic career, but she was undaunted. After qualifying for admission, she enrolled in the Faculty of Sciences at the Sorbonne for an advanced degree in physics. Utterly committed to her studies, she found lodging in a series of Left Bank garrets in which she both starved and froze. But she treasured these years of solitude. "We must believe," she wrote her brother during this difficult time, "that we are gifted for something, and that this thing, at whatever cost, must be attained."[16]

Pioneers do not as a rule settle for the comfortable corners of life, and Maria Sklodowska was no exception.

CHAPTER NINETEEN

~

Family Affairs

(1892)

Following a glorious autumn in their rented house in Mézy-sur-Seine, just to the northwest of Paris, Berthe Morisot and Eugène Manet returned to Paris. After some initial hesitation they had bought a beautiful seventeenth-century château near Mézy, the Château du Mesnil. The entire family, including Julie, adored it, and although for a time they had backed off for practical considerations, they still found the lovely old château irresistible. By autumn, the château was theirs.

Unfortunately, that winter Eugène Manet's health grew steadily worse. Back in Paris, Morisot continued her Thursday dinners. But soon her husband grew too frail even for dinner parties, and Morisot cancelled them indefinitely. On April 13, 1892, Eugène Manet died. Despite his long illness and all the signs of impending death, Berthe Morisot was devastated. "I have descended to the depths of suffering," she scrawled in her notebook. "I have spent the last three nights weeping. Pity! Pity!" And then, after musing on the unimportance of "material objects to be contemplated as relics," she decisively wrote, "It is better to burn the love letters."[1]

She buried herself in her work, preparing for her first solo show, which was to be held at the gallery of Boussod, Valadon. Despite her usual fears (she left Paris immediately after the opening, which she did not attend), the show was a success, propelling her into even more intense work at the easel. But first she had to deal with the château that she and Eugène had bought together for their old age. After spending three weeks supervising workers to fix up the place—a distressing task, as she found the château becoming "prettier

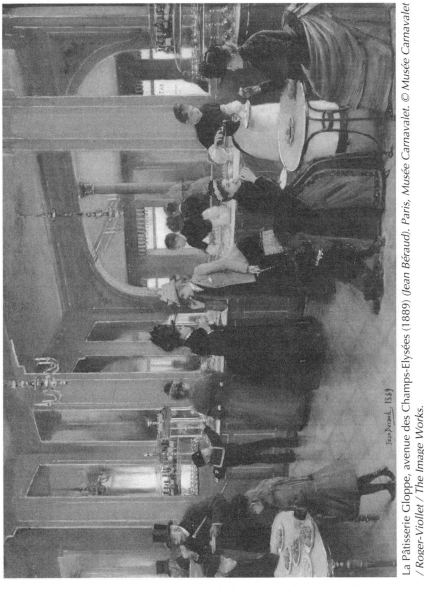

La Pâtisserie Gloppe, avenue des Champs-Elysées (1889) (Jean Béraud). Paris, Musée Carnavalet. © Musée Carnavalet / Roger-Viollet / The Image Works.

and prettier"—she rented it out, to cover expenses. Someday, she hoped, Julie would enjoy it and "fill it with her children." But as for herself, "I feel mortally sad in it, and am in a hurry to leave."[2] The memory of Eugène was too strong for her there.

In September, Morisot wrote Mallarmé that the passage of time was only increasing her sadness, and in October she answered another friend with a brief admission of loneliness. "I have Julie," she added. "But it is a kind of solitude none the less, for instead of opening my heart I must control myself and spare her tender years the sight of my grief."[3]

That autumn, she and Julie took a short trip to the Touraine, but by that time Morisot's older sister, Yves, had become seriously ill. "My heart is filled with sorrow," Morisot wrote a close woman friend, adding, "We now constitute a circle of old ladies of bygone days."[4] Although certainly not an "old lady," Morisot had indeed aged. Now, at fifty-one—although still beautiful—she was completely white-haired.

～

Being a genius can be difficult enough, but being female and a genius in nineteenth-century France must have been infinitely harder. Camille Claudel certainly passed the genius test, as Rodin recognized, and as her brilliant sculpturing clearly showed. From 1888, when she left her family's home to live in an atelier paid for by Rodin, she had strongly impressed the critics, beginning with her sculpture *Sakuntala*, a physically and emotionally charged depiction of two embracing lovers that she showed in that year's Salon, soon after Rodin showed *The Kiss* at the Georges Petit gallery.

Yes, she could imitate Rodin, but from the outset she was true to her own vision. She also was quite clear about what she expected from Rodin, who in an 1886 document agreed to make her his only pupil and to do everything in his power to advance her career. According to this extraordinary document (which he signed), Rodin also agreed to exclude other women from his life, and (after passing a series of tests) to marry Claudel. Rodin certainly did his part in advancing Claudel's career, introducing her to influential people and doing his utmost to help her obtain commissions. After all, he believed in her. But, much to Claudel's consternation, he did not and would not leave Rose.

By late 1892 and early 1893, Claudel's anger over Rose had grown into an obsession, leading to her breakup with Rodin.[5] It was then that Rodin moved with Rose from Paris to Bellevue and, eventually, to Meudon. Yet he continued to do everything he could to continue to help Claudel's career, and even retained the lease on her atelier on the Boulevard d'Italie. He still

loved and admired her, but in 1895, he told Octave Mirbeau that it had been two years since they had even seen or written to one another.

Claudel's adoring younger brother, Paul, later portrayed her as victimized by Rodin, whom Paul castigated as an egocentric and heartless monster, one who took advantage of a dazzled young girl.[6] But others have seen Claudel in a different light—as a brilliant but flawed genius who was destroyed by obsessive jealousy and paranoia.[7]

In any case, by late 1892 it was clear that whichever version of Rodin and Claudel was correct, their affair was not ending happily.

⌢

Debussy met Gaby Dupont in 1890 and began to live with her in 1892. It was a crucial step for the young composer, who until this time had lived with his parents. (In another major change at this time, he now began to sign his name as Claude rather than Claude-Achille or Achille.) One of Debussy's friends, René Peter, described Gaby as "blonde with catlike eyes, a powerful chin and firm opinions." She took care of the housekeeping, which was not without its challenges—partly because they were poor, and partly because Debussy (according to Peter) was "a large, spoilt child who . . . indulged all his whims and was impervious to reason."[8] If, for example, a particular Japanese print caught his eye (he was an avid collector of Japanese prints and objets d'art), he bought it without stopping to think where the money would come from for their next meal. And while Debussy was busy impulse buying, daydreaming, or composing, Gaby was in charge of the practical side of their lives.

Gaby managed their frugal household and Debussy's life, but Debussy found it difficult to manage his moods, especially when a particular composition was not going well or when he felt that the world had turned its back on him. By 1892 he was one of only three musicians attending Mallarmé's Tuesday evening salon—certainly a major accomplishment. But in the autumn of 1892, Debussy was in a bleak mood when he wrote to Prince André Poniatowski, whom he had met at Mallarmé's salon. Poniatowski had hoped to arrange a concert for Debussy in the United States, possibly with Walter Damrosch, but this did not work out. "Whatever happens," Debussy wrote him, "I shall always be grateful to you for keeping me in mind . . . and for helping me escape from the black hole which my life has tended to become."[9]

Debussy went on about "the failures that crush even the strongest" and "the enemies ranged against me"—an interesting complaint given how little known he still was, except among Mallarmé's admittedly exclusive salon. ("It's strange," Debussy added, "but even though my name is almost unknown there are innumerable people who detest me."[10])

But despite the difficulties that faced him, whether real or imagined, Debussy still had Gaby to take care of him—at least, for the time being.

⌇

From February through April 1992, Claude Monet was hard at work painting the cathedral of Rouen. It was grueling work, he reported to Alice, with twelve-hour workdays—standing all the time. But by late spring he was back in Giverny, where he celebrated his return (and the death of Ernest Hoschedé the year before) by marrying Alice. Their wedding, in July, was followed a week later by the marriage of Alice's daughter Suzanne to the American painter Theodore Butler.

Added to another successful exhibition (this one of his Poplars series at Durand-Ruel's gallery) and an income of more than a hundred thousand francs a year, 1892 was a very good year for Claude Monet.

But 1892 was not a good year for Georges Clemenceau, for whom the year hurtled from one disaster to another. Although his marriage had soured long before (some would argue that it had not gone well from the outset), it was not until 1892 that it completely collapsed, highlighted by an especially nasty divorce. Interestingly, Clemenceau assumed the role of the aggrieved partner, for despite his own flagrant infidelities, he was not about to allow his wife to take similar liberties. The story making the rounds (which Edmond de Goncourt—no fan of Clemenceau's—helpfully preserved for posterity) was that, weary of her husband's philandering, Mary Clemenceau herself took a lover. Clemenceau had the lover followed, caught the two *in flagrante*, and sued for divorce. The Napoleonic Code being what it was, the furious husband had the upper hand. The next thing Mary Clemenceau knew, she had a choice between prison or divorce. Having (not surprisingly) agreed to divorce, she was immediately escorted by two policemen to the nearest port, where she was sent back to the States.

But this unhappy story was not yet over, for following Mary's abrupt departure, Clemenceau shipped off her personal belongings to her sister and then proceeded to destroy everything in the house that reminded him of her. Taking out his rage on inanimate objects, Clemenceau smashed a marble statue of his wife and decimated memory-inducing photos and paintings. As for Mary, who had no money and no means of supporting herself, she took to lecturing on the Panama scandal, using her maiden name followed by the words "ex-wife of M. Clemenceau."

But worse was yet to come, for that autumn, the Panama Canal scandal at long last burst into the open, enveloping Clemenceau and ironically giving Mary Clemenceau a sure-fire lecture topic on which to speak.

～

The key figure in Clemenceau's messy involvement with the Panama affair was the financier Cornélius Herz. Clemenceau first met Herz during the early 1880s and quickly developed a close relationship with him, entertaining him in his home and receiving money from him for Clemenceau's beloved and financially challenged newspaper, La Justice. How much money Clemenceau received is not known, although many years later he told an interviewer that there was no reason that he should have refused Herz's funds. "They were for a useful struggle," he said. "Moreover, I completely paid him back."[11] Yet it was not quite that simple, as Clemenceau himself must have realized, because by 1885 he was borrowing from friends in order to buy back Herz's considerable investment in La Justice and disentangle himself from the financier, whose reputation was shady and whose latest dealings included a major effort to acquire a monopoly over Paris's fledgling telephone system.

Unquestionably, Herz was a schemer, and from the outset he had cultivated political figures who could help him. Although Clemenceau paid back Herz and voted against giving him the Paris telephone concession, by the mid- and late 1880s newspapers were already raising questions about this relationship as well as about the entire Panama venture. By the autumn of 1892, the simmering Panama mess exploded into a full-scale scandal.

The scandal was a far-reaching one, involving bribery and corruption on an enormous scale. De Lesseps had badly underestimated the monetary as well as human cost of building the canal and by the mid-1880s desperately needed a fresh infusion of capital, which he tried to get through lottery bonds. Special legislation was necessary for him to do this, and that is where the bribery came into play—about thirteen million francs to journalists and newspaper owners for favorable publicity, and another ten million francs to financial intermediaries and politicians.

Herz was to be paid ten million francs to get Parliament to allow the company to raise capital through lottery bonds, and in 1888 Parliament did indeed pass the necessary legislation—with the assistance of a large number of bribed deputies (more than a hundred may have had their palms greased, although Clemenceau was not among them). But even with this maneuver, the amount of capital raised was not enough, and the company soon went bankrupt.

Criminal proceedings began in 1891, but despite efforts to keep the whole thing quiet, the anti-Semitic newspaper La Libre Parole in September 1892 began to publish a detailed account of the scandal, denouncing not only de Lesseps but also Herz and the company's banker, Baron Jacques de Reinach, both of whom were Jewish. But this was only the beginning. In November,

Ferdinand de Lesseps and his son, Charles, as well as Gustave Eiffel and two of the company's directors, were indicted on charges of swindling and breach of trust.

Reinach committed suicide before he could be indicted, and Herz escaped to England, but the scandal continued to escalate, fueled not only by anti-Semitism but also by anyone who sought political advantage from the affair. Among these was Paul Déroulède, an ardent supporter of Boulanger and an equally ardent enemy of Georges Clemenceau. On December 20, Déroulède attacked Clemenceau in the Chamber of Deputies, claiming that without Clemenceau's patronage, Herz could not and would not have risen so quickly to wealth and influence. "He [Herz] had to have had someone to represent him," Déroulède told the hushed assembly, "an ambassador to open for him every door and every circle, especially political circles." When Déroulède named "this obliging, devoted, indefatigable intermediary" as Clemenceau, an uproar erupted in the Chamber. But Déroulède was not finished, for he now proceeded to label Herz ("this little German Jew") as a foreign agent working—with Clemenceau's full knowledge and assistance—to undermine the French Republic.[12]

Clemenceau defended himself verbally against this "odious slander," but in the end he took the most direct means he knew to counter this attack on his honor and reputation—by challenging Déroulède to a duel. Technically dueling was illegal, but in practice it was only prosecuted if either of the parties did not conduct himself according to the prescribed rules or if the duel resulted in death.[13] Clemenceau was a renowned and feared duelist, and given his temper and the animosity on both sides, it was generally expected that this duel, unlike most others, would be fought to the death.

But it was not. Despite his reputation for expert marksmanship, Clemenceau shot wide of the mark all three times, as did Déroulède. This unsatisfying outcome left some to claim that Clemenceau had deliberately missed (no one made a similar claim for Déroulède). Yet Clemenceau's unexpected vulnerability (or magnanimity) did not take the heat off him. If anything, it seemed to encourage his enemies, who continued their attacks unabated into the following year.

While Clemenceau would never face charges for any of the crimes that Déroulède or others accused him of committing, Gustave Eiffel—caught in the same web—would soon find himself defending his considerable reputation in a court of law.

～

Several years after his mother's death, James McNeill Whistler terminated the last of his relationships with a series of mistresses and, at the age of fifty-

four, finally wed. His bride was Beatrice (Trixie) Birnie Godwin, the widow of architect Edward Godwin and an artist in her own right. Whistler adored his Trixie, and it was in 1892, in the full flush of happiness, that he decided to return for good to Paris.

Born in 1834 in Lowell, Massachusetts, Whistler had from childhood lived an unusually cosmopolitan life. His family moved frequently, including a lengthy stay in Imperial Russia, where Whistler's father, a West Point–educated engineer, oversaw construction of the new Saint Petersburg–Moscow railroad line. Saint Petersburg was followed by six years in London, until the death of Whistler's father upended young James's dreams of becoming an artist. With visions of something more practical for her beloved son, Whistler's mother wangled an appointment for him to West Point.

Whistler stuck it out there for three difficult years (difficult not only for him but for the West Point staff, including its new superintendent, Colonel Robert E. Lee). He chafed at the discipline and earned so many demerits that, taken with his poor academic record, it was no surprise when West Point finally kicked him out. An appointment with the predecessor of the U.S. Coast and Geodetic Survey also ended badly. At last Whistler gave up even the pretense of trying to be what he was not and left for Paris, where he was determined to conquer the art world. He never set foot in America again.

Bilingual and cosmopolitan, young Whistler adapted easily to bohemian Paris life of the late 1850s, attending art classes, living in a series of cheap lodgings, and taking a mistress. Always a dandy, he now dressed more flamboyantly than ever, clearly enjoying standing out in a crowd. But his lively social life came at a price: extravagant by nature, he already was dodging creditors—much as he would for years to come.

Paris may have been socially congenial, but its art establishment was as unreceptive to the kind of style that Whistler was developing as it was to that of Manet, Monet, and Degas, with whom he would eventually become friends. Like them, he departed from the classical subjects and historical tableaux favored by the establishment-controlled Salon, and instead focused on everyday life, which he depicted with increasingly abstract and evocative brushstrokes. In this, he shared much of the vision of the emerging Impressionists, although he never considered himself one of them. Despite the final effect of his etchings and paintings, he created most of them painstakingly in his studio rather than rapidly *en plein air*. And although focusing increasingly on color, his palette was a subtle one, sometimes exploring the various shades of white (*The White Girl*), but more often, as with the portrait of his mother, the infinite shadings of gray and black. Even among those with whom he had the most in common, Whistler remained alone.

Much as he loved Paris, Whistler's rejection by the all-important Salon made him decide to try his fortunes in London instead. Unfortunately, London's art establishment turned out to be even stodgier than the one he had left behind. Fighting the British critics, he embroiled himself in endless other disputes (as delectably recorded in his book *The Gentle Art of Making Enemies*). In the midst of this turmoil, Anna Whistler arrived, determined to settle in London with her dear son. Despite his antipathy to her Puritanism, he tempered his lifestyle on her behalf and, in a heartfelt tribute, painted her portrait.

It may come as a surprise to many Americans, but Whistler's quintessentially American portrait, *Arrangement in Grey and Black: Portrait of the Painter's Mother* (informally known as *Whistler's Mother*), has resided in Paris since 1891—first at the Musée du Luxembourg, then at the Louvre, and more recently at the Musée d'Orsay. Before that, it had spent its entire existence (since its inception in 1871) with Whistler in London, where it did not attract much in the way of favorable attention. It had received tepid reviews after the Royal Academy hung it in 1872, over protest. A decade later, Whistler submitted it to the Paris Salon, where it received only a third-class medal.

Its long-term French residence began soon after Whistler was publicly acclaimed by the art critic Gustave Geffroy, who identified him with the new Symbolist movement. Whistler had not changed, but his art had suddenly found its place at the forefront of the most avant-garde movement of its time—one that rejected Realism as well as the light- and color-infused work of the Impressionists, and instead embraced evocative (and frequently dark) descriptions of atmosphere and mood. Paying tribute to Baudelaire, Poe, and the pre-Raphaelites, the movement's major French spokesman was Mallarmé, who by now was a friend of Whistler, thanks to their mutual friend Monet. Suddenly finding himself as touted as Monet or Rodin (both of whom Geffroy had also praised), Whistler decided that the time was ripe to push for the purchase of one of his paintings by the French government. The painting that he had in mind was the *Portrait of the Painter's Mother*.

Whistler and Mallarmé together worked on the plan. Mallarmé approached the current inspector of fine arts, who was a good friend, while Whistler contacted Geffroy, who was pleased to write an article urging the purchase. Happily, the gallery of Boussod, Valadon agreed to exhibit the painting while these talks were going on, and Georges Clemenceau (by this time a good friend of Monet and therefore of Monet's friend Whistler) persuaded the minister of public instruction and fine arts to consider the painting for government purchase.

The minister agreed, and soon the painting was on its way to the Luxembourg, with the promise of the Louvre in its future. The sum for its purchase was a paltry four thousand francs, but although Whistler had hoped for considerably more, he was delighted by the prestige that the sale conferred. The honor "will show the recognition of my work in France in contrast to elsewhere," he wrote Mallarmé, "and make up for past sufferings."[14]

He added that "since France has permanently taken the 'Mother' it seems to me that she also has to adopt the son a little!"[15] Soon after the French government's purchase of the *Portrait of the Painter's Mother*, Whistler made good on this idea by permanently moving to Paris. Searching the Left Bank, he found an expansive sixth-floor studio on Rue Notre-Dame-des-Champs (6th), with an extraordinary view of the Luxembourg Gardens and much of Paris. And then he and Trixie settled in a comfortable apartment with adjoining garden behind the Rue du Bac (7th). Many long years after Whistler had left Paris for London, he had returned—this time, he hoped, for good.

CHAPTER TWENTY

～

"The bell has tolled. . . ."
(1893)

T he bell has tolled now to mark my thirty-first year," Debussy wrote in
early September 1893 to his friend (and frequent source of supply), the
composer Ernest Chausson. He was not at all happy about what yet another
birthday signified. "Try as I may," he told Chausson, "I can't regard the sadness
of my existence with caustic detachment." Like "a hero of Edgar Allan Poe" his
days were frequently "dull, dark and soundless." Striking a world-weary pose,
he sighed that "too many memories come crowding into my solitude."[1]

This sort of gloomy self-absorption has long been a hallmark of the young,
especially those with unrealized artistic ambitions, but Debussy's language
and the atmosphere that he evoked was also heavy laden with the dark and
mystical dreamworlds that the Symbolists embraced. Indeed, by this time
Debussy was spending much of his time with the Symbolists, not only at
Mallarmé's but also in the bookshop of Edmond Bailly, a bookseller and pub-
lisher specializing in Symbolist literature and the occult, who had published
Debussy's Cinq Poèmes de Baudelaire.

Debussy's days probably were not as "dull, dark and soundless" as he
claimed. For one thing, in this same missive to Chausson he complained that
the girl in the apartment above him had been pounding away on the piano
while he was trying to compose. But despite his melancholic affectations, his
trials and tribulations were not imaginary. He was having family difficulties,
much of it due to his parents' dashed expectations. "My mother," he told
André Poniatowski, "decided I was not providing what a son ought to, no
fame was accruing, and so began a needling campaign."[2] Her jabs had clearly
found their mark.

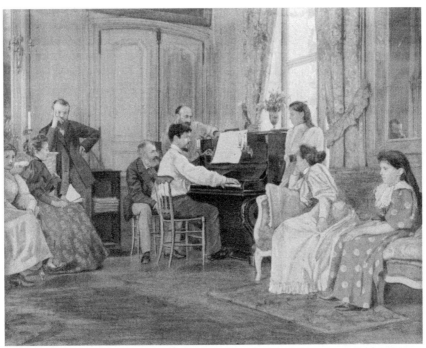

Claude Debussy au piano dans la propriété d'Ernest Chausson, à Luzancy, août 1893 (Claude Debussy at the piano in the home of composer Ernest Chausson at Luzancy, August 1893) (Anonymous). Albumen print [photograph]. Paris, Musée d'Orsay. © Musée d'Orsay / Réunion des Musées Nationaux / Art Resource, NY.

In addition to a nagging feeling of failure, Debussy was constantly in debt and just as constantly battling creditors—a subject on which he waxed most eloquent when corresponding with friends such as Chausson, who had proved a good source for loans in the past. But more than anything, Debussy was still plagued by the uncertainty whether, musically speaking, he was on the right track. In August, after obtaining Maurice Maeterlinck's permission, he had begun to compose *Pelléas et Mélisande*, and by September (as he told Chausson) he was working furiously but was not pleased with the results. He knew what he aspired to, and he was equally clear about what he did not.

Certainly it was not to be an imitator of Wagner, whose popularity and influence Debussy feared would make the German "one of those fortresses the public likes to use to block all new artistic ideas." Just a few months earlier, Debussy himself had served as one of the pianists accompanying several singers who performed excerpts from *Die Walküre* at a lecture prior to that opera's Paris premiere. Debussy knew Wagner's music well and did not claim that it was bad. Quite the contrary. This was exactly what made it such a threat to the new path that Debussy was so painfully attempting to mark out. The purpose of music, as he saw it, was not to tell "lurid anecdotes," which were better left to the newspapers. Instead, music "is a dream from which the veils have been lifted." More than simply the expression of feeling, it was "the feeling itself."[3]

And so, as yet another birthday rolled by, Debussy was feeling dejected about his prospects as well as his accomplishments. Yet there were triumphs to contemplate—albeit on a small scale and spaced too widely to provide the kind of moral sustenance that he required. In April, his *La Damoiselle Elue*—written for the Académie des Beaux-Arts—was finally performed in public, giving Debussy the satisfaction of the first public performance of any of his orchestral works. The Académie had granted that the work was not without charm but had gone on to criticize the composer for refusing to adhere to formal (i.e., traditional) systems. This was exactly the sort of attitude that had curdled Debussy's stomach during his entire stay in Rome, and so it was with particular joy that he received a tribute from the Symbolist painter Odilon Redon following the April performance of *La Damoiselle Elue*. Redon was so delighted with *La Damoiselle* that he presented Debussy with one of his engravings. Debussy responded with deep appreciation, not only for the engraving but for the "artistic sympathy" that the gift implied.[4]

The year would bring further dividends. That autumn, Debussy was introduced to the poet and writer Pierre Louÿs, who quickly became his closest friend. And in December, Debussy's string quartet would be performed by the Société Nationale de Musique. He even received assurances from

Maeterlinck of the Symbolist playwright's gratitude to Debussy for setting his words (*Pelléas et Mélisande*) to music. But creation is difficult and frequently discouraging work, and as the year came to a close, Debussy was still struggling to find his own voice, even as the bill collectors continued to pound on his door.

∼

While Debussy was struggling with *Pelléas et Mélisande*, Claude Monet was struggling with his Cathedrals series, first in Rouen and then (from memory) at Giverny. "Dear God, this cursed cathedral is hard to do!" he wrote Alice from Rouen in February 1893. Conceding that he would eventually succeed, albeit after a hard struggle, he told the patient Alice that "it's only with hard work that I can achieve what I want." Yet in April he was still in Rouen and still battling the creative process. Only after he returned to Giverny and had another look at his work did he at length conclude that "some of my 'Cathédrales' will do."[5]

And yet throughout this difficult gestation period he had not been entirely obsessed by the cathedral, for he had devoted a great deal of time and attention to his garden at Giverny as well. He visited the head of Rouen's botanical gardens, who took him on a tour of the greenhouses, provided him with cuttings of a climbing begonia that Monet admired, and offered Monet lots of gardening advice. Monet also busied himself in searching out plants from local gardeners and sending them back to Giverny, complete with advice on their treatment and on the care of virtually everything else in his ever-expanding garden.

A significant part of this expansion was to be a lily pond, which Monet had long dreamed of. He had just acquired the last piece of land he needed for this important addition to Giverny, but unfortunately not everyone in the neighborhood was pleased with the idea. As a result, the local planning commission dragged its feet on granting permission to excavate a channel between the proposed pond and the Epte. Monet's opponents were relatively few in number but vocal, and they had taken to objecting to the project on public health grounds—a position that infuriated Monet, who erupted with a pungent "*Merde* to the Giverny natives and the engineers."[6] He in turn contended that their objections were merely designed to hide their ill-will to an outsider, especially a Parisian. After several months of this, he finally went above their heads and, with the all-important support of a local journalist, petitioned the prefect of the Eure.

This produced the result he wanted, and by the time Berthe Morisot and her daughter, Julie, visited Giverny in late October, Julie was able to write in

her diary that they visited Monet's "ornamental lake across which is a green bridge which looks rather Japanese."[7]

Julie had just begun to keep a diary—something (she wrote) that she had always wanted to do, although she supposed that she may have come to it a little late. Still, she added, "the longer I wait, the later it will be—and after all I'm only fourteen."[8]

It had been a difficult year, during which she missed her father dreadfully. "I really need him," she confided to her diary. "I want to see him, to hear him, to speak to him, and be nice to him." She then blurted out, "Why can't I be nicer to Maman? Every day I chide myself about this, but don't do enough about it."[9]

Berthe Morisot was an exceptionally caring mother and a warm friend, but she was anything but effusive. Following Eugène's passing, she had grown even more quiet and remote, although she tried for Julie's sake to rise above depression. Her friends, especially Renoir and Mallarmé, worried about her and tried to tempt her to try new scenes to paint, new locales in which she and Julie might forget their grief for a time and be happy. That August she finally responded to Mallarmé's encouragement and, with Julie, came to visit him and his wife and daughter for a week at their summer home in Valvins, on the banks of the Seine near Fontainebleau.

Julie recorded the days' events in her diary, including carriage rides, walks, and times when she painted side-by-side with her mother. They dined under trees beside the Seine, and at night Julie slept in a tiny bedroom overlooking the river. It was exactly the sort of quiet vacation that she and her mother needed, complemented by cheerful companions and Julie's faithful greyhound, Laërtes (a gift from Mallarmé).

Once back in Paris, she and her mother climbed to Montmartre to see Renoir, who had just returned from his own wanderings, and visited Monet at Giverny. Their day at Giverny was rainy, but Julie did not seem to mind. Unlike fashionable Parisian interiors of the time, Giverny was light and colorful in any weather, with blue paneling in Alice Monet's bedroom and mauve in her daughters' rooms, while the drawing room was violet and the dining room, yellow. Monet's bedroom, above his studio, was white and lined with lots of paintings, including (sharp-eyed Julie noted) a pastel by Julie's mother and one by "Oncle Edouard."

Monet showed his two visitors his new Cathedral paintings, which Julie found "magnificent." Still, despite her sophisticated upbringing and her passionate desire to be an artist like her mother, she confessed to finding these paintings a little confusing. "It seems hard to me," she told her diary, "not to draw all the details."[10]

～

On the train ride home from Giverny, Julie could just make out through the pouring rain the trees and roof of Le Mesnil, the château that her parents had so hopefully bought just before Eugène's death, and which Berthe now was renting out. "I think it's quite delightful to have a château one doesn't even live in," Julie wrote, "and to be able from time to time to see it from a train, appearing like a shadow in the night, and to say to oneself, 'It's mine.'"[11]

Whether or not Le Mesnil lay in Julie Manet's future remained to be seen, but her life—even devoid of a father—was certainly more protected and filled with love than that of Winnaretta Singer, a gifted and privileged young woman who lived in Julie's Passy neighborhood. Like Julie, Winnaretta's father had died when she was a young girl. But unlike Julie, Winnaretta would encounter disinterest and neglect as she struggled to establish her own sense of worth and identity, en route to becoming one of the foremost arts patrons in Paris.

Winnaretta's origins were almost as unusual as her name. Her American father, Isaac Merritt Singer, had made a fortune through his invention of the sewing machine, but in his youth he had fancied himself an actor, turning to work as a machinist only to keep from starving. A romantic and impractical soul, he lived with a series of mistresses who, over the years, bore him a total of sixteen illegitimate children. In turn, the Frenchwoman he eventually married proceeded to bear him six more—including Winnaretta.

Winnaretta, the second of Isaac's legitimate family, owed her name to her father, who presumably invented it. But she owed her love of music to her mother, the beautiful young Isabelle Boyer, who used the Singer fortune to further her social ambitions and to surround herself with music. Isaac Singer died in 1875, when Winnaretta was only ten, leaving her a hefty fortune and a mother who was far more concerned with her own social triumphs than she was with her shy and awkward daughter. The beautiful Madame Singer quickly remarried, this time acquiring a title.

Winnaretta, who had neither her mother's beauty nor her social ambition, keenly felt her mother's disappointment in her but found refuge in the arts. As a teenager, she studied painting, and she had established herself as a promising artist by the time she was twenty. She was also a talented organist. But her personal life continued to be painful, exacerbated by her mother's self-absorption as well as by Winnaretta's growing awareness of her own lesbianism.

Marriage under such circumstances, even to escape the family home, offered little in the way of a solution, and Winnaretta's first marriage proved

disastrous. But a second marriage, in 1893, to Prince Edmond de Polignac, turned out extremely well, discreetly accommodating both partners' sexual preferences while providing an affectionate and lasting companionship. The two, who met in a bidding war over a Monet painting, shared a deep love of art and music, and under their auspices the Hôtel de Polignac—the lovely mansion at 43 Avenue Georges-Mandel (16th) that Winnaretta bought and renovated—would soon become one of the foremost salons in Paris.

Since girlhood, Winnaretta had embraced the new with enthusiasm and had become such an ardent devotee of Edouard Manet that, although they never actually met, she was devastated by his death. She also greatly admired Monet, Morisot, and Degas, visiting the latter's studio, where she noted with interest that this particular Impressionist did not paint *en plein air*. In music she was similarly adventurous, and although an early convert to the Wagnerian school that so dismayed Debussy, she had already taken approving note of Debussy's *La Damoiselle Elue* and would become one of his most stalwart supporters.

Even before Winnaretta's marriage, Debussy was already well acquainted with the Prince de Polignac, who was an amateur composer of considerable inventiveness (and occasional eccentricity). Debussy became a friend of the prince and the princess, sharing with them an admiration for the old as well as the new. Debussy admired Palestrina, while the Polignacs' tastes included music from the late medieval period and the Renaissance as well as the Baroque. All of this was perfectly compatible with the increasingly pervasive Symbolist movement, which was sweeping away the jagged and gritty elements of Naturalism and Realism in favor of a distant but approachable ideal, which Symbolists believed was swathed in mystery, hidden in shadows, and attainable only through images permeated with symbolic meaning.

Not surprisingly, Naturalists of the old school such as Edmond de Goncourt viewed Symbolism and its adherents with considerable disdain. Soon after the Polignacs' marriage, in December 1893, Goncourt paid the newlyweds a visit. He was not impressed—but then again, he was not prepared to be impressed. The prince, according to Goncourt, had the "air of a drowned dog," while Winnaretta had "a cold beauty, distinct, cutting"—fitting for the daughter of the inventor of the sewing machine.[12]

Goncourt also had a few choice words on the subject of his old rival Zola, who had finally finished the last novel in his great Rougon-Macquart cycle. Zola's next project was to be about Lourdes, where he had recently visited. He thought he might get a book out of it, he told a dinner party, something on the revival of faith that he thought was behind the mysticism currently pervading art and literature. Goncourt listened and thought "what a cunning rogue [Zola] was, realizing that naturalism was on the decline and

deciding that here he had found an opportunity of going mystic with a big sale."[13]

Perhaps Goncourt was right, for Zola had always possessed a sixth sense about which way the winds of public interest (and sales) were blowing. But it was probably unfair to attribute his choice of topics to rank commercialism alone. Zola was drawn to human passion, and in Lourdes, he thought he had found yet another rich topic in which to immerse himself.

～

From the age of sixteen, Winnaretta Singer had been a steadfast admirer of the composer Gabriel Fauré and his distinctly untraditional compositions, which a number of cultivated Parisians found unfathomable. She remained his friend for many years, providing him with both moral and financial support while he eked out a living teaching piano and serving as a substitute organist for Saint-Saëns at the Church of the Madeleine.

Another of Fauré's admirers was the wealthy and wild young Misia Sert (née Godebska), who was one of Fauré's most promising pupils. Misia, a talented pianist, had begun taking lessons from Fauré at about the age of ten, and Fauré thought she had the makings of a concert pianist. Others had the same thought, but Misia proved unable to stay the course. Raised in affluence but virtually ignored by her father, while strictly disciplined by her first stepmother, this poor little rich girl was starved for love. Yet she possessed a hefty supply of independence and daring, which she had already demonstrated by running away from home as a child (an act of defiance that earned her an eight-year stint at the austere school of the Convent of the Sacred Heart).

Now at the age of eighteen, a quarrel with a new stepmother sent her off on another flight, this time to London and then back to Paris. Here Misia lived alone in a small apartment and taught piano, both wildly inappropriate activities at that time for an unmarried woman of good family. But she refused to return to her father and stepmother, and she warned that she would burn down the convent if they sent her back. Finally she agreed to a compromise that allowed her to continue teaching as well as taking lessons with Fauré, so long as she moved into a chaperoned *pension*. It made a good story—one that attracted the attention of Thadée Natanson, her first stepmother's nephew, who fell in love with her. Basking in his affection and eager to escape her family, Misia agreed to marry him.

Fauré was shocked at the news, which spelled an end to Misia's future as a concert pianist, and begged her to reconsider. But despite the success of her first public concert, given soon after her engagement, she would not turn back. It was not so much a matter of being passionately in love with Thadée, which she was not. Rather it was her need to *be* loved. Thadée unquestionably

adored her, as did virtually every other man among his distinguished group of friends, which included some of the most prominent members of the Parisian literary and artistic avant-garde.

Thadée Natanson's privileged position was the direct product of his current role in the Paris cultural scene. By the time of his marriage to Misia in 1893, Thadée, along with his brothers, had been editor for two years of the *Revue Blanche*, a literary and artistic journal of small circulation but growing influence. Not only did it publish prominent French writers such as Zola, Verlaine, and Mallarmé and foster new talents such as Apollinaire, but it published the first French translations of foreign authors such as Tolstoy, Chekhov, Strindberg, and Ibsen. It also published trenchant articles on current political and social issues, and it ventured well off the beaten path to discover new intellectual influences. In addition, each issue contained an original print by a cutting-edge artist such as Toulouse-Lautrec, Edouard Vuillard, or Pierre Bonnard. Misia blossomed in this cultivated environment, luxuriating in the attention of those who repeatedly painted her (including Toulouse-Lautrec, Vuillard, Bonnard, and that longtime admirer of beautiful women, Renoir), or simply fawned over her, in the hope of being included in her husband's influential magazine.

Misia saw to it that Fauré was included in the Natansons' exclusive group, and soon Debussy would be welcomed as well. Eventually Ravel would also become a regular, thanks to his teacher and mentor Fauré, but in 1893 Ravel was still in his teens and just beginning to write his first compositions. Although clearly no bohemian, he had already struck up an acquaintance with Erik Satie, who continued to support himself as a café pianist near the Ravel family's home in Montmartre. In what turned out to be a burst of inspiration, Ravel's father had introduced the two.

This encounter, which took place early in 1893, turned out to be a significant one, for Satie's music, if not his lifestyle, would have a great influence on Ravel. As Ravel himself later put it, Satie had had "an appreciable effect upon Debussy, myself and indeed most of the modern French composers." Indeed, Ravel added, "Satie pointed the way."[14]

～

Misia and Thadée thoroughly enjoyed the early years of their marriage, whether receiving friends at their stylish Rue Saint-Florentin home in Paris, near the Place de la Concorde, or at their country house in Valvins, near their good friend Mallarmé. Like so many other pleasure-seekers, they frequented the nightspots of Montmartre, especially Le Moulin Rouge and Le Chat Noir. And they attended concerts and the theater, gravitating to the

new, especially works by Ibsen, although they relished evenings with more traditional fare as well, especially when they starred Sarah Bernhardt, whom they adored.

Bernhardt had always attracted members of the avant-garde, possibly more for her performances off-stage than on. Among her admirers was Oscar Wilde, who wrote *Salomé* for her (it was banned in Britain and eventually performed in Paris, but without Bernhardt). Another of her admirers was the flamboyant Count Robert de Montesquiou, no shrinking violet himself and an inside member of the fashionable set that patronized Paris's cutting-edge artists and musicians. Montesquiou, the wealthy descendent of an ancient aristocratic family, was a regular at the most select gatherings of fin de siècle Paris; he knew—and was known by—virtually anyone who counted. He frequented Misia Natanson's soirées and drew on his impeccable taste in assisting Winnaretta Singer to renovate her beautiful mansion on Avenue Georges-Mandel. His friendship with the Prince de Polignac went back even further, and in fact he had helped bring the prince and Winnaretta together—although Montesquiou dramatically broke with the couple after not being included among the guests at their intimate wedding. The guest list had been strictly limited to families of the bridal couple, but Montesquiou still took umbrage. The upshot was the count's undying enmity, directed especially at Winnaretta—not an enviable situation for someone who, despite her formidable exterior, was quite sensitive.

But the Polignac connection to Montesquiou lived on in other more positive ways. Earlier, while in London, Edmond de Polignac had introduced Montesquiou to John Singer Sargent and Henry James, who in turn introduced Montesquiou to another renowned aesthete and dandy, James McNeill Whistler. Montesquiou was captivated by Whistler's wit and exquisite aestheticism, but he was especially enraptured with Whistler's art. It was everything he had hoped for but not seen in the paintings of the Impressionists, which had struck him as essentially Naturalist. Whistler's art, on the other hand, hovered delectably in that misty and mysterious area occupied by Symbolism, and it pointed enticingly toward the sinuous blossoming of Art Nouveau, which Montesquiou would soon embrace. Montesquiou, a decadent Romantic who made a fetish of Beauty, was an ideal subject for Whistler, and Whistler's full-length portrait of him (now hanging in the Frick Collection in New York) is a masterpiece.

As for Sarah Bernhardt, Montesquiou had admired her ever since his teens, when she had enchanted him in an otherwise forgettable *spectacle*, and he had been her friend since the 1880s, when she reportedly began their relationship by seducing him—an event that unfortunately made him lose

his dinner. Undismayed, she continued the relationship on a more platonic plane, showering him with carefully nonsexual affection and relying on him for decorating and fashion advice.

In his *Remembrance of Things Past*, Marcel Proust would model his Baron de Charlus on Montesquiou, just as he would base the Princess Yourbeletieff and Madame Verdurin on Misia, the actress Berma on Sarah Bernhardt, and elements of the character of Bergotte on Prince Edmond de Polignac (although more on Anatole France). Of course in 1893, Proust was still in his early twenties, and *Remembrance of Things Past* still lay in his future. Still, he had already begun to make contacts in this rarified world, introduced by Montesquiou to the Polignacs (Montesquiou would later be the one who introduced Proust to Bernhardt) and by Mallarmé to Whistler.

In 1912, when Proust submitted the first volume of *Remembrance of Things Past* for consideration for publication, André Gide, then serving as the publisher's reader, did not even bother to look at it before rejecting it. He considered Proust "a snob, a dilettante, and a man-about-town," and therefore incapable of writing serious literature.[15] All these things Proust most definitely was, but as it turned out, to the benefit rather than the detriment of his masterpiece.

⁓

Meanwhile, on the other side of the world, Gauguin had hoped to find fame as well as peace and happiness in Tahiti. But when he returned to France in August 1893, he had only four francs to his name. This desperate situation was partially rectified by the death of an uncle, who left him some money. But Gauguin's finances were still in a precarious state when Alphonse Mucha, Gauguin's painter friend from Madame Charlotte's *crémerie*, generously offered to share his studio with him. Gauguin accepted, and this astonishingly disparate duo worked together for a time—each in his own corner.

Clearly the two men had little in common. Not only were their artistic styles and aspirations dramatically different, but their personalities differed as well. Mucha was a serious and steady worker, regularly putting in fourteen-hour days and wasting little time or energy in amusement. Gauguin—according to Mucha—drank too much and was a troublemaker. He was right; Gauguin was a tough customer, whose debauchery was notorious and egotism overwhelming. After all, this was the man who—evidently without much anguish—had abandoned his wife and five children in order to pursue an artistic career. But still, even at this early stage Mucha was aware of his friend's genius and distressed by the public's failure to appreciate him. Gauguin was troubled by this as well and constantly fretted as he prepared for an exhibition in Durand-Ruel's gallery in November. Once, Mucha later recounted,

Gauguin even erupted in complete exasperation, kicking a picture from its easel and bellowing, "*Merde!* I wish at least I could draw!"[16]

Much as Gauguin feared, the exhibition was not a financial success, in large part because of the rather high prices he demanded. According to Pissarro, various men of letters (the Symbolists) admired his work, as did Degas, but other painters, such as Monet, Renoir, and Pissarro himself, were not impressed. Worst of all, the collectors were "baffled and perplexed." Pissarro recognized Gauguin's talent, which Pissarro had nurtured from the outset, but marveled at how difficult it was for Gauguin to find his way. "He is always poaching on someone's ground," Pissarro wrote to his son Lucien, and "now he is pillaging the savages of Oceania."[17]

Mucha was saddened by the exhibition's lack of financial success, and he greatly regretted the public's lack of understanding of Gauguin's art. But Mucha had begun to achieve a certain amount of recognition as an illustrator and had his own affairs to attend to. With his fortunes improving, he now moved to larger quarters across the street from his former room above the *crémerie*. Gauguin rented a small room at the same address, while continuing to share Mucha's studio. There, Mucha indulged himself by installing a longed-for luxury, a harmonium, which he soon learned to play. From then on he practiced an hour a day, playing church music and old Christmas carols.

Mucha typically took his music seriously, but Gauguin seemed to treat the new instrument as a joke. Thanks to another of Mucha's new purchases, a camera, we have a photograph of a mustachioed Gauguin, clad only in briefs and shirt, doing his turn at Mucha's treasured harmonium.[18]

But despite light moments such as this, Gauguin still faced an uncertain future as he continued, still without measurable success, to find his way.

⌒

Gauguin does not seem to have known the sculptor Antoine Bourdelle, but he certainly would have sympathized with his basic philosophy. "Do not copy me," Bourdelle repeatedly told his students. "Sing your own song."[19]

Bourdelle had followed this difficult but essential guide star long before he ever arrived in Paris. Born in 1861, the only child of a cabinetmaker in Montauban (Tarn-et-Garonne), Bourdelle had early shown a fascination with drawing and carving. At school, he drew constantly. At home, he watched his father make cabinets. Finally, around the age of ten, he could not restrain himself any longer and, using his father's tools, began to carve the head of a mythological creature, a faun. Impressed with the quality of the work, the father agreed to let young Bourdelle carve the decorations for some sideboards he was making. Not long after, the youngster quit school altogether to help his father.

But his talent was too great for a simple workshop, and soon he began to attend a communal art school, where he studied drawing and learned to model in clay. He then won a scholarship to the Ecole des Beaux-Arts in nearby Toulouse. After several years of study there, he won yet another scholarship, this time to the Ecole des Beaux-Arts in Paris, where he arrived at the age of twenty-three.

Here he entered the studio of the well-known sculptor Alexandre Falguière. For many, this would have amounted to the fulfillment of a dream, but Bourdelle was not happy. Even in Toulouse he had resisted the rigidity of the teaching, and things were no better for him in Paris. Finally, after two years he quit the Beaux-Arts, telling Falguière that what he was learning there did not interest him. Already he knew that he would have to do things his own way.

As so many others had already discovered, doing things one's own way rarely brings popular acclaim, and Bourdelle was living in poverty. Montparnasse, where he chose to live, was already a center for starving young artists, and a year after arriving in Paris, Bourdelle settled into a studio at 16 Impasse du Maine (now Rue Antoine-Bourdelle, 15th). Here and in adjacent buildings that he acquired over the years, he would remain until his death.[20]

Plugging away in his uphill struggle, Bourdelle studied the art of antiquity, especially Greek mythological characters, as well as medieval art and architecture. Along the way, he encountered Auguste Rodin, who had traveled much the same path. Rodin took notice of Bourdelle and in 1893 hired him as an assistant, or *praticien*, to help carve his growing output of marble sculptures. Bourdelle would remain with Rodin for fifteen years, during which time Rodin would become an important defender of Bourdelle's work, as well as a good friend.

But if 1893 was a good year for Antoine Bourdelle, it was a difficult one for his mentor, Auguste Rodin, who by now was committed to producing several major monuments: the *Gates of Hell* as well as monuments to Balzac and Victor Hugo. None of these was even close to being finished, and to make matters worse, Rodin's relationship with Claudel was at its nadir, distracting him from his work and affecting his health. In addition, Rose's health had also deteriorated.

When he accepted the Balzac commission, Rodin had agreed to complete the sculpture by May 1, 1893. But as the due date approached and then passed, the sculpture did not appear. Zola was greatly disappointed, and there were rumblings of discontent from the society's members. At last, when pinpointed on exactly when and where the commission could view the work prior to its delivery to the foundry, Rodin was forced to reply that his *Balzac* would not be completed for at least another year.

By this time Rodin was indeed focusing on *Balzac* but was delving deeper and deeper into the problem of depicting the great novelist—even going so far as to correspond with Balzac's tailor for details of the great man's measurements. This was realism carried to extremes, and one of Rodin's critics expressed the concern—held by many—that the sculpture might never be finished. Zola, whose term as president of the society was now completed, warned his successor of Rodin's failure to deliver, and of the society's impatience. "Watch out for squalls," he advised.[21]

Prescient advice, indeed, given what lay ahead.

∿

It was a difficult time for many besides Rodin. The year before, Edmond de Goncourt confided to his journal that his life had been "poisoned" by the news from his solicitor that his and Jules' dream to found an Académie Goncourt after Edmond's death was not practical, "a madman's whim." This left Goncourt in a deep funk, in which he dwelled on all he had given up for the project—most especially the marriage he had sidestepped. By 1893, his declining health deepened his anxiety, prompting him to anguish that he would die not knowing what would become of his academy and his *Journal*, the "two great projects of my life intended to ensure my survival."[22]

As it turned out, he need not have worried, but he did not know that. Nor did Georges Clemenceau have any way of knowing that his own political career was not over when, in 1893, he was resoundingly defeated for reelection to the National Assembly.

Clemenceau's defeat came after months of mud-slinging, including rumors that he had taken millions from the Panama Canal Company and that he was about to be arrested. In addition, his enemies claimed to have discovered documents showing that he was in the pay of the British government. Even though these turned out to be clumsy forgeries, they were gleefully aired by Clemenceau's opponents in the Chamber, where deputies were immune from libel laws. In August, Clemenceau successfully pressed libel charges against two of his opponents, who were fined and imprisoned, but still the mud-slinging continued, fostered (and paid for) by wealthy reactionaries and monarchists.

Confessing that assassination would be preferable to the ordeal that he had undergone, Clemenceau opened his campaign with a powerful speech reminding his listeners of his steadfast loyalty to the Republic and to the downtrodden, for whom he had fought for more than thirty years. And then he unburdened himself, telling his audience that according to the charges that had been swirling around him for months, he was supposed to have received fantastic amounts of money from various sources of pay-offs and

extortion, especially from the Panama affair. But where, he demanded rhetorically, were the millions? He had given his daughter in marriage without a dowry; he lived simply in a flat whose furnishings he still was paying for (on installment), and he remained in debt for obligations incurred in his youth.

Yet even more damaging than the personal invective, Clemenceau told his audience, was the distraction that such attacks provided from the real issues, which remained the necessity of social reform—of defending the weak and the poor from their oppressors. It was a powerful speech, and it alarmed Clemenceau's opponents, who took to hiring local toughs to heckle him and prevent him from speaking. At one point, they stoned his carriage, and there even was talk of lynching him.

Clemenceau failed to win an absolute majority in the first ballot and had to go to the second. In this, he was narrowly defeated—a relatively seismic event, given his political longevity, and one that the press generally viewed with favor. After all, Clemenceau had never been a comfortable presence on the political scene, and there was considerable agreement that his removal from politics would only benefit the social order.

Publicly, Clemenceau took his defeat with equanimity, but privately he was devastated. Not only had his political future been destroyed and his good name blackened, but many of his oldest friends now were shunning him. In addition, creditors of La Justice were beating at his door. "I'm riddled with debts," he wrote to a friend, "and I have nothing more, nothing more, nothing more."[23]

～

Unlike Clemenceau, Gustave Eiffel's misfortunes never affected his bank account, but the public humiliation that he suffered because of the Panama affair would critically affect his life.

In January 1893, Eiffel went before the judge to defend himself against charges that he had misused the Panama Canal Company's funds and abused his position of trust and responsibility. His lawyer argued that Eiffel was merely a contractor in the position of carrying out an agreed-upon project. But it seemed that Eiffel had paid large sums to one of the company's chief financiers, as well as to the editor of the influential newspaper Le Temps (who also published the Journal des Travaux Publics, or Civil Engineering). Eiffel defended these payments on the grounds that it was necessary "to ensure cooperation in so important an enterprise." But cooperation can be understood in many ways, and Eiffel's payments certainly had the appearance of a bribe paid to get the Panama contracts, which yielded him a tidy profit of thirty-three million francs. Making matters even worse, Eiffel seems to have received a reimbursement of twelve million francs for materials amounting in

value to only two million, and charged the canal company six million francs
for transporting materials that he never actually delivered.

On February 9, Ferdinand and Charles de Lesseps each received a five-year
prison sentence and were fined three thousand francs. Eiffel was acquitted
of swindling but found guilty of breach of trust—a verdict that earned him
a two-year prison sentence and a twenty-thousand-franc fine, both of which
were suspended pending appeal. It may have been a harsh sentence, given
the fact that Eiffel had never been part of the company's management, and
especially given the widespread bribery that had accompanied the canal's
history every step of the way. Eiffel was one of the few actually prosecuted.
But he had participated in a process in which huge sums of money belonging
to people of little means had been misappropriated, and as a well-known and
respected name, he now was suffering the consequences.

Subsequently, Eiffel's sentence was reversed under appeal, although this
was due to a technical violation by the lower court and had no bearing on his
guilt or innocence. At this point the Legion of Honor decided to take up the
question and summoned Eiffel, as a member, to account for his actions. The
Legion's inquiry concluded favorably, but by this time Eiffel had had enough;
he resigned from his company and removed his name from the company's ti-
tle. Gustave Eiffel would never again embark on another engineering project.

The French eventually sold the Panama rights to the United States,
which completed the canal in 1914. But Gustave Eiffel would play no part
in the conclusion of this enormous project. At the vigorous age of sixty-one,
and with thirty more years to live, he had a life and a reputation to reclaim.

CHAPTER TWENTY-ONE

~

Between Storms

(1894)

By 1894, the Panama affair had run its course, sweeping away political careers and contributing to growing cynicism on the part of a badly burned and disillusioned public. Clemenceau was not the only politician to go down in defeat in 1893; some 190 new deputies entered the Chamber after the elections. These new members, as well as a large number of the old, were careful to distance themselves from the Opportunist government under which the scandal had bloomed. Calling themselves Progressives, they appealed to a moderate-to-conservative swath of the electorate by advocating tariffs, opposing a progressive income tax, and signaling a willingness to ally with non-royalist Catholics against the radical left.

These moderate and conservative republicans harbored a deep fear of socialism, which was starting to make significant headway as a political force, thanks in large part to episodes of police and army violence against striking workers. But even more feared than the socialists were the anarchists, who rejected political action altogether in favor of militancy. A series of bombs had gone off in 1892, decimating the homes of a judge and prosecuting attorney. These two men had dealt savagely with workers whose May Day demonstration ended in bloodshed, after mounted police charged in. The bomb-thrower went to the guillotine, but his fate only stirred up further animosity among his anarchist colleagues, who proclaimed him a martyr and a hero. Not long after, a bomb was delivered to the Paris office of a mining company whose workers were on strike, killing five policemen. Parisians were panic-stricken.

La soirée, ou autour du piano (The Evening Party, *or* Around the Piano) *(Jean Béraud). Oil on wood. Paris, Musée Carnavalet. © Musée Carnavalet / Roger-Viollet / The Image Works.*

Many were terrified that the Commune had risen once again—a fear that seemed justified when, in late 1893, a starving young anarchist by the name of Auguste Vaillant threw a bomb into the Chamber of Deputies. (Louise Michel, who in general objected to bombing because it killed women and children, approved of this particular bombing, aimed at those she held responsible for the injustices she so adamantly protested.) A number were wounded, but no one was killed, and so this gesture of hostility toward the state found a sympathetic response among members of the far right, including royalists, deeply conservative Catholics, and anti-Semites, all of whom had their own reasons for detesting the current government. Even certain of the liberal intelligentsia, including Mallarmé, Paul Valéry, and the journalist and critic Octave Mirbeau, sympathized—at least in theory—with anarchists' fury at the poverty in which so a large portion of the nation was mired.

Vaillant went to the guillotine defiantly crying, "Death to bourgeois society! Long live Anarchy!" But the Chamber of Deputies was determined to put a stop to France's anarchists, whether simply theorists or actual terrorists, and passed laws restricting the press from printing anarchist theories or propaganda and forbidding "associations of evil-doers." Thus armed, the police fanned out, raiding anarchist meeting places and issuing warrants. Camille Pissarro, who had long been drawn to radical politics and was attracted by the theory of anarchism, wrote his son, "You must know about the reactionary wind which is sweeping the country now. . . . Look out!"[1]

Many of France's leading anarchists now left the country. But instead of shutting down the terrorist threat, the new laws seemed only to incite more violence. Only days after Vaillant's death, another bomb went off, this time at the Café Terminus, a popular gathering-place at the Gare Saint-Lazare. One person was killed and twenty were wounded. Subsequently, a bomb went off in the Rue Saint-Jacques, killing a passerby, while another exploded in the Faubourg Saint-Germain, where it mercifully did little damage. Still another detonated in its owner's pocket, as he entered the Church of the Madeleine, and yet another blew up in the chic Restaurant Foyot, where it put out a diner's eye.

Emile Henry, the young man accused of the Café Terminus bombing, was not at all reluctant to claim credit for this explosion as well as the earlier one that had killed the five policemen. It never was clear whether or not he was responsible for the earlier blast, but under the circumstances, that hardly mattered. Parisians were chilled to hear of his response to the judge, who reprimanded him for seeking to kill innocent people. "There are no innocent bourgeois," Henry had coldly replied.[2]

Henry went to the guillotine on May 21, 1894, but this did not put a stop to the violence. Quite the contrary. In June came the most devastating

attack of all, the assassination of Sadi Carnot, president of the Republic. Carnot, who was visiting an exposition in Lyon, was riding in an open carriage when his assassin—shouting "Vive la Révolution! Vive l'Anarchie!"—plunged a dagger into his stomach. Carnot had refused to pardon Vaillant or Henry, and he paid the price.

Carnot was immediately given the secular equivalent of canonization, with heroic statues dedicated to his memory going up throughout France, while the shocked Deputies passed a series of repressive laws intended to shut down anarchism once and for all. These laws, which made advocating anarchism a punishable offense and removed anarchists' rights to trial by jury, also clamped down on all publication of anarchist ideas, including press reports. This in turn stirred up a good deal of fear and indignation among radical republicans and socialists. Pissarro, who was in Bruges at the time, wrote his son that given these new laws, it was impossible to feel safe. "Consider," he added, "that a concierge is permitted to open your letters, that a mere denunciation can land you across the frontier or in prison and that you are powerless to defend yourself!"[3] Under these unfavorable circumstances, he was afraid that he would have to remain abroad for quite some time.

～

Despite an undercurrent of panic throughout Paris, life in many ways seemed to go on as usual. Pissarro held a critically acclaimed if not especially lucrative exhibition of his work at Durand-Ruel's in March, soon after the explosion at the Café Terminus, and returned to France that autumn after deciding that he had nothing to fear, since he was not well-known and had never participated in anarchist activities of any kind.

In March, another important event in the art world took place with the sale of Théodore Duret's collection. Duret, heir to a lucrative cognac business, had met Edouard Manet in Spain in 1865 and had become one of his closest friends and staunchest admirers. Duret wrote an insightful biography of Manet, catalogued his work, and in the end, served as pallbearer at his friend's funeral. Manet painted Duret, as did Whistler, who along with Claude Monet was also a good friend. Over the years, Duret had generously supported the Impressionists by purchasing their work and by writing an early defense on their behalf, *Les peintres impressionnistes* (1878). In time he would also write biographies of Renoir, Whistler, van Gogh, Toulouse-Lautrec, and Courbet.

But in 1894, Duret had suffered severe business reverses due to the repeated loss of grape harvests, and he was forced to sell much of his collection. The day before the sale, Julie Manet attended an exhibition of the collection, where she spotted one of her mother's paintings (*Young Girl in a*

Ball Gown) as well as several paintings by her uncle. These included "a por-trait of Maman dressed in white on a red sofa with one foot stretched out in front" (*Le Repos*) and "a small portrait of Maman . . . dressed in black with a bouquet of violets and wearing a small hat" (*Berthe Morisot with a Bouquet of Violets*).[4] Like everyone else who has seen this delectable portrait (it now hangs in the Musée d'Orsay), Julie adored it. Her mother bid on this and *Le Repos*; although *Le Repos* got away from her, the portrait with the violets did not. Much to Julie's pleasure, it would soon hang in her own bedroom.

Continuing her browsing, Julie singled out Monet's painting of white tur-keys, which Winnaretta Singer, now the Princesse Edmond de Polignac, also spotted and paid a handsome price to acquire. Julie then took in her uncle's unfinished portrait of the Impressionists' nemesis, the critic Albert Wolff, which she thought was quite marvelous—"especially considering how stupid and ugly the sitter is."[5]

Unlike Wolff, Degas was a friend, and Julie warmly admired his paintings in the Duret collection. Julie, who was a favorite of Degas, had few qualms about this prickly gentleman, but Renoir, like so many others, was a little more wary. Later that month, when Renoir invited Julie and her mother to dinner, along with Mallarmé and Durand-Ruel, he added that he wanted to invite Degas, but "I confess that I don't dare." Yet despite Degas' past fallings-out with Renoir and his reputation for (as Paul Valéry put it) "scatter[ing] wit, gaiety, terror" at those dinner parties he attended, Degas by 1894 seems to have been on reasonably good terms with Renoir—sufficiently congenial, in fact, to invite him to dinner, after which Degas took a photograph of him and Mallarmé together.[6]

～

The season's art events continued in April, with an exhibition of Manet paintings at Durand-Ruel's. A group of Independents, including Pissarro's son Lucien, were exhibiting in the annex of the Palais des Arts, while the Société Nationale des Beaux-Arts, re-formed in 1890 as an alternative to the official Salon, held its exhibit at the Champ de Mars. There, Whistler's portrait of Montesquiou (formally titled *Arrangement in Black and Gold*) at-tracted favorable attention. Like so many of Whistler's portraits, this one had required numerous sittings over the course of several years, and when at last completed, Montesquiou rushed away with his prize before the painter—notorious for clinging to his paintings—could change his mind. Montesquiou then lent the portrait to the Société Nationale des Beaux-Arts, where it was warmly received.

Eventually Montesquiou sold this splendid portrait for an enormous sum—a deed that infuriated Whistler, who felt ill-used. "I painted it for a

mere nothing," he mourned, "and it was arranged between gentlemen."[7] Ultimately Henry Clay Frick would acquire it, adding to the growing unease among the French about the number of French paintings vanishing across the Atlantic.

⌣

And life went on. Clemenceau, now in greatly reduced circumstances, moved to a modest ground-floor apartment with garden on Rue Benjamin-Franklin.[8] Here, where he would live for the rest of his long life, he wrote almost daily for his paper, La Justice, and entertained friends—mostly artists and writers.

Maria Sklodowska met Pierre Curie that spring and would become Marie Curie the following year. Zola was seen in the Tuileries gardens (by Madame Daudet, who reported it to Goncourt), scandalously walking his illegitimate family around this most public of places. And Debussy unexpectedly announced his engagement to Thérèse Roger, a soprano who had recently performed his work in public. Their wedding was to be on April 16, but many among Debussy's acquaintances were dismayed to learn that he had made no move to break off relations with Gaby, who still was living with him—presumably without knowledge of his marital plans.

Ernest Chausson, Debussy's friend and source of innumerable loans, indignantly wrote a close family member about Debussy's duplicity. Chausson was especially troubled about the lies that Debussy had told his future mother-in-law, and he broke with Debussy over this. Others in Debussy's circle were also dismayed. It was a difficult time for Debussy, during which he lost many friends, and in the end he called off the engagement.

That same spring, Oscar Wilde caused a sensation by appearing in Paris with Lord Alfred Douglas, where he was made much of by just about everyone except Montesquiou, who shuddered at his lack of discretion, and Whistler, who by now was a rival and bitter enemy. Many years before, a mutual acquaintance had introduced Wilde to the equally flamboyant and scathingly witty Whistler with the sly remark, "I say, which one of you two invented the other?"[9] But by now, the biting wit that shot back and forth between the two had developed a scorched-earth quality—especially as Wilde felt free to help himself to Whistler's better witticisms, adopting them as his own. This led to a famous exchange, prompted by Wilde's patronizing acknowledgment of one of Whistler's epigrams. After Wilde remarked that he wished *he* had said it, he was met with Whistler's prompt retort, "Oh, but you will, Oscar, you will!"[10]

In the meantime, Edmond de Goncourt was caught up in the furor produced by publication of the seventh volume of his *Journal*. Following the uproar that his previous volumes created, especially the most recent (published

in 1892), Goncourt had promised that this would be the last to appear during his lifetime. But then he changed his mind, and in April 1894 the seventh volume began to appear in serialized form in the *Echo de Paris*. Like the previous volumes, this, too, angered a number of its still-living subjects, who retorted in ways that Goncourt found painful. Goncourt was especially hurt by criticism from his good friend, the novelist Alphonse Daudet. Daudet's brother had a go at Goncourt first, but then Alphonse had his say as well, mentioning several personal references that had upset him. Bowing to friendship, Goncourt agreed to let Daudet look at the next volume before publication, with the option of cutting anything that offended him. But worse was yet to come, for in June, the *Echo de Paris* forwarded to Goncourt a particularly unpleasant commentary—an envelope full of soiled rags.

Hostility to the new seemed especially rife that spring in Paris, as the defenders of tradition—already shaken by the threat of political anarchy—took aim at what they regarded as cultural anarchy. Camille Mauclair (in the *Mercure de France*) indiscriminately attacked all contemporary painters, whether Gauguin, Toulouse-Lautrec, Cézanne, or Pissarro. The untimely demise of Gustave Caillebotte in February, at the age of forty-six, gave rise to an especially nasty hullabaloo. Caillebotte, who had played a key role in the Impressionist movement—both as a generous patron and as a painter of considerable talent—left his large collection of important Impressionist paintings to the state, with the stipulation that this collection be accepted in its totality, to be exhibited first in the Musée du Luxembourg and then in the Louvre. Caillebotte's bequest immediately set off an uproar reminiscent of the *Olympia* affair.

Renoir, who was designated as executor of Caillebotte's will, had the difficult job of negotiating a settlement that would come even close to what Caillebotte intended—a task made almost impossible by the degree of antagonism that Impressionist art still evoked. One of the most vocal of the traditionalist painters, Jean-Léon Gérôme, called the collection "garbage," while the prominent review *L'Artiste*, after attempting a questionnaire on the subject, concluded that Caillebotte's bequest was considered "a heap of excrement whose exhibition in a national museum publicly dishonors French art."[11] Not surprisingly, Caillebotte's bequest was not easily resolved and would remain an inflammatory issue for some time to come.

～

Oddly, Caillebotte's collection contained no works by Berthe Morisot, an omission that Morisot's friends took particularly to heart. Realizing that whenever the Caillebotte bequest was settled and its contents hung on

museum walls, Morisot would most unfairly be left out, Renoir, Mallarmé, and Duret began to pull strings to ensure that the state purchase one of her paintings, independent of the Caillebotte bequest, for the Musée du Luxembourg.[12]

The painting that they had in mind was one that had caught Julie's eye—*Jeune Femme en Toilette de Bal* (*Young Girl in a Ball Gown*)—featuring a young woman in a white ball gown draped with white flowers. Duret, who had hung the painting in a place of honor in his home, proposed that Mallarmé pull strings with the director of the Beaux-Arts, who was a good friend. As a result, while all the storm and furor over the Caillebotte bequest was going on, Morisot's devoted friends were able to make their case quietly to the curators of the Luxembourg and the Louvre. Without any notable fuss, a reasonable purchase price was agreed on, and the state bought *Jeune Femme en Toilette de Bal*, which headed for the Luxembourg well ahead of any of the paintings by Morisot's male colleagues in the Caillebotte bequest.

Renoir and Mallarmé continued to look out for the widowed Morisot in other ways as well. Shortly before the Manet exhibit, Renoir wrote to ask if he could paint Julie with Morisot, rather than Julie by herself, as previously arranged. Morisot agreed, and mother and daughter spent a number of pleasant spring mornings sitting for Renoir, followed by jolly lunches with the Renoir family. That summer, when Morisot (attracted by a poster in the Gare Saint-Lazare) took Julie on vacation in Brittany, Mallarmé and Renoir made a point of keeping in touch with her. While in town, Mallarmé escorted her and Julie to Sunday afternoon concerts, and invited her to the theater.

Berthe Morisot was still battling grief, but she was blessed with a lively, appreciative daughter and with friends who cherished her and cared deeply about her welfare. As Renoir once commented to Mallarmé, after a dinner with Morisot: "It must be said that any other woman with everything she has would find a way of being quite unbearable."[13]

⌁

One of the painters whose work Julie Manet saw and admired at the spring Duret sale was Paul Cézanne. "Above all," she confided to her diary, "it's his well-modeled apples that I like." She was not alone, for Cézanne, who had long before given up on Paris for his native Provence, was slowly gaining recognition in Paris. A big breakthrough came shortly after the Duret sale, where Julie Manet was not the only one to notice his paintings. On March 25, the influential art critic Gustave Geffroy wrote a very complimentary piece on Cézanne in *Le Journal*. "There is a direct relationship," Geffroy

wrote, "a clearly established continuity, between the painting of Cézanne and that of Gauguin . . . as well as with the art of Vincent van Gogh."[14]

Cézanne was pleased with the article, attributing it to Monet's influence. After all, Geffroy had long been one of Monet's biggest boosters, and the two were good friends. The upshot was that in November 1894, Cézanne left his Provençal sanctuary and traveled to Giverny to renew his long-standing friendship with Monet and to meet Geffroy. Until the last moment, Monet was afraid that Cézanne would not come. "He's so odd," he wrote Geffroy, "so afraid to see a new face that I'm afraid he'll give us a miss, despite his keen wish to make your acquaintance." He then added, "How sad that such a man hasn't had more support in his life! He's a true artist and has come to doubt himself overmuch. He needs encouragement."[15]

Cézanne did indeed summon up the courage to visit Giverny, arriving in late November. There, Monet introduced him to Rodin, Mirbeau, and Clemenceau, as well as to Geffroy. It was a happy occasion, although Cézanne's oddities sometimes startled the rest of the company—especially after he took Geffroy and Mirbeau aside to tell them tearfully, "He's not proud, Monsieur Rodin; he shook my hand! Such an honored man!" And the awkwardness must have been acute when Cézanne followed this up by kneeling before Rodin to thank him for actually having shaken his hand.[16]

Cézanne seemed to like Geffroy and asked to paint his portrait, with the hope of exhibiting it. At the time, Geffroy lived on the heights of Belleville, directly across from the Butte of Montmartre, and for three months Cézanne came almost every day to his apartment, painting and then lunching with Geffroy and Geffroy's mother and sister. Unfortunately, Cézanne at last gave up on the picture, saying that it "was too great for his powers," and returned to Aix. Still, "in spite of its unfinished state," Geffroy considered it "one of his most beautiful works."[17]

During the course of their many lunches and painting sessions, Geffroy came to value the passion and the faith with which Cézanne painted and, indeed, with which he conducted his entire existence. It was a rigorous life, conducted according to self-imposed standards. Not surprisingly, Cézanne imposed similar standards on his peers. Among contemporary painters, only Monet garnered Cézanne's praise: "Monet!" he would exclaim. "I would place him in the Louvre." For others, especially Gauguin, he had nothing but contempt. Gauguin, Cézanne would say angrily, had "stolen" from him, from Cézanne's own discoveries.[18]

But perhaps most characteristic of the man, according to Geffroy, was his enthusiasm. Only Cézanne could exclaim, with almost childlike gusto, "I will astonish Paris with an apple!"[19]

~

While Cézanne dreamed of astonishing Paris with an apple, Rodin was in the midst of a terrible struggle over his monumental Balzac sculpture. In May, an impatient committee from the Société des Gens de Lettres paid a visit to Rodin's studio and was alarmed to find that the sculptor had progressed no further than a nude Balzac—a disconcertingly realistic one, with an enormous belly. Rodin was searching for Balzac's very soul, and given the difficulty of this task, he could set no date for the sculpture's completion. And then, shattered by overwork and stress, he escaped Paris for a summer of peace and quiet in the countryside.

Unfortunately, the situation had not improved when he returned. The committee declared that the sculpture in its present form was "artistically inadequate," and yet there was strong feeling among some committee members that Rodin should be instructed to deliver it within twenty-four hours or return his sizable advance. Was it a question of the delivery date, or was it dissatisfaction with Rodin's vision? Or was it something else entirely? Some among the press, which soon learned of the affair, speculated that an unnamed sculptor who wanted the commission had prompted friends on the committee to do everything they could to upset Rodin and delay the sculpture's completion. Others believed that the entire imbroglio was simply a maneuver to prevent Zola's reelection as president of the Société.

In the midst of the clamor, there still were those who were trying to bring the affair to a positive conclusion. After quiet talks with the new president of the Société, Rodin agreed to place the commission on deposit until delivery was made, and he estimated that the monument would be finished within a year. The committee was satisfied with this arrangement and agreed. Unfortunately, this was not the end of the matter; troublemakers once again stirred the pot, leading the committee to try to reconsider its decision. At this point the Société's president and six committee members resigned.

Their resignation, on November 26, took place only two days before Rodin's luncheon at Giverny with Cézanne. It was not only Rodin's friendship with Monet that drew him there at this tumultuous time; it was also the presence of Geffroy and Clemenceau, both of whom had been his staunchest supporters throughout the entire Balzac affair. Rodin well understood the importance of standing by those who stood by him.

Soon after, yet another president of the Société met with Rodin and drew up a contract providing that Rodin's commission be put into escrow while he completed the statue, for which there would be no time constraints. It was an arrangement that gave Rodin his necessary freedom, even if it meant that he would now have to invest his own money to bring the work to completion.

But he still had to bring that work to completion—along with two separate monuments to Victor Hugo (for the Panthéon and the Jardin du Luxembourg) and *The Burghers of Calais*.

～

Throughout the last half of 1894, Debussy—now free from marital entanglements—was working on what would turn out to be three masterpieces: his opera, *Pelléas et Mélisande*; his early sketches for the three orchestral *Nocturnes*; and his *Prélude à l'Après-Midi d'un Faune* (*Prelude to the Afternoon of a Faun*). This last work, first performed on December 22, brought him his first success, even if no one at the time recognized it for the groundbreaking masterpiece that it was. Debussy had been inspired by Mallarmé's poem *L'après-midi d'un faune*, published in 1876 in a limited edition illustrated by Edouard Manet. In 1890, Mallarmé took note of young Debussy and asked if he would be interested in collaborating in a theatrical production of *L'après-midi d'un faune*. In the end, Debussy's inspiration did not take this particular form, but Mallarmé—although surprised when he first heard Debussy play the work on the piano—commented (as Debussy later recalled) that "this music prolongs the emotion of my poem and conjures up the scenery more vividly than any colour."[20]

The audience was similarly enthralled. As the conductor, Gustave Doret, later described the occasion, "I felt behind me, as some conductors can, an audience that was totally spellbound." It was, in his words, "a complete triumph," and accordingly he did not hesitate to break the rule forbidding encores. The critics, irritated by the encore, were less charitable, but in the years to come their reviews would disappear into the dust. As Pierre Boulez would later put it, in this work "the art of music began to beat with a new pulse."[21]

～

"Ultimately," Debussy wrote to a friend that summer, "we must just cultivate the garden of our instincts and officiously trample on the flower-beds all symmetrically laid out with ideas in white ties." No one had ever claimed that this kind of work was easy, and that autumn he wrote to the Belgian violinist Eugène Ysaÿe that he was "feeling like a stone that's been run over by carriage wheels."[22]

Across town from Debussy, on the Left Bank, Alphonse Mucha was experiencing much the same feeling—although his depression was due less to exhaustion from staying the course than to a sudden lack of work, coupled with the fact that it was Christmas. Alone and depressed, he found himself

proofing some lithographs for a vacationing friend. He was just finishing up when fate suddenly intervened—in the form of Sarah Bernhardt.

The manager of the print shop rushed in, all in a panic. Sarah Bernhardt, the divine Sarah herself, had just telephoned to demand a new poster for her current play, *Gismonda*. Not only that, she wanted it by New Year's Day. It was impossible! There were no available artists who could do such a job. And then the manager looked thoughtfully at Mucha. Could this young man, still virtually an unknown, produce a work that would please the great Bernhardt?

It was worth a try, and Mucha was more than willing. And so the young man set off for the glorious Théâtre de la Renaissance (which Bernhardt had bought after selling the Théâtre de la Porte-Saint-Martin), where *Gismonda* was playing. Enchanted with Bernhardt, Mucha immediately set to work creating the poster that would change his life.

Where did the ideas come from that set him off in this completely new direction, so unlike anything he had ever done before? No one knows, although it is true that for some time Mucha had been soaking up ideas from his colleagues at the *crémerie*. These influences included Symbolism and the Japanese art that were sweeping avant-garde Paris, as well as the curved, organic elements of the emerging Art Nouveau movement—although Mucha himself was convinced that his only source of inspiration was the Czech tradition of folk ornamentation.

But Mucha, much as Debussy advised, now cultivated the garden of his instincts, and the *Gismonda* poster that emerged was something uniquely and even startlingly his own. The manager and owner of the print shop were in fact horrified by what they saw; they sent the poster off to Bernhardt only because they felt they had no other choice. Sunk in gloom, Mucha awaited the verdict.

Bernhardt loved it. Summoning Mucha to the theater, she immediately signed him to a six-year contract to design not only posters but also sets and costumes. In time he would design her jewelry, advise her on hair styles, and select the material for her dresses off-stage as well as on. But it all began with his *Gismonda* poster. When it appeared on New Year's Day, it became the talk of the town. Nothing like it had ever been seen before, and the public scrambled to get copies. (A shrewd businesswoman, Sarah ordered four thousand more to sell at a profit.)

According to Mucha's son, Bernhardt became for Mucha "the ideal woman; her features and even the way she dressed, in flowing robes spiraling round her slim figure." These Mucha "transformed and etherealized" in his posters (he created a total of nine for her). He would soon become a successful designer, painter, and sculptor, eventually returning to the land of his

birth, where he spent the last thirty years of his life painting the epic history of his homeland.

By the end, all the posters and pursuits of his Paris years had become for him a frivolity. Yet it is as a poster artist that he is best remembered—not only of Bernhardt, but also of numerous unknown models, all beautiful and flower-wreathed, with swirling gowns and long, flowing hair. Despite his rejection of the term "Art Nouveau" ("Art is eternal," he protested, "it cannot be new"),[23] Mucha soon became its foremost exponent, leading many Parisians to refer to Art Nouveau itself simply as the "Mucha style."

∼

Yet while life in the theater, the art galleries, and the cafés—as well as in the slums—went on much as usual, Paris and all of France was about to be shaken by a storm far more devastating than the Panama affair and far more destructive than any anarchist bomb.

The ingredients for this social and political explosion had been present for some time: the festering wound to national pride inflicted by Germany in 1870–1871, and the corresponding humiliation suffered by the French army; the long-standing hostility between republicans and monarchists, and the comparable enmity between the Republic and the Church; an ongoing economic malaise, especially in the agricultural sector; and, most troubling of all, a rising tide of virulent anti-Semitism.

It was a nasty mix, but so far even the Boulanger affair and the Panama scandal—although coming dangerously close—had not been enough to ignite it. But now, in December of 1894, the fatal spark was about to emerge.

Its cause was the conviction of a young Jewish artillery officer for treason. His name, Alfred Dreyfus, would soon call forth the full range of fear, hate, and misguided national pride that was France's burden as the century drew to a close.

CHAPTER TWENTY-TWO

~

Dreyfus
(1895)

It was the ferocity of the crowd that stood out that bleak January day. The painter Eugène Carrière could see nothing of what was happening in the courtyard of the Ecole Militaire, but he caught the mood of the crowd from some little boys who had climbed up into the trees. When Dreyfus arrived, he heard them shout, "The swine!" And a few moments later, when Dreyfus bowed his head, they shouted, "The coward!"[1]

Two weeks earlier, on December 22, 1894, the senior Paris court-martial had unanimously found Captain Alfred Dreyfus guilty of giving secrets to the Germans and had sentenced him to deportation for life on Devil's Island—a desolate and fever-wracked penal colony off the coast of South America. His subsequent public humiliation came on the terrible day that Carrière witnessed, when Dreyfus's insignia was stripped from him and his sword broken, to the jeers of the crowd.

It was an appalling and unexpected end to what had appeared to be a promising career. Dreyfus, the last of thirteen children (seven of whom survived infancy), was born in 1859 into a family of wealthy and respected Alsatian Jews. When war came and the Germans wrested Alsace from France, the Dreyfus family made the decision to opt for French citizenship and (as required) move westward from their Alsatian home. Dreyfus, then a twelve-year-old, had witnessed enough of the war and its outcome to decide that he wanted to join the army when he grew up and rescue Alsace from German rule. He and his family dearly loved France—enough to upend their lives for it—and France's defeated but unbowed army.

Shy and sensitive, Dreyfus was not an obvious match for the military. But he forged ahead with his dream, winning admission to the elite Ecole Polytechnique and emerging as an artillery officer. That he was also a Jewish officer seems not to have been a problem—at least, not at first. The army he joined in 1880 was undergoing a complete shake-up and rebuilding, with modernization and—ultimately—revenge as its goal. Officer ranks were now filled in accord with merit, rather than by birth, a development that opened the doors to able outsiders like Dreyfus. But this army, held in high esteem by its defeated and humiliated nation, was also attracting an increasing number of young men from the aristocracy and from the conservative Catholic bourgeoisie (such as the family in which young Charles de Gaulle was raised). The army that Dreyfus joined had thus become, in addition to a democratized and modernized fighting machine, the last bastion of traditional and anti-republican values—one that republicans were wary of crossing.

This self-consciously elite organization prided itself on protecting France's honor, France's flag, and France's religion—the Catholic faith. Moreover, in its single-minded devotion to this mission, it came perilously close to denying the supremacy of the government it served and the laws of the land. This was the army that Dreyfus joined, with all initial appearances of brilliant success. Based on his thriving career, he married Lucie Hadamard, the daughter of a Parisian diamond merchant, and by 1893 was the father of two children.

Yet Dreyfus was not and never had been truly accepted by the army he loved. For one thing, unlike most of his associates, he was a member of the new industrial bourgeoisie rather than of the landed aristocracy or the traditional middle class, and his nouveau origins as well as his obvious wealth differentiated him, to his disadvantage. In addition, as a native of Alsace, he spoke German—the language of France's sworn enemy. But most importantly, in a period of rising anti-Semitism, he was Jewish.

Ever since the Revolution, Jews had been full citizens in France, without any restrictions on their citizenship. But this did not mean that anti-Semitism had disappeared from France. It remained at a low but real level for most of the nineteenth century until, during the early 1880s, it rose up in a markedly pervasive and virulent form. France was not the only nation experiencing this rising viciousness; it appeared first in Russia and Eastern Europe before sweeping into Germany and Austria, and from there into France. Perhaps the arrival of Jews from the east, escaping persecution, helped fuel the growing intolerance in France, especially in Paris, where most of these immigrants settled. But probably the most to blame was the full gamut of upheaval and challenges to the old way of life caused, or at least hastened, by the new industrial and increasingly urban society.

Hommage au Capitaine Dreyfus, *1985 (Louis Mitelberg, 1919–2002, known as Tim). Rue Notre-Dame-des-Champs at Boulevard Raspail, Paris. © J. McAuliffe.*

Anti-Semites did not, of course, recognize this, and in a kind of moral shorthand held the Jews responsible for what traditionalists described as the decadence of the times. The last years of the century in Paris were, of course, notable for their self-indulgence and dissipation. Yet despite the pride that the Parisian avant-garde and its hangers-on took in thumbing their noses at bourgeois morality, this segment of the population represented only a portion—albeit a highly visible portion—of what was roiling the waters. It was not only the avant-garde's deliberate disregard for traditional morality, or the new industrial capitalists' ostentatious display of wealth, but also anything embracing the new, such as Impressionism or Symbolism, that screamed of decadence to those anxious souls watching their old world and its values disappear. This rapidly disappearing world, remembered in nostalgic hindsight as reassuringly secure, had been replaced by one in which anarchist bombs killed innocent people and the wolf of poverty was at the door.

Times of high anxiety call for a scapegoat, and in the last years of the century, the growing number of French Jews provided the requisite target. In 1882, the collapse of the Catholic bank, the Union Générale, had been wrongly attributed to the Rothschilds and the large Jewish banks. A decade later, the Panama affair was blamed on those Jews who figured prominently in the scandal. In between, Edouard Drumont published his violently anti-Semitic book *La France Juive*, and in 1892 he founded the virulently anti-Semitic newspaper *La Libre Parole*. Whatever the problem—whether poverty, anarchism, or declining morality—Drumont denounced Jews as the culprits.

It was against this background that the Dreyfus affair began.

～

In late September 1894, General Auguste Mercier, the minister of war, received a troubling document from the Section of Statistics, aka the French Intelligence Service, which claimed to have gotten it from a charwoman whom it had hired to empty the wastebasket of the German military attaché in Paris and pass the torn bits along. This memorandum, or *bordereau*, informing the German military attaché of the dispatch of confidential French military documents, was unsigned, and the documents themselves have never been found. But the nature of the memorandum indicated a treasonous transaction—one of a series, in fact—and from the internal evidence, the traitor was an officer on the General Staff, probably an artillery officer.

There were few officers who met these criteria, and among them, Dreyfus stood out. Although the ministry was not originally seeking a Jewish scapegoat, it quickly found one in Dreyfus. As a Jew, he was already categorized as an outsider, and this quickly led to the conviction that, by his very nature, he was a spy and a traitor. Already convinced of his guilt, General Mercier

directed that Dreyfus be summoned to the ministry on October 15 for a handwriting test and then be incarcerated while awaiting court-martial. Not unexpectedly, the handwriting test showed some similarities between Dreyfus's writing and the *bordereau*; after all, handwriting as then taught produced general stylistic similarities from individual to individual. Those notable differences between Dreyfus's handwriting and that of the *bordereau* were handily accounted for by a bizarre theory of "self-forgery"—that is, Dreyfus had cleverly imitated his own handwriting, with enough differences that he could pretend that it was not his.

Abruptly plummeted into this Kafkaesque scenario, Dreyfus endured a series of ordeals without having the slightest idea of why he was being interrogated. When, after two weeks of incarceration, he finally was informed of the charges, he regained some hope that in confronting the accusation directly, he could demonstrate its complete absurdity. But to his dismay, he was told that the inquest was complete and that his only option was to confess.

Despite his despair, Dreyfus maintained his innocence, and minus this all-important confession, General Mercier was faced with the weakness of the case. Commandants Hubert Joseph Henry and Mercier du Paty de Clam, the officers charged with the inquiry, helpfully made up for this lack of evidence by fabricating some of their own, collected in what became known as the secret file. By now, the press had learned of the affair and, with *La Libre Parole* in the forefront, was snapping at General Mercier's heels, accusing the military of trying to hide a traitor. Fearful of the court-martial's outcome, Mercier directed that it be held behind closed doors, and that the perfidious secret file be submitted as evidence, while at the same time withholding its contents from the defense (a decision that alone made the trial illegal).

The outcome was foreordained. On December 22, the court-martial unanimously ruled that Dreyfus was guilty and sentenced him to deportation for life on Devil's Island, a harsh and disease-infested rock off the coast of French Guiana.

As far as the army and the state were concerned, the Dreyfus case was over. What they did not know was that the Dreyfus affair had only just begun.

~

Edmond de Goncourt was not convinced of Dreyfus's guilt. Listening to Carrière's description of the ghastly ceremony surrounding Dreyfus's military degradation, Goncourt caustically remarked that the judgments of the press were little better than those of the little boys who had catcalled from their perches high in the trees. In such a case one certainly could not establish the

innocence or guilt of the accused as did the crowd, from whether or not he stood upright or bowed his head.

Zola, too, was unconvinced of Dreyfus's guilt—or at least thought that some reflection was in order. Responding to the journalist (and ardent monarchist) Léon Daudet, son of the novelist Alphonse Daudet, who had enthusiastically described the scene surrounding Dreyfus's public humiliation, Zola was indignant. Without addressing the question of Dreyfus's innocence or guilt, he objected to "the ferocity of mobs stirred up against a single man." Even were he guilty many times over, he wrote, "under no circumstances should one appeal to the mob."[2]

But few at the time agreed with Goncourt or Zola. Clemenceau at this date thought that Dreyfus was guilty, and in a hard-hitting article he accused the judges of being too lenient. Even those among the Parisian avant-garde with Jewish roots, such as Pissarro and Marcel Proust (Pissarro's father and Proust's mother were Jewish), had not yet entered the lists on Dreyfus's behalf, nor had Thadée Natanson (also Jewish) so far engaged his prestigious *Revue Blanche*. Their time would come. In the meantime, members of Paris's artistic and literary circles preoccupied themselves with other matters, such as the still-to-be-determined fate of the Caillebotte legacy and the upcoming celebration of Puvis de Chavannes' seventieth birthday, in which both Rodin and Monet took prominent roles.

Rodin, who had just gotten himself off the hook for an imminent delivery of the Balzac monument, immediately turned around and committed himself to another huge project—an official monument to Argentina's first president. But nothing had been done for a year on Rodin's monument to Victor Hugo intended for the Panthéon, although he had made considerable progress on the Hugo sculpture for the Luxembourg Gardens.

There still remained *The Burghers of Calais*. For some time the mayor of Calais had been pressing Rodin on the project, and at length Rodin turned over the final stages of the work to his trusty assistant Antoine Bourdelle, who by January of 1895 was able to inform Rodin (with an appropriate exclamation point), "We can send the Burghers of Calais to the mold makers!"[3] Four months later—ten years after the project was initiated—*The Burghers of Calais* was at last installed on top of a five-foot pedestal in the heart of Calais. Rodin, who had envisioned the sculpture on something either higher or lower, was not entirely pleased with the results, although almost everyone else was. It would be several years after Rodin's death before this masterwork would be placed at ground level, as he desired.

As for Monet, he bravely spent the months of February and March in Norway, where he contended with winter weather and (ever the Frenchman) "horrid food." But he ended his visit with the comment to Durand-

Ruel that he was "not too unhappy" with the paintings he had done there. He proceeded to mount a major exhibit at Durand-Ruel's gallery, starring a grand total of twenty paintings of the Rouen cathedral. These were warmly received by colleagues such as Cézanne and Pissarro, but they typically created a ruckus among the older academic painters.

Yet it was not only the older but also the younger painters who now were hostile to Monet's latest work—placing Monet in the uncomfortable position of being considered behind the times among the younger set while still antagonizing the old guard. Nonetheless, with only a few exceptions, the Impressionists now were finding collectors willing to pay substantial prices for their work. Monet in particular was demanding and getting higher prices than ever. Degas and Renoir were also doing well, and even Cézanne was beginning to win recognition—as he demonstrated with his first one-man show (at Vollard's) later that year. In fact, of the original group of Impressionists, only Pissarro and Sisley lagged behind—as Pissarro noted in a touching letter to his son dating from that spring. "I rate poorly with the collectors," he wrote, adding, "I don't know why they are so frightened, for really my pictures are not inferior."[4]

Gauguin was also having a hard time. In February, before leaving once more for Tahiti, he attempted to raise some money by selling about fifty of his paintings, but did poorly. Unquestionably, the market for Gauguin paintings had yet to appear.

~

By this time Berthe Morisot, like the majority of her Impressionist colleagues, had become established, a painter with an appreciative, albeit small, audience. And yet she remained dissatisfied with her work, continuing to strive toward that simple but elusive goal of capturing the transient on canvas.

Following Eugène's death, she continued this search, painting Julie with ever quicker and looser brush strokes, as if to capture time itself. But time would not wait. Early in 1895, Julie Manet came down with a bad case of influenza. Morisot was alarmed and, despite enticing invitations from friends such as Renoir and Mallarmé, withdrew from social engagements to stay by her side. Julie eventually got better, but Morisot caught the contagion, which for a while she managed to ignore. But then her illness became worse, and soon it became clear that Berthe Morisot, the lovely pioneer of Impressionist art, was not going to survive.

Julie was inconsolable. "Oh, sorrow!" she burst out in her diary, a full month after Morisot's death. "I have lost Maman." After reliving some of her last moments with her mother, she concluded, "Oh, misery!, never did I think I would be without Maman." Morisot herself left a poignant letter for

her daughter, in which she told her, "My dearest little Julie, I love you as I die; I will still love you when I am dead; I beg of you, do not cry . . . you have never caused me one sorrow in your little life." And then, after providing for Julie's future, she concluded, "I love you more than I can tell you."[5]

Renoir's son, the future film director Jean Renoir, later told Julie that his father was painting with Cézanne in Provence when he heard the unexpected news of Morisot's death. Renoir took the next train back to Paris, where he rushed to Julie. She never forgot how he arrived in her room and put his arms around her.

Others were also deeply affected by Morisot's death. Mallarmé wrote Mirbeau that he was the messenger "of a truly terrible piece of news." Monet, then in Norway, was grief-stricken. Pissarro wrote his son, "You can hardly conceive how surprised we all were and how moved, too, by the disappearance of this distinguished woman."[6] Word traveled quickly among those who knew and loved her, even though, self-effacing as always, Morisot had not wanted any mass letter sent communicating her death. Instead, those closest to her were personally informed. Her funeral was similarly low-key: only intimate friends and family were invited to nearby Passy cemetery, where she was buried with her husband, Eugène, and brother-in-law, Edouard.

As with her marriage certificate, her death certificate described her as having "no profession."

⌒

"Jeannie, I leave Julie in your care," were Morisot's last words in her letter to Julie.[7] After Morisot's death, Julie—in accord with her mother's wishes— went to live with her orphaned cousins Jeannie (close in age to Julie, and a good friend) and Paule (twelve years older). All three lived in an apartment on the third floor of the house where Julie had lived before her father's death, watched over by an appropriate housekeeper (whom Mallarmé had provided).

Julie's guardians—Renoir, Mallarmé, and Degas—immediately began their shared watch over her, with Renoir taking her on a lengthy holiday with him and his family to Brittany. But the return to Paris was difficult for Julie, where every object in the apartment brought her mother to mind. Even Morisot's beautiful paintings made her daughter cry.

Going through Morisot's output in preparation for an exhibition at Durand-Ruel's in early 1896, Julie was especially moved by the watercolors that Morisot had long ago created to teach her to read. These included a woman in a boat on a lake, inscribed with the words "lady" and "duck," and a nursemaid and children playing hide-and-seek. Morisot had intended to make a whole album like this, to teach children how to read, but never completed it.

Memories of her mother intruded on Julie's seventeenth birthday celebration, on November 14. She occupied herself by copying the portrait of her mother with violets "by Oncle Edouard." By now this treasure was hanging in her bedroom, and she could see it from her bed. One would hardly believe, she marveled, that he did it "in one or at the most two sittings." In an interesting aside, she noted that her mother told her that she had sat for it before one of the dinners that used to be held at Grandmother Morisot's. That day, Edouard Manet told Berthe that "she ought to marry Papa and they talked about it for a very long time."[8]

Renoir and Mallarmé were by nature warm and congenial, and it was no wonder that Julie found them pleasant and reassuring company, but Degas was another matter. Surprisingly, he adored Julie, and she found nothing fearsome in him whatever. One day in late November, when Julie and her cousins visited Renoir, he asked if they would like to go to see Monsieur Degas. And so off they went to Degas' studio ("very cluttered," in Julie's opinion), where he was working on several sculptures. Degas covered all of his plaster maquettes with wet cloths before heading downstairs, arm in arm with Renoir. They then all trooped off to Vollard's gallery to see the Cézanne exhibition. There, Julie bought one of the paintings that Renoir admired, "thinking that it would be the sensible thing to do."[9] Degas expressed his approval, patting her affectionately under the chin. Later, he gave her a kiss as she left. And then Renoir paternally saw her and her cousins to the tram.

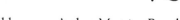

The problem wasn't that Maurice Ravel could not play well. He could perform quite well at the piano when he practiced—but all too often, he did not. As a consequence, he repeatedly failed to win the piano prize at the Conservatory and in July 1895 was dismissed from his harmony class. Devastated by this failure, Ravel abruptly quit the Conservatory, even though he could have remained on as a student in other classes. It was now that he began to focus more and more on composition, completing both the *Haberna* for two pianos and the *Menuet Antique* in November 1895.

Ravel's colleagues at the Conservatory considered his compositions "highly audacious," and Ravel, who at the age of twenty was already reaching for new harmonies, rhythms, and musical colors, had clearly begun to immerse himself in the heady currents of Paris's avant-garde. Described by a Conservatory colleague as "slightly bantering, intellectual, and somewhat distant," Ravel read Mallarmé and visited Satie—unquestionable credentials for life on the cutting edge. Unlike Satie, though, Ravel was no bohemian. Styling himself as a dandy, much like Baudelaire, he gave serious consideration to every element of his appearance. Yet according to Ravel's longtime

friend, the pianist Ricardo Viñes, this attention to the superficial was merely a mask. Behind this mask Ravel was attracted by all that was "poetry, fantasy, precious and rare, paradoxical and refined."[10]

While young Ravel was transferring his aspirations from concertizing to composition, Debussy was completing the first version of his opera, *Pelléas et Mélisande*. "I thought the second act . . . would be child's play," Debussy wrote his friend Raymond Bonheur, "and it's the very devil!" Debussy was now receiving a subsidy of five hundred francs a month from the perceptive publisher Georges Hartmann, but despite this aid to his financial security, he still was finding it difficult to earn a living as a composer. Complicating matters was his fear of what contemporary conductors or directors would do to his works, especially to his beloved *Pelléas et Mélisande*. "How will the world behave toward these two poor creatures?" he demanded of one friend. Debussy still fervently believed (as he had written Pierre Louÿs earlier in the year) that "I'm working on things which will be understood only by our grandchildren in the 20th century."[11]

∼

Within two years of her arrival in Paris, in 1891, Maria Sklodowska (who had learned to speak and write French fluently) received her advanced degree in physics from the Faculty of Sciences at the Sorbonne. She then promptly went on for a degree in mathematics, which she received the following year. It was then that she met Pierre Curie, a brilliant physicist who shared her passion for research, disdain for wealth and worldly trappings, and love for the simple things in life. "Women of genius are rare," he had written long before in his diary,[12] and now, as a thirty-five-year-old bachelor, he found in Maria the woman of his dreams. Their marriage in July 1895 was an uncomplicated affair, eschewing the usual white dress, gold ring, wedding breakfast, and most of all, religious ceremony (to accommodate the free-thinking Pierre Curie, the marriage was performed at the town hall in Sceaux). Afterward, with money given them by a cousin, they bought two bicycles, and for their honeymoon they bicycled along the byways of the Ile de France.

Emile Zola was similarly enraptured with his mistress and their two children, although not with his wife, who scared the daylights out of him. A highly emotional woman and by now an extremely jealous one, she took to shrieking at Zola, who had to shut himself up in his bedroom so as not to hear her. The worst of it, he confided tearfully to Daudet, was that for two years he had "gone in fear of seeing himself splashed with the blood of his children and his mistress, murdered by his wife."[13]

In a somewhat similar situation, Alexandre Dumas *fils*, the adamant foe of adultery, had for eight years been conducting a clandestine affair with a

young woman who was but a fraction of his age. Her name was Henriette Escalier, and since her teens she had been the unhappy wife of the architect Félix Escalier. Separated and at length divorced from him, she returned to the home of her parents, who were friends of Dumas *fils*. He had known Henriette since she was a little girl, and now he found her irresistible.

But what of his own wife, the half-mad Russian princess Nadejda Naryschkine—herself a married woman with a child when he first met her? They had become lovers (over the strong objections of the czar), and then, after the princess became pregnant with his child, they pretended for years that the princess had adopted an orphan. Only in 1864, upon the death of her husband, was Dumas *fils* at last able to marry the beautiful and volatile Nadejda and acknowledge his daughter, Colette.

But after Nadejda (whom her husband called "Nadine") suffered two difficult miscarriages and another pregnancy, her health declined. With moods swinging from lethargy to nervous irritability and jealous violence, her mental health was none too robust, either. As his romantic marriage disintegrated, Dumas *fils* found comfort in the arms of the lovely actress Aimée Desclée, followed by the beautiful Ottilie Flahault.

But while Aimée and Ottilie were content with their status as mistress, Henriette was not. She waited patiently during those many years while Dumas refused to leave his unbalanced and seriously ailing wife. By now, Madame Dumas was in her sixties, and in an acknowledgment of the failure of her marriage, had gone to live with her daughter. She died in April 1895, and Dumas *fils* quickly married his beloved Henriette.

Dumas *fils*, then seventy-two, knew that he, too, was ailing and did not hold much hope of lasting out the year. He was right. On November 28, scarcely three months after marrying Henriette, he died. Yet the story was not yet over, for there was money at stake. Dumas *fils* had been a remarkably successful playwright, but his daughter, Colette, found his fortune disturbingly smaller than anticipated. Not unexpectedly, she blamed the young widow for the missing francs, hinting that Henriette had managed to finagle a large sum of cash from Dumas *fils* before his death.

And so the family life of Dumas *fils*, begun with great expectation of fidelity and enduring happiness, ended in an old man's May-December marriage and his daughter's disgruntlement over the stepmother she viewed (with some reason) as an interloper and fortune hunter.

~

On October 19, the so-called Savoyarde bell—donated by the Savoy region of France—reached Sacré-Coeur. Weighing nineteen tons and boasting a circumference of almost ten meters and a height of more than three meters,

it was and remains the largest bell in the world, at least among those that can be swung. Not surprisingly, those undertaking to get it to Paris and up the Butte of Montmartre had a major job on their hands. A decade later, this monster bell would take its place in the bell tower of Sacré-Coeur, to be eventually joined by four other bells. But in the meantime, it was baptized in a solemn November ceremony as Françoise-Marguerite-Marie du Sacré-Coeur.

About the time that Françoise-Marguerite-Marie was making her stately progression to her final home, five-year-old Charles de Gaulle was trotting off to a school run by the Brothers of the Christian Schools of St. Thomas Aquinas, near de Gaulle's home in Paris's fifteenth arrondissement. Here he was subjected to rigorous discipline as well as sufficient education to prepare him for eventual admission (at the age of ten) to the great Jesuit institution the Collège de l'Immaculée-Conception, on Rue de Vaugirard.

Only a few months earlier Oscar Wilde had been convicted in England of "gross indecency" and sentenced to two years of hard labor, which he was serving at Reading Gaol. Wilde had deeply offended middle-class morality, both in Britain and in France, and having witnessed the resulting uproar, a significant number of Parisian aesthetes were backing off from their commitment to the Decadent and Symbolist movements. Some even went so far as to lash out at everything they had previously valued, to the extent of embracing respectability, patriotism, and ultranationalism.

In the midst of this aesthetic retrenchment, Louise Michel returned to Paris from her exile in London and resumed her speaking tours around the country in support of anarchist and workers' causes. Simultaneously, the first radical republican ministry took office, with a program of economic and social reform intended to fend off the challenge of socialism. But the radical republicans' proposed progressive income tax frightened enough conservatives in the Senate that, in short order, this government had to resign.

This was the year when a new shopping emporium, the Galeries Lafayette, opened on the Rue de la Chaussée-d'Antin, much to the delight of consumers, who had more goods than ever before to choose from. And those who enjoyed the thrill of vehicular crashes had a spectacular one to savor when, in October, a train barreled right through the Gare Montparnasse and landed, nose-down, in the Place de Rennes below.

But none of this mattered to Alfred Dreyfus, kept in solitary confinement in his brutal prison on Devil's Island. He had decided against suicide—he had determined to live. But the odds against his survival were tremendous.

"Write to me often, and tell me everything about you and our dear children," he begged his faithful and equally despairing wife. "[Your letters]

seem to speak to me in your beloved voice," he told her, "which helps me to live."[14]

Not long before this, Edmond de Goncourt, walking the streets of Paris, was almost overwhelmed by a sense of bleakness. "Never has Paris," he wrote, "struck me so forcibly as the capital of a land of madness, inhabited by lunatics."[15]

CHAPTER TWENTY-THREE

~

Passages

(1896)

On Monday, March 2, 1896, Julie Manet wrote in her diary that it was the anniversary of that terrible day when her mother had died. Already she was working to perpetuate her mother's artistic legacy. Later that day she went to the Durand-Ruel gallery, to prepare for the Berthe Morisot memorial exhibition. There she found Monet, who kissed her tenderly. Degas was busy with the hanging, while Mallarmé had gone to the printer's for the catalogue. And Renoir also showed up, although Julie thought he did not look very well.

By Tuesday, Julie concluded that everything was looking quite good, but Degas was being difficult over a large screen that served as a mount for Morisot's watercolors and drawings. Everyone but Degas wanted the screen moved to the end gallery, but Degas was adamant about keeping it in the middle of the largest gallery, where it cut the room in two. Monet then tried his hand at persuasion, asking Degas if he wouldn't mind at least trying the screen in the end gallery, but Degas insisted that the drawings on it would not be visible, and he thought more of them than everything else.

Mallarmé then weighed in, pointing out that it would confuse the public to see drawings in the midst of the paintings. "Do I care a jot about the public?" roared Degas. "They see nothing—it's for myself, for ourselves, that we are mounting this exhibition; you can't honestly mean that you want to teach the public to see?"[1]

Renoir chose this moment to suggest putting a couch in the middle of the room, which inflamed the peppery Degas even more. By then it had become dark, and Degas was pacing back and forth, fuming. Monet, by now also on

La Samaritaine, Building 1 (Rue de Rivoli, between Rue du Pont-Neuf and Rue de la Monnaie, Paris). © J. McAuliffe.

his feet, had begun to shout, and Mallarmé was trying to smooth things over. Renoir, exhausted, retired to a chair.

Soon the argument started up again, until Degas suddenly made for the door. Monet held him back, and they shook hands, but then Mallarmé made the mistake of uttering the word "couch." Degas bolted into the corridor, slamming the door behind him. They all left one another that evening "a bit dumbfounded, to say the least," Julie reported.[2]

The next morning Julie arrived before any of the others and continued numbering the paintings. Soon after, Monet and Renoir arrived. "You can bet Degas won't be coming," Renoir commented. "He'll be here later in the day . . . and will say, 'Can't we put a cord across the door to prevent people from getting in?'"[3] Sure enough, Degas did not show up, and in his absence his colleagues put the screen in the end gallery, with Morisot's watercolors and drawings hung on it.

The exhibition, Julie concluded happily, "looked marvelous."[4]

～

Others besides Berthe Morisot were slipping from the scene. In May 1896, James McNeill Whistler's beloved Trixie died, after a lengthy illness that had necessitated bringing her back to London to be nearer her family. Close friends such as Monet understood the depth of Whistler's loss and attempted to console him, but Whistler remained inconsolable. Even though he had kept his studio and apartment in Paris, he found that, after Trixie's death, the apartment they had shared held too many memories for him to return. In addition, his own poor health made it increasingly difficult to climb the many stairs to his studio. At last, he sadly agreed to let both go and returned to London, this time for good. He died there in 1903.

The great Symbolist poet Paul Verlaine also died in 1896, after a life of alcoholism, drugs, and debauchery. Recognized as "Prince of Poets" by the Symbolists and generally admired by the avant-garde (including Debussy and Fauré, who set some of his poems to music), Verlaine's unhesitating embrace of decadence had for years appalled Edmond de Goncourt and his colleagues. No prudes themselves, they nonetheless reacted with angry disbelief to the flurry of complimentary newspaper articles and graveside speeches surrounding Verlaine's death.

Verlaine's popularity had always baffled Goncourt, who the year before had attempted to figure it out. After some reflection he decided that one of the reasons for the enemies that he himself had encountered throughout his career was "the decency of my life." After all, he mused, this was an age with "a liking for unsavory conduct."[5] And Verlaine, he noted, although admittedly talented, was unquestionably unsavory.

It was not long after this reassuring internal conversation that Goncourt's self-esteem received a much-needed boost from the news that he was about to be elevated to the rank of Officer in the Legion of Honor. The ceremony itself turned out to be satisfyingly over-the-top, including a magnificent banquet in which he was feted and given glowing accolades by more than three hundred notables. The honoree was uncharacteristically moved by the tributes—among the best of which, in his eyes, was Zola's admission that his own work "owed something" to Goncourt.[6]

But the congratulatory atmosphere surrounding this celebration, held in what everyone expected was the twilight of Goncourt's career, did not last long. Publication of the ninth volume of Goncourt's *Journal* in May 1896 brought fresh recriminations and even a libel suit. "Really," he protested, "this ninth volume is causing me too much trouble, and I shall be lucky if I escape a recurrence of my liver complaint."[7]

He wrote this on June 19. On July 3, after spending the day with Mirbeau and other friends at Mirbeau's home in Clos Saint-Blaise, he took a late train back to Paris with his longtime friend Robert de Montesquiou, who regaled him with countless amusing anecdotes about the fading aristocracy of the Faubourg Saint-Germain.

It was Goncourt's last entry in the journal that he and his brother Jules had begun in 1851, which Goncourt had continued, alone, ever since his brother's death. Twelve days after his pleasant train ride with Montesquiou, Edmond de Goncourt was dead.

Toward the end of his life, he had anguished over the fate of the Goncourt name, worrying that he would die without knowing what would become of his academy. Yet despite the opinion of his solicitor and litigation by his natural heirs, Goncourt's entire fortune did eventually go, as he so fervently intended, to the establishment of an Académie Goncourt, whose purpose was to recognize the most outstanding of each year's current crop of French-language fiction. More than a century after Edmond de Goncourt's death, the Prix Goncourt remains a prestigious one, and Jules and Edmond de Goncourt's *Journal* has become a treasured legacy from their Paris.

～

In early 1896, the French government at last agreed to a settlement of the Caillebotte affair, accepting some—but not all—of the sixty-seven paintings that Caillebotte had donated to the state. The forty that made the cut included works by Monet, Renoir, Pissarro, Cézanne, and Sisley, with Monet (represented by eight paintings from his Argenteuil and Vétheuil years) and Pissarro (with seven) having the largest number in the group. All seemed well until the collection was at last hung in the Musée du Luxembourg, when

the Académie des Beaux-Arts sent a protest to the Ministry of Education, on the grounds that the Caillebotte legacy was "an insult to the dignity of our school." Taking a similar tone, the acerbic painter Jean-Léon Gérôme expressed his astonishment that "the State should protect filth of this kind!"[8]

Neither of these protests should have constituted much of a surprise. Both represented the old academic point of view, which was rapidly losing its foothold. Still, Gérôme's acidic comment indicated that what panicked these defenders of tradition was not only the threat to their own standing, but also a deeper threat to society. "The fact that the State has accepted such garbage," Gérôme stridently declared, "implies a substantial weakening of the moral fiber. There's anarchy everywhere, and nothing is done to repress it."[9]

The memorable opening night of Alfred Jarry's play, *Ubu Roi*, which took place in late 1896, could only have reinforced the alarm and contempt of Gérôme and others like him. To begin with, the director upset convention by turning down the house lights as the performance began, annoying many in the audience who felt that a good night at the theater involved the sport of watching each other. But most grating to the traditionalists was the fact that everything about the play, most especially its title character, overturned virtually every known dramatic tradition. What to make of a set that supposedly takes place in Poland ("that is to say: Nowhere") and consisted, on one side, of a bed and chamber pot on which snow was falling, and on the other, a dangling skeleton and a large palm tree around which twisted a large boa constrictor? (The set was the joint inspiration of Pierre Bonnard, Edouard Vuillard, and Toulouse-Lautrec.) And then there was the language, which was far from golden: the play's first word, resoundingly spoken, was "*Merde!*" And it proceeded from there.

Even more shocking, the title character was hardly the noble hero or even the traditional villain that audiences had come to expect. Instead, Jarry used his cruel, cowardly, and greedy antihero to satirize modern man and the bourgeois society he inhabits. Torn between disgust and amusement, the audience erupted in the kind of bedlam that had not been seen since the opening of Victor Hugo's *Hernani* in 1830 and would not be seen again until Stravinsky so memorably premiered his *Le Sacre du Printemps* in 1913. Members of the audience hurled insults at the actors and at one another while their neighbors laughed, applauded, or booed. It was in its own way a triumph for Jarry, who would become a legend—even if his play was quickly shut down.

∿

Like everyone else in their set, Misia and Thadée Natanson attended that first performance of *Ubu Roi*, but they also participated in a huge banquet

given that same day for Sarah Bernhardt, whom they adored. For all that Bernhardt was idolized everywhere from London and New York to Istanbul, she had never received any honors or recognition from her own country. ¯inally, in late 1896, a group of actors and writers decided to remedy this by ›rganizing a grand banquet in her honor.

It was her day and she reveled in it, from her grand entrance at the top of a dramatic winding staircase to the "Hymn to Sarah Bernhardt" at its conclusion. The entire crowd, which by then was mere putty in her hands, now moved to the Théâtre de la Renaissance, where Bernhardt regaled them with excerpts from some of her most famous performances, and poets read sonnets composed in her honor. It was a triumph, and at the afternoon's end, she stood, lips trembling and hands clasped to her heart, as flowers fell around her and the cheers of the entire audience thundered satisfyingly in her ears.

⌒

Sarah Bernhardt did not enjoy sharing center stage with anyone or anything, and so it was fortunate that she had not been present on the evening, only a few months earlier, when a portion of the great chandelier fell at the Opéra Garnier, killing one spectator and injuring many others. Not long after, this dramatic event inspired a colorful French journalist by the name of Gaston Leroux to write *The Phantom of the Opera*.

Leroux had embraced creativity from the start. As a youngster, instead of agreeing to join his family's thriving shipping business, he dreamed of becoming a writer, in the footsteps of Victor Hugo and Alexandre Dumas. This made no sense at all to his father, who insisted that he study law. Eventually Leroux capitulated and went to Paris, but there he lived flamboyantly, majoring in revels rather than in studies. Somehow, he managed to attain that elusive law degree, but his father did not live long enough to savor the moment. Dying prematurely, the senior Leroux bequeathed a large fortune to his young heir, who now added to his already considerable reputation as a man-about-town by going through the entire legacy in less than a year.

Now Leroux had to earn a living, but the law still did not interest him. Fortunately journalism did, and after a stint as a courtroom reporter, he became a foreign correspondent. When the fateful evening at the Opéra Garnier occurred, he was checking in at a variety of exotic trouble spots around the globe, covering simmering situations in Egypt, Morocco, and Korea. Eventually, showing exquisite timing, he would be on scene for the 1905 Russian Revolution as well.

How much of his foreign coverage was enhanced by a deft hand cannot be easily determined. Still, it was clear that when Leroux began a new career as a fiction writer, he not only was fulfilling a long-held dream but also was

embarking on something for which he had considerable natural ability. Novels came first, followed by mysteries (his *The Mystery of the Yellow Room* is a classic), before he hit on the story revolving around the great 1896 disaster at the Opéra Garnier—which he creatively handled as if it were a breaking news story, one that was absolutely true.

It turned out to be a mega-hit, generating fame and fortune for Leroux, who seemed as taken by his creation as anyone. Throughout the rest of his life (he died in 1927) he continued to insist that he had essentially served as a reporter for an amazing but true story, and that the Phantom of the Opera really did exist.

～

Montmartre nightlife continued to titillate Parisians as the century drew to a close, although the legendary cabaret Le Chat Noir—which had thrived in its second and final location with the assistance of its much-acclaimed shadow theater—finally closed in 1896, with the death of its owner and founder Rodolphe Salis. But now another Montmartre cabaret was about to become a legend. Its roots went back to 1860, when Paris incorporated Montmartre as part of the new eighteenth arrondissement, after the hated tax walls came down. Industrialization had already begun to chew up the nineteenth and twentieth arrondissements, but the higher portions of Montmartre remained relatively bucolic—except for those areas around the gypsum quarries, which had only recently closed. A small tavern now appeared on the backside of the Butte, at the corner of Rue Saint-Vincent and Rue des Saules. Over the next few years it would take several different names, until the painter André Gill created a memorable sign for it featuring a laughing rabbit clutching a bottle of wine and leaping out of a saucepan. Soon locals were calling the tavern the "Lapin à Gill," or "Gill's Rabbit"—a pun on Gill's name. From there it was only a step to "lapin agile," or "nimble rabbit." Thus the Lapin Agile was born.

The legendary Aristide Bruant bought the place in 1903 and leased it to Frédéric (Frédé) Gérard, who turned out to be as colorful in his own way as Bruant himself. Gérard soon turned the Lapin Agile into a hub of bohemian nightlife, somewhat on the order of Le Chat Noir. But unlike Le Chat Noir, the crowd that habituated the Lapin Agile during these years consisted largely of impoverished poets and artists, with names that had not yet become famous—such as Modigliani, Utrillo, Braque, Apollinaire, and Picasso.

～

A short distance but a world away from Montmartre and the Lapin Agile, another famed establishment was about to appear. At the age of forty-six,

César Ritz had established his name in numerous luxury hotels throughout Europe, but had not yet achieved his dream, a hotel of his own. He knew the kind of hotel he wanted, and he knew where he wanted it—in Paris.

And then, in 1896, much to his interest, Ritz learned that the building adjoining the Ministry of Justice in the Place Vendôme was for sale. He was ecstatic, even though his financial backers were not. The property was too small, they argued, and the price too high. But Ritz, who knew this part of Paris well (the property was right around the corner from the Voisin restaurant where he had once worked), believed that this moneyed quarter badly needed the kind of elegant hotel that only he could bring. He also knew that the property was the size he wanted. Despite his backers' preferences, he was not interested in creating a huge hotel. Instead, he wanted a kind of private mansion, one that would be (in his wife's words) "small, intimate, exclusive." Or, in his own words, "a hotel in which a gentleman would wish to live."[10]

With the help of some wealthy personal friends, Ritz managed to pull off the purchase and acquire the property. And then this dynamo, who originally hailed from a remote Swiss mountain village, set about making his dream a reality. The legendary Hotel Ritz was about to emerge.

⌒

About the same time that Ritz was acquiring the property that would soon become his famed hotel, Paris was building yet another bridge across the Seine—this one the beautiful and ornate Pont Alexandre III, connecting the Esplanade des Invalides with two new and enormous Right Bank exhibition halls, the Grand Palais and the Petit Palais. Much like these other structures, the Pont Alexandre III was part of the grand design for the upcoming Exposition of 1900, itself nicely timed to coincide with the turn of the century. But this magnificent bridge served an important diplomatic function as well. Named after Russian czar Alexander III, the ceremonial laying of its cornerstone in 1896 served as a symbolic affirmation of the Franco-Russian Alliance that the French had finally maneuvered into place only two years before.

Ever since the Franco-Prussian War, France had gone it alone, unallied with any other major European nation. During these years, France had nervously looked over its shoulder at Germany, whose alliance with Russia had played an important part in Bismarck's policies. But this diplomatic arrangement began to change in 1890, when—following Bismarck's resignation—Germany decided not to continue his policies with its neighbor to the east. This in turn opened interesting new opportunities for the French Republic. It was not that the czar's government had much taste for a republic, but it did find the prospect of loans from French bankers such as the Rothschilds enticing. In addition, the renewal of the Triple Alliance between Germany,

Austria-Hungary, and Italy, as well as an agreement associating England, Italy, and Austria-Hungary, prompted careful consideration. The outcome, after several years of careful prodding and maneuvering, was the Franco-Russian Alliance, leading in turn to the state visit of Czar Nicholas II to France in October 1896—a visible sign that France no longer was alone and vulnerable to German attack.

The czar's ceremonial arrival in Paris was a huge event, witnessed by nearly a million onlookers, including Julie Manet, who recorded her impressions as the great day approached. Three days out, she reported that the Champs-Elysées was being decorated for the czar's visit, with rows of white globes bordering the avenue and artificial white, pink, and red flowers in all the trees at Rond-Point (trees that had replaced those chopped down during the siege of 1870–1871). On the day of the czar's arrival, she had a bird's-eye view from a friend's balcony, from which she reported with amusement that first to be seen was an ordinary carriage carrying a gentleman "twiddling his moustache," followed by a second carriage bearing yet another mustache-twiddler. At length, though, the crowd began to ooh and ah, signifying that the procession had appeared.

The procession was suitably grand and appealed mightily to her artist's eye, with hussars "all in blue and mounted on lovely white horses" and turbaned Algerian troopers dressed "in the most delicious tones of almond green, red, yellow, with greatcoats which flapped in the wind, riding ravishing Arab steeds." But when the imperial carriage at last appeared, with the czarina dressed in white, Julie initially had little to say about the czar, although she would later report that he was blond and "looked very young," while the czarina "looked rather stiff and had a big nose." Julie snickered considerably, though, at the sight of the president of the Republic, Félix Faure, who by her account was sitting uncomfortably on the carriage's folding seat, where he seemed "very embarrassed to be where a child is usually seated," with his knees reaching his chin.[11]

The following day came the ceremonial laying of the cornerstone of the bridge dedicated to the current czar's father, Alexander III, the reactionary ruler under whom the Franco-Russian Alliance had been so lengthily negotiated. A noted actor declaimed verses that attempted to link, as gracefully as possible, the president of the French Republic with the imperial majesties of all of Russia, using the images of the rivers Seine and Neva. This in turn led to the laying of the cornerstone, containing a parchment which the notables had all signed.

Immediately afterward, a barge appeared, from which sixteen young girls dressed in white descended to present the czarina with a silver vase overflow-

ing with orchids. France was doing this event up properly, and rightly so, for with the Franco-Russian Alliance, France could boast (in the words of the poet François Coppée) that France now held "the center of Europe between the two jaws of a vice. At the first insult, we will tighten that vice."[12]

The Pont Alexandre III was the visible symbol of that deeply nationalist spirit.

~

François Coppée—the poet who expressed himself so belligerently on the subject of the Franco-Russian Alliance—was an extreme nationalist who would become one of the most strenuous opponents of Alfred Dreyfus. But throughout much of 1896, public clamor about Dreyfus virtually disappeared. Indeed, after Dreyfus vanished to his remote hellhole on Devil's Island, he was almost forgotten. His family and a few staunch sympathizers continued to work to prove his innocence, but without success. In the meanwhile, the army was doing everything in its power to cover up the steps it had taken to obtain his conviction. By autumn, the cover-up was growing, as compelling evidence appeared that pointed to the real culprit.

This new stage of the affair had begun earlier in the year, when Lieutenant Colonel Georges Picquart, the recently appointed head of the French Intelligence Service, made a disturbing discovery. Studying the latest gleanings collected from the German embassy, he found troubling evidence that the traitor in their midst was not Dreyfus but a certain Commandant (Major) Esterhazy. This Esterhazy possessed a surfeit of undesirable characteristics, having for many years been a chronic debtor with a dissolute life, a love of luxury, and a gambling habit. All of these negatives made him susceptible to betraying his country for much-needed cash. In addition, he was no patriot. Indeed, he had become deeply embittered because—despite his connections, which he used frequently and vigorously—France had not to date sufficiently recognized his merits.

In late August, Picquart's doubts about Dreyfus's guilt turned to certainty when he discovered a communication from Esterhazy whose handwriting was identical to that of the *bordereau* that had figured so large in Dreyfus's conviction. Worse yet, Picquart's perusal of the secret file led him to the conclusion that it contained nothing of any significance—certainly nothing sufficient to convict Dreyfus. The culprit, he now knew, was Esterhazy, but his superiors were not pleased by this discovery, which carried with it much peril for everyone involved in Dreyfus's conviction. A deep instinct for self-preservation now compounded the original fiasco, as Picquart's superiors refused to acknowledge Dreyfus's innocence. Refusing to back down from

their determination to keep him permanently on Devil's Island, with the entire scandal hushed up, they saw to it that Picquart was quietly transferred to Tunisia.

But the affair was gradually becoming the Affair. In May, Zola had published an article, "Pour les Juifs," in which he vehemently denounced the anti-Semitism surrounding Dreyfus's conviction. This led to a high-voltage response from the vitriolic anti-Semite Edouard Drumont, and an attack on Drumont from the Jewish writer Bernard Lazare. This in turn led to a duel between Drumont and Lazare, who now was becoming a champion of the Jewish cause. Then in September, *L'Eclair*—an anti-Semitic Paris newspaper with large circulation—drew attention to the "proofs" that had resulted in Dreyfus's conviction. Although these articles were fervidly anti-Dreyfus, with one of the documents misquoted to implicate Dreyfus ("scoundrel D" replaced by "that animal Dreyfus"), they created a sensation by indicating the existence of the secret file and the judicial abuse at the heart of Dreyfus's trial.

With the heat on, Commandant Henry went to work to create a new forgery, a so-called "discovery" that would end any ambiguity in the secret file and be devastating for Dreyfus and his supporters. But while the General Staff was consolidating its position, Dreyfus's family was now publicly fighting back. Following the revelation of the secret file's existence, Dreyfus's wife sent a petition to the president of the Chamber of Deputies in which she demanded justice for her husband. This petition was widely reproduced in the press. In early November, Dreyfus's brother Mathieu sent a pamphlet (written by Lazare) to all members of Parliament, as well as to every major journalist and personality in town, in which he reproduced the contents of the infamous *bordereau* in its entirety and underscored the essential point that the document did not contain the name "Dreyfus" but only the initial "D." Three days later, *Le Matin* created a sensation by publishing a facsimile of the *bordereau* (leaked by one of the original handwriting experts, who had kept a facsimile with the intent of selling it). Now, all that remained to close the loop was to identify the author of the *bordereau*. Mathieu Dreyfus immediately went on the offensive, creating a poster of the facsimile framed by letters by his brother, to show the disparities in the handwriting.

These developments, especially publication of the *bordereau*, created panic among the General Staff even as they began to disturb certain thinking people who had previously been convinced of Dreyfus's guilt. Yet despite these inklings of hope, there still was no hope for the deportee on Devil's Island. While Commandant Henry was busy creating his new forgeries to reinforce the original judicial crime, Alfred Dreyfus was being held in double

shackles in a malaria-infested hut—overwhelmed by the heat, tortured by insects, and unable to sleep. He managed to keep a journal for the first year and a half of this hell-like existence, but on September 10, 1896, he could no longer sustain the effort.

On that date, exhausted and broken, he flung it aside for good.

CHAPTER TWENTY-FOUR

~

A Shot in the Dark

(1897)

Sometime during the early part of February, a shot or shots rang out in Claude Debussy's apartment on Rue Gustave-Doré. His mistress, Gaby Dupont, had discovered a letter in his pocket which (in Debussy's words) "left no doubt as to the advanced state of a love affair, and containing enough picturesque material to inflame even the most stolid heart." The outcome was "Scenes. . . Tears . . . A real revolver . . . ," as Gaby grabbed for a gun. It is not clear who the other woman was, or whether Gaby was aiming at herself or Debussy, but fortunately no one seems to have been injured. The whole thing (again in Debussy's words) was "senseless, pointless, and [changed] absolutely nothing." As he remarked to his friend Pierre Louÿs, "You can't wipe out a mouth's kisses or a body's caresses by passing an india-rubber [eraser] over them."[1]

Sardonically, Debussy added that an eraser for removing adultery would be "a handy invention"[2]—and probably meant it. He certainly had no intention of changing his ways. Yet despite it all, Gaby stayed with him. Unfortunately, Debussy's eyes soon lit on yet another woman, the daughter of a successful Belgian painter, to whom he proposed. Fortunately for all concerned, she did not approve of his lifestyle or his financial prospects, and she flatly turned him down.

One wonders what kind of mincemeat a woman such as Sarah Bernhardt might have made of young Claude Debussy, but their paths do not seem to have crossed. In any case, by late spring of 1897 Bernhardt was sufficiently preoccupied with an upcoming face-off of potentially epic proportions with

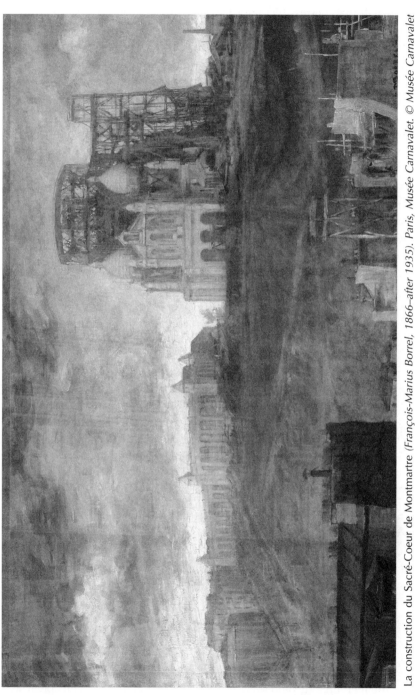

La construction du Sacré-Cœur de Montmartre (François-Marius Borrel, 1866–after 1935). Paris, Musée Carnavalet. © Musée Carnavalet / Roger-Viollet / The Image Works.

the great Italian actress Eleonora Duse. Learning that "La Duse"—in what could only be understood as a direct challenge—was planning to give her first performances in Paris at the end of the spring season, Bernhardt decided that the best course would be to warmly welcome her younger rival. Indeed, Bernhardt even offered to give her Bernhardt's own theater in which to perform, free of charge (a substantial gift, since under these terms all the box office receipts would go to Duse rather than being shared with the house). Duse accepted and then astounded Bernhardt by scheduling to play, not the Ibsen for which Duse was famous, but three plays directly from Bernhardt's own repertoire, including Bernhardt's trademark *La dame aux camélias*. In Bernhardt's own theater, no less!

Bernhardt was outraged, but she proceeded to welcome La Duse with open arms, even if her claws were barely hidden. The two circled each other in a series of encounters, each attempting to draw the first blood while pretending to be overcome with admiration for the other. La Duse bombed in *La dame aux camélias*, but she was impressive in her other vehicles. Bernhardt then proposed a kind of sudden-death ending to the affair by suggesting that the two appear together at an upcoming gala held to raise funds for a memorial to Dumas *fils*. It would only be appropriate, she suggested, that each perform separate acts from Dumas' *La dame aux camélias*. No fool, Duse opted for another work by Dumas, one better suited to her talents. This time she held her own with Bernhardt, ending the entire confrontation with a draw.

Bernhardt was not pleased, but she had the last word, as she so often did, by seducing Duse's lover. In the end, La Duse, who should have known better than to challenge Sarah Bernhardt on her own turf, retreated from Paris with good reviews and a badly broken heart.

～

Just as the Bernhardt-Duse confrontation was heating up, a tragic event occurred in the heart of Paris. There, on Rue Jean-Goujon (8th), seventy society women held a charity bazaar in a long wooden structure, large enough to hold twenty-two medieval-style booths. Decorated with gaily colored fabric and topped with a draped canopy, the event was a popular one and drew large crowds. Highlighting the attractions was a cinematography show, an early version of moving pictures.

But tragedy intervened when, on the second day of the show, the projector caught fire. Within minutes the flames had spread throughout the fabric-draped structure, engulfing the panicked crowd. When it was all over, the fire had claimed more than 125 victims—almost all of them women. Virtually all of the men present (and there were many) had managed to escape. It was rumored that these had beaten their way out with their canes, striking help-

less women en route to safety. It was also rumored that among these heartless escapees was Robert, Count de Montesquiou. Montesquiou, deeply offended, fought a duel over the slur.

～

Many prominent families were affected by this disaster and would in time build the beautiful chapel of Notre-Dame-de-la-Consolation on the spot, as a memorial to their lost loved ones. But outside these circles, life seemed to go on as if the tragedy had never happened.

On the Left Bank, Rodin had at last completed his sculpture of Victor Hugo for the Luxembourg Gardens and sent the model to a master crafts-man for enlargement, before exhibiting it in the 1897 Salon. But the master craftsman was experiencing bouts of rheumatism and could not complete the work. At last Rodin decided to exhibit his *Victor Hugo* in the Salon anyway, calling it a "study." Portions were held up by pieces of iron, and the arms were attached by straps. Of even more concern was the radical nature of the sculpture itself, which depicted the seated Hugo in the nude, surrounded by Muses and covered only by a swirling drape across his lap.

But Rodin need not have worried. Unlike his previous attempt to depict Hugo (for the Panthéon), this Hugo, although startlingly nude, was sur-rounded by acceptable-looking Muses.[3] The reviewers raved, and the praise kept pouring in throughout the three months during which the exhibition was open. With his Victor Hugo almost complete and his Balzac monument now in its finishing stages (Rodin's master craftsman was at work here, too), Rodin could at long last take some time off. That summer, he embarked on a trip to Bayreuth for the Wagner festival, and continued his vacation into the early autumn.

～

That September, Marie Curie gave birth to her first child, a daughter—a smiling, happy baby whom she and Pierre named Irène. Marie dearly loved her daughter, but neither she nor Pierre ever had any question about Marie becoming a stay-at-home mother. Soon after Irène's birth, Marie Curie re-turned to the laboratory. Both she and Pierre had become intrigued by some curious spontaneous emissions that Henri Becquerel had recently discovered, and she was studying this phenomenon for her doctoral thesis. Keeping careful notes on her daughter's development even as she dived into her lab work, Marie spent long hours in grueling research, systematically extracting, measuring, and analyzing in the unheated shed that Pierre had obtained for her in the Ecole de Physique et de Chimie Industrielles, the technical school where he worked.

During these same months, Berthe Morisot's daughter, now eighteen, was beginning to contemplate the mysterious realm of sex and marriage. Her curiosity was mixed with repulsion, such as the occasion when she saw Renoir un-bandage his arm. "I was frightened at the sight of all those hairs," she wrote. "How ugly men are!" she exclaimed, adding, "One certainly needs plenty of courage to marry them." Soon after, she observed that her cousin Jeannie thought it was a woman's duty to marry and have children, but Julie emphatically did not agree. "As for this duty," she wrote indignantly, "does it go as far as marrying someone you don't like just to populate France? If this is the case, it's a very harsh requirement."[4]

Her fleeting exposures to sexual images were similarly off-putting. A visit to the Folies Bergère left her thoroughly disgusted. Parents take *children* to a show like this, she fumed, children whom they would never allow to see a painting of nudes. For her part, she thought it far worse to show children "frightful women with plunging necklines, tightly-laced waists, and skimpy pantaloons." The Folies Bergère struck her as "unhealthy, in every sense of the word," and she determined that she was *never* going back.[5]

Of course this was the young woman who, since childhood, had been exposed to paintings and sculptures of nudes, which she viewed with complete composure. After all, the nude was an essential part of the artist's repertoire. It was not the human body that repulsed her—at least, not as it was depicted in art. What disgusted her was the sleazy tarting up of the human body, especially women's bodies, for male consumption. In this, her mother would have strongly agreed.

After all, both Berthe Morisot and Julie Manet were members of the *haute bourgeoisie*, which presumed (and demanded) a certain quiet decorum. Morisot had pushed the boundaries of her social milieu with her art, and Julie, who revered her mother, was quite prepared to do the same. Yet like her mother, Julie had no inclination for life in the fast lane, although she was inquisitive and open to new ideas. Thus she unwittingly shocked her aunt during the summer of 1897 by bringing a copy of Joris-Karl Huysmans' *A rebours* (*Against Nature*) to read while on vacation. The title, she said, sounded interesting. More than this she did not know, for the book had been published in 1884, when she was six, and so she had no inkling of the sensation it had created, especially for its depictions of homosexuality. Goncourt had called the hero (who was inspired in large part by Count Robert de Montesquiou) a "wonderful neurotic,"[6] and the Symbolists had similarly hailed the book for its aestheticism, mysticism, and daring depiction of decadence. But Julie's aunt—quite horrified—promptly disposed of it.

As it happened, Huysmans himself had wearied of his former subject and, by the time of Julie Manet's brief encounter with *A rebours*, had totally im-

mersed himself in Catholicism. In 1892, Edmond de Goncourt reported that Huysmans was spending every Sunday in church and—even more interesting—planned to spend his summer in a Trappist monastery. During the following years Huysmans continued on his spiritual quest, and by the late 1890s had become a leading literary figure in what was known as the Neo-Catholic movement.

As she grew to adulthood, Julie Manet, the child of non-practicing Catholics, was also becoming increasingly devout. Upon reading some of Marie Bashkirtseff's diary, she commented that she found it interesting to read, even though she thought the deceased artist painted badly. But this in turn led Julie to consider her own abilities, about which she was harboring doubts. "Until now," she wrote in September 1897, "I was very ambitious—I wanted to have real talent. Now I want only to be more than the young girl who paints fans and blinds, and perhaps in due course I won't even have that ambition." In a burst of piety, she then declared that "pleasing God is really the only true happiness."[7]

~

Many in Paris, of course, did not agree with Julie, and earlier in the year anticlerical republicans had made yet one more concerted effort to put a stop to Sacré-Coeur—despite the fact that this beacon for right-wing politics and conservative Catholicism was nearing completion. Its interior was already open for worship, and its great dome was almost finished. But despite the odds, the anticlerical opposition pressed forward once again with legislation to eradicate the detested symbol. By now, this would have involved indemnifying some thirty million francs to more than eight million contributors—a prospect that proved far too daunting for the Chamber of Deputies, which rejected the motion. Still, the 196 deputies who voted to remove Sacré-Coeur, at whatever cost, represented almost 40 percent of the total vote. Sacré-Coeur would continue to go up, but anticlerical feeling in Paris was far from dead.

~

That autumn, both Renoir and Rodin had their first encounters with speed, having decided to learn to ride the bicycle. Rodin invested in two expensive bikes (which he purchased in exchange for a bronze sculpture) but complained of his inability to get the hang of cycling. This evidently was the case, for he soon fell and broke his arm, leading him to swear off (and presumably at) his expensive acquisitions. In a dismayingly similar experience, Renoir also broke his arm, leading him to fulminate against "all the latest mechanical contraptions," most especially automobiles, which he thought

were "idiotic."[8] After all, they served no useful purpose—there was no need to go so fast.

Unquestionably, Renoir was becoming more conservative as he grew older, railing at the change he saw upending everything around him. His particular bugaboo was mechanization, which he blamed for a raft of horrors, including ills from France's growing empire. "The gentleman who has a factory making 100,000 pairs of socks per day," he pronounced, "can't always find an outlet for them." As a consequence, "we have to sell socks to the savages, and persuade them that they have to wear socks in order to keep some gentleman's factory going." And in an observation with which Pissarro would have fully agreed, Renoir emphatically concluded, "We want to conquer in order to sell our products."[9]

Pissarro, of course, had for many years been politically far to the left of Renoir and the other Impressionists (who with the exception of Degas had been of a liberal bent), but even he was feeling the winds of change sweeping past him. The Symbolist painters, especially Bonnard, appalled him, while the Revue Blanche seemed hostile. At the same time, the American market—so successful for Monet—had thus far been closed to him. "The Americans can't get used to my painting, which is too sad for them," he concluded.[10] Still, his 1896 exhibition at Durand-Ruel's was a success, and if it hadn't been for health problems and the demands of his large family, he would have been content. "Is it that I am getting too old?"[11] he wondered—a lament that intensified with the death in late 1897 of his beloved son Félix, known as Titi.

In a touching tribute published in Le Journal, Octave Mirbeau wrote of Félix's fine qualities and artistic talent, and then turned his consideration to Pissarro himself. Here was a man, said Mirbeau, "surrounded by five sons, all of them artists, all different!" Amazingly, he "doesn't impose on any of them his theories and doctrines, his way of seeing and feeling. He cultivates instead the flower of their individuality."[12] Pissarro had in Mirbeau's view achieved high marks, not only as an artist but as a father.

Pissarro was touched by this tribute, but characteristically said nothing about himself. To his son Lucien, still in England, he merely wrote: "Mirbeau has written a remarkable piece about our poor child."[13]

⟋

Monet, too, had a large family, and that summer he faced a difficult family situation. His eldest son, Jean, had fallen in love with Alice's daughter Blanche Hoschedé, and the two wished to marry. Although not brother and sister, they had been raised in the same household, and this disturbed Monet greatly. But Alice was enthusiastic about the match and pushed through marriage arrangements, including the decision to exclude Pissarro from the

guest list—on the grounds of insufficient social standing (a decision that no doubt encompassed Pissarro's radical politics and scruffy appearance, but most probably was based on the fact that Pissarro's wife came from peasant stock and, before marriage, had been a maid to Pissarro's mother). It was an unpleasant omission, leaving Monet with the awkward task of having to apologize to his old friend.

The friendship between Monet and Pissarro went back many years, as did both men's friendship with Sisley and Renoir. One evening Renoir told Julie Manet that when he was young, he used to go to Fontainebleau with Sisley, equipped with only a paintbox and a change of shirts. "We would walk until we found a village," he continued, "and sometimes only come back a week later when we had run out of money." Even then, Pissarro was the scruffiest of the friends, and when Renoir first met him, he "mistook him for an accordion player."[14]

Renoir enjoyed reminiscing for Julie's benefit, regaling her with his opinions on a variety of subjects, from the state of the modern world to his literary preferences. As for the current crop of writers, he had his reservations. His taste ran to the novels of Dumas *père*, which he vastly preferred to those of Zola. Art must be amusing and understandable, he told her, saying nothing of what he thought of the work of his good friend Mallarmé, who had defined poetry as "the expression of the sense of mystery in the aspects of existence." Mallarmé's poetry was considered inaccessible and difficult, but Julie did not agree. Whenever she heard Mallarmé's poetry, she wrote in her diary, "I find it beautiful and I have to ask myself why it's supposed to be 'incomprehensible.'. . . I really believe I understand it."[15]

∼

In November 1897, the Dreyfus Affair suddenly blew into life with volcanic force when Dreyfus's brother Mathieu publicly denounced Esterhazy as the real spy, the author of the memorandum that had falsely served to convict Alfred Dreyfus. Mathieu had received his information by chance, when a certain stockbroker by the name of de Castro happened to buy one of the facsimiles of the infamous *bordereau* juxtaposed with Alfred Dreyfus's handwriting that Mathieu had so widely distributed. De Castro was shocked to recognize the handwriting in the *bordereau* as that of one of his clients, a Commandant Esterhazy, and quickly contacted Mathieu Dreyfus, bringing Esterhazy's letters with him. There could be no doubt—they were identical. Mathieu now knew what the minister of war and the General Staff had known, and been attempting to cover up, for more than a year.

Stunned, Mathieu arranged for an urgent meeting with Auguste Scheurer-Kestner, the respected former deputy from Alsace and vice president of the

Senate, who for several months had been expressing his fervent belief in Dreyfus's innocence, even while steadfastly refusing to reveal the evidence upon which he based his statements. Scheurer-Kestner was the roundabout recipient of information from the disgraced (and virtually exiled) Georges Picquart, who had confided his secret knowledge to a trusted friend, who in turn confided it to Scheurer-Kestner, again upon an oath of secrecy. When Mathieu Dreyfus began his meeting with Scheurer-Kestner by shouting, "I am going to tell you the name of the traitor. It is Esterhazy," Scheurer-Kestner was only too glad to confirm what Mathieu had in fact learned from someone else.

Le Figaro first leaked the news, in an article that presented the essential facts without giving Esterhazy's name. Alarmed, newly promoted lieutenant colonels Henry and du Paty de Clam met with Esterhazy (with whom they had been colluding since October) to write a similarly anonymous article for La Libre Parole, to claim that the officer in question was innocent and being framed by Picquart and the so-called Jewish syndicate. This prompted Mathieu Dreyfus to respond with his letter, in which he named Esterhazy as the true author of the bordereau.

In the subsequent uproar, the military opened an investigation. Mathieu Dreyfus brought the facsimile of the bordereau and the letters from Ester-hazy that he had received from de Castro. Esterhazy in turn claimed that Alfred Dreyfus had traced Esterhazy's handwriting from a specimen he had obtained. This first investigation ended with Esterhazy cleared of suspicion and Picquart (whom Henry, du Paty de Clam, and Esterhazy had framed) in trouble. But the council of ministers was not satisfied and ordered a new investigation.

This in turn appeared to be headed the same direction as the first, with the enthusiastic support of the press, which exalted Esterhazy as a splendid French soldier whom the Jews were attempting to implicate for the crimes committed by Dreyfus. And then, an irate former mistress of Esterhazy stepped forward with letters from her former lover that contained extreme diatribes against France and its military. Le Figaro published the worst of it ("I would not hurt a puppy, but I would have a hundred thousand Frenchmen killed with pleasure"), but Esterhazy claimed a forgery, and much of the press came to his defense. In any case, as one of his defenders argued, "Who has never had such fits of anger?"[16]

Yet by now, an increasing number of thinking people were beginning to question Dreyfus's conviction. The injustice of Dreyfus's trial and sentence had already galvanized into action Emile Zola and a young Jewish lawyer and literary critic by the name of Léon Blum. By late 1897 Georges Clemenceau had also reversed his initial position and joined the Dreyfusards. Clemenceau

had only recently left *La Justice* for the newly established *L'Aurore* where—after being convinced by his good friend Scheurer-Kestner that the Dreyfus case should be investigated—he began to write insistently on the issue. At first he limited himself to attacking the grave irregularities of the trial, but soon he evolved into a combative defender of Dreyfus's innocence. On November 30 and December 2, he entered the fight in earnest, asking, "Who is protecting Commandant Esterhazy? . . . What secret power, what unstatable reasons are countering the action of justice? Who is obstructing its path?"[17]

In the meantime, the panicked General Staff was busy trying to stave off all efforts to get to the bottom of the matter by turning aside any and every effort to examine the forged documents at the heart of Dreyfus's conviction. The second inquiry was heading toward a dismissal of charges, when it occurred to the General Staff that in order to put the entire unfortunate affair behind them, it would be necessary for Esterhazy to ask to be heard before a court-martial. This was an entirely safe option, they reasoned, for he most certainly would be acquitted, leaving Dreyfus's guilt established for good.

While the army expressed its indignation that its officers (read Esterhazy, not Dreyfus) were "criticized and subject to suspicion," the right-wing deputy and monarchist Count Albert de Mun harangued the Chamber of Deputies on the subject of the Jewish syndicate. "We must know," he solemnly stated, "whether it is true that there is in this country a mysterious and hidden power strong enough to be able to cast suspicion at will on those who command our Army. . . .We must know whether such a hidden power is strong enough to overwhelm the entire country."[18]

The Chamber wildly cheered de Mun, but elsewhere flickers of doubt were continuing to emerge. "How horrible it would be," wrote Julie Manet on December 23, "to have condemned this man if he isn't guilty"—and then she quickly brushed aside this thought, adding, "but it couldn't possibly be so."[19]

CHAPTER TWENTY-FIVE

~

"J'accuse!"

(1898)

There is no Dreyfus Affair."[1] This was the solemn pronouncement of Prime Minister Jules Méline in December 1897, shortly before the Senate unanimously passed a motion approving everything the government had so far done to determine Dreyfus's guilt.

The anti-Dreyfusards cheered at the news and proceeded to dump yet more invective on what they termed the treasonous Jewish syndicate. Yet the Dreyfus case was not completely over, at least as far as the General Staff was concerned, for there remained the necessity of having Esterhazy acquitted by court-martial. This began in early January 1898, after a month of careful preparation by the General Staff, which in turn passed along detailed instructions and advice to Esterhazy via Henry and du Paty de Clam.

In particular, this meant finessing the handwriting analysis, which was easily accomplished by concluding that the *bordereau* had been forged (to compromise Esterhazy) and by disallowing comparisons with Dreyfus's handwriting (on the grounds that this would "taint an established verdict"). From then on, the outcome was reached with remarkable speed. Esterhazy was allowed to testify in public, where he assumed the role of a noble and much-abused warrior, while Picquart's testimony was taken in secret, behind closed doors. After a travesty of a trial, capped by deliberations that took no more than three minutes, Esterhazy was unanimously acquitted. Soon after, the smiling Esterhazy was carried in triumph by his fellow officers through the frenzied crowd. "Long live Esterhazy!" the mob shouted as he passed. "Long live the army!" And more ominously, they cried, "Death to the Jews!"[2]

Place Alfred-Dreyfus at Avenue Emile-Zola, Paris. © J. McAuliffe.

While Esterhazy was cheered as a hero, Picquart—who had been roughly treated for implicating the top brass—was immediately arrested, pending indictment on a variety of trumped-up charges, and taken to the fortress on nearby Mont-Valérien. Just as quickly, the Senate stripped Scheurer-Kestner of his long-held position as vice president of the Senate.

But even before hearing the news, Emile Zola had retreated to his house on Rue de Bruxelles, at the foot of Montmartre, and locked himself in his study, where he began to work feverishly. Like Clemenceau, he, too, had visited Scheurer-Kestner, and by this time Zola was not only convinced of Dreyfus's innocence, but was equally convinced that the secret file used to convict Dreyfus was a sham. In response, in late 1897 he had begun to write a series of articles for Le Figaro, with the first defending Scheurer-Kestner's wisdom and passionate commitment to truth and justice. He next proceeded to Dreyfus, and to Zola's certainty of the convicted man's innocence. Zola's last article for Le Figaro zeroed in on the moral tragedy that the Dreyfus Affair spelled for France. After this, the invective that poured in was so intense that it forced Le Figaro to stop publishing his articles and to dismiss its editor.

With no major newspapers still willing to accept his articles, Zola began to publish pamphlets at his own cost, appealing to the students of the Latin Quarter and then to all of France to fight for the truth and to redress the terrible wrong that was gnawing at the nation's very heart. The mid-December death of his longtime friend Alphonse Daudet seemed to elevate the stakes. Of the original group of four companions—Flaubert, Goncourt, Daudet, and Zola—only Zola remained. Speaking at Daudet's funeral, Zola was almost overcome with emotion. "We were four brothers," he said. "Three have already departed. I remain alone."[3]

Zola, as Goncourt so memorably recorded, had spent years in self-aggrandizement and self-involvement. But the fiery Zola of old had begun to reemerge. "Truth is on the march, and nothing will stop it," he avowed,[4] and he now took up the standard in earnest, with full knowledge of the damage that this would do to his career, especially to his long-held dream of entering the Académie Française. Esterhazy's acquittal did not surprise him, as it did so many among Dreyfus's supporters. The only recourse, he realized, was the court of public opinion, but someone would have to mobilize it. And there was virtually no one else with the national and international audience that he then enjoyed.

And so Zola set to work on a fiery twenty-page summary of the entire case, simplifying its Byzantine complexity in terms that the general public could understand. He wrote it in the form of an open letter addressed to the president of the Republic, and he ended with a passionate series of accusations that rang out like rifle shots, targeting Colonel du Paty de Clam, General

Mercier, and four other generals, as well as the entire War Office. Originally, he had intended to publish this as a brochure, but with Clemenceau's encouragement he decided to publish it in *L'Aurore*. And so, on the evening of January 12, 1898, Zola delivered this bombshell to the offices of *L'Aurore*.[5]

It was Clemenceau who came up with the title that would ring through history: "J'accuse."

⌒

"When the truth is buried underground," Zola wrote in "J'accuse," "it grows, it chokes, it gathers such an explosive force that on the day when it bursts out, it blows everything up with it."[6]

He had not underestimated the explosive force of his open letter, which *L'Aurore* spread broadside throughout Paris on the morning of January 13—with a special edition of three hundred thousand copies, hawked by several hundred news criers. The impact was immediate and ugly. Mobs demonstrated in the streets, burning Zola in effigy and hurling the remnants into the Seine. More mobs gathered outside his residence (whose address *La Libre Parole* had published), shouting invectives and hurling stones through his windows. Anonymous threats and packages containing excrement arrived at his door, and not-so-anonymous threats appeared in the press, most especially in *La Libre Parole*, which called for sacking his house and even for his assassination. Other members of the press loudly demanded his trial, imprisonment, or execution. Worse yet, mobs rioted and sacked Jewish quarters in most of the larger towns and cities throughout France, while in Algiers, Jews were killed and their shops destroyed. On February 7, in the midst of this hysteria, the government—prodded by the army and the political Right—brought Zola to trial for libel.

It was, of course, what he had dared the government to do, in every line of his open letter, most specifically in his last sentence: "Let them dare then," he had written, "to carry me to the court of appeals, and let there be an inquest in the full light of the day! I am waiting."[7] Convinced that all other avenues to justice were closed, he had decided that the only way to bring the truth to light was through a civil trial—his own.

It was, as the socialist leader Jules Guesde called it, "the greatest revolutionary act of the century."[8] It was also a far riskier step than Zola yet knew. Although he had not gotten every detail right, nor did he yet know about the role of Colonel Henry (which he ascribed to du Paty de Clam), he had been astonishingly accurate in his overall portrayal of the affair. So accurate, in fact, that it was imperative for those he had exposed to shut him down. Zola had hoped and expected that a civil trial for libel would allow him to bring the truth of the Dreyfus Affair into broad daylight, to strengthen his

and others' demands for Dreyfus's retrial and exoneration. But when the citation reached him, he found that he had been outmaneuvered. The charges against him were extraordinarily narrow, dealing with only one of his accusations—that Esterhazy's court-martial had knowingly acquitted a guilty man. This meant that the rest of Zola's charges—the bulk of "J'accuse"—could be ignored in court, and the entire Dreyfus Affair kept under wraps. It also meant that Zola's own conviction became ominously certain.

Still, as the opening day of the trial approached, a new wave of supporters was entering the Dreyfus camp. Young Marcel Proust and his brother headed up a petition calling for a *revision*, or review, of the original Dreyfus verdict, which quickly collected three thousand signatures—including that of Anatole France, who had previously not been a Dreyfus supporter but who now told the young men, "I'll sign, I'll sign anything. I am revolted."[9]

Most of those who signed were intellectuals, a previously little-used descriptive that anti-Dreyfusards were quick to use pejoratively but that Clemenceau rescued for proudly positive use when he called this petition—published daily for almost a month in *L'Aurore*—the Manifesto of the Intellectuals. In addition to Anatole France, these *intellectuels* included Octave Mirbeau, Emile Duclaux (director of the Pasteur Institute), and numerous other scholars, scientists, writers, and thinkers. Despite approaching elections, a few political figures were also beginning to join the Dreyfusards, including the socialist leader Jean Jaurès. Socialists had previously kept their distance from the Dreyfus Affair, on the grounds that it amounted to little more than a conflict between two sectors of the privileged class and did not concern them. But on the day that "J'accuse" appeared, Jaurès suddenly saw the danger and took vehement umbrage at his fellow deputies, most of whom were taking great pains to kowtow to the army and to the political Right. "I tell you," he bellowed from the proscenium of the Chamber of Deputies, "that you are in the process of delivering over the Republic to the generals!"[10]

Sarah Bernhardt was an especially passionate supporter of Dreyfus—no surprise, given her Jewish heritage and frequent encounters with anti-Semitism. But to her dismay, her beloved son, Maurice, was openly anti-Dreyfus and staunchly aligned with the fashionable crowd that supported the army, the political Right, and the Catholic Church. Proust's family was similarly divided, with a Jewish mother and an adamantly anti-Dreyfusard father, who did not speak to either of his sons for some time following their active role in the Manifesto of the Intellectuals.

Winnaretta Singer, now the Princesse Edmond de Polignac, firmly believed in Dreyfus's innocence but did her best to steer a middle course through the uproar, in an attempt to keep friends of diametrically opposite

persuasions behaving civilly to one another. It was no easy task, as "J'accuse" unleashed a perfect storm of fear and fury. Right and Left, monarchism and republicanism, ardent Catholicism and equally ardent secularism had somehow coexisted since the birth of the Third Republic, but these opposing camps, which had been at loggerheads ever since the Revolution, were descending into warfare once again.

Pissarro had already taken his stand alongside his old friend Zola, although—despite his own Jewish roots—he had originally shared with fellow left-wingers a certain disinterest in the fate of the well-to-do Dreyfus. But he soon determined that the real enemy here was the unholy combination of the generals and the Church. As he put it to his son Lucien, "it is becoming clear now that what we are threatened with is a clerical dictatorship, a union of the generals with the sprayers of holy water."[11]

Monet, too, was quick to congratulate Zola on his articles in Le Figaro and especially on "J'accuse." "My dear Zola," he wrote on January 14, "bravo again and with all my heart for your gallantry and your courage."[12] Monet also signed the Manifesto of the Intellectuals, his name appearing in the January 18 edition of L'Aurore along with other statements of support for "J'accuse," including one from Louise Michel.

Later, Monet expressed his thanks to Clemenceau for his "fine campaign on behalf of right and truth"[13] by giving him a painting that Clemenceau had long admired (it still hangs in Clemenceau's apartment on Rue Benjamin-Franklin, now the Musée Clemenceau). Nevertheless, Monet kept his distance from Zola's trial, pleading ill health, and refused to join the League of the Rights of Man, formed in February 1898 to promote human rights and justice, in particular a retrial for Dreyfus. "As to taking part in some committee or other," he replied, "that's not my business." Although "capable of impulsive generosity and monumental bad temper," his biographer Daniel Wildenstein observes, Monet remained "a conciliator or moderate who deliberately left it to others to adopt heroic attitudes."[14]

Despite the Impressionists' inclination to combine progressive politics with avant-garde art, they were hardly of one mind on the Dreyfus Affair, and in fact were as badly divided on the issue as was so much of Paris. Degas, the most conservative of the group, was adamantly anti-Dreyfus and adamantly anti-Semitic as well. Shortly after "J'accuse" appeared, Julie Manet went to his studio to invite him to dinner and found him "in such a state about the Jews" that she left without actually inviting him. Renoir, as it turned out, was also deeply anti-Semitic. The Jews, he railed, "come to France to earn money, but if there is any fighting to be done they hide behind a tree." Contemptuous of Pissarro and his sons for being Jewish, he added, "It's tenacious, this Jewish race. Pissarro's wife isn't one, yet all the children are, even more

so than their father."[15] In this spirit, when Thadée Natanson asked Renoir to sign the Manifesto of the Intellectuals on behalf of Dreyfus, Renoir abruptly refused. Renoir was of course a good friend of the Natansons, despite the fact that Thadée was Jewish, and subsequently remained on cordial terms with them both; but it was not Thadée who drew Renoir to the Natansons' country house in Valvins. Renoir adored Misia and continued to paint her after she and Thadée split up and she remarried.

As for Julie Manet, whose parents were deceased and whose immediate relatives in the politically progressive Manet clan were now gone, her most influential mentors were her three guardians, Renoir, Degas, and Mallarmé. Of the three, only Mallarmé was disposed to praise Zola and take the pro-Dreyfus side (although Misia Natanson later wrote in her memoirs that Mallarmé "not only refused to take sides but did not even allow the subject to be broached in his presence").[16] Julie's Aunt Suzanne, Edouard Manet's widow, was still alive and thought kindly of Zola, who had been a personal friend of her husband, but as far as she was concerned, Zola was "acting in good faith but is mad." This left only Mallarmé to guide Julie in the direction that her parents undoubtedly would have taken, but he did not provide much in the way of guidance. Only a couple of months before "J'accuse," Julie had noted in her diary that Renoir "has a great deal of influence over the young people who admire him, and says such philosophical things, so charmingly, that one automatically believes them."[17] As for the gentler Mallarmé, she thought that he didn't give enough advice.

Julie badly wanted to be told what to think and do, and on the anniversary of her mother's death, she visited her grave and prayed, "Maman, Maman! Tell me if I am displeasing you. Tell me if I am taking a path which you don't approve of." But shortly afterward, when Renoir and Mallarmé once again began what Julie described as "the interminable discussion on the Dreyfus Affair," she was unmistakably bored. The same things were being said over and over again, she complained to her diary, and although they may be interesting, "one has had quite enough of the whole affair by now."[18]

〜

Zola's trial for libel began almost immediately, on February 7, with Fernand Labori serving as his attorney and Albert Clemenceau, Georges Clemenceau's younger brother, representing the managing editor of L'Aurore, who was also named in the government's suit. (Georges Clemenceau, who was not a lawyer like his brother, had received permission to speak, although not to ask questions—a clear indication of things to come.) Labori had represented Dreyfus's wife, Lucie Dreyfus, in her attempt to file a civil suit at Esterhazy's court-martial—an attempt which the court unanimously rejected

on the ground that Dreyfus had been "justly and lawfully convicted." Labori now was looking forward to another chance to bring the truth to light.

An enormous and agitated crowd gathered for this event, with thousands massed on the Place Dauphine and a full house inside the courtroom, deep within the labyrinthine Palais de Justice. (Marcel Proust, equipped with coffee and sandwiches, became a fixture in the public gallery for the entire sixteen-day trial, not wanting to miss a moment.) Not only Parisians but the world watched this extraordinary show—fed by a voracious press and gripped by the drama of the most internationally acclaimed author in France confronting his country's army with accusations of almost inconceivable crimes. That such crimes could even be imagined, or that this author could be subject to the indignities he had endured, was both appalling and riveting. Zola, who had never enjoyed as much success with his plays as with his novels, was now starring in the drama of a lifetime.

Zola's lawyer and defense committee had prepared a raft of questions to present to nearly two hundred witnesses, with the aim of demonstrating once and for all Dreyfus's innocence and Esterhazy's guilt. But it soon became dismayingly clear that such questioning would not be allowed. "The question will not be put!" bellowed the judge again and again. All the army officers who testified swore, as General Mercier put it, that "Dreyfus was a traitor who has been justly and lawfully convicted." Their testimony never underwent cross-examination, while Scheurer-Kestner was not allowed to read aloud the letters between Picquart and his commanding officer that directly challenged this testimony. All the while, the hostility of the crowds grew, with fighting erupting in the corridors and with agitators assaulting the Dreyfusards and threatening Zola, who could move about only under the personal protection of the commissioner of police.

Still, the defense managed to score a number of salient points, especially with Colonel Picquart's heartfelt testimony and the testimony of a prominent professor (Arthur Giry, from the Ecole des Hautes Etudes) who reduced to shambles the army's theory of Dreyfus's so-called "self-forgery." The handwriting on the *bordereau*, according to Professor Giry, was identical to that of Esterhazy.

It was then, goaded by these reverses, that one of the generals informed the courtroom of the "devastating" document that provided, in his words, "absolute proof of Dreyfus's guilt!" Although the document itself never appeared, its very existence seemed to put an end to every effort to prove Dreyfus's innocence. It seemed a total triumph for the army.

But Labori saw an opening and immediately pounced. He had, in fact, already learned of this document's existence from Scheurer-Kestner, who had heard of it from a friend of his on the General Staff bent on persuad-

ing Scheurer-Kestner to back off. By this time it is probable that Labori was also aware of the doubts concerning this particular document's authenticity. Italy's ambassador to Paris had warned the French minister of foreign affairs that such a document did not exist and could only be a forgery. Although the French generally gave little credence to German and Italian disavowals regarding Dreyfus, Zola, too, emphatically doubted the existence of such a letter, or certainly its import. As he categorically stated in "J'accuse," "I deny that paper! . . . One exists, yes. A ridiculous paper. . . . But a paper involving the defense of the nation, that could not be produced without war being declared tomorrow—no, no! it is a lie."[19]

Zola's instincts here as elsewhere concerning the Dreyfus Affair were dead right, even if he had not yet unscrambled all the facts. The Section of Statistics had indeed intercepted a flirtatious letter between the Italian and German military attachés in which the letter "D" was mentioned—not "Dreyfus," as the military later claimed. It certainly had not seemed sufficient to convict Dreyfus, and prior to Dreyfus's court-martial, the General Staff had communicated its concerns, which soon reached the patriotic and ever-helpful Commandant Henry. In response, Henry had inserted here and forged there, creating two falsified reports that became the backbone of the secret file. Although this file served its purpose in convicting Dreyfus, it would not hold up under scrutiny. As Picquart pursued his own investigations, creating waves of concern throughout the upper reaches of the General Staff, Henry had helpfully provided yet another forgery, this one unambiguously framing Dreyfus. This was the "devastating" document that supposedly provided absolute proof of Dreyfus's guilt.

But Henry's forgeries were crude and certainly not fit to be subjected to expert scrutiny. Fearing disaster, the chiefs of the General Staff now hunkered down, claiming national security reasons for not producing this all-important document, "which exists, which is real, which is absolute." And that was all the generals would say on this hush-hush matter. Instead, their spokesman warned that relations with Germany were at stake, to the point of war (which was patently not the case), and then appealed to the jury's patriotism and sense of honor. "You are the Nation," he told them. "If the Nation does not have confidence in the leaders of its Army, in those who bear the responsibility for the national defense, they are ready to relinquish that onerous task to others."[20] It was up to the jury, then, to choose between the army and the Dreyfusards. In the face of a favorable verdict for the accused, the General Staff was prepared to resign.

Clemenceau was aghast. "A threat of imminent war," he exclaimed, "the slaughter announced, the resignation of the General Staff ready to be tendered. . . . No more is needed to bring twelve trembling citizens to the point

of making the law bow before the saber."[21] He was right; the army had won. It did not even matter when Picquart returned to the stand to affirm that the document in question (which had been concealed from him at the time of its "discovery") could only be a forgery. One of the generals immediately denounced Picquart's effrontery in accusing three generals "of having fabricated a forgery or of having made use of one." Of course ever since 1897, the chiefs of the General Staff must have known that they were defending a German spy and keeping an innocent man incarcerated on Devil's Island. But Dreyfus, as one of the generals had remarked when Picquart presented him with evidence of the captain's innocence, was only a Jew. So what did it matter?

What did matter was the honor of the army and its General Staff, which now seemed assured. Zola, in his moment to address the jury, told them that he only desired "that my country take no longer the way of deception and injustice. I may be sentenced here," he added. "But some day France will thank me for having helped to save her honor."[22]

Labori pleaded, "Do not sentence Emile Zola, gentlemen of the jury! You know well that he is the honor of France."[23] And Clemenceau insisted that Zola and his fellow Dreyfusards were not attacking the army but were instead the true defenders of the army. They were the true patriots.

Clemenceau concluded, "Your task, gentlemen of the jury, is to pronounce a verdict less upon us than upon yourselves. We are appearing before you. You are appearing before history."[24] The jurors, all tradesmen whose names and addresses had been published by La Libre Parole, listened intently. In the end, they declared Zola guilty. But their vote was hardly unanimous. In an extraordinary show of courage, five of the twelve voted for acquittal.

Still, Zola was made to feel the full brunt of the law—the maximum possible sentence of a year in prison plus a fine of three thousand francs. (His fellow defendant, the managing editor of L'Aurore, received a similar fine and a jail sentence of four months.) Upon hearing the verdict, the crowd inside the courtroom erupted into cheers and shouts of "Long live the army!" as well as more ominous cries of "Death to Zola!" and "Death to the Jews!" This jubilation was magnified a hundredfold outside the Palais de Justice, where the mob roared its approval. "They are cannibals," Zola said sadly, as he slowly exited the building, protected by his friends. Later, Clemenceau observed that if Zola had been acquitted, none of them would have made it through that crazed mob alive.[25]

Soon after, Picquart was officially discharged from the army for "grave misdeeds while in service" and deprived of his pension. The lawyer to whom he had confided, and who in turn had confided in Scheurer-Kestner, was relieved of his functions as deputy mayor of the seventh arrondissement and

suspended from the Paris bar for six months. Professor Edouard Grimaux, a leading chemist who had signed the manifesto and testified at Zola's trial, was dismissed from his post at the Ecole Polytechnique.

And yet despite these reverses, the truth was seeping out. The illegality of the 1894 trial that had originally convicted Dreyfus was now known, as was the likeness of the handwriting in the *bordereau* to that of Esterhazy. The General Staff's attempts to silence Picquart had also come to light. Then in March 1898, Belgian newspapers published the accounts of an Italian political columnist to whom the German military attaché at the heart of the Dreyfus case had flatly stated that Dreyfus was innocent and Esterhazy was "capable of anything." These accounts appeared in the Paris press in April and May, causing a sensation.

Fighting for time as well as for vindication, Zola in April successfully appealed his conviction. The military now filed suit for a second time, in addition to demanding that Zola be expelled from the Legion of Honor. Zola's second trial was set for late May, safely after the May elections and just as safely away from Paris, under carefully controlled conditions at Versailles. The elections themselves, in which the Dreyfus Affair was scarcely mentioned, returned to the Chamber the same sort of centrist government to which the voters in recent years had been accustomed. Yet although the elections were not about Dreyfus, they revealed a resurgence of Boulangist-style nationalism that the Dreyfus Affair, and its attendant anti-Jewish hysteria, had set loose. This resurgent nationalism, with its base in the ardently conservative and Catholic right, claimed to defend France and its traditional values—most especially against the Jews, whom these right-wing patriots blamed for anything and everything that had gone wrong in recent years. Deep fissures quickly emerged in the Chamber, where a number of centrist deputies—uneasy about this resurgence of Church power under the guise of nationalism—now bolted for the Left. The outcome was a radical republican government.

At first this political outcome appeared to have little bearing on Dreyfus's fate, for Godefroy Cavaignac, the new minister of war and a strong anti-Dreyfusard, now decided to put an end to the Dreyfus Affair once and for all. Cavaignac quickly requested to see the secret file, in the expectation of finding the evidence he wanted to annihilate any and all claims of Dreyfus's innocence. He selected three items that he thought were the most damning and on July 7 proceeded to read them to the Chamber of Deputies. Two of these were Colonel Henry's forgeries, one of them in totality and another in part. The third was a document that falsely attested that an officer had heard Dreyfus confess. Cavaignac then vouched personally for all three documents and received the overwhelming acclamation of the entire Chamber.

Flattened by this assault, Dreyfus's supporters were understandably discouraged. But Jean Jaurès rallied them by elucidating the clear openings that Cavaignac had unwittingly given them, while a new friend, Esterhazy's nephew Christian, unexpectedly showed up. Esterhazy had bilked Christian of large sums, and Christian was eager to spill the beans on his reprehensible uncle. Since Esterhazy had used Christian as a go-between with the General Staff, the nephew had a bonanza of useful information for the Dreyfusards. By early July, he was testifying to the magistrate who for several months had been investigating Colonel Picquart's charges of forgery (Colonel Henry had forged a couple of telegrams that attempted to make Picquart appear to be an agent of the Dreyfusards). Two days after Cavaignac's speech, Christian began his testimony, and the Dreyfusards began to hope again.

It was now, in mid-July, that the second Zola trial was due to begin. In Versailles, as in Paris, the atmosphere was threatening. One newspaper went so far as to point out, on behalf of those interested in an ambush, that the court at Versailles had no rear or side exits. On the day of the trial, Labori requested the right to testify to Zola's accusations in the whole of "J'accuse," not merely the three lines excerpted for the indictment. Not surprisingly, this was refused. In the face of this unbreachable stone wall, the defense refused to present its case, and Zola was summarily convicted by default.

Concerned for his safety, Clemenceau and Labori now convinced Zola to flee Paris for London. Instead of serving as a noble and sympathy-garnering symbol of resistance for the Dreyfusards, he would bide his time under cover until the important proofs that cleared Dreyfus had at last emerged, making it safe for him to return. It would not be long now, Clemenceau and Labori argued. At the most, two or three months.

And so it was that on the evening of July 18, Emile Zola left Paris by train, his hat pulled down over his face in the attempt at disguise. Throughout France, train stations, ports, and borders were placed under surveillance, while police agents tried to track him down. No longer a hero, even to his most ardent supporters, Zola had become a notorious fugitive from the law.

CHAPTER TWENTY-SIX

~

"Despite all these anxieties . . ."
(1898)

Soon after "J'accuse" appeared, Pissarro wrote to his son Lucien that he need not worry about his father's safety while in Paris. Yes, there were anti-Semitic demonstrations, and the day before he had found himself in the midst of a gang of young ruffians shouting "Death to the Jews!" and "Down with Zola!" But Pissarro quietly passed through them, without the young toughs even taking him for a Jew.[1]

"France is really sick," he mused, wondering if his beloved country would recover. And yet, he added, "despite the grave turn of affairs in Paris, despite all these anxieties, I must work at my window as if nothing has happened."[2] Pissarro, like so many others, had to keep working. One simply could not give up one's livelihood—or life's work—even if the times were fraught with anxiety.

Indeed, by March, Pierre and Marie Curie had begun to pursue their life's work together, with Pierre temporarily abandoning his own research on crystals to join his wife in what was becoming a search for an unknown substance. Gustave Bémont, head of chemical works at the Ecole de Physique et de Chimie Industrielles, the technical school where Pierre was employed, joined in the hunt. Their work was grueling and their work conditions terrible—an unheated shed that the school had provided. But by July the trio had discovered and announced a new element, which they called polonium, after Marie's native land.

Still, their search was far from over, for the trio's research had also revealed the existence of a second unknown substance. This elusive substance

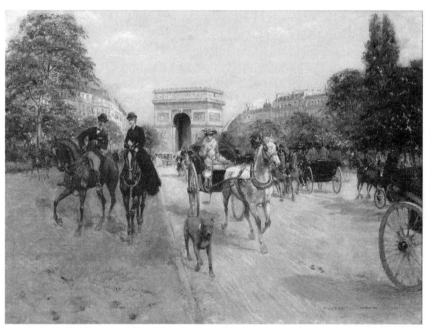

Cavaliers et attelages sur l'avenue du Bois (vers 1900) (Riders and carriages on the Avenue du Bois, circa 1900) (Georges Stein). Oil on wood. Paris, Musée Carnavalet. © Musée Carnavalet / Roger-Viollet / The Image Works.

was present in extremely small quantities along with the polonium, but it gave off even more of the spontaneously emitting rays, or radioactivity (a word that the Curies invented), that Marie was so passionately investigating. This second substance was quite different from polonium, with entirely different chemical properties, and by December they had determined that it was yet another new element, which they named radium. Now began the enormous job of separating out a weighable amount of radium from its most prolific source, a highly radioactive mineral called pitchblende. They started off with kilograms of pitchblende but quickly found that they would have to process tons of the material in order to separate out even a minute amount of the radium salt that they wanted.

The shed where all of this dirty and exhausting work went on was a rough wooden building "lacking all amenities," as Marie Curie would later write, constructed over asphalt and with a glazed roof that "incompletely protected from the rain."[3] It was in this makeshift laboratory that she worked on up to twenty kilograms of material at a time, a process that filled the shed with huge tubs of precipitates and liquids. It was exhausting work to move the containers, stir the boiling material, and decant the liquids. And yet she later recalled that, despite the appalling work conditions, she and Pierre were supremely happy. Sometimes they even returned to their grim lab in the evening, to gaze at the precious fruits of their labors, which glowed gently at them in the dark.

～

It was during this same period that Maurice Ravel was beginning to find himself as a composer. In January 1898, after turning down a music professorship in Tunisia, he returned to the Conservatoire, where he entered Gabriel Fauré's composition class. It was an inspired decision, for Fauré was an exceptional teacher and a kind friend, one who would take great interest in Ravel's career. Ravel in time would dedicate compositions to his "dear teacher Gabriel Fauré,"[4] and he indeed bloomed under Fauré's tutelage, completing his first work for orchestra (the overture to *Shéhérazade*) and making his formal debut as a composer in a concert given by the Société Nationale de Musique.

This event, which took place on March 5, featured pianists Ricardo Viñes and Marthe Dron performing Ravel's *Sites Auriculaires*, a two-part work consisting of *Entre Cloches* and *Habanera* (which eventually found its way, in orchestrated form, into Ravel's *Rapsodie Espagnole*). The *Habanera* was a success, but unfortunately *Entre Cloches* was not, largely because the pianists, who were in the difficult position of trying to play from the manuscript, got out of sync with one another, with unpleasant results.

Still, Ravel was beginning to make his way in the rarified Paris music scene, including the salons of Madame René de Saint-Marceaux and the Princesse Edmond de Polignac. Fauré provided the entrée to these exclusive gatherings, but Ravel seems to have made his own mark—not only with his music, but also with his "ironic, cool humor," as Madame de Saint-Marceaux commented in her diary.[5] In addition to becoming an accepted member of these select artistic circles, Ravel was about to become a close friend of Misia Natanson's artistically discriminating and well-connected half-brother, Cipa Godebski, whose family warmly embraced the young composer.

Small, dapper, and elegant, Maurice Ravel was beginning to be noticed, and by the right people.

⌒

Ravel may have been having a good year, but Debussy was not. For one thing, he was inundated with debts. But there was something else as well—a "crisis," as he confided in March to his good friend Pierre Louÿs. The nature of this crisis is not clear. Possibly it involved Gaby, or possibly another woman—or quite possibly both. But whatever it was, Debussy's work was suffering from it. "I've never been able to work at anything when my life's going through a crisis," he told Louÿs, adding that "those who write masterpieces in floods of tears are barefaced liars."[6]

This crisis that was laying Debussy low may have involved Alice Peter, the sister-in-law of Debussy's friend René Peter, to whom Debussy dedicated the second of his ravishing *Chansons de Bilitis*. Set to poems by Louÿs (although Louÿs for a time tweaked the critics by successfully claiming that they were translations from Greek texts), these poems were sufficiently sensual in their language that Debussy was concerned about the songs' decency. The second one especially worried him, so much so that before its first public performance he visited the mother of the young singer to assure that she was sufficiently innocent to be unembarrassed by the words. He need not have worried. By the time of the performance, the young singer was the mistress of Debussy's benefactor Georges Hartmann and presumably free from embarrassment.

As for Debussy's dedicatee, Alice Peter most certainly was not burdened with an excess of innocence. Described by her brother-in-law as "a woman of the world," Peter was by early 1898 "more or less" separated from her husband and happy to encourage an attachment with Debussy. Although there appears to have been a rupture between them sometime in the spring of 1898, Debussy wrote her in May or June to resume their relationship.

Whether or not Alice Peter was the culprit, the cause of Debussy's distress seems to have been a married woman, for in mid-July Debussy wrote

Hartmann of the "barriers erected by law to separate those who strive for their own kind of happiness." As a consequence, he added, his life was still "decorated with complications of a sentimental nature, turning it into the most awkward and involved thing I know."[7]

Across town, Auguste Rodin certainly understood the painful complications that love could create. His decade-long affair with Camille Claudel had ended in 1893, leaving her distraught and him broken-hearted, but his *Balzac* sculpture, begun when their affair was at its height, was now finished and awaiting enlargement. In late 1897, he asked Claudel to look at the *Balzac* and give him her opinion. She went and wrote him that she found it "truly great," adding that he had better expect "a big success, especially with all your connoisseurs, who will not be able to find any comparison between this and the rest of the statues that now adorn the city of Paris."[8]

She then proceeded to fill the rest of her letter with a series of complaints about the people she felt were taking advantage of her, especially those with wives or other women in their lives. "You know perfectly well all these women have a black hatred of me," she told him. "As soon as a generous man comes along to help me out of my quandary, a woman takes him in her arms and keeps him from acting."[9]

Rodin thanked her for her praise but could not agree with her anguished assessments, which he felt were products of her imagination. "I am so sorry to see you this nervous," he wrote, "and going in a direction that I, alas, know too well." And then, in an attempt to steer her in a more constructive direction, he praised her genius and told her to forge ahead, showing her "wonderful works."[10]

It would be the last direct communication between them. In 1904, as her mental health became increasingly fragile, Claudel told an acquaintance that Rodin had ordered two of his male models to kill her.

⌢

In March 1898, Rodin informed the president of the Société des Gens de Lettres that, after years of work, his sculpture of Balzac was finally finished and ready to go to the foundry. If the Société wanted it shown in that year's Salon, he added, it would have to be satisfied with the plaster version. The Société agreed, and in late April, *Balzac*, along with Rodin's marble enlargement of *The Kiss*, went to the Galerie des Machines in the Champ de Mars, where that year's Salon was exhibiting.

Some among its many viewers, including Oscar Wilde (recently released from prison), recognized it for the masterpiece it was, but most who saw it were appalled. Critics and the general public vied to come up with the most insulting descriptions, and thousands angrily described it as "garbage" and

"monstrous," making it clear that a vast majority of the public wanted to prevent Rodin's *Balzac* from ever becoming a public monument. Reflecting the times, one critic observed, "Before long it will be necessary to be for or against Rodin, as it is necessary to be for or against Esterhazy."[11]

Indeed, the Dreyfus Affair was beginning to color what was quickly becoming the Balzac Affair. As the Société des Gens de Lettres backed off from its commitment to accept *Balzac*, Rodin's friends and supporters opened a subscription to buy the sculpture and erect it in Paris. Yet it quickly became apparent that almost all of the subscribers were also supporters of Dreyfus and Zola—a political solidarity that disturbed Rodin, who wanted no part in the Dreyfus Affair. A firm believer in the necessity of separating art from politics, Rodin had refrained from declaring himself either for or against Dreyfus. He was not about to allow his art to draw him into some sort of political statement, even if only by association.

Aware of Rodin's deeply held convictions, Clemenceau withdrew his name from the subscription list in an attempt to depoliticize the issue. But this was not enough. The furor and brickbats worsened until at last Rodin decided to halt the subscription drive, return the money, and retain sole possession of *Balzac*. In a total withdrawal, he now removed the statue from public view in the Salon and announced that it would not be erected in any public place.

The Société now gave the commission to Rodin's friend and fellow sculptor, Alexandre Falguière, who died before he could complete his version—and which consequently did not make its public appearance until several years after the Balzac centenary. By then, Rodin's *Balzac* had been standing for several years in Rodin's own garden in Meudon. Despite the praise he continued to receive from colleagues such as Monet, Rodin was deeply discouraged by the entire experience, especially by the abuse he had received. For him, *Balzac* represented a defeat, and he never again undertook another monument.

⌒

No one, however, even thought of criticizing the new hotel that César Ritz opened in June 1898 on the Place Vendôme. From the outset, it was a marvel of luxury and attention to detail. Ritz's wife later recalled that three months before the opening, she and Ritz took a large top-floor apartment overlooking the hotel (the apartment where Coco Chanel would later live). Each night after the workmen left, husband and wife would slowly walk through the hotel rooms, paying attention to every detail. They would note if a room had too many shadows or if it was too bare. They noticed if a room was too cool in tone, requiring a warmer color in the curtain linings, or if it begged

for thinner curtains to let in the view. Whether it was a table with unequal legs or a drawer that did not slide properly, Ritz took note. And the next day, the problem would be fixed. Perfectly.

Three weeks before opening, this obsession with detail almost resulted in a major problem. Ritz and his wife were trying out the restaurant furniture, to see if they should put armrests on some of the chairs. This was not an overnight project, but with Ritz pushing, it was accomplished by the morning of the opening. Yet there was no time to draw a breath of relief, because with the new armchairs in place, it suddenly became apparent that the tables were too high. This left Ritz to run out in the pouring rain in search of a carpenter who on short notice could shorten the offending tables. He found his man, and the job was finished just as the first guests entered for the opening gala.

There were many in the hotel world, of course, who undoubtedly were hoping for just such a turn of bad luck. Ritz had made enemies as he relentlessly worked his way to the top of the hotel business, most recently at London's Hotel Savoy, with whose board of directors he had recently parted company on less-than-friendly terms. But he was not about to give his enemies that pleasure. His new Paris hotel was small (at first only eighty-four rooms), intimate, and perfect—at least, once the tables were cut down to size. Following his own fixed rule of providing only the best, Ritz was prepared to surround his demanding guests with the very finest of everything, including top-notch period reproductions, abundant flowers, and exquisite silverware, glassware, and linens. The hotel's interior, which was carefully constructed behind the building's seventeenth-century mansard roof and façade, was light, comfortable, and airy, with electric lighting, luxurious bathrooms, noise-reducing wall-to-wall carpeting (a novelty), and telephones in each suite. Plus it boasted not one but three gardens. It was, in fact, everything he had wanted it to be.

By the evening of the grand opening on June 1, the rain had stopped and—much to Ritz's relief and gratification—an impressive number of the crème de la crème began to arrive. In the midst of this illustrious crowd Madame Ritz suddenly noticed a small nervous man who was earnestly watching everyone. It turned out to be young Marcel Proust, who subsequently would spend much time at the Ritz, making good use of the people he met in its salons and restaurant to populate his Remembrance of Things Past.

Within days of the opening, a Vanderbilt marriage and a Talleyrand-Périgord wedding were celebrated there, and the Rothschilds were among many other leading families who quickly made themselves at home. It was the place to be, and in acknowledgment of the fact, the Duchess of Marlborough soon arrived from England, while the Morgans, the Goulds, and the Vanderbilts sailed in from New York. Three grand dukes of Russia quickly

made their way to the Hotel Ritz, and Parisians flocked to dine and entertain there, contrary to the way things had always been done before. (With his usual insistence on order, Ritz required that all diners have reservations.)

The day after the grand opening, *Le Figaro* praised the Hotel Ritz as something far more than a mere hotel for travelers. "Is it not instead," it asked, "the mansion of a grand lord," and in the most appropriate quarter in Paris?[12]

Ritz, of course, agreed. "I want a hotel in which a gentleman would wish to live,"[13] he had said, and this was the culmination of his dream.

ᕦ

Soon after the splashy opening of Ritz's hotel, Erik Satie packed up his few belongings on a handcart and moved from Montmartre to Arcueil, a suburb south of Paris. There he established himself in a second-floor room over a bistro, in a run-down neighborhood just beyond the wasteland that snaked alongside the Thiers fortifications. It was downwind, as well, of the tanning factories that by now had turned the river Bièvre into a fetid sewer. (With a straight face, Satie remarked that the mosquitoes that frequented the place were unquestionably sent by the Freemasons.)

He did his own cleaning in this small room to which he invited no one, regularly emerging with his pitcher to draw water from the nearby public fountain. Even when carrying out such menial tasks, he dressed entirely in gray corduroy, having used a small legacy to purchase a dozen suits in this material, along with a large supply of stiff collars, numerous umbrellas (he never went anywhere without one), and piles of shirts and waistcoats, most of which he never wore and which were discovered untouched (except by moths) in his room after his death. Yet despite his odd appearance, his neighbors began to accept him, and he in turn began to take an active part in his adopted town, joining the Radical-Socialist Committee, writing (with his usual bizarre humor) for the local newspaper, organizing concerts and festivities, and actively working on behalf of those even poorer than himself—especially children, whom he adored.

He still earned his meager living by playing the piano in the music halls and bars of Montmartre; he trudged to and fro, walking the entire distance to save the omnibus fare. During these difficult years he survived by writing for the music hall, which in turn managed to insinuate itself into his more serious work, infusing it with a sense of play reminiscent of the *café-concert* and the circus. It was this openness to the music of the streets that in time made Satie a revered pioneer and leader of the group of young composers, including Darius Milhaud, Francis Poulenc, and Arthur Honegger, who—with their spokesman, Jean Cocteau—would become famous as the Groupe des Six.

⁓

Godefroy Cavaignac, with the deputies' ringing approval still in mind, had decided to shut down the pro-Dreyfus movement by convicting its leaders (including Scheurer-Kestner, Picquart, Clemenceau, Jaurès, Zola, and Mathieu Dreyfus) of conspiring against the security of the state. With this goal in mind, he gave orders to his military staff to reexamine the documents in the Dreyfus case's secret file. It was late on the evening of August 13, while engaged in this thorough scrutiny, that a certain Captain Louis Cuignet made an astonishing discovery. The letter he was examining—the very one that the generals had claimed provided absolute proof of Dreyfus's guilt—was not one letter, but two. That is, it consisted of pieces of two letters gummed together to give the appearance of being one. It was, in fact, a forgery.

Cuignet was deeply troubled by this discovery. He knew that Cavaignac was looking for material to use against Dreyfus and his supporters, not the other way around. He also knew that the document in question had been "discovered" by Colonel Henry, who was a friend of his. But now there was this irrefutable evidence that the document in question, indeed the principal document against Dreyfus, was a fraud.

Fortunately Cuignet was an honorable man and did his duty, however unpleasant. The next morning he reported his findings to his superior, one General Roget. The forgery was not as immediately evident in broad daylight, but in a darkened room and under lamplight it was unmistakable. Roget and Cuignet immediately rushed off to tell Cavaignac. After seeing the document under lamplight, Cavaignac, too, was convinced of the forgery, and to his credit had no thought of hiding the discovery. Soon after, he personally interrogated Colonel Henry, who at last broke down and confessed. Cavaignac made this news public on August 30, including the information that Colonel Henry had been arrested and taken to the fortress of Mont-Valérien.

"I am doomed; they are abandoning me,"[14] a shaken Colonel Henry told his wife shortly before leaving for prison. On a hot afternoon soon after his arrival, he stretched out on his bed and slit his throat with a razor.

⁓

Yet despite the mounting evidence of Dreyfus's innocence, the anti-Dreyfusards would not concede defeat. Far from it, since there were larger issues and causes than Dreyfus now at stake. For the anti-Dreyfusards, the critical issue was the defense of France's traditional morality and institutions, most especially the army and the Church, while for the Dreyfusards, it was the defense of a free and just Republic unhampered by the political power of

either the army or the Church. In this bitter confrontation, nationalism and anti-Semitism combined to rise up against the threat of secularism and the modern, industrialized world. As the uncompromising nationalist and anti-Semite Maurice Barrès made abundantly clear, even if Dreyfus were innocent, his supporters should be regarded as criminals. "They insult everything that is dear to us," he wrote. "Their plot is dividing and disarming France."[15]

Cavaignac, who despite his role in uncovering the Henry forgery was determined to maintain his fight against the Dreyfusards, claimed that his discovery had only reinforced his anti-Dreyfus credentials. Simultaneously, the anti-Dreyfusards were busy turning Colonel Henry into a hero, claiming that he had been murdered by Jews who wanted to prevent him from speaking out and telling the truth. In the face of Lucie Dreyfus's request for a revision of sentence, the government—critically divided on the question—dragged its feet. During September the level of political agitation in Paris rose dramatically, intensified by a massive strike led by workers who had been employed to build the upcoming World's Fair. These were joined by most of the construction workers in Paris, followed by the railway workers. Adding to the turmoil, there were rumors of an army coup in favor of a Bonapartist pretender. In the midst of rising panic, a number of Dreyfusards decided that it would be best to go into temporary hiding. Sensing that his own game was just about up, Esterhazy also took the precaution of changing his address—in his case, slipping over the border to Belgium and eventually arriving in London, where he settled under an assumed name.

At last, a full month after Henry's confession, the Council of Ministers voted (by a slim majority) to send Lucie Dreyfus's request to the High Court of Appeal. Two days later the Criminal Chamber of the High Court of Appeal began its deliberations, issuing its decision a full month later, on October 29. Its decision was the one that Dreyfus's supporters had longed for, allowing the procedures to go forward for a retrial.

For a glorious moment, it looked as if the tide had turned.

〜

On October 16, Julie Manet wrote in her diary that the chaos that was disrupting Paris was "very disquieting" and prayed that it would soon end. Prayer was playing an increasingly important role in her life. In June, she had joined Les Enfants de Marie, making the resolution "to be a better Christian and to help others more." Noting that she was about to turn twenty, she added, "It's about time I began helping the poor and serving other people."[16]

But death continued to intrude on her privileged life. In September, she received word of Mallarmé's unexpected demise. She attended the funeral in

Valvins, along with so many others who loved and revered Mallarmé, including Thadée and Misia Natanson and Paul Valéry (who was so overcome that he could not complete his eulogy and had to leave the cemetery in tears). From London, Whistler wrote to Mallarmé's widow and daughter, "I weep with you two . . . I loved him so!"[17]

"Death is terrible," Julie wrote, adding, "Valvins has lost its soul." And yet for the young people, at least, life went on. On October 17, Julie confided to her journal that her friend Yvonne Lerolle, daughter of painter Henry Lerolle, had announced that she was engaged to be married to Eugène Rouart, grandson of the painter and collector Henri Rouart. Her friends were beginning to marry, Julie noted, adding solemnly, "we are most decidedly not little girls any more."[18]

She celebrated her twentieth birthday in November, and in late December attended the party celebrating Yvonne's marriage contract, which took place at Degas' residence. At the entrance, Ernest Rouart, brother of the groom-to-be and a pupil of Degas, gave Julie his arm and led her to greet Yvonne. Julie spent the evening matchmaking her cousin Jeannie with Paul Valéry and ended up wondering whether she, too, was on the arm of the person with whom she would spend the rest of her life. "Yes," she concluded, "I must say I liked Ernest this evening." Noting that they shared the same tastes and lived "in the same milieu," she wondered whether he might not be "the one for me."[19]

Others certainly had the same idea. "I have straightened Ernest out for you," Degas teased her. "Now it's up to you to carry on."[20]

∽

Rennes

(1898–1899)

At home and abroad, France's army was taking it on the chin. Not long after the pandemonium set off by Colonel Henry's suicide and the revelation of his forgeries came the bitter news of French military defeat in an obscure place in the Sudan called Fashoda. A race with Britain for colonial territory in Africa had sent a French force under Commandant Jean-Baptiste Marchand on a two-year trek from the Congo to this remote spot on the upper Nile. There the French found themselves facing several British gunboats, leading to a month-long standoff and some serious saber rattling back home. In the end, the French backed down, leading to a settlement in which both countries agreed to their particular spheres of influence in Africa. But although there were diplomatic as well as practical considerations at work here—most especially France's awareness of the strength of the British navy—many French found Fashoda's immediate outcome humiliating. That it came just as the High Court of Appeal opened the way for a Dreyfus retrial only exacerbated the pain and anger of the deeply nationalist and loudly patriotic anti-Dreyfusards.[1]

The anti-Dreyfus furor continued to grow. By December, a group of professors and men of letters intent on countering the pro-Dreyfus *intellectuels* formed the Ligue de la Patrie Française; they immediately enrolled numerous members of the Institut, twenty-three members of the Académie Française, and hundreds of university professors, with a total membership approaching forty thousand. But although carrying a certain amount of clout thanks to the prominence of its members, the Ligue de la Patrie Française never had the

same taste for blood as did the Ligue des Patriotes and the Ligue Antisémitique, whose members were more than willing to use their fists to reinforce their passions.

It was now, late in the year, that *La Libre Parole* initiated a suit in the name of Colonel Henry's widow to defend the honor of "the French officer killed, murdered by the Jews." Thousands of contributors immediately responded to this rallying cry, many of them adding violently anti-Semitic comments that also targeted the Protestants, Freemasons, and supporters of the Republic. But it was the Jews who invariably drew the most hate-filled invective. One military physician actually recommended that Jews be vivisected, while a worker at Baccarat yearned to place them "in glass furnaces." Still others talked of "convert[ing] the flesh of the kikes into mincemeat" and "rent[ing] a deportation car."[2] The language and the sentiments were horrific, and whether or not these enraged individuals literally meant what they said, they were nonetheless invoking the language of genocide and extermination.

Julie Manet and her friends, although anti-Semitic, were hardly of this mentality. Yet in early December, as her interest in Ernest Rouart bloomed, Julie admiringly confided to her diary that the Rouarts made a practice of attending the anti-Dreyfusard meetings, and that Ernest had even once hit a Dreyfusard. In the meantime the army's top brass had decided to remove all blame from Colonel Henry and place it squarely on Colonel Picquart, thus effectively removing Picquart as a viable witness on Dreyfus's behalf. After spending 122 days in prison, 49 of them in solitary confinement, Picquart was scheduled to come before the court-martial in December, on charges of forgery and espionage. His prospects looked bleak, and only the last-minute consent of the High Court of Appeal's Criminal Chamber to consider his case offered a faint ray of hope. In a sign that his supporters took to be a positive one, the Criminal Chamber requested that the military turn over the secret file for its consideration.

The military did not comply with the Criminal Chamber's request until late in the year, and then under the most stringent conditions, insisting that the file be brought in the morning and returned to the army each evening. But even under these restrictions, the judges of the Criminal Chamber soon realized how little hard evidence this file contained. With their misgivings now evident, they came under heavy fire from the anti-Dreyfusards, but they patiently plodded on. Finally, in early February 1899, the judges announced that they were nearing the end of their investigation. This galvanized anti-Dreyfusards at the highest levels of government to remove the case from the Criminal Chamber's jurisdiction. In the view of these highly placed individuals, the honor of the army and the security of the Republic required no less.

The Petit Palais, from its courtyard (Paris). © *J. McAuliffe.*

In late January 1899, Monet received a request from his friend and colleague Alfred Sisley to come and see him. Sisley, the only Englishman in the original group of Impressionists, was on his deathbed and wanted to bid Monet farewell. He also wished to entrust Monet with the care of his children, whose mother had died several months before.

The Sisley children were indeed in need of help. Sisley had never managed to earn much of a living at his painting and for years had just managed to scrape by, residing with his longtime mistress (who in 1897 at last became his wife) in a small village near Fontainebleau. He had spent his last years in virtual seclusion.

Monet returned with Pissarro and Renoir for the funeral and then immediately arranged for a sale of Sisley's paintings to benefit the Sisley children. Upon Monet's return to Giverny, his own beloved stepdaughter, Suzanne Butler, suddenly took ill and died. Yet Monet soldiered on with arrangements for the Sisley exhibit, consisting not only of the paintings that Sisley left in his studio but also a number of paintings donated by friends and colleagues, including a Morisot picture that Julie contributed.

During this and other exhibitions immediately following Sisley's death there was an uptick of interest in—and prices for—Sisley's works. That winter and spring Monet, too, appeared prominently in group exhibitions and public sales, in which his paintings continued to bring ever-higher prices. He also began to paint the water lilies in the pond in his garden.

Throughout these same months, Henri de Toulouse-Lautrec was busy drinking himself to death. Eccentric, aristocratic, and deformed, with an adult's torso and the legs of a child, he immersed himself in his art—and his drinking. He carried out the latter in the company of the artistic set that congregated around Thadée and Misia Natanson, as well as in some of the most notorious and insalubrious whorehouses in Paris. His drinking did not seem to disrupt his work, which profited from his inside knowledge of the seamier side of fin de siècle Paris. But by the spring of 1899, it certainly was wreaking havoc with his health—and endangering others as well. He was experiencing hallucinations and fearing "vague enemies and plots against him," as his friend Thadée Natanson later put it.[3] Worse yet, according to his landlady he was setting fires in his house (on Avenue Frochot), "pouring petrol on rags he's put into our toilets and then lighting the liquid, which flames up!"[4]

The Natansons and other friends pleaded with him to lay off the booze, including his trademark cocktail, a formidable mixture of absinthe and cognac. But Toulouse-Lautrec was accustomed to doing exactly as he pleased,

and it did not please him to stop. At last, in desperation, his mother arranged to have him committed to a private asylum—an expensive one in a Neuilly mansion, which he insisted on calling his prison (even signing one letter to his mother "The Prisoner"). He temporarily improved and was released ("Lautrec is out of gaol!" he crowed) but soon returned to his suicidal drinking. Still a young man of thirty-four, Lautrec—who suffered from syphilis as well as alcoholism—had only two more years to live. Throughout his life, as Thadée Natanson later recalled, "Everything made him laugh. He loved to laugh." But by the end, "the old joy [was] no longer there."[5]

〜

In late May 1899, Ravel conducted his first orchestral work, *Shéhérazade*, for the Société Nationale. It was a big moment, and the derisive whistles and boos that greeted *Shéhérazade* disconcerted him. Still, there was also a reassuring amount of vigorous applause, and the crowd brought him back for two bows. Yet the critics were not persuaded, and writer and music critic Henri Gauthier-Villars (then married to Colette) was especially devastating, calling *Shéhérazade* "a clumsy plagiarism of the Russian school of Rimsky faked by a Debussyian who is anxious to equal Erik Satie." But d'Indy (according to Ravel) diplomatically expressed his delight "that people could still become impassioned about anything."[6]

That same month, Sarah Bernhardt also inflamed passions by undertaking the most controversial role of her career, that of Hamlet. She had already sold the Renaissance Theatre and signed a lease at the much larger Théâtre des Nations (on the Place du Châtelet), grandly renaming it the Théâtre Sarah Bernhardt, where she opened with *La Tosca*. Then in May she strode onto the stage as Hamlet. There were fervent critics, of course, but her *Hamlet* was hugely popular with audiences—Julie Manet saw her in the role and, much to her surprise, liked her in it—and the production was a remarkable success. Bernhardt then took it on tour for six months, where she encountered mixed but decidedly not lukewarm reviews. She then returned to her theater in Paris, where she successfully played Hamlet for fifty more performances.

In typical Bernhardt fashion, she had daringly raised the stakes and won.

〜

That spring found Julie Manet in a romantic mood. In early March she went to her parents' beloved Château du Mesnil to check on some much-needed repairs and, as the mist lifted, she sat on the grass and thought of how "it would be paradise" to live there. But, she reminded herself, "one would have to come here as a family, have friends here, be married."[7]

Degas was happy to serve as matchmaker, and in late April, as she was attentively regarding a choice Delacroix at a presale exhibition, Degas took her by the arm and told her, "Here's a young man for you to marry!"[8] She turned and saw Ernest Rouart. She and Ernest both laughed, and neither seemed to mind Degas' active interference.

As spring drifted into summer, Paul Valéry and Julie's cousin Jeannie were becoming a couple, while Julie was experiencing all the embarrassments and tremors of new love. At a gallery showing in early May, she encountered Ernest and wanted to talk with him but didn't dare. The future now was filled with direst doubts, the worst of which was the prospect of never seeing him again. "Oh," she yearned, "if only I appealed to him!"[9]

But scarcely a month later, she once again was on cloud nine. After a dinner with Degas, she and Ernest went to look at Degas' collection of paintings. Julie marveled at Ernest's manners, his thoughtfulness, and his dark eyes. "I really like him, yes I really do," she confided to her diary. And on the way home in the carriage, she thought about the evening and decided that Ernest Rouart "is the one for me."[10]

～

By New Year's Day 1899, Gaby Dupont had packed up and left Debussy for good. Although she certainly had had good cause to storm out long before, the reason for their final breakup is not clear: Debussy simply announced her departure to Georges Hartmann with a bitter put-down, saying that he had been quite busy of late, what with his change of apartments. And, oh yes, "Mlle Dupont, *my secretary*, has resigned her position."[11] That was all.

Then came Lilly. In a July letter to Hartmann, Debussy wrote that there was "a young lady I love with all my heart (a blonde, naturally) with the most beautiful hair in the world and eyes which lend themselves to the most extravagant comparisons." In short, he concluded, she was "good enough to marry!" And in a letter that same evening to Lilly, whom he addressed as "Ma Lilly adorée," he wrote, "Too well my mouth remembers yours, your caresses have left an indelible mark, as hot as fire, as gentle as a flower." Declaring that their love was the most beautiful thing in the world, he told her, "Let's never demean it with those constricting little rules fit only for nonentities."[12]

Lilly was Rosalie Texier, known as Lilo or Lilly. She was twenty-five years old, a clothing model in a fashionable shop, and judging from this as well as other Debussy letters, had already become his mistress. Why marry her, then? She certainly possessed no fortune, and Debussy was just as certainly in need of one. But marry her he did, in a civil ceremony on October 19—a simple affair that Debussy described as "without pomp or ceremony or bad music."[13]

Debussy's good friend Pierre Louÿs, who had taken the plunge and married (much more advantageously) that June, was one of the witnesses. Another was Erik Satie. The newly wedded couple was virtually insolvent—the morning of the marriage ceremony, Debussy had to give a piano lesson in order to pay for the wedding breakfast. But they seem to have been happy—at least, for a time.

～

As it turned out, love not only sent Julie Manet dreaming and turned Debussy's life upside-down, but it had an unexpected impact on the Dreyfus Affair as well. On February 16, Parliament was on the brink of passing legislation removing the Criminal Chamber from its investigation—an investigation in which the majority of the Chamber's judges now appeared favorable to a Dreyfus retrial—when President Félix Faure was discovered dead in his bed in the Elysée Palace, the victim of a heart attack. Everything about his death was hush-hush, but word soon spread about the titillating circumstances in which Faure was found. Gossip dwelled with special relish on the mistress in whose arms he died and who subsequently was quietly hustled out a side door.

Faure had become an adamant anti-Dreyfusard, and his abrupt departure from the scene gave new hope to Dreyfus's supporters. In his place Parliament quickly elected Emile Loubet, president of the Senate and a Dreyfusard. "To think that the army is obliged to serve and defend a man who is on the side of its enemies," Julie Manet exclaimed in her diary. "He can't be French if he's a Dreyfusard."[14] Other anti-Dreyfusards strongly agreed, and Paul Déroulède, leader of the anti-Dreyfus Ligue des Patriotes, prepared for battle. Holding forth beneath the statue of Jeanne d'Arc, Déroulède pledged to boot out the enemies of France (i.e., the Dreyfusards) just as Jeanne d'Arc had done to the English, and he strongly hinted that following Faure's funeral, he and his shock troops would march on the Elysée Palace.

As it happened, far fewer showed up for this event than Déroulède expected, and the army—despite its record on Dreyfus—was not interested in participating in a coup. But the prime minister, Charles Dupuy, remained staunchly anti-Dreyfus and continued to push for the removal of the Criminal Chamber from the case—technically the Picquart case, but inseparably bound up with the Dreyfus Affair, especially on the question of a Dreyfus retrial. Dupuy got the legislation he wanted, but the Criminal Chamber now decisively proceeded to outmaneuver him, declaring that Picquart's case fell under civil rather than military jurisdiction—a clear victory for Picquart, who had now escaped the possibility of trial by court-martial. The Dreyfusards were elated.

Now that the High Court's Criminal Chamber had been booted from the case, the High Court's Combined Chambers took over, again summoning the secret file, which was daily brought to it under strictest secrecy. Dreyfusards and anti-Dreyfusards kept running tabulations on how they expected the individual judges to vote when the time came, but many of the justices were inscrutable and—as it turned out—annoyed by the slanderous campaign that anti-Dreyfusards had conducted against individual justices in the Criminal Chamber. In the meantime, Mathieu Dreyfus had surreptitiously obtained copies of the minutes of the Criminal Chamber's sessions, which he leaked to Le Figaro. Le Figaro began publication in late March, continuing, to the public's edification, throughout the month of April.

Thanks to Mathieu Dreyfus's maneuver, all aspects of the Dreyfus case now were open to the public, and it seemed as if nothing could prevent Dreyfus's retrial. Even Esterhazy was cashing in on his confessions while they still held value, selling detailed accounts to the press about his collusion with the General Staff. Still, the nationalist and anti-Dreyfus tide continued to run strong, with Déroulède and his chief associate in the aborted coup brought to trial and acquitted after only the briefest of deliberations, and then carried in triumph by his cohorts through the Palais de Justice and into the streets.

At last, on June 3, the Combined Chambers of the High Court of Appeal gave its judgment. Its justices had been severely torn, especially on the question of the bordereau, which a majority believed was not written by Dreyfus, but which only a minority was willing to attribute to Esterhazy. But they could agree that a retrial was in order, and consequently annulled the verdict of Dreyfus's 1894 court-martial and ordered Dreyfus to appear before a new court-martial, to be held in Rennes.

The same day, Esterhazy confessed in an interview with Le Matin that he had written the bordereau—under orders from his superior officer, as he put it, and with the knowledge of three commanding generals.

It still wasn't exactly the truth, but Esterhazy's confessions hardly mattered in light of the High Court's decision. Those who had fought so long for this moment, including Clemenceau, Jaurès, and of course Mathieu Dreyfus, embraced and wept, as did Lucie Dreyfus when she heard the news. It meant victory, of course. Didn't it?

∼

Zola was exuberant. He had spent the previous eleven months in England, where the English seemed content to allow him to live in peace at a series of addresses outside of London. There he began to study English and continued to work on yet another novel, while the events of the Dreyfus Affair continued to unfurl. Impatiently reading every scrap of news he could find

from across the Channel, he swung between hope and despair, especially after learning of Henry's confession and suicide; after all, the document at the heart of Zola's conviction was now a proven forgery. It could only be a matter of days before the exile's longed-for return. But Clemenceau and Zola's attorney, Fernand Labori, managed to convince him that the situation in France still remained sufficiently turbulent that his return would only further inflame passions and endanger him as well as the entire Dreyfus cause. And so, even as one element after another of the truth began to emerge, Zola remained in England, suffering from depression.

In the meantime, the three handwriting experts whom Zola had denounced in "J'accuse" sued him for a staggering three hundred thousand francs and were awarded a lesser but still substantial sum in damages— enough to wipe out his savings, such as they were (Zola had always spent most of what he earned). In lieu of sufficient ready cash, his Paris house was seized and its possessions put up for sale—that is, until his publisher's junior partner came to the rescue, offering enough for Zola's writing table to cover the litigants' claims.

Perhaps worst of all, Zola suffered the humiliation of being suspended from the Legion of Honor. Although the Legion had attempted a sort of compromise by not completely ousting him, its action pleased neither those who sought his ouster nor those who avidly supported him. In protest, Anatole France and other Legion members tore the esteemed red ribbon of the Legion from their coats, while debate over this latest tempest raged throughout the cafés of Paris.

On the evening of June 3, Zola received word that the High Court of Appeal had authorized a new trial for Dreyfus. Zola immediately left for Paris. In his statement, headlined "Justice," which appeared in *L'Aurore* on the morning of his arrival, Zola joyously exclaimed that "today, truth having vanquished, justice reigning at length, I . . . return and take again my place upon French soil."[15]

⌒

The anti-Dreyfusards were furious at the High Court's decision, and immediately made the magistrates targets of verbal abuse, while a cane-wielding assailant physically assaulted President Loubet. Fortunately, Loubet was not hurt. But the attack and resulting brawl (led by royalists and anti-Semites, identifiable by the white carnations or bluets in their lapels), following as it did so closely on the heels of Déroulède's aborted coup d'état and triumphant acquittal, contributed to a widespread fear of impending crisis. With Drumont and others calling for the people to take to the streets to chase Loubet out of office, many feared that all hell might break loose. As the anti-Dreyfusard

Maurice Barrès put it, "The Dreyfus anecdote, that obscene and confused affair, does not interest me; what does is civil war."[16]

The Dreyfus Affair had become deeply political, with the future of the Republic now at the heart of the battle between Dreyfus's enemies and his defenders. Soon after the Loubet incident, some one hundred thousand Parisians singing the Marseillaise marched in support of Loubet and the Republic, even as military officers in Paris and Rennes were making public their own intentions of defending the army against the Dreyfusards. One officer at Paris's Ecole Militaire even ordered his troops to use their arms against "the Army's insulters," with only the vague caveat, "should the situation call for it."[17] It was in this volatile atmosphere that Prime Minister Dupuy, who seemed unable to impose order, was turned out of office. After unsuccessfully attempting to form a new government under a center-rightist, President Loubet turned to the center-leftist René Waldeck-Rousseau, a respected lawyer and politician who had been minister of the interior under Gambetta and had defended Gustave Eiffel during the Panama scandals.

Waldeck-Rousseau selected a government of unusual political range, from General Gaston de Galliffet, the notorious "butcher of the Commune," to Alexandre Millerand, the first socialist to join the government of the Third Republic (Galliffet as minister of war, Millerand as minister of commerce). Not surprisingly, the peculiar composition of this government raised objections from just about everyone, from the socialist left to the nationalist right, but it was the anti-Dreyfusards who were especially infuriated. Every member of Waldeck-Rousseau's government, including Waldeck-Rousseau himself, was either openly or quietly supportive of Dreyfus. But of far more importance to the majority of deputies was the fact that each member of this government was a staunch defender of the Republic. It was this promise to defend the Third Republic against the forces of reaction that won Waldeck-Rousseau's government the support it needed in the Chamber—a small majority, but enough to govern. At the time, no one could guess that Waldeck-Rousseau would govern for three years, the longest ministry in the history of the Third Republic.

Immediately, Waldeck-Rousseau took precautionary steps, replacing the prefect of police and transferring several prominent generals to the hinterlands. "Silence in the ranks," General Galliffet sternly ordered the astonished army, and then he proceeded to impose structural reforms to ensure that the army remained subordinate to civilian authority. With a minister of war whom it could no longer manage or bully, the army quietly submitted.

Waldeck-Rousseau then took out after Déroulède and his nationalist cohorts (forty of whom barricaded themselves in their Paris headquarters, where they were temporarily supplied with food by colleagues who creatively

handed it over from the top decks of passing buses). Soon after, Déroulède and the other nationalist leaders were arrested, accused of conspiracy against the Republic, and brought to trial before the Senate sitting as High Court. After a long trial, they were convicted and banished.

As for the Church, although Waldeck-Rousseau was not anticlerical, he firmly believed that the Church should be subordinate to the Republic. With this in mind, he suspended the salaries of those priests who had opposed the government, and he took legal action against the Augustinian Fathers of the Assumption, who devoted their widely distributed newspapers to attacking Jews and the Republic. Unimpressed with the Assumptionists' take on Christian charity (one of their paper's editorials on Zola, following "J'accuse," was titled "Disembowel Him!"),[18] Waldeck-Rousseau took legal action under a law forbidding unauthorized associations. In early 1900 the Assumptionists were tried and disbanded.

Within a few short months, Waldeck-Rousseau had taken by surprise the army, the nationalists, and the Church and had knocked each of them into submission. Now all that remained to ensure the tranquility of the Republic was to bring an end to the Dreyfus Affair.

⁓

While Waldeck-Rousseau was vigorously pursuing his agenda, Zola was back and active in Paris, where he was pleased to see his own case postponed until late November. In another positive development that reflected the changing political scene, all charges against Colonel Picquart had been dismissed, and after 384 days in prison, he was at long last free. But even more critically, after four years and three months, Alfred Dreyfus was now released from Devil's Island and removed to the military prison in Rennes. His new court-martial was about to begin.

On the trial's opening day, August 7, 1899, Alfred Dreyfus appeared in public for the first time since 1894. Above all, he did not want to be pitied, and he did everything in his power to keep pity at bay. But when he appeared, pity swept the courtroom. Even Maurice Barrès was shocked by what he saw—"a miserable human rag was being thrown into the glaring light," he wrote. Yet he added, "If what were at stake were merely a man, we would have covered his shame with a shroud. But what is at stake here is France."[19]

Other anti-Dreyfusards somehow managed to write (in the nationalist and anti-Semitic press) that Dreyfus had in no way suffered during his experience and that he was the very picture of health. Julie Manet, reflecting the attitudes of those around her, seemed totally unmoved by Dreyfus's suffering, and in fact did not even bother to mention it. "So these Dreyfusards are going to get their revision of sentence," she wrote bitterly, "the only result

of which will be even more trouble for our poor country." In a final burst of indignation, she added, "How powerful these Jews are!"[20]

Even Dreyfusards were not above a certain amount of casual anti-Semitism, although it did not shake their support. "As a human specimen," Misia Natanson Sert later wrote, "the little Jewish Captain for whom we were all ready to murder our parents represented everything we most disliked." Still, she added, "his cause was so manifestly the cause of justice that all we could do was to embrace it totally."[21]

Julie Manet would not have agreed, but her attention had never been particularly focused on events of the day, no matter how momentous, and this was all the more the case now that Ernest Rouart had entered her life. Soon after Dreyfus's retrial began, she left for a week's vacation outside of Paris, in the Impressionists' early haunt of Louveciennes. She then traveled on to Valvins and Burgundy, where she occupied herself with thoughts of Ernest Rouart, who had told her that he would be going shooting nearby. He was indeed, and he and Julie furthered their acquaintance, which by now was turning into courtship.

While Julie Manet was enjoying herself in the company of her dark-eyed young beau, Dreyfus was once again encountering the same questions—and the same lies—especially after the court-martial decided ("in the interest of the national defense") to meet in closed session to consider the secret file. General Mercier, the minister of war during Dreyfus's first court-martial and a major figure in all the deception involved in obtaining his conviction, was once again taking a leading role, promising new and astonishing truths, especially concerning the *bordereau*. This, he now proclaimed, was a copy, whose original was annotated by none other than the emperor of Germany. Mercier had also managed to insert new material surreptitiously into the secret file.

Especially shattering for Dreyfus's supporters, though, was the assassination attempt on Fernand Labori, who was serving as one of Dreyfus's lawyers. One morning, as Labori was walking toward the courtroom, a would-be killer shot him in the back. Labori miraculously survived, but his assailant was never found. Although Dreyfus requested an adjournment of the proceedings until Labori had recovered, the judges unanimously refused.

Unfortunately it was Labori who was scheduled to question Mercier, and with Labori absent, Mercier was able to escape rigorous questioning. But the real problem was the series of generals and former ministers of war who reaffirmed their complete and unwavering certainty in Dreyfus's guilt. Picquart's testimony, coming as it was from a defrocked soldier, was brushed aside, and despite Waldeck-Rousseau's efforts, Germany was not interested in providing any more assistance to Dreyfus beyond its previous statement that it had never had any dealings whatever with the man.

The judges reached their verdict on September 9. Two of the seven judges voted for Dreyfus's acquittal, but this was not enough to save him. Once again he was found guilty, but—in an odd and unsettling postscript—a majority declared that there were "attenuating circumstances." This allowed the judges to condemn Dreyfus to ten years of detention rather than to a life sentence. It may have relieved their consciences, but it did little to avert the distinct impression (especially throughout the shocked international community) that these military judges had capitulated to the high command and its implied ultimatum that the choice was between Dreyfus and the army. Once again the generals had made it clear that if France had no confidence in the honor of its army, then the army could no longer ensure the defense of France.

Waldeck-Rousseau was displeased but not surprised by the verdict. Knowing the personalities involved, he had expected the worst, and now was prepared to call in the High Court of Appeal to seek an acquittal. It was Galliffet who persuaded him otherwise. It was of the utmost importance, Galliffet told him, not to put "the entire Army, a majority of the French, and all the agitators" on one side, and "the cabinet, the Dreyfusards, and the international community" on the other.[22] Waldeck-Rousseau agreed, but he also understood that Dreyfus was in no physical or mental state for yet another court-martial, just as he was in no state to remain in prison.

The solution that Waldeck-Rousseau arrived at was a pardon rather than an acquittal. He was concerned about Dreyfus's fate, but even more concerned about the necessity of quieting the passions that were dividing his country. Dreyfus's brother, Mathieu, who saw the pardon as a means to save his brother's life, was quick to accept the concept. Justice could come later, he decided; for now, it was essential to get Alfred out of prison. Others, including Zola but especially Clemenceau, were appalled that Dreyfus would even consider a pardon, which implied guilt. Moreover, as far as Clemenceau was concerned, much more was at stake than the fate of a single human being. For two years he had written almost an article a day on Dreyfus, drawing the connection between the Dreyfus Affair and the principles at the Republic's heart. He had not fought out of pity for Dreyfus, but for the principle of justice. Unlike Waldeck-Rousseau, Clemenceau wanted to prolong the Dreyfus Affair as long as possible, using it to shape public opinion against the political power of the Church. After all, in Clemenceau's eyes, the forces of reaction, including the Church, had seized on the case as part of a plot to overthrow the Republic.

Mathieu Dreyfus eventually brought Clemenceau to agree—reluctantly— to the pardon by refusing to advise Albert to ask for one without Clemenceau's approval. Soon after Albert's request, President Loubet issued the pardon, and Dreyfus's long martyrdom at last came to an end.

The day after, Julie Manet sourly wrote in her diary that she was sending six francs to La Libre Parole in contribution to a fund for the repatriation of Jews to Jerusalem.[23] A day after that, as Mathieu Dreyfus escorted his brother from prison to the home of their sister and brother-in-law near Avignon, General Galliffet sent orders to the army that opened with the declaration, "The incident is over!" Pointedly reminding his many subordinates that "without mental reservations, we submitted to their [the military judges'] decision," he just as pointedly told them that "we will also submit to the act [the pardon] which a deep feeling of pity has dictated to the president of the Republic." Making clear that reprisals of any sort were not acceptable, he asked—and ordered—each and every one of them "to forget the recent past and think only of the future."[24] Clemenceau and the others who firmly believed that the Dreyfus Affair was not over were infuriated, but Galliffet was doing everything he could to ensure tranquility.

He was not the only one. That same year, as Sacré-Coeur's dome was at last completed, the pope attempted some tranquility-building of his own by dedicating the cult of the Sacred Heart "to the ideal of harmony among the races, social justice and conciliation."[25] Although Sacré-Coeur was still a provocative presence high on the Butte of Montmartre, Rome was doing what it could to separate the basilica from its incendiary monarchist past.

But as Rome would soon discover, it would be difficult to protect the French Catholic Church as a whole from fallout from the Dreyfus Affair. Thanks in large part to Clemenceau, soon after the turn of the century France would pass a law of separation between Church and state. After all, as Clemenceau and his fellow republicans saw it, the Dreyfus Affair had been fueled by the Church's efforts to overthrow the Republic. Now, in the aftermath of the Dreyfus Affair, the Republic would take steps to ensure that this never happened again.

~

A New Century

(1900)

The Dreyfus Affair was now over, but the moral problem at its heart remained. Anti-Semitism had subsided, but it had not disappeared. And Dreyfus himself, although pardoned, had not received justice. That would eventually come, but for now, few remained to continue to fight for his vindication. Instead, most of the Dreyfusards returned to the various interests, political parties, and causes that had preoccupied them before the Dreyfus Affair began. Even the nationalists seemed to have put the affair behind them.

Dreyfus by now was free and recovering in Switzerland, although in late 1900 he returned to Paris, where he and his family lived quietly with his father-in-law on the Rue de Chateaudun (9th). A general weariness seemed to have settled over the city, along with a preference to move on—a preference encouraged by good harvests in the rural areas and returning urban prosperity. As 1900 approached, the upcoming Universal Exposition and the celebration of the new century seemed far more enticing subjects than the battles of the past.

And yet there remained several trials that threatened to revive all the passions of the Dreyfus Affair. One was Zola's retrial; another was the suit brought by Colonel Henry's widow against Joseph Reinach, who had (quite rightly) accused Henry of treasonous activities in cahoots with Esterhazy. Even Colonel Picquart, who was seeking a judicial investigation, was not done with the legal process. Any or all of these trials threatened to disrupt the public peace, and Waldeck-Rousseau now took the precaution of proposing a general amnesty for all concerned, with the intention of tamping down any prospect of unrest.

These trials were placed on hold as the legislative wheels slowly began to turn, but all of the figures concerned heartily protested the prospect of amnesty. Dreyfus wrote the Senate (from Switzerland) that the proposed legislation would only benefit the guilty and stifle his own prospects for justice. Zola similarly protested that he wanted to be judged "and to complete my work." Picquart was adamant that "to grant amnesty to a man who has been unjustly accused is to deprive him of the moral reparation which is his right."[1] For their part, the anti-Dreyfusards were livid because Déroulède would be excluded from amnesty. Still, Waldeck-Rousseau was far more interested in the welfare of the Republic than in individual justice, and the general public was by now indifferent. The amnesty bill passed the Senate in the spring of 1900, with every prospect of being passed by the Chamber.

The final law did not emerge until late 1901, but by then, it was clear that amnesty was going to happen. It was equally clear that, with the exception of the individuals most directly involved, few still cared.

∽

If the start of a new year signals a new beginning, the start of a new century offers the prospect of an even more decisive rebirth. Putting the ugliness of the Dreyfus Affair behind them, Parisians now prepared to welcome the world to their door. It was not immediately clear, however, whether the ambitious centennial exposition they were planning would be ready on time, or even whether the rest of the world would come.

The latter question hinged on the outcome of Dreyfus's second court-martial, which had shocked people around the globe, from Melbourne to Odessa and Chicago. There had been demonstrations in Antwerp, Milan, Naples, London, and New York, and it had been necessary to provide police protection to French embassies in several cities. Even Queen Victoria was distressed, telegraphing Lord Russell of her shock at the verdict, while the Norwegian composer Edvard Grieg refused an invitation to conduct his music at the Théâtre du Châtelet because of his indignation over the outcome. Along with protest came widespread threats of boycotting the Paris Exposition.

But even more troubling was the city's lack of readiness for the great event. Only two days before the exposition's opening, on April 14, President Loubet's secretary, Abel Combarieu, was deeply discouraged by what he saw. "What chaos, what congestion of scaffolding, cases, materials, filthiness of every sort!" he reported.[2] A majority of the exhibitors had not yet finished their installations, and the starring attraction, the Palace of Electricity, was not yet electrified and would not be for several weeks.

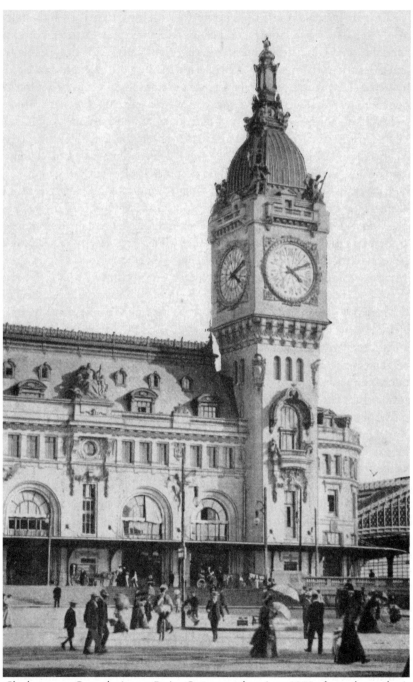

Clock tower, Gare de Lyon, Paris. Carte postale, circa 1900, from the author's collection.

Part of the problem was the enormity of the task that Paris had undertaken. Not only was it constructing major edifices for the exposition itself—including the Grand Palais and the Petit Palais, along with the spectacular Pont Alexandre III that linked them with the rest of the exposition across the Seine—but it was also preparing a new transportation network for the expected crowds. This meant constructing the present Gare de Lyon, including its famous clock tower and its equally famous restaurant, Le Train Bleu. It also meant erecting the Gare d'Orsay on the Left Bank site of the Palais d'Orsay, which had burned during the Commune. It meant adding a new spur to the Petite Ceinture, the passenger and freight railroad circling the city. And—in the most ambitious and forward-looking project of all—it meant digging an underground subway, the first stretch of the new Métro (now Line 1). Much or most of this huge undertaking remained unfinished on the exposition's opening day. The Gare d'Orsay, an essential piece of the envisioned transportation network, was not inaugurated until three months after the exposition opened, and the Métro was not finished until five days after the Gare d'Orsay. In the meantime, all of this construction, especially the huge holes dug for the Métro, was creating havoc throughout the heart of Paris.

Still, when everything was at last finished, the results were suitably impressive, and the crowds indeed came. The Petite Ceinture, which completed its spur to the Champ de Mars two days before the exposition opened, boosted its ridership that year to some forty million passengers, while the Métro, despite its late start, carried some seventeen million passengers, many of them to points located near the fairgrounds. Fifty million visitors swarmed into the exposition, almost half of them from France. Of these, nearly a million visited the star of the previous French exposition, the Eiffel Tower, which had survived various ill-conceived plans for its modification, including one that envisioned turning it into a Palace of Electricity and Engineering, with an enormous iron-and-glass structure added to its base.

But the Eiffel Tower no longer was the only wonder to gawk at. Visitors marveled at the huge globe of the world, complete with a panorama simulating an around-the-world sea voyage, and the giant Ferris wheel that held hundreds of people. Another major attraction was the Palace of Electricity, especially by night, when it was illuminated with thousands of electric lights. And a particular crowd-pleaser was the electrically powered moving sidewalk, which carried visitors around the Left Bank portion of the exposition.

Indeed, the exposition's organizers had gone to considerable lengths to promote electricity as the energy source of the future, and in addition to providing twinkling electric lights and the electrically powered sidewalk and Ferris wheel, they invited several thousand of France's mayors to a much-

ballyhooed banquet. Since this mob was seated at hundreds of tables, the necessary coordination was done (as its promoters proudly announced) by telephone and electric automobile.

As is usually the case in world expositions, education and amusement were closely intermingled, with amusement having the clear upper hand. Despite the serious-sounding designations of the exhibition's four areas (entertainment and leisure, decorative arts and home furnishings, fine arts and architecture, and the military), the spirit of fantasy prevailed. Even the Palais des Armées de la Terre et de la Mer, France's prized exhibit of the latest in military equipment for land and sea, was a vision straight out of the Arabian Nights, complete with minarets and crenellated towers. Its neighboring pavilion, housing the Creusot iron works, was similarly fanciful, shaped like an exotic dome.

As quickly became apparent, the effort to find new uses for electricity had some especially entertaining applications, including not only the moving sidewalk, but also the Lumière brothers' moving pictures and the arresting dances of Loie Fuller, who harnessed colored lights to extraordinary effect. Fuller, an American who had come up through the vaudeville and carnival circuit (at one point working as a sidekick for Buffalo Bill), had by now found her true vocation as a dancer of striking originality. Working with electrical lights, colored gels, and yards of billowing silks, she danced "The Dance of Fire," "The Dance of the Butterfly," and numerous other numbers that generally climaxed with her dramatic appearance as the pistil of an enormous and colorful flower. By 1900 she was the toast of Paris—or at least the Paris that hung out at the Folies Bergère, where she performed. And after she investigated the fluorescent effects of radium (resulting in her "Radium Dance"), she became a friend of Pierre and Marie Curie as well.

As Fuller is now considered a pioneer of modern dance, it was no wonder that her path crossed that of Isadora Duncan, who arrived in Paris during the 1900 exposition. A native of San Francisco, Isadora had traveled to Paris with her close-knit and thoroughly bohemian family, hoping to take the City of Light by storm. Since childhood she had felt compelled to express the essence of music through what she termed the "lost art of dancing," but it had been a long and difficult journey, during which she had suffered hardship and innumerable humiliations, including a stint in vaudeville. Now in Paris, and aided by the Princesse Edmond de Polignac, Isadora at last found her audience (such as one especially fashionable soirée, where Ravel played the piano for her).

Still, Parisian society tended to regard Isadora as a passing diversion, and it would take far more to propel her into international stardom. The person who would truly help her launch her career was Loie Fuller, whom Isadora

finally encountered the year after the Paris exposition. It was then that Isadora danced for Fuller, who invited her to tour Germany with her own troupe. Isadora Duncan was about to take Europe by storm.

⁓

While Fuller and Duncan were dancing their way to destiny, Rodin was experiencing a major triumph of his own. Looking for ways to exhibit a full range of his works in a one-man show, he had lit on the idea of exhibiting at the Paris exposition. Since he could not mount any show of this size within the framework of the exposition itself, he had a large private pavilion built just outside the exhibition gates, on the small triangle at the corner of Avenue Montaigne and the Cours Albert-1er in the Place de l'Alma (8th). This piece of ground had a hallowed history in the art world, for Courbet had exhibited here, and Manet had famously tried to fight the Salon and the art establishment by exhibiting here in 1867.

Here on this same spot Rodin exhibited some 150 sculptures, from *The Man with the Broken Nose* and *Saint John* to *The Burghers of Calais, Balzac*, and the still-unfinished *Gates of Hell*. Visitors did not flock to this exhibit—after all, Rodin charged admission, and in any case an exhibit of contemporary sculpture was a bit esoteric for the average fairgoer, who probably preferred a ride on the Ferris wheel. But those who did come were for the most part awed by what they saw. Among them, Oscar Wilde lauded Rodin as the "greatest poet in France."[3] By November, when it was all over, Rodin had recouped his expenses. Several collectors as well as museums in Philadelphia, Hamburg, Dresden, and Budapest had placed commissions, and he could anticipate more to follow. But most importantly, his reputation—battered by the controversy over *Balzac*—was now secure.

⁓

By now, Antoine Bourdelle had been working for Rodin for several years, and the two were good friends. Rodin had been influential in winning Bourdelle the commission for a large war memorial in Bourdelle's hometown of Montauban, and Bourdelle had been prominent in the group of artists supporting Rodin during the Balzac affair. Not surprisingly, Rodin's influence can be seen in several pieces that Bourdelle sculpted during the early years of their association. But gradually Bourdelle began to break away from Rodin's style. As Bernard Champigneulle puts it, Bourdelle had a feeling for architecture, and he "thought of all sculpture in structural terms."[4] His eventual design input as well as bas-reliefs for the façade of the Théâtre des Champs-Elysées (Avenue Montaigne, 8th), including his bas-relief of an imagined dance between Isadora Duncan and Nijinsky, clearly illustrate this

point. But Bourdelle's individual style had emerged as early as 1900, with the completion of his remarkable *Tête d'Apollon* (*Head of Apollo*). As soon as Rodin saw it, he understood. "Ah, Bourdelle," he said. "You are leaving me."[5] Rodin meant this as a comment on Bourdelle as an artist, for Bourdelle remained with Rodin for several more years, during which he mounted the first exhibition of his own work, to great acclaim.

In the meantime, Gabriel Cognacq, who would eventually provide the funds to purchase Bourdelle's studio and convert it into a museum, was turning into a good investment for his adoptive parents. Not only did Gabriel eventually take over the management of the Samaritaine department store, which he handled well, but he had exceptional taste, which Ernest Cognacq relied upon in developing his own collection, and which Gabriel applied to forming his own fabled art collection (sold at a head-spinning auction in 1952, after his death). Taking far more interest in contemporary art and artists than did Ernest, Gabriel became a patron of many living artists, including Bourdelle, who in return gave Gabriel a touching bust of Gabriel's young son, Michel, shortly after Michel's death.

Bourdelle was generous with his time and advice, and over the course of many years nurtured and taught a remarkable group of students, including the young Swiss sculptor Alberto Giacometti. In his early years, Giacometti was searching for his own individual form of expression, just as Bourdelle had done, and at times he found the quest discouraging. One day, in the attempt to reassure him, Bourdelle's wife told him that both Rodin and Bourdelle had never ceased to search. To which the despondent Giacometti replied, "Yes, but they have found."[6]

～

One of Bourdelle's last works was his gilt bronze portrait bust of Gustave Eiffel, which was placed beneath the Eiffel Tower in 1929, the same year as Bourdelle's death. Eiffel did not live to see this event, as he had died in 1923 at the age of ninety-one, having spent the years after the Panama affair in relative obscurity. But he had not been inactive—far from it. Following his abrupt retirement, he spent much of his time in his famous tower, conducting scientific experiments. This was no mere hobby, for by the time of his death Eiffel had made pioneering contributions in several emerging fields. Prompted by his interest in meteorology and the effects of wind on structures, he studied the effects of wind on aviation, leading to his construction of a wind tunnel at the foot of his tower and the subsequent construction of a laboratory and additional wind tunnel at the southwestern edge of Paris, in Auteuil. Not surprisingly, the French military was quick to appreciate what Eiffel was doing, and soon Eiffel was concentrating on military problems,

contributing in a major way to the success of French aircraft during World War I.

But that was not all, for Eiffel was also active in developing the new field of radio communications. In 1898, after having a transmitter system set up on the third platform of his tower, he and another experimenter were able to transmit a signal to the Panthéon, located more than two miles away. Soon, under Eiffel's encouragement (and subsidies), his tower became the army's principal laboratory for wireless experiments. By the time of World War I, the Eiffel Tower provided the basis for communication with Berlin, Casablanca, and North America, and allowed the army to intercept enemy messages, including the famous intercept that led to the arrest and conviction of the German spy Mata Hari.

～

Despite his many other works produced over an illustrious fifty-two-year career, the Statue of Liberty remained Frédéric Bartholdi's most noteworthy creation. In 1900, four years before he died of tuberculosis, Bartholdi gave the City of Paris a copy of his famed statue for its Universal Exposition. This copy, cast in 1889 and standing less than ten feet high (not including its pedestal), was one of five bronze replicas cast following the 1886 dedication of the original in New York Harbor. Of the four that went to various French cities, the Germans melted down three for ammunition during World War II, while the fourth disappeared soon after. But this one survived and now stands quietly to the west of the pool in the Luxembourg Gardens.

Although the exposition centered on the extensive grounds around the Eiffel Tower, extending to both banks of the Seine, it fostered a ripple of face-lifting and improvement throughout the city. Just to the south of the Luxembourg Gardens, for example, the Closerie des Lilas was one of many Paris cafés that spruced themselves up in preparation for the expected crowds. Emerging from its sleepy past as a modest outdoor tavern, the Closerie acquired a new look and importance at the century's turn. Within the decade, as Montparnasse began to replace Montmartre as the center of Paris's art world, the Closerie would become one of the hottest spots in Montparnasse, where writers and artists gathered to sip absinthe and argue endlessly over the topic of the moment.

～

After only a few short months, Debussy's marriage was already showing small but distinct signs of trouble. In January 1900, he described Lilly to a friend as a beauty, whose favorite song was one about a grenadier who wears his hat

over one ear—a musical selection that Debussy found "indescribable and not exactly challenging."[7]

But boredom with Lilly had not yet set in, and in fact Debussy in August was considerably concerned about the state of her health, which a miscarriage had exacerbated. Adding to his worries, his publisher, Georges Hartmann, had unexpectedly died, leaving Debussy without a benefactor and—even worse—in need of repaying all the funds he had received from Hartmann to Hartmann's heir, who considered them as loans, not gifts.

Still, there were promising breakthroughs for Debussy on the professional front, the first in August (coinciding with Lilly's hospitalization), when Blanche Marot sang his *La Damoiselle Elue* as part of one of the concerts marking the Universal Exhibition. And he had at last completed the *Nocturnes*, the first two of which were performed in December at the Concerts Lamoureux, to generally favorable and even enthusiastic reviews. (The last nocturne, *Sirènes*, was not performed at this time because a female chorus was not available.)

Maurice Ravel attended the December performance and was sufficiently delighted by what he heard that by the following spring he had embarked on a transcription of the *Nocturnes* for two pianos, four hands. This marked the beginning of a friendship between the two composers, although in time Debussy's admiration for Ravel would cool into rivalry.

But for the moment, Debussy—who was emerging as the leader of the new French music scene—was in the mood to be supportive. In addition to Debussy, Ravel had begun to attract the interest of patrons such as the Princesse Edmond de Polignac, to whom he dedicated the *Pavane pour une Infante défunte*, and Misia Natanson, who became a lifelong devotee. Ravel had also begun to gravitate toward a group of like-minded young friends who called themselves the Apaches (Outcasts). These avant-garde poets, painters, pianists, and composers (who included Manuel de Falla and, eventually, Stravinsky), met regularly for many years, right up until the war—by which time Ravel's reputation as one of France's leading composers was finally established. It was in this congenial setting that Ravel performed some of his early compositions, and it was here that the rather reserved young man made lifelong friendships.

~

As it happened, Ravel's friend and patron Misia Natanson was not about to remain Misia Natanson very much longer. In 1900, en route to becoming the prominent arts patron Misia Sert, she encountered the man who would become her second husband, Alfred Edwards.

Edwards, an adventurer and self-made man, was everything that her first husband, Thadée Natanson, was not—crude, abrasive, and very, very rich. He was also in love with Misia. Accustomed to getting everything he wanted, Edwards meant to have her, even though Misia was at first distinctly disinterested. There matters might have remained, except that Thadée's *Revue Blanche* had run up substantial debts, prompting him to turn his energies into money-making schemes that brought him to the edge of bankruptcy. Swimming in deep financial waters, Thadée held out the desperate hope that Edwards would give him financial backing. Couldn't Misia, Thadée begged, put her legendary charm to good use?

Misia resisted, but in the end, both Thadée and Edwards got what they wanted, with Misia becoming Edwards' mistress and then Mrs. Edwards, once the previous Mrs. Edwards was out of the way. In time, Misia learned to put up with her new husband and enjoy her enormous wealth. After all, she adored her yacht, where she entertained magnificently. And in some ways, her life continued as before: Ravel dedicated *Le Cygne* and (eventually) *La Valse* to her, and Bonnard and Renoir continued to paint her. But one wonders whether it ever gave her pause to be living with Edwards in his grand apartment overlooking the Tuileries, so close to her former abode with Thadée.

～

While Misia Natanson Edwards was embarking on her adventurous career, Sarah Bernhardt was taking her own glorious career to new heights. Having performed Hamlet, she now appeared in yet another trouser role, this time as the son and heir of Napoleon, the young and tragic Eaglet, or *L'Aiglon*, who died at the age of twenty-one. The playwright was Edmond Rostand, author of *Cyrano de Bergerac*, which had swept Paris by storm two years before. In *L'Aiglon*, Rostand created the winning combination of a tearjerker infused with patriotic uplift. Bernhardt, who by now was in her mid-fifties, dived into the part with all her usual energy, wearing her costume, complete with boots and sword, for weeks before the play opened. That she was portraying a teenager did not in the least dismay her, and judging from pictures of her in the tight-fitting uniform, she could still do it credit.

The play opened in March and continued for 250 performances, giving Bernhardt what many thought was the greatest role to date of her career. *L'Aiglon* had everything: rousing patriotic speeches, romantic settings, and a moving death scene, which of course was Bernhardt's specialty. Parisians who had been at swords' points over the Dreyfus Affair united in their acclaim, while Bernhardt's photograph as the dashing but unfortunate Eaglet was multiplied many times over on postcards, which sold by the thousands.

In short, *L'Aiglon* was a triumph, and based on its success, Bernhardt departed for another lengthy American tour.

～

Celebrating Bernhardt's success as *L'Aiglon*, Escoffier created a new dessert in her honor, something called *Pêches l'Aiglon*. A longtime friend and admirer of Bernhardt, Escoffier had already created *Fraises Sarah Bernhardt*, a creation of strawberries with pineapple sorbet and a citrus-flavored ice cream infused with curaçao.

Escoffier adored his women clientele and adored cooking for them, coming up with a special consommé for the still-slender Bernhardt and creating Melba Toast and Peach Melba for the significantly heavier Australian soprano, Nellie Melba. His dishes were considered light for their day, and the women who could afford to eat in his dining rooms doted on him.

But Escoffier was not to remain for long in Paris. In 1900, he returned to London, where he oversaw the kitchens of Ritz's new hotel, the Carlton, which Ritz (as always) was determined to establish as the premier hotel in the city. Indeed, following the death of Queen Victoria in early 1901, Ritz won the vied-for contract for the elaborate coronation reception for Edward VII, and he invested considerable time, energy, and money into making it as perfect as everything else he had done.

But then disaster struck. Two days before the coronation, the future king became severely ill. There was nothing to be done except move the coronation from June to August. Ritz, who was already exhausted from his perfection-driven management style as well as from his constant travels, collapsed at the news.

He never recovered. In a dismal ending to his upwardly spiraling career, he spent the rest of his long life in a series of institutions, while his indomitable wife, Marie-Louise, carried on.

～

After decades of abuse and neglect, the Impressionists at last received official recognition at the 1900 Universal Exposition, where they were represented right along with the traditional artists of the Salon in a huge and prestigious display of French art. Not that they were bowled over by this long-overdue tribute; in fact, Monet and Pissarro originally turned down the opportunity, on the grounds that they feared that they were being merely tolerated and that their works would be badly hung.

Whatever their alarm, which seems to have been occasioned at least in part by long-held resentment, in the end the Impressionists and Manet were indeed represented in the section of the Grand Palais devoted to art from

1800 to 1889 (the date of the previous Universal Exposition). Although there were some who complained that the Impressionists and Manet were underrepresented, Monet had fourteen paintings exhibited, while Manet had thirteen and Renoir, eleven. Degas, Pissarro, Morisot, and Sisley were less fulsomely represented but certainly were not overlooked (Pissarro had seven paintings included, while Sisley had eight). In any case, Pissarro seems to have been well pleased, especially as the prices for his paintings had recently gone up significantly.

～

Late that November, Oscar Wilde died in poverty at the Hôtel d'Alsace in Paris. Isadora Duncan, who had read Wilde but as yet knew little about him, was at first baffled when a young man who had proved singularly resistant to her charms came to her in shock and depression after learning of Wilde's death. Sympathetic, she asked how Wilde had come to die in such a miserable place. In response, the young man only blushed and refused to answer.

Death would soon carry off Zola as well, although in his case the suspicion existed, and still exists, that he was murdered. No concrete evidence was ever produced to prove this, and yet the circumstances of his death were sufficiently odd to encourage speculation.

The known facts were simple enough. One chilly evening in the autumn of 1902, Zola and his wife retired to their bedchamber for the night and left a small coal fire burning. All the windows were closed tight, as usual, since Zola had received enough death threats that he made it a practice of locking and bolting up the place for the night. But this particular night was not like the others, for by morning he was dead—of carbon monoxide poisoning. Madame Zola narrowly survived.

An inquest was held, and specialists tried to replicate the fatal incident, but could not. They lit fires in the bedchamber and shut the windows, but could find little trace of carbon monoxide. They left guinea pigs in the room, but the creatures showed no signs of harm. The specialists then took apart the flue, but found nothing of note there, except some soot buildup. The coroner, who for whatever reasons seemed disinterested in pursuing the matter further, kept these reports private and announced that Zola's death was due to natural causes. It was left at that—although many, including Zola's mistress, had their doubts. Many years later, a Parisian roofer claimed on his deathbed that he had closed the chimney in revenge for "J'accuse," unclosing it the next morning before anyone noticed. But there was little beyond his word to substantiate his claim, and so the question has lingered.

News of Zola's death—so strange, so needless—created enormous shock, and the outpouring of grief was huge and heartfelt, with tributes and flowers

flooding in from around the world. Among these tributes, one was especially noteworthy: Alfred Dreyfus quietly appeared at the Zolas' Rue de Bruxelles address and kept vigil with Madame Zola over the body.

The morning of the funeral, thousands gathered before the Zola residence, and countless thousands more followed the cortège to the nearby Cemetery of Montmartre, where Anatole France—a fierce opponent before he became a comrade-in-arms—gave the graveside speech on behalf of Zola's friends. With heartfelt eloquence, France concluded, "Let us envy him. . . . He has honored his country and the world with an immense work and through a great action. Envy him his destiny and his heart, which made his lot that of the greatest: he was a moment in the conscience of man!"[8]

Two carriages filled with flowers followed the hearse, which was accompanied by a detachment from the Twenty-Eighth Infantry. Among the first ranks of the mourners was Alfred Dreyfus, who had insisted on attending, despite fears that his presence might set off demonstrations. There were none.

Several years later, however, when Zola received the ultimate tribute that his nation could offer—the transfer of his remains to the Panthéon—it was a different story. Fearing violence from the vastly reduced but still-simmering group of anti-Semitic nationalists and monarchists, some thirty of Zola's closest friends and associates accompanied the hearse along a secret course across the city during the night before the ceremony. But as they approached the Panthéon, they were attacked by a mob of thugs who tried to overthrow the hearse and desecrate the bier. A small contingency of police came to the rescue, and at last the bier was safely carried into the Panthéon, where it awaited the ceremony. It was during this solemn affair, attended by the heads of the government, the diplomatic corps, and the army, that a would-be assassin fired two shots at Dreyfus. Fortunately, Dreyfus was only wounded.

But by now, Dreyfus—although still the target of hate groups—had finally received justice. Thanks to his stalwart supporters, but especially to Jean Jaurès, he had received official declaration of his innocence in 1906. (The decision to glorify Zola by officially moving his remains to the Panthéon came directly on the heels of this long-overdue pronouncement; it was a decision in which Jaurès was also instrumental.) Dreyfus was restored in rank and seniority and was awarded the Cross of the Legion of Honor. He soon retired from the military, but despite the permanent damage that Devil's Island had done to his health, he reentered the army upon the outbreak of World War I, participating in the battles of Chemin des Dames and Verdun. After the war, the Legion of Honor elevated him to the rank of Officer.[9]

Picquart also was restored to the army, with the rank of brigadier general. Soon after, when Clemenceau became prime minister of France, he appointed Picquart as his minister of war.

Clemenceau's many well-argued and forceful articles not only helped win Dreyfus's eventual exoneration but also paved the way for Clemenceau's second career in politics. He had abandoned the field following his shattering 1893 electoral defeat, but in 1902 he returned to Parliament and in 1906 was invited to join the government as minister of the interior. Here he won public acclaim by using the military to break up workers' strikes—a dramatic shift from his previous championship of labor, and one that angered the Left but launched him into the premiership.

After leading France for three years, he encountered yet another political speed bump and returned to journalism, where he insistently warned of German militarism and exhorted France to prepare for the war that indeed came. After three grueling years of trench warfare, the French turned to Clemenceau for help, once again making him (at the age of seventy-six) their prime minister. In turn, Clemenceau, the "Father of Victory," rallied and inspired the entire nation, serving as a kind of latter-day Jeanne d'Arc.

～

Perhaps as heroic in its own way was Clemenceau's patient encouragement and support of his good friend Monet during the long years when the painter was struggling to produce his epic *Water Lilies*. It was Clemenceau who, after the death of Monet's beloved Alice, cajoled and prodded his friend to undertake the enormous project. "Go ahead and stop procrastinating," Clemenceau told him. "You can still do it, so do it."[10]

In the years that followed, even throughout the war, Clemenceau provided Monet with essential moral as well as practical support, helping to negotiate a future home for the panels (at first planned for a free-standing building on the grounds of the Hôtel Biron, and then in the ground floor of the Musée de l'Orangerie), as well as making possible Monet's eventual donation of the entire work to the state. In time, Clemenceau was also successful in pressing Monet to undergo operations for his cataracts.

As Monet's health ebbed, Clemenceau visited Giverny ever more frequently, encouraging his friend to eat and to walk in his beloved garden. Shortly before Monet's death, Clemenceau was still wont to buck him up with advice such as, "Stand up straight, hold your head up, and kick your slipper up as far as the stars." But the Tiger was gently humorous with Monet as well, calling him his "poor old crustacean."[11]

Monet died on December 5, 1926, and Clemenceau was with him at the end. Later, at the funeral, he replaced the black flag draped over the coffin with a flower-patterned cloth, with the words, "No black for Monet!"[12]

～

In death, Zola joined Victor Hugo and Alexandre Dumas *père* in the Panthéon, where the three occupy the same niche—leading some to wonder whether they enjoy their conversations together. And in 1995, the Panthéon at last admitted two-time Nobel Prize–winner Marie Curie. It was some sixty years after her death, but she had finally cracked through the mausoleum's gender barrier, just as she cracked through the professional gender barriers in life. Both she and her beloved husband, Pierre, occupy tombs in the northern arm of the crypt, making the Panthéon's dedicatory words ("To the Great Men") satisfyingly outdated.

As for Julie Manet, who in 1899 was falling in love with Ernest Rouart, she married him in 1900 in a double wedding with her cousin Jeannie Gobillard, who (as Julie had hoped) did indeed marry Paul Valéry. The two couples honeymooned together and then returned to Paris, where Julie and Ernest lived on the fourth floor of the house that Berthe Morisot and Eugène Manet had built on the Rue de Villejust, while Jeannie and Paul lived on the third floor. (In recognition of Valéry's subsequent literary fame, the Rue de Villejust has been renamed the Rue Paul-Valéry.)

Julie and Ernest proceeded to restore and redecorate her parents' beloved Château du Mesnil, much as Julie had once dreamed, and brought up their three sons there, keeping their Paris address as well. It was a rich and full life, devoted to art and culture, and one suspects that Berthe Morisot, in her typically quiet way, would have been delighted.

Notes

Introduction: The Terrible Year (1870–1871)

For background on the Franco-Prussian War, the Siege of Paris, and the Commune, the following sources are especially helpful: Alistair Horne, *The Fall of Paris: The Siege and the Commune 1870–71* (Harmondsworth, UK: Penguin, 1981 [first published 1965]); Stewart Edwards, *The Paris Commune, 1871* (London: Eyre and Spottiswoode, 1971); Louise Michel, *The Red Virgin: The Memoirs of Louise Michel*, ed. and trans. Bullitt Lowry and Elizabeth Ellington Gunter (Tuscaloosa: University of Alabama Press, 1981); Edith Thomas, *Louise Michel, ou, La Velléda de l'anarchie*, trans. Penelope Williams (Montréal: Black Rose Books, 1980); Nic Maclellan, ed., *Louise Michel* (Melbourne, N.Y.: Ocean Press, 2004); Jack D. Ellis, *The Early Life of Georges Clemenceau, 1841–1893* (Lawrence: Regents Press of Kansas, 1980); David Robin Watson, *Georges Clemenceau: A Political Biography* (New York: David McKay, 1974); J. P. T. Bury and R. P. Tombs, *Thiers, 1797–1877: A Political Life* (London: Allen & Unwin, 1986); Robert Tombs, *France, 1814–1914* (London: Longman, 1996); and Jules Bertaut, *Paris, 1870–1935*, trans. R. Millar, ed. John Bell (London: Eyre and Spottiswoode, 1936).

1. These terms included the loss of Alsace and Lorraine, a huge war indemnity (five billion francs, payable by September 1875), and—perhaps most difficult of all for the long-suffering Parisians to swallow—a Prussian victory march through Paris.

2. Ordinals in parentheses refer to the arrondissement. Since 1860, Paris has been divided into twenty arrondissements, or administrative units, each having its own *mairie*, or town hall. City hall for all of Paris is the Mairie de Paris, located in the Hôtel de Ville.

1 Ashes (1871)

Selected sources for this and subsequent chapters are listed, by chapter, in the approximate order in which they informed the text: Sarah Bernhardt, *Memories of My Life: Being My*

Personal, Professional, and Social Recollections as Woman and Artist (New York: Benjamin Blom, 1968 [first published 1907]); Emile Zola, *Correspondance*, ed. B. H. Bakker (Montréal: Presses de l'Université de Montréal; Paris: Editions du Centre National de la Recherche Scientifique, 1978–), vol. 2; Emile Zola, *L'assommoir*, trans. Leonard Tancock (Harmondsworth, UK: Penguin, 1970); Edmond de Goncourt and Jules de Goncourt, *Pages from the Goncourt Journal*, ed. and trans. Robert Baldick (New York: New York Review of Books, 2007); Ellis, *Early Life of Georges Clemenceau*; Watson, *Georges Clemenceau*; Marie Louise Ritz, *César Ritz, Host to the World* (New York: Lippincott, 1938); Victor Hugo, *Actes et paroles* (Paris: M. Lévy, 1875–1876), vol. 3; Victor Hugo, *The Hunchback of Notre-Dame*, trans. Walter J. Cobb (New York: Signet, 2001 [first published 1964]); Graham Robb, *Victor Hugo* (London: Picador, 1997); Edouard Manet, *Manet by Himself: Correspondence and Conversation, Paintings, Pastels, Prints, and Drawings*, ed. Juliet Wilson-Bareau (London: Macdonald, 1991); Berthe Morisot, *The Correspondence of Berthe Morisot with Her Family and Friends: Manet, Puvis de Chavannes, Degas, Monet, Renoir, and Mallarmé*, ed. Denis Rouart, trans. Betty W. Hubbard (London: Camden Press, 1986); Anne Higonnet, *Berthe Morisot* (New York: Harper & Row, 1990); Jean Renoir, *Pierre-Auguste Renoir, mon père* (Paris: Hachette, 1962); Daniel Wildenstein, *Monet, or the Triumph of Impressionism*, vol. 1, trans. Chris Miller and Peter Snowdon (Cologne, Germany: Taschen/Wildenstein Institute, 1999); Daniel Wildenstein, *Claude Monet: Biographie et catalogue raisonné*, vol. 1 (Lausanne and Paris: Bibliothèque des Arts, 1974); John Rewald, *Camille Pissarro* (New York: Henry N. Abrams, 1963); Robert L. Herbert, *Impressionism: Art, Leisure, and Parisian Society* (New Haven, Conn.: Yale University Press, 1988); John Rewald, *The History of Impressionism*, 4th ed. (New York: Museum of Modern Art, 1973 [first published 1946]); Philip G. Nord, *Impressionists and Politics: Art and Democracy in the Nineteenth Century* (London: Routledge, 2000); Colin Jones, *Paris: Biography of a City* (New York: Viking, 2005).

1. Bernhardt, *Memories of My Life*, 233.
2. Bernhardt, *Memories of My Life*, 233–34.
3. Zola to Cézanne, 4 July 1871, in Zola, *Correspondance*, 2:293–94.
4. César Ritz later recalled that by spring of 1871, Paris was "almost treeless" (Marie Louise Ritz, *César Ritz*, 43, 47).
5. Zola, *L'assommoir*, 21.
6. Hugo, *Actes et paroles*, 3:5–7.
7. Hugo was never formally exiled, but left France after the coup d'état that prefaced the Second Empire, rightly anticipating that he and Napoleon III's regime would not be compatible.
8. Hugo quoted in Robb, *Victor Hugo*, 453–55.
9. Hugo quoted in Robb, *Victor Hugo*, 452.
10. Four of these still remain: the Rotonde de la Villette (19th), at the foot of the Bassin de la Villette; a small rotunda at the northern entrance to Parc Monceau (8th); two columns in the Place de la Nation (11th and 12th); and twin buildings at Place Denfert-Rochereau (14th), one of which now serves as an entrance to the catacombs.
11. The Bois de Boulogne and the Bois de Vincennes, at the far edges of Paris, belong to the city but lie outside these arrondissements.
12. Manet to Morisot, 10 June 1871, in Morisot, *Correspondence*, 74.
13. While in uniform, neither Manet nor Degas encountered any significant danger. However, their friend Tiburce Morisot fought on the front, where he had a far more dashing—and dangerous—military career. Another friend, the artist Frédéric Bazille, was killed in action.

14. Monet's quote comes from a 25 September 1869 letter to Frédéric Bazille reproduced in Wildenstein, *Claude Monet: Biographie et catalogue raisonné*, 1:427.
15. Goncourt, *Journal*, 28 March and 24 May 1871, 185, 190.
16. Goncourt, *Journal*, 28 May 1871, 192–93.
17. Goncourt, *Journal*, 29 and 31 May, 1871, 193–94.
18. Zola to Cézanne, 4 July 1871, in Zola, *Correspondance*, 2:294.
19. Bernhardt, *Memories of My Life*, 234.
20. Manet to Morisot, Morisot, *Correspondence*, 74.

2 Recovery (1871)

Selected sources for this chapter: Jean-Marie Mayeur and Madeleine Rebérioux, *The Third Republic from Its Origins to the Great War, 1871–1914*, trans. J. R. Foster (Cambridge, UK: Cambridge University Press, 1989); Bury and Tombs, *Thiers*; Henri Troyat, *Zola* (Paris: Flammarion, 1992); Morisot, *Correspondence*; Robb, *Victor Hugo*; Michel, *Memoirs*; Thomas, *Louise Michel*; Maclellan, *Louise Michel*; Ellis, *Early Life of Georges Clemenceau*; Watson, *Georges Clemenceau*; Frédéric Auguste Bartholdi, *The Statue of Liberty Enlightening the World* (New York: New York Bound, 1984 [first published 1885]); Cara A. Sutherland, *Portraits of America: The Statue of Liberty* (New York: Museum of the City of New York, 2002); Barry Moreno, *The Statue of Liberty Encyclopedia* (New York: Simon & Schuster, 2000); Marvin Trachtenberg, *The Statue of Liberty* (New York: Penguin, 1986); David I. Harvie, *Eiffel: The Genius Who Reinvented Himself* (Gloucestershire, UK: Sutton, 2004); John McManners, *Church and State in France, 1870–1914* (London: SPCK, 1972); Raymond Anthony Jonas, *France and the Cult of the Sacred Heart: An Epic Tale for Modern Times* (Berkeley: University of California Press, 2000); Thomas A. Kselman, *Miracles and Prophecies in Nineteenth-Century France* (New Brunswick, N.J.: Rutgers University Press, 1983); David Harvey, *Consciousness and the Urban Experience: Studies in the History and Theory of Capitalist Urbanization* (Baltimore: Johns Hopkins University Press, 1985).

1. Troyat, *Zola*, 115–16.
2. Madame Morisot to Edma Morisot Pontillon, 29 June 1871, Morisot, *Correspondence*, 79.
3. The rate of return was more than 6 percent (Bury and Tombs, *Thiers*, 212).
4. Michel, *Memoirs*, 66.
5. Michel, *Memoirs*, 87.
6. The position was at first provisional, until elections confirmed it.
7. Clemenceau's mother and her family were Protestant, while his father, whose family had been Protestant before being forced to convert, was an atheist. Clemenceau's birthplace, the Vendée, although once a center for Protestantism, had since the 1790s been a byword for fanatical Catholicism and counterrevolutionary activities.

3 Scaling the Heights (1871–1872)

Selected sources for this chapter: Bernhardt, *Memories of My Life*; Arthur Gold and Robert Fizdale, *The Divine Sarah: A Life of Sarah Bernhardt* (New York: Vintage Books, 1992); Robb, *Victor Hugo*; Wildenstein, *Monet, or the Triumph of Impressionism*, vol. 1; Denis Rouart, *Claude Monet*, trans. James Emmons (Paris: Albert Skira, 1958); Camille Pissarro, *Letters to His Son Lucien*, ed. John Rewald, with assistance of Lucien Pissarro, trans. Lionel Abel (Santa Barbara: Peregrine Smith, 1981 [first published 1944]); Rewald, *Camille Pissarro*; Manet, *Correspondence and*

Conversation; Françoise Cachin, *Manet: Painter of Modern Life*, trans. Rachel Kaplan (London: Thames and Hudson, 1995); T. J. Clark, *The Painting of Modern Life: Paris in the Art of Manet and His Followers*, rev. ed. (Princeton, N.J.: Princeton University Press, 1999 [first published 1984]); Beth Archer Brombert, *Edouard Manet: Rebel in a Frock Coat* (Boston: Little, Brown, 1995); Rewald, *History of Impressionism*; Marie Louise Ritz, *César Ritz*; Georges Brunel, "Ernest Cognacq, the Collector and His Collection," in *Cognacq-Jay Museum Guide* (Paris: Paris-Musées, 2003); Michael R. Miller, *The Bon Marché: Bourgeois Culture and the Department Store, 1869–1920* (Princeton, N.J.: Princeton University Press, 1981); Emile Zola, *The Ladies' Paradise* [*Au bonheur des dames*], intro. Kristin Ross (Berkeley: University of California Press, 1992); Fernand Laudet, *La Samaritaine: Le génie et la générosité de deux grands commerçants* (Paris: Dunod, 1933); Matthew Josephson, *Zola and His Time* (Garden City, N.Y.: Garden City Publishing, 1928); Frederick Brown, *Zola: A Life* (New York: Farrar, Straus & Giroux, 1995); F. W. J. Hemmings, *Emile Zola* (Oxford, UK: Clarendon, 1966); Bury and Tombs, *Thiers*; Pierre Laligant, *Montmartre: La basilique du voeu national au Sacré-Coeur* (Grenoble, France: B. Arthaud, 1933).

1. Bernhardt, *Memories of My Life*, 228, 235.
2. Bernhardt, *Memories of My Life*, 235, 237, 240–41.
3. Manet quoted in Wildenstein, *Monet, or the Triumph of Impressionism*, 1:56.
4. Zola quoted in Rouart, *Claude Monet*, 35.
5. Zola quoted in Cachin, *Manet*, 68.
6. Gill quoted in Rouart, *Claude Monet*, 35.
7. Monet quoted in Rouart, *Claude Monet*, 44–45.
8. Quoted in Marie Louise Ritz, *César Ritz*, 50–53.
9. The first Bon Marché was founded in 1852, followed by the Louvre department store in 1855. But Michael R. Miller argues that the first department store in the modern sense of the term came in 1869, with the construction of a new building built specifically to house the Bon Marché department store. "For the first time," he states, "a store was being constructed that was formally conceived and systematically designed to house a *grand magasin*" (*Bon Marché*, 20).
10. Zola, *Ladies' Paradise*, 32.
11. Madame Cognacq quoted in Laudet, *La Samaritaine*, 173.
12. Madame Cognacq quoted in Laudet, *La Samaritaine*, 174.
13. Ernest Cognacq quoted in Laudet, *La Samaritaine*, 178.
14. Zola quoted in Josephson, *Zola and His Time*, 73.
15. Zola quoted in Josephson, *Zola and His Time*, 176–77.
16. Zola quoted in Josephson, *Zola and His Time*, 177.
17. The rate of return for the second loan, like the first, was attractive—only slightly less than 6 percent (Bury and Tombs, *Thiers*, 213–14).
18. Laligant, *Montmartre*, 26, note 1.

4 The Moral Order (1873–1874)

Selected sources for this chapter: Mayeur and Rebérioux, *Third Republic*; Harvey, *Consciousness and the Urban Experience*; Jonas, *France and the Cult of the Sacred Heart*; Goncourt, *Journal*; Bury and Tombs, *Thiers*; Michel, *Memoirs*; Maclellan, *Louise Michel*; Manet, *Correspondence and Conversation*; Claude Monet, *Monet by Himself: Paintings, Drawings, Pastels, Letters* [henceforth cited as Monet, *Letters*], ed. Richard R. Kendall, trans. Bridget Stevens Romer (London: Macdonald, 1989); Wildenstein, *Monet, or the Triumph of Impressionism*, vol. 1; Rouart, *Claude*

Monet; Morisot, *Correspondence*; Higonnet, *Berthe Morisot*; Robert Gordon and Andrew Forge, *Degas* (New York: Abrams, 1988); Rewald, *History of Impressionism*; Herbert, *Impressionism*; Laure Beaumont-Maillet, *L'eau à Paris* (Paris: Hazan, 1991); Paul Lemoine and René Humery, *Les forages profonds du bassin de Paris: La nappe artésienne des sables verts* (Paris: Editions du Muséum, 1939); Ellis, *Early Life of Georges Clemenceau*; Rachel G. Fuchs, *Poor and Pregnant in Paris: Strategies for Survival in the Nineteenth Century* (New Brunswick, N.J.: Rutgers University Press, 1992); Bernard Champigneulle, *Rodin*, trans. J. Maxwell Brownjohn (London: Thames and Hudson, 1967); Ruth Butler, *Rodin: The Shape of Genius* (New Haven, Conn.: Yale University Press, 1993).

1. This statue is located at the corner of the Rue de Rivoli facing the Place de l'Hôtel de Ville, in the middle tier.

2. For several years before this dinner, Béhaine had distinguished himself in the diplomatic service, especially in his dealings with Bismarck. This dinner took place soon after yet another mission to Germany (Goncourt, *Journal*, 22 January 1873, 201). Note: in this translation of the Goncourt journal, Béhaine is identified only by his first name, Edouard. See the French original for his complete identification (*Journal: Mémoires de la vie littéraire* [Paris: E. Flammarion, 1935], 5:62).

3. Mayeur and Rebérioux, *Third Republic*, 19.

4. Bury and Tombs, *Thiers*, 229.

5. Michel, *Memoirs*, 89.

6. Manet to Duret, [2 April 1874?], in Manet, *Correspondence and Conversation*, 169.

7. Joseph Guichard to Mme Morisot, in Morisot, *Correspondence*, 92.

8. Berthe Morisot to Edma, [1871, 1872], in Morisot, *Correspondence*, 82, 89–90.

9. Berthe Morisot to Edma, [1871], and Mme Morisot to Edma, [1871], in Morisot, *Correspondence*, 82–83.

10. Degas' family tried to give the impression of landed aristocracy by spelling their name "De Gas" or "de Gas," but Degas reverted to the original spelling (Gordon and Forge, *Degas*, 15–16).

11. In Degas' own art collection, at his death, there were paintings by Manet, Cézanne, Pissarro, Morisot, Cassatt, Gauguin, and van Gogh, but nothing by Monet (Gordon and Forge, *Degas*, 37).

12. Monet later gave a description of it as the "pink house with green shutters." Here he continued his avid gardening.

13. Manet to Antonin Proust, [1870s]; Manet, as recorded by Charles Toché, winter 1874–1875, both in Manet, *Correspondence and Conversation*, 169, 172.

14. Morisot, *Correspondence*, 82.

15. Morisot, *Correspondence*, 93–94.

16. Morisot, *Correspondence*, 94.

5 "This will kill that." (1875)

Selected sources for this chapter: Hugo, *Hunchback of Notre-Dame*; Morisot, *Correspondence*; Higonnet, *Berthe Morisot*; Zola, *The Belly of Paris*, trans. Brian Nelson (New York: Oxford University Press, 2007); Josephson, *Zola and His Time*; Brown, *Zola*; Manet, *Correspondence and Conversation*; Herbert, *Impressionism*; Rewald, *History of Impressionism*; Rouart, *Claude Monet*; Wildenstein, *Monet, or the Triumph of Impressionism*, vol. 1; Goncourt, *Journal*; Champigneulle,

Rodin; Butler, Rodin; Bernhardt, Memories of My Life; Gold and Fizdale, Divine Sarah; Henry James, Parisian Sketches: Letters to the New York Tribune, 1875–1876, ed. Leon Edel and Ilse Dusoir Lind (New York: Collier, 1961 [first published 1957]); Roger Nichols, The Life of Debussy (Cambridge, UK: Cambridge University Press, 1998); Harvie, Eiffel; Beaumont-Maillet, L'eau à Paris; Renaud Gagneux, Jean Anckaert, and Gérard Conte, Sur les traces de la Bièvre parisienne: Promenades au fil d'une rivière disparue (Paris: Parigramme, 2002); Bertaut, Paris; Harvey, Consciousness and the Urban Experience; Jonas, France and the Cult of the Sacred Heart; Moreno, Statue of Liberty Encyclopedia; Sutherland, Statue of Liberty; Mayeur and Rebérioux, Third Republic; Tombs, France.

1. The title of chapter 2, book 5, Hunchback of Notre-Dame.
2. Morisot, Correspondence, 101.
3. Morisot, Correspondence, 101.
4. Manet to Zola, [6 July 1873, and late July–August 1876], and Manet, as recorded by Antonin Proust, [1879], all in Manet, Correspondence and Conversation, 166, 180, 185.
5. Rouart, Claude Monet, 63.
6. See for example Goncourt's dismay when, after reading a passage of his work to Zola, he later found the passage in Zola's latest novel—"if not entirely cribbed, most certainly inspired" by what Goncourt had read to him (Goncourt, Journal, 17 December 1876, 225).
7. Goncourt, Journal, 13 February 1874, 206.
8. Rodin quoted in Champigneulle, Rodin, 14.
9. Rodin quoted in Champigneulle, Rodin, 42. See also Butler, Rodin, 92.
10. James, Parisian Sketches, 124.
11. Rodin quoted in Gold and Fizdale, Divine Sarah, 132.
12. It now houses Thiers' massive library, which was saved and has become the Bibliothèque Thiers.
13. James, Parisian Sketches, 35–36.
14. Quoted in Jonas, France and the Cult of the Sacred Heart, 204.
15. As Robert Tombs puts it, "Most Orleanists and republicans looked forward to revising the constitution in favourable circumstances, the former to replace the president with a king, the latter to create a truly democratic republic" (France, 440).

6 Pressure Builds (1876–1877)

Selected sources for this chapter: Ellis, Early Life of Georges Clemenceau; Watson, Georges Clemenceau; Robb, Victor Hugo; Michel, Memoirs; Maclellan, Louise Michel; Claude Roulet, Ritz: Une histoire plus belle que la légende (Paris: Quai Voltaire/La Table Ronde, 1998); Adalbert Chastonay, César Ritz: Life and Work (Niederwald, Switzerland: César Ritz Foundation, 1997); Manet, Correspondence and Conversation; Monet, Letters; Wildenstein, Monet, or the Triumph of Impressionism, vol. 1; Rouart, Claude Monet; Morisot, Correspondence; Herbert, Impressionism; Rewald, History of Impressionism; Clark, Painting of Modern Life; Goncourt, Journal; H. L. Wesseling, Certain Ideas of France: Essays on French History and Civilization (Westport, Conn.: Greenwood Press, 2002); Sanford Elwitt, The Making of the Third Republic: Class and Politics in France, 1868–1884 (Baton Rouge: Louisiana State University Press, 1975); James R. Lehning, To Be a Citizen: The Political Culture of the Early French Third Republic (Ithaca, N.Y.: Cornell University Press, 2001); P. B. Gheusi, Gambetta: Life and Letters, trans. Violette M. Montagu (London: T. Fisher Unwin, 1910); Tombs, France; Mayeur and Rebérioux, Third Republic; Bury and Tombs, Thiers; McManners,

Church and State in France; Jonas, France and the Cult of the Sacred Heart; Sutherland, Statue of Liberty; Goncourt, Journal; Champigneulle, Rodin; Butler, Rodin.

1. Clemenceau quoted in Watson, Georges Clemenceau, 64.
2. Clemenceau quoted in Watson, Georges Clemenceau, 64–65.
3. It should be noted that Clemenceau was a member of the radical republican left, not the revolutionary left. Sympathetic to the Communards, he consistently condemned violence as a force for social change and never supported the Commune uprising itself or any party of revolution.
4. Hugo quoted in Robb, Victor Hugo, 487.
5. Quotes from Michel, Memoirs, 112, and Maclellan, Louise Michel, 15. Michel loved music, played both piano and organ, and even composed. At the cutting edge here as elsewhere, she seems to have been familiar with the use of quarter tones when she encountered them in Kanak music: "The Kanaks get those quarter tones from the cyclones," she wrote in her memoirs, "just as the Arabs draw theirs from the hot and violent wind of the desert" (Michel, Memoirs, 96).
6. "Sap is like blood," she wrote in her memoirs, at a time when even vaccination for humans was widely opposed and misunderstood, "and the same principles that govern diseases of the blood apply to the illnesses of plants" (Memoirs, 98).
7. Edouard Manet to Eugène Manet [summer 1875?], in Manet, Correspondence and Conversation, 175; Monet to Edouard Manet, 28 June [1875], in Monet, Letters, 28.
8. Morisot, Correspondence, 111.
9. Manet, as recorded by Antonin Proust, [1876], in Manet, Correspondence and Conversation, 179.
10. Manet to Wolff, 19 March [1877]; Manet, conversation with Antonin Proust, [1877], both in Manet, Correspondence and Conversation, 179, 181.
11. Eugène Manet to Berthe Morisot, [September 1876], in Morisot, Correspondence, 111.
12. Goncourt, Journal, 19 February 1877, 229.
13. Goncourt, Journal, 25 January 1875, 210–11.
14. Rodin quoted in Champigneulle, Rodin, 47.
15. Gambetta quoted in Mayeur and Rebérioux, Third Republic, 28.
16. Hugo quoted in Robb, Victor Hugo, 503.

7 A Splendid Diversion (1878)

Selected sources for this chapter: James, Parisian Sketches; Roger Price, A Social History of Nineteenth-Century France (London: Hutchinson, 1987); Wildenstein, Monet, or the Triumph of Impressionism, vol. 1; Rouart, Claude Monet; Herbert, Impressionism; Bertaut, Paris; Sutherland, Statue of Liberty; Harvie, Eiffel; Sarah Bernhardt, Dans les nuages: Impressions d'une chaise, in The Memoirs of Sarah Bernhardt: Early Childhood through the First American Tour, and Her Novella, In the Clouds, ed. Sandy Lesberg (New York: Peebles Press, 1977); Bernhardt, Memories of My Life; Manet, Correspondence and Conversation; Monet, Letters; Goncourt, Journal; Zola, L'assommoir; Josephson, Zola and His Time; Brown, Zola; Morisot, Correspondence; Phil Baker, The Dedalus Book of Absinthe (Sawtry, UK: Dedalus, 2001); Michel, Memoirs.

1. James, Parisian Sketches, 130.
2. James, Parisian Sketches, 130–31.
3. This station is still in use and is still impressive.

4. Bernhardt, *In the Clouds*, 221, 223.

5. Bernhardt, *In the Clouds*, 230.

6. The château was sold soon after Hoschedé went into bankruptcy, and the panels dispersed.

7. Monet's offer originally seems to have been one in which both families shared expenses, with Monet responsible for his own family and Hoschedé for his, although at first Hoschedé seems to have become responsible for most or all of the expenses, especially the rent.

8. Manet to Duret, [September–October? 1878], in Manet, *Correspondence and Conversation*, 182.

9. Goncourt, *Journal*, 14 April 1874 and 16 April 1877, 207, 231.

10. Goncourt, *Journal*, 30 March 1878 and 14 December 1880, 237, 260.

11. Goncourt, *Journal*, 23 April 1878, 238.

12. Josephson, *Zola and His Time*, 262.

13. Maupassant quoted in Josephson, *Zola and His Time*, 270.

14. Goncourt, *Journal*, 3 April 1878, 237.

15. Preface to *L'assommoir*, 21.

16. Absinthe was banned in France in 1915, legalized again throughout Europe in the 1990s, and subsequently legalized in the United States.

17. Goncourt, *Journal*, 2 February 1892, 371. Musset's alcoholism contributed to his death of heart failure at the age of forty-seven.

18. Quoted in Josephson, *Zola and His Time*, 233.

19. Michel, *Memoirs*, 111–12.

20. Michel, *Memoirs*, 112.

8 Victory (1879–1880)

Selected sources for this chapter: Mayeur and Rebérioux, *Third Republic*; Goncourt, *Journal*; Tombs, *France*; Lehning, *To Be a Citizen*; John O'Malley, *The First Jesuits* (Cambridge, Mass.: Harvard University Press, 1993); John W. Padberg, *Colleges in Controversy: The Jesuit Schools in France from Revival to Suppression, 1815–1880* (Cambridge, Mass.: Harvard University Press, 1969); Ralph Gibson, *A Social History of French Catholicism, 1789–1914* (London, New York: Routledge, 1989); Price, *Social History of Nineteenth-Century France*; McManners, *Church and State in France*; Ellis, *Early Life of Georges Clemenceau*; Watson, *Georges Clemenceau*; Bertaut, *Paris*; Michel, *Memoirs*; Bernhardt, *Memories of My Life*; Gold and Fizdale, *Divine Sarah*; Gordon and Forge, *Degas*; Morisot, *Correspondence*; Higonnet, *Berthe Morisot*; Monet, *Letters*; Wildenstein, *Monet, or the Triumph of Impressionism*, vol. 1; Rewald, *History of Impressionism*; Herbert, *Impressionism*; H. Sutherland Edwards, *Old and New Paris: Its History, Its People, and Its Places*, 2 vols. (London: Cassell, 1893); Zola, *L'assommoir*; Josephson, *Zola and His Time*; Brown, *Zola*.

1. De Meaux quoted in Mayeur and Rebérioux, *Third Republic*, 36.

2. Its intimidating-looking building still exists (at 391 Rue de Vaugirard, 15th), currently housing the Université Panthéon-Assas, Paris II.

3. Macé quoted in Price, *Social History of Nineteenth-Century France*, 282.

4. Frémont quoted in McManners, *Church and State in France*, 44.

5. Ferry quoted in Mayeur and Rebérioux, *Third Republic*, 84.

6. Gambetta quoted in Mayeur and Rebérioux, *Third Republic*, 36.

7. Michel, *Memoirs*, 120–122.

8. Gold and Fizdale, *Divine Sarah*, 155.

9. Bernhardt's mother was Jewish.

10. Sisley's and Cézanne's submissions to the Salon that year were rejected, but Renoir's portrait *Madame Georges Charpentier and Her Children* was accepted and well received.

11. In Morisot, *Correspondence*, 116.

12. Monet to de Bellio, 17 August 1879, in Monet, *Letters*, 31.

13. Monet to de Bellio, 5 September 1879, in Monet, *Letters*, 32.

14. Monet to Pissarro, 26 September 1879, in Monet, *Letters*, 32.

15. H. Sutherland Edwards tells this story in *Old and New Paris*, 2:166.

9 Saints and Sinners (1880)

Selected sources for this chapter: Nichols, *Life of Debussy*; Claude Debussy, *Debussy Letters*, ed. François Lesure and Roger Nichols, trans. Roger Nichols (Cambridge, Mass.: Harvard University Press, 1987); Marcel Dietschy, *Passion de Claude Debussy*, ed. and trans. William Ashbrook and Margaret G. Cobb (New York: Oxford University Press, 1990); Auguste Rodin [and Paul Gsell], *Rodin on Art*, trans. Mrs. Romilly Fedden (New York: Horizon, 1971 [first published 1912]); Champigneulle, *Rodin*; Butler, *Rodin*; Gordon and Forge, *Degas*; Morisot, *Correspondence*; Higonnet, *Berthe Morisot*; Wildenstein, *Monet, or the Triumph of Impressionism*, vol. 1; Herbert, *Impressionism*; Rewald, *History of Impressionism*; Manet, *Correspondence and Conversation*; Cachin, *Manet*; Brombert, *Edouard Manet*; T. J. Clark, *Painting of Modern Life*; Alain Corbin, *The Foul and the Fragrant: Odor and the French Social Imagination*, trans. Miriam Kochan (Cambridge, Mass.: Harvard University Press, 1986); Emile Zola, *Nana*, trans. George Holden (Harmondsworth, UK: Penguin, 1972); André Maurois, *The Titans: A Three-Generation Biography of the Dumas*, trans. Gerard Hopkins (New York: Harper, 1957); Bernhardt, *Memories of My Life*; Gold and Fizdale, *Divine Sarah*; Goncourt, *Journal*; Sutherland, *Statue of Liberty*; Moreno, *Statue of Liberty Encyclopedia*; Harvie, *Eiffel*; Harvey, *Consciousness and the Urban Experience*.

1. Quoted in Nichols, *Life of Debussy*, 12–13.

2. According to the composer and Debussy colleague Paul Vidal, Debussy's mother "turned his stomach by always wanting him to be with her and to make sure he was working hard" (Vidal quoted in Debussy, *Letters*, xiv).

3. Debussy quoted in Nichols, *Life of Debussy*, 6. According to Vidal, Debussy "felt bitter towards his father too, who wanted to make money out of his virtuosity" (Debussy, *Letters*, xiv).

4. Gsell quoted in *Rodin on Art*, 25.

5. *Rodin on Art*, 25–26.

6. *Rodin on Art*, 27–28.

7. Rodin quoted in *Rodin on Art*, 30–31.

8. Champigneulle, *Rodin*, 101.

9. Renoir quoted in Champigneulle, *Rodin*, 233.

10. Caillebotte quoted in Gordon and Forge, *Degas*, 31.

11. Caillebotte, who joined the group as both a patron and a contributor, had inherited his fortune. Morisot watched her expenditures carefully, especially as the economy foundered.

12. It was Georges Charpentier's wife and children whom Renoir so famously painted.

13. Manet, as recorded by Antonin Proust [1878], in Manet, *Correspondence and Conversation*, 184.

14. Manet, as recorded by Antonin Proust [1878–79], in Manet, *Correspondence and Conversation*, 187.

15. Manet to Mme Emile Zola, Monday [before April 1880], in Manet, *Correspondence and Conversation*, 244.

16. Manet to Zacharie Astruc, [Summer 1880], in Manet, *Correspondence and Conversation*, 249.

17. Zola, *Nana*, 411. The bed, complete with Valtesse de la Bigne's "coat of arms"—a "V" surmounted by a crown—now resides in the Musée des Arts Décoratifs, Paris. See illustration for this chapter.

18. As told by Gold and Fizdale in *Divine Sarah*, 31–32.

19. Emile Gaget and J. B. Gauthier, partners in the firm of Monduit et Béchet, bought out Honoré Monduit in 1878 and renamed the foundry Gaget, Gauthier et Companie.

20. Quoted in Harvey, *Consciousness and the Urban Experience*, 244–45.

21. Goncourt, *Journal*, 11 May 1880, 257.

22. Goncourt, *Journal*, 8 May 1880, 256.

10 Shadows (1881–1882)

Selected sources for this chapter: Tombs, *France*; Mayeur and Rebérioux, *Third Republic*; Watson, *Georges Clemenceau*; Ellis, *Early Life of Georges Clemenceau*; Robb, *Victor Hugo*; *Sacré-Coeur of Montmartre* (Villeurbanne, France: Lescuyer, 2006); Sutherland, *Statue of Liberty*; Bertrand Lemoine, *Architecture in France, 1800–1900*, trans. Alexandra Bonfante-Warren (New York: Abrams, 1998); Harvie, *Eiffel*; Herbert, *Impressionism*; Rewald, *History of Impressionism*; Clark, *Painting of Modern Life*; Rouart, *Claude Monet*; Wildenstein, *Monet, or the Triumph of Impressionism*, vol. 1; Monet, *Letters*; Pissarro, *Letters to His Son Lucien*; Morisot, *Correspondence*; Manet, *Correspondence and Conversation*; Champigneulle, *Rodin*; Butler, *Rodin*; Gordon and Forge, *Degas*; Goncourt, *Journal*; Herbert R. Lottman, *Return of the Rothschilds: The Great Banking Dynasty through Two Turbulent Centuries* (London: Tauris, 1995); Bertaut, *Paris*.

1. Pissarro to Lucien, 20 December 1890, *Letters to His Son Lucien*, 168.

2. Monet to Paul Durand-Ruel, [27 April 1884], in Monet, *Letters*, 112; Morisot, 11 January 1886, notebook entry in Morisot, *Correspondence*, 145. According to Wildenstein, Monet's activity upon his return from Rouen in 1882 "gives the lie to the claim that, after his formative years, he never finished a painting in the studio" (*Monet, or the Triumph of Impressionism*, 1:183).

3. Manet, as recorded by Antonin Proust, [1880–1881], in Manet, *Correspondence and Conversation*, 259.

4. Manet, as recorded by Georges Jeanniot, [1881], in Manet, *Correspondence and Conversation*, 261.

5. Manet to Ernest Chesneau, [December 1881–January 1882], in Manet, *Correspondence and Conversation*, 264.

6. Champigneulle, *Rodin*, 64.

7. Valéry quoted in Gordon and Forge, *Degas*, 34.

8. Goncourt, *Journal*, 29 January 1881, 261.

9. Quoted in Lottman, *Return of the Rothschilds*, 85.

10. *Le Figaro* quoted in Bertaut, *Paris*, 81.

11 A Golden Tortoise (1882)

Selected sources for this chapter: Goncourt, *Journal*; Herbert, *Impressionism*; Gordon and Forge, *Degas*; Morisot, *Correspondence*; Manet, *Correspondence and Conversation*; Cachin, *Manet*; Clark, *Painting of Modern Life*; Monet, *Letters*; Higonnet, *Berthe Morisot*; Martha Ward, "The Rhetoric of Independence and Innovation," in *The New Painting, Impressionism, 1874–1886: An Exhibition* (Seattle: University of Washington Press, 1986); Mayeur and Rebérioux, *Third Republic*; Lehning, *To Be a Citizen*; Gheusi, *Gambetta*; McManners, *Church and State in France*; Harvey, *Consciousness and the Urban Experience*; Bertaut, *Paris*; Michel, *Memoirs*; Arbie Orenstein, *Ravel: Man and Musician* (New York: Dover, 1991 [first published 1968]); Marcel Schneider, "Toujours plus haut," in André Boucourechliev, Dennis Collins, Jacques Février, et al., *Debussy* (Paris: Hachette, 1972); Debussy, *Letters*; Misia Sert, *Misia and the Muses: The Memoirs of Misia Sert*, trans. Moura Budberg (New York: John Day, 1953); Arthur Gold and Robert Fizdale, *Misia: The Life of Misia Sert* (New York: Morrow, 1981); Champigneulle, *Rodin*; Butler, *Rodin*; Maurois, *Titans*.

1. Goncourt, *Journal*, 9 September 1882, 276–77.
2. Herbert, *Impressionism*, 104.
3. Degas quoted in Herbert, *Impressionism*, 121.
4. Degas quoted in Gordon and Forge, *Degas*, 36.
5. Manet to Morisot, 29 December 1881, in Morisot, *Correspondence*, 117–18.
6. Pierre Prins, as recalled by his son (in Cachin, *Manet*, 135).
7. Morisot to Eugène Manet, [March 1882], in Morisot, *Correspondence*, 125–26.
8. Manet to Morisot [February–March 1882], in Morisot, *Correspondence*, 118 (first portion of this letter also in Manet, *Correspondence and Conversation*, 264).
9. His body was almost immediately exhumed and moved to Nice, where it was buried in the Gambetta family grave.
10. Quoted in McManners, *Church and State in France*, 59–60.
11. Clemenceau quoted in Harvey, *Consciousness and the Urban Experience*, 247.
12. Michel, *Memoirs*, 134.
13. Ravel and Stravinsky quotes from Orenstein, *Ravel*, 10, 66. Edouard Ravel eventually followed the father in his career.
14. Eiffel's new address was 60 Rue de Prony, 17th. The foundry of Gaget, Gauthier et Compagnie was located nearby at 25 Rue de Chazelles. Both addresses were just north of the park.

12 Digging Deep (1883)

Selected sources for this chapter: Colin Jones, "Theodore Vacquer and the Archaeology of Modernity in Haussmann's Paris," *Transactions of the Royal Historical Society* 17 (2007):157–83; Jones, *Paris*; Philippe de Carbonnières, *Lutèce: Paris ville romaine* (Paris: Gallimard, 1997); Paul-Marie Duval, *Paris antique: Des origins au troisième siècle* (Paris: Hermann, 1961); Robb, *Victor Hugo*; Pissarro, *Letters to His Son Lucien*; Morisot, *Correspondence*; Higonnet, *Berthe Morisot*; Manet, *Correspondence and Conversation*; Cachin, *Manet*; Monet, *Letters*; Julie Manet, *Growing Up with the Impressionists: The Diary of Julie Manet*, trans. and ed. Rosalind de Boland Roberts and Jane Roberts (London: Sotheby's, 1987); Philip Nord, *The Republican Moment: Struggles for Democracy in Nineteenth-Century France* (Cambridge, Mass.: Harvard University Press, 1995); Rewald, *History of Impressionism*; Mayeur and Rebérioux, *Third Republic*; Goncourt, *Journal*;

Ellis, *Early Life of Georges Clemenceau*; Garry Hogg, *Orient Express: The Birth, Life, and Death of a Great Train* (London: Hutchinson, 1968); Roulet, *Ritz*; Zola, *The Ladies' Paradise*; Brunel, "Ernest Cognacq: The Collector and His Collection"; Laudet, *La Samaritaine*; Josephson, *Zola and His Time*; Brown, *Zola*; Gold and Fizdale, *Divine Sarah*; Butler, *Rodin*; Champigneulle, *Rodin*; Wildenstein, *Monet, or the Triumph of Impressionism*, vol. 1; Wildenstein, *Claude Monet: Biographie et catalogue raisonné*, vol. 1; Stéphane Mallarmé, *Selected Letters of Stéphane Mallarmé*, ed. and trans. Rosemary Lloyd (Chicago: University of Chicago Press, 1988); Gold and Fizdale, *Misia*; Robert L. Herbert, *Seurat and the Making of* La Grande Jatte (Chicago: Art Institute of Chicago, 2004); Michel, *Memoirs*.

1. This Pilier des Nautes, or Boatmen's Pillar, is today regarded as the oldest surviving sculpture from Gallo-Roman Lutetia. It resides in the Roman baths, or thermes, of the Musée National du Moyen Age—Thermes et Hôtel de Cluny.
2. Berthe to Edma, 9 March 1883, in Morisot, *Correspondence*, 131.
3. Degas and Zola quoted in Cachin, *Manet*, 127 (the Zola quote taken from observations by Jacques-Emile Blanche, a young apprentice painter in Manet's studio); Wolff quoted in Pissarro, *Letters to His Son Lucien*, 13, note 1.
4. Julie Manet, *Diary*, 3 October 1896, 98. Julie had been reading family letters.
5. Exceptions were Degas, who was no liberal, and Pissarro, who was a committed socialist. Monet seems to have kept quite apart from politics and political debates, although in an 1871 letter to Pissarro, he angrily denounced the Versailles government of Thiers (Monet à Pissarro, 27 mai 1871, in Wildenstein, *Claude Monet: Biographie et catalogue raisonné*, 1:427).
6. Berthe to Edma, [early 1884], in Morisot, *Correspondence*, 135.
7. Madame Cognacq quoted in Laudet, *La Samaritaine*, 170.
8. Goncourt, *Journal*, 2 April 1884, 291.
9. Zola quoted in Josephson, *Zola and His Time*, 322.
10. Goncourt, *Journal*, 20 June 1881, 266.
11. Rodin quoted in Butler, *Rodin*, 184.
12. Monet to Alice Hoschedé, 2 February 1883, in Monet, *Letters*, 104.
13. Monet to Alice Hoschedé, 19 February [1883], in Monet, *Letters*, 105.
14. Monet to Alice Hoschedé, 19 February [1883], in Monet, *Letters*, 105.
15. Goncourt, *Journal*, 17 September 1868, 141.
16. Michel, *Memoirs*, 158, 167–68.
17. Michel, *Memoirs*, 170–71.
18. Pissarro to Lucien, 25 July 1883, in Pissarro, *Letters to his Son Lucien*, 30.

13 Hard Times (1884)

Selected sources for this chapter: Michel, *Memoirs*; Bertrand Tillier, *La Commune de Paris: Revolution sans images? Politique et représentations dans la France républicaine (1871–1914)* (Paris: Champ Vallon, 2004); Ellis, *Early Life of Georges Clemenceau*; Mayeur and Rebérioux, *Third Republic*; Morisot, *Correspondence*; Harvie, *Eiffel*; Sutherland, *Statue of Liberty*; Butler, *Rodin*; Champigneulle, *Rodin*; Monet, *Letters*; Wildenstein, *Monet, or the Triumph of Impressionism*, vol. 1; Rewald, *History of Impressionism*; Herbert, *Seurat*; John Russell, *Seurat* (New York: Frederick A. Praeger, 1965); Pissarro, *Letters to His Son Lucien*; Rewald, *Camille Pissarro*; Martha Ward, *Pissarro, Neo-Impressionism, and the Spaces of the Avant-Garde* (Chicago: University of Chicago Press, 1996).

1. Michel, *Memoirs*, 1.
2. The present simple plaque at the site dates from 1908.
3. Michel, *Memoirs*, 65.
4. Clemenceau quoted in Ellis, *Early Life of Georges Clemenceau*, 84.
5. Berthe to Edma, [summer 1884], in Morisot, *Correspondence*, 140.
6. Clemenceau quoted in Ellis, *Early Life of Georges Clemenceau*, 116.
7. Koechlin quoted in Harvie, *Eiffel*, 80–81.
8. Rodin quoted in Champigneulle, *Rodin*, 76; Butler has a somewhat different wording of the same quote, in *Rodin*, 200.
9. Quoted in Champigneulle, *Rodin*, 83.
10. Monet to Durand-Ruel, [12 January 1884], in Monet, *Letters*, 108.
11. Monet to Alice Hoschedé, 24 and 26 January 1884, both in Monet, *Letters*, 108–109.
12. Monet to Alice Hoschedé, 3 and 5 March 1884, both in Monet, *Letters*, 109–110.
13. The exhibits at the Musée de la Grenouillère, in Croissy-sur-Seine, provide a far racier view of goings-on at this popular *guinguette* than either Monet or Renoir lets on.
14. Morton quoted in Harvie, *Eiffel*, 73, and de Lesseps quoted in Sutherland, *Statue of Liberty*, 39. Morton would in time serve as vice president of the United States and governor of New York.

14 That Genius, That Monster (1885)

Selected sources for this chapter: Robb, *Victor Hugo*; Hugo, *Hunchback of Notre-Dame*; Manet, *Correspondence and Conversation*; Jones, *Paris*; Lehning, *To Be a Citizen*; Maurois, *Titans*; Goncourt, *Journal*; Sutherland, *Statue of Liberty*; André Tuilier, *Histoire de l'Université de Paris et de la Sorbonne*, 2 vols. (Paris: Nouvelle Librairie de France, 1994); Ellis, *Early Life of Georges Clemenceau*; Watson, *Georges Clemenceau*; Tombs, *France*; Mayeur and Rebérioux, *Third Republic*; Armond Fields, *Le Chat Noir: A Montmartre Cabaret and Its Artists in Turn-of-the-Century Paris* (Santa Barbara, Calif.: Santa Barbara Museum of Art, 1993); Daniel Bonthoux and Bernard Jégo, *Montmartre: Bals et cabarets au temps de Bruant et Lautrec* (Paris: Musée de Montmartre, 2002); Gale B. Murray, ed., *Toulouse-Lautrec: A Retrospective* (New York: Hugh Lauter Levin, 1992); Debussy, *Letters*; Nichols, *Life of Debussy*; Monet, *Letters*; Wildenstein, *Monet, or the Triumph of Impressionism*, vol. 1; Rouart, *Claude Monet*; Rewald, *History of Impressionism*.

1. Hugo quote from *Hunchback of Notre-Dame*, 134; Manet to Mme Méry Laurent [September? 1880], in Manet, *Correspondence and Conversation*, 256.
2. Dumas *fils* quoted in Maurois, *Titans*, 440; Zola quoted in Goncourt, *Journal*, 24 May 1885, 307.
3. Goncourt, *Journal*, 5 August 1873 and 2 June 1885, 204, 307.
4. Hugo quoted in Sutherland, *Statue of Liberty*, 44.
5. See the illustration for chapter 16.
6. Debussy to Eugène Vasnier, 4 June 1885, in Debussy, *Letters*, 8 and (for the quote from his examiners) 10, note 1.
7. Debussy to Vasnier, 16 September and 19 October 1885, both in Debussy, *Letters*, 11–13.
8. Debussy to Vasnier, 24 November 1885, in Debussy, *Letters*, 14.
9. Monet to Alice Hoschedé, 20 October [1885] and [27 November 1885], both in Monet, *Letters*, 113 and 115.

10. Monet to Alice Hoschedé, [27 November 1885], in Monet, *Letters*, 115.
11. Monet to Alice Hoschedé, [22 February 1886], in Monet, *Letters*, 116.

15 Onward and Upward (1886)

Selected sources for this chapter: Harvie, *Eiffel*; Sutherland, *Statue of Liberty*; Goncourt, *Journal*; Champigneulle, *Rodin*; Butler, *Rodin*; Monet, *Letters*; Wildenstein, *Monet, or the Triumph of Impressionism*, vol. 1; Pissarro, *Letters to His Son Lucien*; Morisot, *Correspondence*; Higonnet, *Berthe Morisot*; Ward, "Rhetoric of Independence and Innovation"; Ward, *Pissarro, Neo-Impressionism, and the Spaces of the Avant-Garde*; Rewald, *Camille Pissarro*; Herbert, *Seurat*; John Rewald, *Paul Cézanne: A Biography*, trans. Margaret H. Liebman (New York: Simon & Schuster, 1948); John Rewald, *Cézanne et Zola* (Paris: A. Sedrowski, 1936); Rewald, *History of Impressionism*; Zola, *L'oeuvre* [*The Masterpiece*], ed. Ernest Alfred Vizetelly (London: Chatto & Windus, 1902); Zola, *Correspondance*, vol. 5; Paul Cézanne, *Paul Cézanne Letters*, ed. John Rewald, trans. Marguerite Kay (Oxford: B. Cassirer, 1946); Paul Cézanne, *Conversations with Cézanne*, ed. Michael Doran, trans. Julie Lawrence Cochran (Berkeley: University of California Press, 2001); Josephson, *Zola and His Time*; Brown, *Zola*; John Rewald, *Post-Impressionism: From van Gogh to Gauguin*, 3rd ed. (New York: Museum of Modern Art, 1978 [first published 1956]); Debora Silverman, *Van Gogh and Gauguin: The Search for Sacred Art* (New York: Farrar, Straus & Giroux, 2000); Stephen Studd, *Saint-Saëns: A Critical Biography* (Madison, N.J.: Fairleigh Dickinson University Press, 1999); Leon Botstein, "Beyond the Illusions of Realism: Painting and Debussy's Break with Tradition," in *Debussy and His World*, edited by Jane F. Fulcher (Princeton, N.J.: Princeton University Press, 2001); Debussy, *Letters*; Nichols, *Life of Debussy*; Roulet, *Ritz*; Chastonay, *César Ritz*; Marie Louise Ritz, *César Ritz*; Mayeur and Rebérioux, *Third Republic*.

1. Bartholdi quoted in Sutherland, *Statue of Liberty*, 62.
2. Goncourt, *Journal*, 17 April 1886, 318.
3. Goncourt, *Journal*, 17 April 1886, 319.
4. Goncourt, *Journal*, 17 April 1886, 319.
5. Goncourt, *Journal*, 17 April 1886, 317.
6. "Between 1883 and 1896 an incontestable 'tendency to stagnation' [in France] . . . is to be observed" (Mayeur and Rebérioux, *Third Republic*, 46). Mayeur and Rebérioux also quote economic historian Rondo Cameron, that from the 1880s, "France was affected for more than fifteen years by one of the most serious depressions that have ever marked the history of an industrialized nation" (46).
7. Morisot to Edma, [February 1884], in Morisot, *Correspondence*, 137; Pissarro to Lucien, [January] 1886, in Pissarro, *Letters to His Son Lucien*, 64.
8. Morisot to her sister Edma [1885], in Morisot, *Correspondence*, 143.
9. Pissarro to Monet, 7 December 1885, in Pissarro, *Letters to His Son Lucien*, 60–61.
10. Cézanne quoted in Rewald, *Paul Cézanne*, 96. In later years, Cézanne listed himself in exhibition catalogues as "Pupil of Pissarro" and designated Pissarro as "the true master, the uncontested leader of the Impressionists." In 1906, he said: "Monet and Pissarro, the two great masters, the only ones!" (quoted in Rewald, *Paul Cézanne*, 216, 221, and 222).
11. Despite the rift that later grew between them, Gauguin in 1902 wrote (from Tahiti): "He [Pissarro] was one of my masters and I do not deny him" (quoted in Rewald, *Camille Pissarro*, 45).

12. Moore quoted in Pissarro, *Letters to His Son Lucien*, 88, note 1.

13. Zola quoted in Pissarro, *Letters to His Son Lucien*, 79, note 1.

14. Pissarro to Lucien, [November 1886] and 3 December 1886, both in Pissarro, *Letters to His Son Lucien*, 87 and 90.

15. Moore quoted in Herbert, *Seurat*, 118.

16. Monet to Zola, 5 April 1886, in Monet, *Letters*, 116–17.

17. Zola, as quoted by George Moore, in Rewald, *Paul Cézanne*, 167.

18. Vincent van Gogh quoted in Wildenstein, *Monet, or the Triumph of Impressionism*, 1:243.

19. Berlioz quoted in Studd, *Saint-Saëns*, 66.

20. Saint-Saëns quoted in Studd, *Saint-Saëns*, 271. Not surprisingly, Debussy returned the compliment: Saint-Saëns was "one of Debussy's least favorite composers." Botstein, "Beyond the Illusions of Realism," 177, note 53.

21. Debussy to Claudius Popelin, 24 June [1886], in Debussy, *Letters*, 17.

22. Debussy to Emile Baron, 23 December 1886, in Debussy, *Letters*, 18, 20.

23. Marie Louise Ritz, *César Ritz*, 114.

24. As quoted in Marie Louise Ritz, *César Ritz*, 113.

16 Fat and Thin (1887–1888)

Selected sources for this chapter: Goncourt, *Journal*; Léon Daudet, *Memoirs of Léon Daudet*, ed. and trans. Arthur Kingland Griggs (New York: L. MacVeagh, Dial Press, 1925); Josephson, *Zola and His Time*; Brown, *Zola*; Bernhardt, *Memories of My Life*; Gold and Fizdale, *Divine Sarah*; Morisot, *Correspondence*; Higonnet, *Berthe Morisot*; Debussy, *Letters*; Nichols, *Life of Debussy*; Paul Roberts, *Claude Debussy* (London: Phaidon, 2008); Pissarro, *Letters to His Son Lucien*; Ward, "Rhetoric of Independence and Innovation"; Butler, *Rodin*; Wildenstein, *Monet, or the Triumph of Impressionism*, vol. 1; Rewald, *History of Impressionism*; Ronald Anderson and Anne Koval, *James McNeill Whistler: Beyond the Myth* (New York: Carroll & Graf, 1994); Mallarmé, *Letters*; Michel, *Memoirs*; Thomas, *Louise Michel*; Emile Zola, *Germinal*, trans. L. W. Tancock (Hammondsworth, UK, and Baltimore: Penguin, 1968); Tombs, *France*; Ellis, *Early Life of Georges Clemenceau*; Mayeur and Rebérioux, *Third Republic*; Lehning, *To Be a Citizen*; Butler, *Rodin*; Harvie, *Eiffel*; Rewald, *Post-Impressionism*; Silverman, *Van Gogh and Gauguin*.

1. Zola quoted in Goncourt, *Journal*, 25 January 1875, 210.

2. Zola quoted in Josephson, *Zola and His Time*, 283.

3. The children were born in September 1889 and September 1891.

4. Léon Daudet, *Memoirs*, 149.

5. Bernhardt, *Memories of My Life*, 299.

6. The British attaché who made this comment is quoted in Bernhardt, *Memories of My Life*, 339.

7. That Morisot seems to have at times suffered from an eating disorder makes their criticism all the more cruel.

8. Bernhardt, *Memories of My Life*, 332–33.

9. Bernhardt, *Memories of My Life*, 333–34.

10. Goncourt, *Journal*, 11 April and 11 May 1887, 328.

11. Goncourt, *Journal*, 7 June 1887, 328–29.

12. Goncourt, *Journal*, 12 March 1887, 327.

13. Debussy to Emile Baron, 9 February 1887, in Debussy, *Letters*, 20–21.

14. Quoted in Debussy, *Letters*, 21, note 1.

15. Debussy to Eugène Vasnier, [March 1887], in Debussy, *Letters*, 22.

16. Morisot to Monet, 7 March 1889, in Morisot, *Correspondence*, 168.

17. Morisot to Edma, [1885], in Morisot, *Correspondence*, 144.

18. Morisot to Mallarmé, [September 1888], in Morisot, *Correspondence*, 156.

19. Michel, *Memoirs*, 161.

20. Paul Cambon quoted in Mayeur and Rebérioux, *Third Republic*, 126.

21. Clemenceau quoted in Ellis, *Early Life of Georges Clemenceau*, 151.

22. Puvis de Chavannes to Morisot, [November–December 1888], and Renoir to Morisot, [1888–1889], both in Morisot, *Correspondence*, 162–63.

23. Quoted in Harvie, *Eiffel*, 97–98.

24. Gauguin to Théo van Gogh, quoted in Silverman, *Van Gogh and Gauguin*, 267, and Rewald, *Post-Impressionism*, 241. Vincent van Gogh quoted in Silverman, *Van Gogh and Gauguin*, 268.

25. Rewald, *Post-Impressionism*, 241, 243.

17 Centennial (1889)

Selected sources for this chapter: William D. Irvine, *The Boulanger Affair Reconsidered: Royalism, Boulangism, and the Origins of the Radical Right in France* (New York: Oxford University Press, 1989); Lehning, *To Be a Citizen*; Mayeur and Rebérioux, *Third Republic*; Tombs, *France*; Ellis, *Early Life of Georges Clemenceau*; Watson, *Georges Clemenceau*; Harvie, *Eiffel*; Miriam R. Levin, *When the Eiffel Tower Was New: French Visions of Progress at the Centennial of the Revolution* (South Hadley, Mass.: Mount Holyoke College Art Museum, 1989); Debussy, *Letters*; Nichols, *Life of Debussy*; Morisot, *Correspondence*; Higonnet, *Berthe Morisot*; Champigneulle, *Rodin*; Butler, *Rodin*; Orenstein, *Ravel*; Burnett James, *Ravel* (London: Omnibus Press, 1987); Goncourt, *Journal*; Bertaut, *Paris*; Monet, *Letters*; Wildenstein, *Monet, or the Triumph of Impressionism*, vol. 1; Cachin, *Manet*; Victor Arwas, *Alphonse Mucha: Master of Art Nouveau* (New York: St. Martin's Press, 1985); Jiří Mucha, *Alphonse Maria Mucha: His Life and Art* (London: Academy Editions, 1989); Jiří Mucha, *Alphonse Mucha: His Life and Work* (New York: St. Martin's Press, 1974); Mallarmé, *Letters*; Stanley Weintraub, *Whistler: A Biography* (Cambridge, Mass.: Da Capo, 2001 [first published 1974]); Gold and Fizdale, *Divine Sarah*.

1. Debussy to Pierre Louÿs, 22 January 1895, in Debussy, *Letters*, 76.

2. Goncourt, *Journal*, 2 July 1889, 347.

3. Goncourt, *Journal*, 2 July 1889, 348.

4. Monet quoted in Butler, *Rodin*, 222; Rodin quoted in Wildenstein, *Monet, or the Triumph of Impressionism*, 1:253.

5. Monet to Alice Hoschedé, 9 May [1889], in Monet, *Letters*, 132.

6. Zola quoted in Wildenstein, *Monet, or the Triumph of Impressionism*, 1:257.

7. Monet to Armand Fallières, 7 February 1890, in Monet, *Letters*, 133.

8. Mucha quoted in Jiří Mucha, *Alphonse Maria Mucha*, 47.

9. Debussy quoted in Nichols, *Life of Debussy*, 57.

10. Mallarmé quoted in Cachin, *Manet*, 104.

11. Bernhardt quoted in Gold and Fizdale, *Divine Sarah*, 239–40.

18 Sacred and Profane (1890–1891)

Selected sources for this chapter: Jean Lacouture, *De Gaulle: The Rebel, 1890–1944*, trans. Patrick O'Brian (New York: Norton, 1993); Charles Williams, *The Last Great Frenchman: A Life of General de Gaulle* (New York: Wiley, 1993); Gibson, *Social History of French Catholicism*; McManners, *Church and State in France*; Alexander Sedgwick, *The Ralliement in French Politics, 1890–1898* (Cambridge, Mass.: Harvard University Press, 1965); Mayeur and Rebérioux, *Third Republic*; Tombs, *France*; Ellis, *Early Life of Georges Clemenceau*; Watson, *Georges Clemenceau*; Harvie, *Eiffel*; Thomas, *Louise Michel*; Maclellan, *Louise Michel*; Pissarro, *Letters to His Son Lucien*; Morisot, *Correspondence*; Higonnet, *Berthe Morisot*; Debussy, *Letters*; Nichols, *Life of Debussy*; Rollo H. Myers, *Erik Sati*, rev. ed. (New York: Dover, 1968 [first published 1948]); Roger Shattuck, *The Banquet Years: The Origins of the Avant Garde in France, 1885 to World War I; Alfred Jarry, Henri Rousseau, Erik Satie, Guillaume Apollinaire* (New York: Vintage, 1968 [first published 1955]); Monet, *Letters*; Wildenstein, *Monet, or the Triumph of Impressionism*, vol. 1; Rouart, *Claude Monet*; Rewald, *History of Impressionism*; Russell, *Seurat*; Orenstein, *Ravel*; Arwas, *Alphonse Mucha*; Champigneulle, *Rodin*; Butler, *Rodin*; Eve Curie, *Madame Curie: A Biography*, trans. Vincent Sheean (Garden City, N.Y.: Garden City Publishing, 1943); Pierre Radvanyi, "Les Curie: Deux couples radioactifs," *Pour la Science* 9 (novembre 2001–février 2002), 1–96.

1. Quoted in Sedgwick, *Ralliement in French Politics*, 39. For somewhat different wording but identical meaning, see McManners, *Church and State in France*, 72.

2. Nor was Georges Clemenceau, who fought *ralliement* as an effort by the Church to undermine the total separation of Church and state.

3. Clemenceau quoted in Ellis, *Early Life of Georges Clemenceau*, 168.

4. Despite their mutual respect and wary friendship, Cassatt and Morisot's relationship was subject to considerable professional jealousy, largely on Cassatt's part. Following Morisot's solo exhibition in 1892, Morisot wrote a friend: "As you can imagine, Miss Cassatt is not one to write me about an exhibition of mine." Morisot to Louise Riesener, 1892, in Morisot, *Correspondence*, 194.

5. Debussy to Vincent d'Indy, 20 April 1890, in Debussy, *Letters*, 30. The *Fantaisie* would not be performed until 1919, the year after Debussy's death. Debussy, *Letters*, 33–34, note 3.

6. Debussy to Raymond Bonheur, 5 October 1890, in Debussy, *Letters*, 31.

7. Satie quoted in Myers, *Erik Satie*, 31–32.

8. Myers, *Erik Satie*, 19.

9. Although Monet's Rouen cathedral paintings are dated 1894, he painted them during the previous two years.

10. Both quotes from Wildenstein, *Monet, or the Triumph of Impressionism*, 1:273–75.

11. Pissarro to Lucien, 8 April 1891, in *Letters to His Son Lucien*, 197.

12. According to Mayeur and Rebérioux, during the 1890s only three thousand people in France had incomes of more than a hundred thousand francs (*Third Republic*, 68).

13. At this time Pissarro had six surviving children, of whom two were not yet ten years old.

14. Pissarro to Lucien, 30 March 1891, in *Letters to His Son Lucien*, 191.

15. Now located in the sixteenth-century Hôtel Donon, at 8 Rue Elzévir (3rd), in the Marais.

16. Marie Curie quoted in Eve Curie, *Madame Curie*, 116.

19 Family Affairs (1892)

Selected sources for this chapter: Morisot, *Correspondence*; Higonnet, *Berthe Morisot*; Butler, *Rodin*; Champigneulle, *Rodin*; Debussy, *Letters*; Nichols, *Life of Debussy*; Monet, *Letters*; Wildenstein, *Monet, or the Triumph of Impressionism*, vol. 1; Goncourt, *Journal*; Ellis, *Early Life of Georges Clemenceau*; Watson, *Georges Clemenceau*; Harvie, *Eiffel*; Mayeur and Rebérioux, *Third Republic*; Eugen Weber, *France, Fin de Siècle* (Cambridge, Mass.: Belknap and Harvard University Press, 1986); Anderson and Koval, *James McNeill Whistler*; Weintraub, *Whistler*.

1. Morisot, *Correspondence*, 189.
2. Morisot to Louise Riesener, [1892], in Morisot, *Correspondence*, 194.
3. Morisot to Mallarmé, [September or October] 1892; Morisot to Sophie Canat, 7 October 1892, both in Morisot, *Correspondence*, 196–97.
4. Morisot to Sophie Canat, 7 October 1892, in Morisot, *Correspondence*, 197.
5. Butler dismisses stories of an abortion as insufficiently documented and thus rules out an aborted pregnancy as the cause of the breakup (*Rodin*, 271, 538, note 9). Butler also views Claudel as less interested in marriage per se than in replacing Rose in Rodin's life (272).
6. Champigneulle includes a multipage quotation from Paul Claudel along these lines (*Rodin*, 165–67, 169).
7. See Butler, *Rodin*, 272, 274, 279, 281.
8. René Peter quoted in Nichols, *Life of Debussy*, 86.
9. Debussy to Poniatowski, 5 October 1892, in Debussy, *Letters*, 39.
10. Debussy to Poniatowski, 5 October 1892, in Debussy, *Letters*, 39.
11. Clemenceau quoted in Ellis, *Early Life of Georges Clemenceau*, 139.
12. Déroulède quoted in Ellis, *Early Life of Georges Clemenceau*, 176–77.
13. However, if the rules had been observed, the survivor usually was acquitted (Weber, *France*, 218–19).
14. Whistler quoted in Anderson and Koval, *James McNeill Whistler*, 342.
15. Whistler quoted in Weintraub, *Whistler*, 354.

20 "The bell has tolled. . . ." (1893)

Selected sources for this chapter: Debussy, *Letters*; Nichols, *Life of Debussy*; Monet, *Letters*; Wildenstein, *Monet, or the Triumph of Impressionism*, vol. 1; Rouart, *Claude Monet*; Julie Manet, *Diary*; Morisot, *Correspondence*; Michael de Cossart, *The Food of Love: Princesse Edmond de Polignac (1865–1943) and Her Salon* (London: Hamish Hamilton, 1978); Goncourt, *Journal*; Misia Sert, *Memoirs*; Gold and Fizdale, *Misia*; Orenstein, *Ravel*; Myers, *Erik Satie*; Gold and Fizdale, *Divine Sarah*; Philippe Jullian, *Prince of Aesthetes: Count Robert de Montesquiou, 1855–1921*, trans. John Haylock and Francis King (London: Secker & Warburg, 1967); Weintraub, *Whistler*; Anderson and Koval, *James McNeill Whistler*; Weber, *France*; Jiří Mucha, *Alphonse Maria Mucha*; Arwas, *Alphonse Mucha*; Pissarro, *Letters to His Son Lucien*; Bourdelle, *Dossier de l'Art* 10 (janvier–février 1993); Champigneulle, *Rodin*; Butler, *Rodin*; Ellis, *Early Life of Georges Clemenceau*; Watson, *Georges Clemenceau*; Harvie, *Eiffel*.

1. Debussy to Chausson, [3 September 1893], in Debussy, *Letters*, 51.
2. Debussy to Poniatowski, February 1893, both in Debussy, *Letters*, 40, 52.

3. Debussy to Chausson, [7 May 1893]; Debussy to Poniatowski, February 1893, in Debussy, *Letters*, 41, 45.

4. Debussy to Odilon Redon, 20 April [1893], in Debussy, *Letters*, 43.

5. Monet to Alice Monet, 22 February, 3 March, and [4 April] 1893, all in Monet, *Letters*, 177, 179. Monet also quoted in Wildenstein, *Monet, or the Triumph of Impressionism*, 1:293.

6. Monet quoted in Wildenstein, *Monet, or the Triumph of Impressionism*, 1:290.

7. Julie Manet, *Diary*, 30 October 1893, 45.

8. Julie Manet, *Diary*, 29.

9. Julie Manet, *Diary*, 1 November 1893, 46.

10. Julie Manet, *Diary*, 30 October 1893, 43–44.

11. Julie Manet, *Diary*, 30 October 1893, 45.

12. Goncourt quoted in Cossart, *Food of Love*, 43.

13. Goncourt, *Journal*, 6 March 1892, 373.

14. Ravel quoted in Orenstein, *Ravel*, 16–17.

15. Gide quoted in Weber, *France*, 244.

16. As told by Mucha to his son, Jiří Mucha (*Alphonse Maria Mucha*, 52–53).

17. Pissarro to Lucien, 23 November and 27 November 1893, both in *Letters to His Son Lucien*, 280–81.

18. A copy of the photograph is in Arwas, *Alphonse Mucha*, 9.

19. Bourdelle's quote, as remembered by his daughter, is in *Bourdelle*, 23.

20. These studios are now preserved as the Musée Bourdelle, thanks to the generosity of Gabriel Cognacq, who was an admirer and patron of Bourdelle.

21. Zola quoted in Butler, *Rodin*, 286.

22. Goncourt, *Journal*, 18 June 1892 and 20 March 1893, 376, 383.

23. Clemenceau quoted in Ellis, *Early Life of Georges Clemenceau*, 185.

21 Between Storms (1894)

Selected sources for this chapter: Tombs, *France*; Barbara Tuchman, *The Proud Tower: A Portrait of the World before the War, 1890–1914* (New York: Bantam, 1976 [first published 1966]); Weber, *France*; Mayeur and Rebérioux, *Third Republic*; Michel, *Memoirs*; Pissarro, *Letters to His Son Lucien*; Julie Manet, *Diary*; Morisot, *Correspondence*; Higonnet, *Berthe Morisot*; Cossart, *Food of Love*; Gordon and Forge, *Degas*; Goncourt, *Journal*; Weintraub, *Whistler*; Anderson and Koval, *James McNeill Whistler*; Watson, *Georges Clemenceau*; Debussy, *Letters*; Nichols, *Life of Debussy*; Wildenstein, *Monet, or the Triumph of Impressionism*, vol. 1; Monet, *Letters*; Cézanne, *Conversations*; Butler, *Rodin*; Champigneulle, *Rodin*; Jiří Mucha, *Alphonse Mucha: His Life and Work*; Arwas, *Alphonse Mucha*.

1. Pissarro to Lucien, 15 December 1893, in *Letters to His Son Lucien*, 284.

2. Henry quoted in Tuchman, *Proud Tower*, 107–108.

3. Pissarro to Lucien, 30 July 1894, in *Letters to His Son Lucien*, 312.

4. Julie Manet, *Diary*, 17 March 1894, 52.

5. Julie Manet, *Diary*, 17 March 1894, 52.

6. Julie Manet, *Diary*, 17 March 1894, 52; Renoir to Morisot, 31 March 1894, Morisot, *Correspondence*, 205; Valéry quoted in Gordon and Forge, *Degas*, 34.

7. Whistler quoted in Weintraub, *Whistler*, 460.

8. Clemenceau's apartment, which has been kept exactly as it was on the day of his death, is now the Musée Georges Clemenceau.

9. Quoted in Weintraub, *Whistler*, 291.

10. Quoted in Anderson and Koval, *James McNeill Whistler*, 281, and Weintraub, *Whistler*, 296.

11. Quoted in Pissarro, *Letters to His Son Lucien*, 304, notes 1 and 2.

12. Unfortunately Mary Cassatt—also omitted from the Caillebotte collection—was not given similar assistance.

13. Renoir quoted by Julie Manet, *Diary*, 31 December 1896, 104–105.

14. Julie Manet, *Diary*, 17 March 1894, 52; Geffroy quoted in Wildenstein, *Monet, or the Triumph of Impressionism*, 1:301.

15. Monet to Geffroy, 23 November 1894, in Monet, *Letters*, 180.

16. This episode described by Geffroy in *Claude Monet, His Life, His Times, His Works*, trans. and excerpted in Cézanne, *Conversations*, 4.

17. Cézanne and Geffroy quoted in Cézanne, *Conversations*, 5–6.

18. Cézanne quoted in Cézanne, *Conversations*, 6.

19. Cézanne quoted in Cézanne, *Conversations*, 6.

20. Mallarmé quoted in Nichols, *Life of Debussy*, 83.

21. Doret quoted in Nichols, *Life of Debussy*, 83; Boulez quoted in Debussy, *Letters*, 50.

22. Debussy to Henri Lerolle, 28 August 1894; Debussy to Ysaÿe, 22 September 1894; both in Debussy, *Letters*, 73, 75.

23. Mucha quoted in Jiří Mucha, *Alphonse Mucha: His Life and Work*, 14.

22 Dreyfus (1895)

Selected sources for this chapter: Goncourt, *Journal*; Jean-Denis Bredin, *The Affair: The Case of Alfred Dreyfus*, trans. Jeffrey Mehlman (New York: George Braziller, 1986); George R. Whyte, *The Dreyfus Affair: A Chronological History* (New York: Palgrave Macmillan, 2005); Michael Burns, *Dreyfus: A Family Affair, 1789–1945* (New York: HarperCollins, 1991); Alfred Dreyfus, *Five Years of My Life, 1894–1899*, trans. James Mortimer (London: G. Newnes, 1901); Pierre Dreyfus, *Dreyfus: His Life and Letters*, trans. Dr. Betty Morgan (London: Hutchinson, 1937); Alfred Dreyfus, *Lettres d'un innocent* (Paris: Stock, 1898); Mayeur and Rebérioux, *Third Republic*; Tombs, *France*; Lottman, *Return of the Rothschilds*; Léon Daudet, *Memoirs*; Watson, *Georges Clemenceau*; Pissarro, *Letters to His Son Lucien*; Monet, *Letters*; Wildenstein, *Monet, or the Triumph of Impressionism*, vol. 1; Butler, *Rodin*; Champigneulle, *Rodin*; Morisot, *Correspondence of Berthe Morisot*; Higonnet, *Berthe Morisot*; Julie Manet, *Diary*; Morisot, *Correspondence*; Mallarmé, *Letters*; Orenstein, *Ravel*; Debussy, *Letters*; Nichols, *Life of Debussy*; Eve Curie, *Madame Curie*; Radvanyi, "Les Curie"; Maurois, *Titans*; *Sacré-Coeur of Montmartre*; Williams, *Last Great Frenchman*; Cossart, *Food of Love*; Thomas, *Louise Michel*; Maclellan, *Louise Michel*.

1. Goncourt, *Journal*, 6 January 1895, 398.

2. Zola quoted in Wildenstein, *Monet, or the Triumph of Impressionism*, 1:301.

3. Bourdelle quoted in Butler, *Rodin*, 295.

4. Pissarro to Lucien, 11 April 1895, in *Letters to His Son Lucien*, 338.

5. Julie Manet, *Diary*, 17 April 1895, 58–61; Morisot to Julie, 1 March 1895, in Morisot, *Correspondence*, 212.

6. Mallarmé to Mirbeau, [3 March 1895], in Mallarmé, *Letters*, 204; Pissarro to Lucien, 6 March 1895, in *Letters to His Son Lucien*, 333.

7. Julie Manet, *Diary*, 61; Morisot to Julie, 1 March 1895, in Morisot, *Correspondence*, 212.

8. Julie Manet, *Diary*, 3 December 1895, 79.

9. Julie Manet, *Diary*, 29 November 1895, 76.

10. Viñes quoted in Orenstein, *Ravel*, 18.

11. Debussy to Bonheur, [9 August 1895], Debussy to Henri Lerolle, 17 August 1895, and Debussy to Pierre Louÿs, [23] February 1895, all in Debussy, *Letters*, 77, 80.

12. Pierre Curie quoted in Eve Curie, *Madame Curie*, 120.

13. Goncourt, *Journal*, 10 February 1895, 400.

14. Alfred to Lucie Dreyfus, 26 février 1896, in *Lettres d'un innocent*, 166.

15. Goncourt, *Journal*, 10 December 1894, 396.

23 Passages (1896)

Selected sources for this chapter: Julie Manet, *Diary*; Monet, *Letters*; Anderson and Koval, *James McNeill Whistler*; Goncourt, *Journal*; Wildenstein, *Monet, or the Triumph of Impressionism*, vol. 1; Pissarro, *Letters to His Son Lucien*; Shattuck, *Banquet Years*; Gold and Fizdale, *Misia*; Gold and Fizdale, *Divine Sarah*; Gaston Leroux, *The Phantom of the Opera*, intro. John L. Flynn (New York: Signet, 2001); Bonthoux and Jégo, *Montmartre*; Chastonay, *Cézar Ritz*; Marie Louise Ritz, *Cézar Ritz*; Sophie-Marguerite S. Montens, *Paris, de pont en pont* (Paris: Bonneton, 2004); Jones, *Paris*; Mayeur and Rebérioux, *Third Republic*; Tombs, *France*; Bredin, *The Affair*; Whyte, *Dreyfus Affair*; Pierre Dreyfus, *Dreyfus*; Alfred Dreyfus, *Five Years of My Life*.

1. Julie Manet, *Diary*, 4–6 March 1896, 86.

2. Julie Manet, *Diary*, 4–6 March 1896, 87.

3. Julie Manet, *Diary*, 4–6 March 1896, 87.

4. Julie Manet, *Diary*, 4–6 March 1896, 88.

5. Goncourt, *Journal*, 27 January 1895, 399.

6. Goncourt, *Journal*, 1 March 1895, 402.

7. Goncourt, *Journal*, 19 June 1896, 409.

8. Quoted in Wildenstein, *Monet, or the Triumph of Impressionism*, 1:318–19.

9. Gérôme quoted in Pissarro, *Letters to His Son Lucien*, 304, note 2.

10. Ritz quoted in Chastonay, *César Ritz*, 39.

11. Julie Manet, *Diary*, 6 and 8 October 1896, 100, 104.

12. Coppée quoted in Montens, *Paris*, 140.

24 A Shot in the Dark (1897)

Selected sources for this chapter: Debussy, *Letters*; Nichols, *Life of Debussy*; Gold and Fizdale, *Divine Sarah*; Jullian, *Prince of Aesthetes*; Butler, *Rodin*; Radvanyi, "Les Curie"; Eve Curie, *Madame Curie*; Julie Manet, *Diary*; Goncourt, *Journal*; Harvey, *Consciousness and the Urban Experience*; Pissarro, *Letters to His Son Lucien*; Wildenstein, *Monet, or the Triumph of Impressionism*, vol. 1; Bredin, *The Affair*; Pierre Dreyfus, *Dreyfus*; Alfred Dreyfus, *Five Years of My Life*; Watson, *Georges Clemenceau*.

1. Debussy to Pierre Louÿs, 9 [February] 1897, in Debussy, *Letters*, 88–89.
2. Debussy to Pierre Louÿs, 9 [February] 1897, in Debussy, *Letters*, 89.
3. Rodin's monument to Hugo for the Panthéon was never completed, possibly because of the astonishing image of a spread-legged female messenger of the gods (Iris) that he placed directly above Hugo's head. This image graphically conveyed the sexual energy that had driven Hugo's creative process, but probably shocked members of the fine arts committee supervising the project.
4. Julie Manet, *Diary*, 17 September and 22 October 1897, 111, 116.
5. Julie Manet, *Diary*, 28 November 1897, 119.
6. Goncourt, *Journal*, 16 May 1884, 294.
7. Julie Manet, *Diary*, September [undated] and 16 September 1897, 110–11.
8. Renoir quoted in Julie Manet, *Diary*, 28 September 1897, 112.
9. Renoir quoted in Julie Manet, *Diary*, 28 September 1897, 112.
10. Pissarro to Lucien, 7 March 1896, in *Letters to His Son Lucien*, 362.
11. Pissarro to Lucien, 11 May 1896, both in *Letters to His Son Lucien*, 371.
12. Mirbeau quoted in Pissarro, *Letters to His Son Lucien*, 404, note 1.
13. Pissarro to Lucien, 15 December 1897, in *Letters to His Son Lucien*, 404.
14. Renoir quoted in Julie Manet, *Diary*, 11 October 1897, 113.
15. Julie Manet, *Diary*, 27 November 1897, 118. Mallarmé quoted in Butler, *Rodin*, 191.
16. Quoted in Bredin, *The Affair*, 222–23.
17. Clemenceau quoted in Bredin, *The Affair*, 224.
18. De Mun quoted in Bredin, *The Affair*, 228–29.
19. Julie Manet, *Diary*, 23 December 1897, 121.

25 "J'accuse!" (1898)

Selected sources for this chapter: Bredin, *The Affair*; Josephson, *Zola and His Time*; Brown, *Zola*; Tuchman, *Proud Tower*; Tombs, *France*; Mayeur and Rebérioux, *Third Republic*; Wesseling, *Certain Ideas of France*; Gold and Fizdale, *Divine Sarah*; Cossart, *Food of Love*; Pissarro, *Letters to His Son Lucien*; Monet, *Letters*; Wildenstein, *Monet, or the Triumph of Impressionism*, vol. 1; Nord, *Impressionists and Politics*; Julie Manet, *Diary*; Misia Sert, *Memoirs*; Gold and Fizdale, *Misia*; Watson, *Georges Clemenceau*.

1. Bredin, *The Affair*, 230.
2. Bredin, *The Affair*, 232, 241–42.
3. Zola quoted in Josephson, *Zola and His Time*, 430, and Brown, *Zola*, 711.
4. This phrase, used in his first article in *Le Figaro*, reappeared in "J'accuse" (quoted in Josephson, *Zola and His Time*, 444).
5. It is printed in its entirety in Josephson, *Zola and His Time*, 437–45.
6. Zola quoted in Josephson, *Zola and His Time*, 444.
7. Zola quoted in Josephson, *Zola and His Time*, 445.
8. Guesde quoted in Mayeur and Rebérioux, *Third Republic*, 183.
9. Anatole France quoted in Tuchman, *Proud Tower*, 232.
10. Jaurès quoted in Bredin, *The Affair*, 253.
11. Pissarro, 21 January 1898, in *Letters to His Son Lucien*, 409.

12. Monet quoted in Wildenstein, *Monet, or the Triumph of Impressionism*, 1:324. Monet had earlier congratulated Zola on his articles in *Le Figaro* (Monet to Zola, 3 [December] 1897, in Monet, *Letters*, 184).

13. Monet quoted in Nord, *Impressionists and Politics*, 103.

14. Wildenstein, *Monet, or the Triumph of Impressionism*, 1:326.

15. Renoir quoted in Julie Manet, *Diary*, 15 and 30 January 1898, 124, 127. Julie Manet on Degas, *Diary*, 20 January 1898, 126.

16. Misia Sert, *Memoirs*, 46.

17. Julie Manet, *Diary*, 28 October 1897 and 12 February 1898, 116, 128.

18. Julie Manet, *Diary*, 2 and 17 March 1898, 129.

19. Zola quoted in Josephson, *Zola and His Time*, 440.

20. Quoted in Bredin, *The Affair*, 268.

21. Clemenceau quoted in Bredin, *The Affair*, 268.

22. Zola quoted in Josephson, *Zola and His Time*, 462.

23. Labori quoted in Josephson, *Zola and His Time*, 463.

24. Clemenceau quoted in Tuchman, *Proud Tower*, 231.

25. Zola and Clemenceau quoted in Bredin, *The Affair*, 270.

26 "Despite all these anxieties . . ." (1898)

Selected sources for this chapter: Pissarro, *Letters to His Son Lucien*; Radvanyi, "Les Curie"; Eve Curie, *Madame Curie*; Orenstein, *Ravel*; Cossart, *Food of Love*; Gold and Fizdale, *Misia*; Debussy, *Letters*; Nichols, *Life of Debussy*; Butler, *Rodin*; Champigneulle, *Rodin*; Monet, *Letters*; Julie Manet, *Diary*; Marie Louise Ritz, *César Ritz*; Roulet, *Ritz*; Chastonay, *César Ritz*; Myers, *Erik Satie*; Shattuck, *Banquet Years*; Bredin, *The Affair*; Weintraub, *Whistler*.

1. Pissarro to Lucien, 19 January 1898 [listed as 19 November 1898], in *Letters to His Son Lucien*, 431. [This letter has been dated 19 November 1898, although its content and place of origin serve to identify its proper location as immediately before Pissarro's 21 January 1898 letter.]

2. Pissarro to Lucien, 19 January 1898 [listed as 19 November 1898], in *Letters to His Son Lucien*, 431.

3. Marie Curie quoted in Radvanyi, "Les Curie," 19.

4. *Jeux d'Eau* and the String Quartet. Orenstein, *Ravel*, 19.

5. Mme de Saint-Marceaux quoted in Orenstein, *Ravel*, 21.

6. Debussy to Louÿs, 27 March 1898, in Debussy, *Letters*, 94.

7. Debussy to Georges Hartmann, 14 July 1898, in Debussy, *Letters*, 98.

8. Claudel quoted in Butler, *Rodin*, 279.

9. Claudel quoted in Butler, *Rodin*, 279.

10. Rodin quoted in Butler, *Rodin*, 279–80.

11. Quoted in Butler, *Rodin*, 317–19.

12. Quoted in Roulet, *Ritz*, 59.

13. Ritz quoted in Chastonay, *César Ritz*, 39.

14. Henry quoted in Bredin, *The Affair*, 331–32.

15. Barrès quoted in Bredin, *The Affair*, 348.

16. Julie Manet, *Diary*, 5 June and 16 October 1898, 132, 147.

17. Whistler quoted in Weintraub, *Whistler*, 435.

18. Julie Manet, *Diary*, 10 and 11 September, and 17 October 1898, 141, 143, 148. Debussy knew and evidently admired Yvonne Lerolle, to whom he dedicated his 1894 piano *Images*. Degas photographed her, and Renoir painted her with her sister at the piano.

19. Julie Manet, *Diary*, 22 December 1898, 155.

20. Degas quoted in Julie Manet, *Diary*, 22 December 1898, 155

27 Rennes (1898–1899)

Selected sources for this chapter: Mayeur and Rebérioux, *Third Republic*; Williams, *Last Great Frenchman*; Bredin, *The Affair*; Julie Manet, *Diary*; Monet, *Letters*; Wildenstein, *Monet, or the Triumph of Impressionism*, vol. 1; Rouart, *Claude Monet*; Julia Frey, *Toulouse-Lautrec: A Life* (London: Weidenfeld and Nicolson, 1994); Murray, *Toulouse-Lautrec*; Henri de Toulouse-Lautrec, *The Letters of Henri de Toulouse-Lautrec*, ed. Herbert D. Schimmel, trans. divers hands (New York: Oxford University Press, 1991); Gold and Fizdale, *Misia*; Sert, *Memoirs*; Orenstein, *Ravel*; Gold and Fizdale, *Divine Sarah*; Debussy, *Letters*; Nichols, *Life of Debussy*; Josephson, *Zola and His Time*; Brown, *Zola*; Tuchman, *Proud Tower*; Tombs, *France*; Watson, *Georges Clemenceau*; Harvey, *Consciousness and the Urban Experience*.

1. Charles de Gaulle grew up in a household where the "surrender to the British at Fashoda" left a deep impression on him of French impotence and British treachery (Williams, *Last Great Frenchman*, 19).

2. Quoted in Bredin, *The Affair*, 350–52.

3. Natanson quoted in Murray, *Toulouse-Lautrec*, 271.

4. Quoted in Frey, *Toulouse-Lautrec*, 453.

5. Toulouse-Lautrec to his mother, late April or early May 1899; Toulouse-Lautrec to an unidentified correspondent, mid-May 1899, both in Toulouse-Lautrec, *Letters*, 353–54; Natanson quoted in Murray, *Toulouse-Lautrec*, 269, 316.

6. Gauthier-Villars and d'Indy quoted in Orenstein, *Ravel*, 23–24.

7. Julie Manet, *Diary*, 11 March 1899, 165–66.

8. Degas quoted in Julie Manet, *Diary*, 25 April 1899, 170.

9. Julie Manet, *Diary*, 6 May 1899, 173.

10. Julie Manet, *Diary*, June 6, 1899, 176.

11. Debussy to Hartmann, 1 January 1899, in Debussy, *Letters*, 103.

12. Debussy to Hartmann, Debussy to Lilly Texier, both dated 3 July 1899, in Debussy, *Letters*, 105–106.

13. Debussy to Hartmann, 24 September 1899, in Debussy, *Letters*, 108.

14. Julie Manet, *Diary*, 18 February 1899, 162.

15. Zola quoted in Josephson, *Zola and His Time*, 483.

16. Barrès quoted in Bredin, *The Affair*, 384–85.

17. As quoted in Bredin, *The Affair*, 386.

18. As quoted in Bredin, *The Affair*, 289.

19. Barrès quoted in Bredin, *The Affair*, 404–405, 407.

20. Julie Manet, *Diary*, 7 August 1899, 183.

21. Misia Sert, *Memoirs*, 46.

22. Galliffet to Waldeck-Rousseau, 8 September 1899, quoted in Bredin, *The Affair*, 430.

23. Julie Manet, *Diary*, 186.

24. Galliffet quoted in Bredin, *The Affair*, 434–35.

25. Harvey, *Consciousness and the Urban Experience*, 248.

28 A New Century (1900)

Selected sources for this chapter: Mayeur and Rebérioux, *Third Republic*; Bredin, *The Affair*; Burns, *Dreyfus*; Pierre Dreyfus, *Dreyfus*; Josephson, *Zola and His Time*; Brown, *Zola*; Tuchman, *Proud Tower*; Debussy, *Letters*; Nichols, *Life of Debussy*; Butler, *Rodin*; Champigneulle, *Rodin*; Jones, *Paris*; Gilles Thomas, "La Petite Ceinture," in *Atlas du Paris souterrain: La doublure sombre de la ville lumière*, by Alain Clément and Gilles Thomas (Paris: Editions Parigramme, 2001); Levin, *When the Eiffel Tower Was New*; Peter Kurth, *Isadora: A Sensational Life* (Boston: Little, Brown, 2001); Cossart, *Food of Love*; Mme Dufet-Bourdelle, "Bourdelle, sa vie, son oeuvre," and Véronique Gautherin, "Le Musée Bourdelle," in *Bourdelle, Dossier de L'Art* 10 (janvier–février 1993); Harvie, *Eiffel*; Moreno, *Statue of Liberty Encyclopedia*; Valérie Bougault, *Paris, Montparnasse: The Heyday of Modern Art, 1910–1940* (Paris: Editions Pierre Terrail, 1997); Orenstein, *Ravel*; Gold and Fizdale, *Misia*; Gold and Fizdale, *Divine Sarah*; Marie Louise Ritz, *César Ritz*; Roulet, *Ritz*; Wildenstein, *Monet, or the Triumph of Impressionism*, vol. 1; Pissarro, *Letters to His Son Lucien*; Watson, *Georges Clemenceau*; Julie Manet, *Diary*.

1. Zola and Picquart quoted in Bredin, *The Affair*, 440–41.

2. Combarieu quoted in Butler, *Rodin*, 349–50.

3. Wilde quoted in Butler, *Rodin*, 354.

4. Champigneulle, *Rodin*, 140.

5. Rodin quoted in Dufet-Bourdelle, "Bourdelle, sa vie, son oeuvre," 22.

6. Giacometti quoted in Dufet-Bourdelle, "Bourdelle, sa vie, son oeuvre," 23.

7. Debussy to Robert Godet, 5 January 1900, in Debussy, *Letters*, 109.

8. France quoted in Josephson, *Zola and His Time*, 510.

9. Dreyfus lived long enough (1935) to see the rise of Hitler, but not the German occupation of France, during which his grandchildren worked for the Resistance. His granddaughter died in Auschwitz.

10. Clemenceau quoted in Wildenstein, *Monet, or the Triumph of Impressionism*, 1:403.

11. Clemenceau quoted in Wildenstein, *Monet, or the Triumph of Impressionism*, 1:447, 449.

12. Clemenceau quoted in Wildenstein, *Monet, or the Triumph of Impressionism*, 1:458.

Bibliography

Anderson, Ronald, and Anne Koval. *James McNeill Whistler: Beyond the Myth*. New York: Carroll & Graf, 1994.

Arwas, Victor. *Alphonse Mucha: Master of Art Nouveau*. New York: St. Martin's Press, 1985.

Baker, Phil. *The Dedalus Book of Absinthe*. Sawtry, UK: Dedalus, 2001.

Barrows, Susanna. "After the Commune: Alcoholism, Temperance, and Literature in the Early Third Republic." In *Consciousness and Class Experience in Nineteenth-Century Europe*, edited by John M. Merriman, 205–18. New York: Holmes & Meier, 1979.

Bartholdi, Frédéric Auguste. *The Statue of Liberty Enlightening the World*. 1885. New York: New York Bound, 1984. First published 1885.

Beaumont-Maillet, Laure. *L'eau à Paris*. Paris: Hazan, 1991.

Benoist, Jacques, ed. *Le Sacré-Coeur de Montmartre: Un voeu national*. Paris: Délégation à l'Action Artistique de la Ville de Paris, 1995.

Berlanstein, Lenard R. *The Working People of Paris, 1871–1914*. Baltimore: Johns Hopkins University Press, 1984.

Bernhardt, Sarah. *The Memoirs of Sarah Bernhardt: Early Childhood through the First American Tour, and Her Novella, In the Clouds*. Edited by Sandy Lesberg. New York: Peebles Press, 1977.

——. *Memories of My Life: Being My Personal, Professional, and Social Recollections as Woman and Artist*. New York: Benjamin Blom, 1968. First published 1907.

——. *My Double Life: The Memoirs of Sarah Bernhardt*. Translated by Victoria Tietze Larson. Albany: State University of New York Press, 1999.

Bertaut, Jules. *Paris, 1870–1935*. Translated by R. Millar. Edited by John Bell. London: Eyre and Spottiswoode, 1936.

Boime, Albert. *Art and the French Commune: Imagining Paris after War and Revolution*. Princeton, N.J.: Princeton University Press, 1995.

——. *Hollow Icons: The Politics of Sculpture in Nineteenth-Century France*. Kent, Ohio: Kent State University Press, 1987.

Bonthoux, Daniel, and Bernard Jégo, *Montmartre: Bals et cabarets au temps de Bruant et Lautrec*. Paris: Musée de Montmartre, 2002.

Botstein, Leon. "Beyond the Illusions of Realism: Painting and Debussy's Break with Tradition." In *Debussy and His World*, edited by Jane F. Fulcher. Princeton, N.J.: Princeton University Press, 2001.

Bougault, Valérie. *Paris, Montparnasse: The Heyday of Modern Art, 1910–1940*. Paris: Editions Pierre Terrail, 1997.

Bourdelle. Dossier de l'Art 10 (janvier–février 1993).

Bredin, Jean-Denis. *The Affair: The Case of Alfred Dreyfus*. Translated by Jeffrey Mehlman. New York: George Braziller, 1986.

Brombert, Beth Archer. *Edouard Manet: Rebel in a Frock Coat*. Boston: Little, Brown, 1995.

Brown, Frederick. *Zola: A Life*. New York: Farrar, Straus & Giroux, 1995.

Brunel, Georges. "Ernest Cognacq, the Collector and His Collection." In *Cognacq-Jay Museum Guide*. Paris: Paris-Musées, 2003.

Burns, Michael. *Dreyfus: A Family Affair, 1789–1945*. New York: HarperCollins, 1991.

Bury, J. P. T., and R. P. Tombs. *Thiers, 1797–1877: A Political Life*. London: Allen & Unwin, 1986.

Butler, Ruth. *Rodin: The Shape of Genius*. New Haven, Conn.: Yale University Press, 1993.

Cachin, Françoise. *Manet: Painter of Modern Life*. Translated by Rachel Kaplan. London: Thames and Hudson, 1995.

Carbonnières, Philippe de. *Lutèce: Paris ville romaine*. Paris: Gallimard, 1997.

Carrière, Bruno. *La saga de la Petite Ceinture*. Paris: Editions La Vie du Rail, 1992.

Cézanne, Paul. *Conversations with Cézanne*. Edited by Michael Doran. Translated by Julie Lawrence Cochran. Berkeley: University of California Press, 2001.

———. *Paul Cézanne Letters*. Edited by John Rewald. Translated by Marguerite Kay. Oxford: B. Cassirer, 1946.

Chadych, Danielle, and Charlotte Lacour-Veyranne. *Paris au temps des Misérables de Victor Hugo*. Paris: Musée Carnavalet, 2008.

Champigneulle, Bernard. *Rodin*. Translated by J. Maxwell Brownjohn. London: Thames and Hudson, 1967.

Chastonay, Adalbert. *César Ritz: Life and Work*. Niederwald, Switzerland: César Ritz Foundation, 1997.

Clark, T. J. *The Painting of Modern Life: Paris in the Art of Manet and His Followers*. Rev. ed. Princeton, N.J.: Princeton University Press, 1999. First published 1984.

Clemenceau, Georges. *Claude Monet: The Water Lilies*. Translated by George Boas. Garden City, N.Y.: Doubleday, Doran, 1930.

Corbin, Alain. *The Foul and the Fragrant: Odor and the French Social Imagination*. Translated by Miriam Kochan. Cambridge, Mass.: Harvard University Press, 1986.

Cossart, Michael de. *The Food of Love: Princesse Edmond de Polignac (1865–1943) and Her Salon*. London: Hamish Hamilton, 1978.

Courthion, Pierre. *Georges Seurat*. New York: Harry N. Abrams, 1988.

Curie, Eve. *Madame Curie: A Biography*. Translated by Vincent Sheean. Garden City, N.Y.: Garden City Publishing, 1943.

Daudet, Léon. *Memoirs of Léon Daudet*. Edited and translated by Arthur Kingsland Griggs. New York: L. MacVeagh, Dial Press, 1925.

Debussy, Claude. *Debussy Letters*. Edited by François Lesure and Roger Nichols. Translated by Roger Nichols. Cambridge, Mass.: Harvard University Press, 1987.

Dietschy, Marcel. *Passion de Claude Debussy*. Edited and translated by William Ashbrook and Margaret G. Cobb. New York: Oxford University Press, 1990.

Dillon, Wilton S., and Neil Kotler, eds. *The Statue of Liberty Revisited*. Washington, D.C.: Smithsonian Institution Press, 1994.

Douglas, David C. "Medieval Paris." In *Time and the Hour*, 77–93. London: Eyre Methuen, 1977.

Dreyfus, Alfred. *Five Years of My Life, 1894–1899*. Translated by James Mortimer. London: G. Newnes, 1901.

———. *Lettres d'un innocent*. Paris: Stock, 1898.

Dreyfus, Pierre. *Dreyfus: His Life and Letters*. Translated by Dr. Betty Morgan. London: Hutchinson, 1937.

Dufet-Bourdelle, Mme. "Bourdelle, sa vie, son oeuvre." *Bourdelle. Dossier de l'Art* 10 (janvier–février 1993).

Duval, Paul-Marie. *Paris antique: Des origins au troisième siècle*. Paris: Hermann, 1961.

Edwards, H. Sutherland. *Old and New Paris: Its History, Its People, and Its Places*. 2 vols. London: Cassell, 1893.

Edwards, Stewart. *The Paris Commune, 1871*. London: Eyre and Spottiswoode, 1971.

Ellis, Jack D. *The Early Life of Georges Clemenceau, 1841–1893*. Lawrence: Regents Press of Kansas, 1980.

Elwitt, Sanford. *The Making of the Third Republic: Class and Politics in France, 1868–1884*. Baton Rouge: Louisiana State University Press, 1975.

Fields, Armond. *Le Chat Noir: A Montmartre Cabaret and Its Artists in Turn-of-the-Century Paris*. Santa Barbara, Calif.: Santa Barbara Museum of Art, 1993.

Frey, Julia. *Toulouse-Lautrec: A Life*. London: Weidenfeld and Nicolson, 1994.

Fuchs, Rachel G. *Poor and Pregnant in Paris: Strategies for Survival in the Nineteenth Century*. New Brunswick, N.J.: Rutgers University Press, 1992.

Gagneux, Renaud, Jean Anckaert, and Gérard Conte. *Sur les traces de la Bièvre parisienne: Promenades au fil d'une rivière disparue*. Paris: Parigramme, 2002.

Gautherin, Véronique. "Le Musée Bourdelle." *Bourdelle. Dossier de l'Art* 10 (janvier–février 1993).

Gheusi, P. B. *Gambetta: Life and Letters*. Translated by Violette M. Montagu. London: T. Fisher Unwin, 1910.

Gibson, Ralph. *A Social History of French Catholicism, 1789–1914*. London, New York: Routledge, 1989.

Gillmore, Alan M. *Erik Satie*. New York: Norton, 1988.

Gold, Arthur, and Robert Fizdale. *The Divine Sarah: A Life of Sarah Bernhardt*. New York: Vintage Books, 1992.

———. *Misia: The Life of Misia Sert*. New York: Morrow, 1981.

Goncourt, Edmond de, and Jules de Goncourt. *Journal: Mémoires de la vie littéraire*. 9 vols. Paris: E. Flammarion, 1935.

———. *Pages from the Goncourt Journal*. Edited and translated by Robert Baldick. New York: New York Review of Books, 2007.

Gordon, Robert, and Andrew Forge. *Degas*. With translations by Richard Howard. New York: Abrams, 1988.

Harvey, David. *Consciousness and the Urban Experience: Studies in the History and Theory of Capitalist Urbanization*. Baltimore: Johns Hopkins University Press, 1985.

Harvie, David I. *Eiffel: The Genius Who Reinvented Himself*. Gloucestershire, UK: Sutton, 2004.

Hemmings, F. W. J. *Emile Zola*. Oxford, UK: Clarendon, 1966.

Herbert, Robert L. *Impressionism: Art, Leisure, and Parisian Society*. New Haven, Conn.: Yale University Press, 1988.

———. *Seurat and the Making of La Grande Jatte*. Chicago: Art Institute of Chicago, 2004.

Higonnet, Anne. *Berthe Morisot*. New York: Harper & Row, 1990.

Hogg, Garry. *Orient Express: The Birth, Life, and Death of a Great Train*. London: Hutchinson, 1968.

Horne, Alistair. *The Fall of Paris: The Siege and the Commune, 1870–71*. Harmondsworth, UK: Penguin, 1981. First published 1965.

Hugo, Victor. *Actes et paroles*. Paris: M. Lévy, 1875–1876.

———. *L'année terrible*. Paris: Librarie Hachette, 1876.

———. *The Hunchback of Notre-Dame*. Translated by Walter J. Cobb. New York: Signet, 2001. Cobb translation first published 1964.

———. *Les misérables*. Translated by Norman Denny. New York: Penguin, 1985. Denny translation first published 1976.

Irvine, William D. *The Boulanger Affair Reconsidered: Royalism, Boulangism, and the Origins of the Radical Right in France*. New York: Oxford University Press, 1989.

James, Burnett. *Ravel*. London: Omnibus Press, 1987.

James, Henry. *Parisian Sketches: Letters to the New York Tribune, 1875–1876*. Edited by Leon Edel and Ilse Dusoir Lind. New York: Collier, 1961. First published 1957.

Jonas, Raymond Anthony. *France and the Cult of the Sacred Heart: An Epic Tale for Modern Times*. Berkeley: University of California Press, 2000.

Jones, Colin. *Paris: Biography of a City*. New York: Viking, 2005.

———. "Theodore Vacquer and the Archaeology of Modernity in Haussmann's Paris." *Transactions of the Royal Historical Society* 17 (2007): 157–83.

Jonquet, R. P., and François Veuillot. *Montmartre autrefois et aujourd'hui*. Paris: Bloud & Gay, 1919.

Josephson, Matthew. *Zola and His Time*. Garden City, N.Y.: Garden City Publishing, 1928.

Jullian, Philippe. *Prince of Aesthetes: Count Robert de Montesquiou, 1855–1921*. Translated by John Haylock and Francis King. London: Secker & Warburg, 1967.

Kselman, Thomas A. *Miracles and Prophecies in Nineteenth-Century France*. New Brunswick, N.J.: Rutgers University Press, 1983.

Kurth, Peter. *Isadora: A Sensational Life*. Boston: Little, Brown, 2001.

Lacouture, Jean. *De Gaulle: The Rebel, 1890–1944*. Translated by Patrick O'Brian. New York: Norton, 1993.

Laligant, Pierre. *Montmartre: La basilique du voeu national au Sacré-Coeur*. Grenoble, France: B. Arthaud, 1933.

Laudet, Fernand. *La Samaritaine: Le génie et la générosité de deux grands commerçants*. Paris: Dunod, 1933.

Lehning, James R. *To Be a Citizen: The Political Culture of the Early French Third Republic*. Ithaca, N.Y.: Cornell University Press, 2001.

Lemoine, Bertrand. *Architecture in France, 1800–1900*. Translated by Alexandra Bonfante-Warren. New York: Abrams, 1998.

———. *La Tour Eiffel*. Paris: Mengès, 2004.

Lemoine, Paul, and René Humery. *Les forages profonds du bassin de Paris: La nappe artésienne des sables verts*. Paris: Editions du Muséum, 1939.

Leroux, Gaston. *The Phantom of the Opera*. Introduction by John L. Flynn. New York: Signet, 2001.

Levin, Miriam R. *When the Eiffel Tower Was New: French Visions of Progress at the Centennial of the Revolution.* South Hadley, Mass.: Mount Holyoke College Art Museum, 1989.

Lottman, Herbert R. *Return of the Rothschilds: The Great Banking Dynasty through Two Turbulent Centuries.* London: Tauris, 1995.

Maclellan, Nic, ed. *Louise Michel.* Melbourne, N.Y.: Ocean Press, 2004.

Mallarmé, Stéphane. *Oeuvres complètes.* Etabli et annoté par Henri Mondor et G. Jean-Aubry. Paris: Gallimard, 1945.

———. *Selected Letters of Stéphane Mallarmé.* Edited and translated by Rosemary Lloyd. Chicago: University of Chicago Press, 1988.

Manet, Edouard. *Manet by Himself: Correspondence and Conversation, Paintings, Pastels, Prints, and Drawings.* Edited by Juliet Wilson-Bareau. London: Macdonald, 1991.

Manet, Julie. *Growing Up with the Impressionists: The Diary of Julie Manet.* Translated and edited by Rosalind de Boland Roberts and Jane Roberts. London: Sotheby's, 1987.

Maurois, André. *The Titans: A Three-Generation Biography of the Dumas.* Translated by Gerard Hopkins. New York: Harper, 1957.

Mayeur, Jean-Marie, and Madeleine Rebérioux. *The Third Republic from Its Origins to the Great War, 1871–1914.* Translated by J. R. Foster. Cambridge, UK: Cambridge University Press, 1989.

McManners, John. *Church and State in France, 1870–1914.* London: SPCK, 1972.

Michel, Louise. *The Red Virgin: The Memoirs of Louise Michel.* Edited and translated by Bullitt Lowry and Elizabeth Ellington Gunter. Tuscaloosa: University of Alabama Press, 1981.

Miller, Michael R. *The Bon Marché: Bourgeois Culture and the Department Store, 1869–1920.* Princeton, N.J.: Princeton University Press, 1981.

Monet, Claude. *Monet by Himself: Paintings, Drawings, Pastels, Letters.* Edited by Richard R. Kendall. Translated by Bridget Strevens Romer. London: Macdonald, 1989.

Montens, Sophie-Marguerite S. *Paris, de pont en pont.* Paris: Bonneton, 2004.

Moreno, Barry. *The Statue of Liberty Encyclopedia.* New York: Simon & Schuster, 2000.

Morisot, Berthe. *The Correspondence of Berthe Morisot with Her Family and Friends: Manet, Puvis de Chavannes, Degas, Monet, Renoir, and Mallarmé.* Edited by Denis Rouart. Translated by Betty W. Hubbard. London: Camden Press, 1986.

Mucha, Jiří. *Alphonse Maria Mucha: His Life and Art.* London: Academy Editions, 1989.

———. *Alphonse Mucha: His Life and Work.* New York: St. Martin's Press, 1974.

Murray, Gale B., ed. *Toulouse-Lautrec: A Retrospective.* New York: Hugh Lauter Levin, 1992.

Myers, Rollo H. *Erik Satie.* Rev. ed. New York: Dover, 1968. First published 1948.

Nichols, Roger. *The Life of Debussy.* Cambridge, UK: Cambridge University Press, 1998.

Nord, Philip G. *Impressionists and Politics: Art and Democracy in the Nineteenth Century.* London: Routledge, 2000.

———. *The Republican Moment: Struggles for Democracy in Nineteenth-Century France.* Cambridge, Mass.: Harvard University Press, 1995.

O'Malley, John. *The First Jesuits.* Cambridge, Mass.: Harvard University Press, 1993.

Ordish, George. *The Great Wine Blight.* London: Pan Macmillan, 1987.

Orenstein, Arbie. *Ravel: Man and Musician.* New York: Dover, 1991. First published 1968.

Padberg, John W. *Colleges in Controversy: The Jesuit Schools in France from Revival to Suppression, 1815–1880.* Cambridge, Mass.: Harvard University Press, 1969.

Perloff, Nancy. *Art and the Everyday: Popular Entertainment and the Circle of Erik Satie.* Oxford: Clarendon Press, 1991.

Pissarro, Camille. *Letters to His Son Lucien.* Edited by John Rewald, with assistance of Lucien Pissarro. Translated by Lionel Abel. Santa Barbara: Peregrine Smith, 1981. First published 1944.

Price, Roger. *A Social History of Nineteenth-Century France.* London: Hutchinson, 1987.

Radvanyi, Pierre. "Les Curie: Deux couples radioactifs." *Pour la Science* 9 (novembre 2001–février 2002): 1–96.

Renoir, Jean. *Pierre-Auguste Renoir, mon père.* Paris: Hachette, 1962.

Rewald, John. *Camille Pissarro.* New York: Henry N. Abrams, 1963.

———. *Cézanne et Zola.* Paris: A. Sedrowski, 1936.

———. *Georges Seurat.* New York: Wittenborn, 1943.

———. *The History of Impressionism.* 4th ed. New York: Museum of Modern Art, 1973. First published 1946.

———. *Paul Cézanne: A Biography.* Translated by Margaret H. Liebman. New York: Simon & Schuster, 1948.

———. *Paul Gauguin.* New York: Harry N. Abrams, 1954.

———. *Post-Impressionism: From van Gogh to Gauguin.* 3rd ed. New York: Museum of Modern Art, 1978. First published 1956.

Rigouard, Jean-Pierre. *La Petite Ceinture: Memoire en images.* Saint-Cyr-sur-Loire: Editions Alan Sutton, 2002.

Ritz, Marie Louise. *César Ritz, Host to the World.* New York: Lippincott, 1938.

Robb, Graham. *Victor Hugo.* London: Picador, 1997.

Roberts, Paul. *Claude Debussy.* London: Phaidon, 2008.

Rodin, Auguste. *Art: Conversations with Paul Gsell.* Translated by Jacques de Caso and Patricia B. Sanders. Berkeley: University of California Press, 1984.

Rodin, Auguste [and Paul Gsell]. *Rodin on Art.* Translated by Mrs. Romilly Fedden. New York: Horizon, 1971. First published 1912.

Rollet-Echalier, Catherine. *La politique à l'égard de la petite enfance sous la IIIe République.* [Paris]: Institute National d'Etudes Démographiques; Presses Universitaires de France, 1990.

Ross, Kristin. Introduction to *The Ladies' Paradise (Au bonheur des dames),* by Emile Zola. Berkeley: University of California Press, 1992.

Rouart, Denis. *Claude Monet.* Translated by James Emmons. Paris: Albert Skira, 1958.

Roulet, Claude. *Ritz: Une histoire plus belle que la légende.* Paris: Quai Voltaire/La Table Ronde, 1998.

Russell, John. *Seurat.* New York: Frederick A. Praeger, 1965.

Sacré-Coeur of Montmartre. Villeurbanne, France: Lescuyer, 2006.

Schneider, Marcel. "Toujours plus haut." In André Boucourechliev, Dennis Collins, Jacques Février, et al., *Debussy.* Paris: Hachette, 1972.

Sedgwick, Alexander. *The Ralliement in French Politics, 1890–1898.* Cambridge, Mass.: Harvard University Press, 1965.

Sert, Misia. *Misia and the Muses: The Memoirs of Misia Sert.* Translated by Moura Budberg. New York: John Day, 1953.

Shattuck, Roger. *The Banquet Years: The Origins of the Avant Garde in France, 1885 to World War I; Alfred Jarry, Henri Rousseau, Erik Satie, Guillaume Apollinaire.* New York: Vintage, 1968. First published 1955.

Silverman, Debora. *Van Gogh and Gauguin: The Search for Sacred Art.* New York: Farrar, Straus & Giroux, 2000.

Studd, Stephen. *Saint-Saëns: A Critical Biography.* Madison, N.J.: Fairleigh Dickinson University Press, 1999.

Sutherland, Cara A. *Portraits of America: The Statue of Liberty*. New York: Museum of the City of New York, 2002.

Thomas, Edith. *Louise Michel, ou, La Velléda de l'anarchie*. Translated by Penelope Williams. Montréal: Black Rose Books, 1980.

Thomas, Gilles. "La Petite Ceinture." In *Atlas du Paris souterrain: La doublure sombre de la ville lumière*, by Alain Clément and Gilles Thomas. Paris: Editions Parigramme, 2001.

Tillier, Bertrand. *La Commune de Paris: Revolution sans images? Politique et représentations dans la France républicaine (1871–1914)*. Paris: Champ Vallon, 2004.

Tombs, Robert. *France, 1814–1914*. London: Longman, 1996.

———. *The Paris Commune, 1871*. London: Longman, 1999.

Toulouse-Lautrec, Henri de. *The Letters of Henri de Toulouse-Lautrec*. Edited by Herbert D. Schimmel. Translated by divers hands. New York: Oxford University Press, 1991.

Trachtenberg, Marvin. *The Statue of Liberty*. New York: Penguin, 1986.

Troyat, Henri. *Zola*. Paris: Flammarion, 1992.

Tuchman, Barbara. *The Proud Tower: A Portrait of the World before the War, 1890–1914*. New York: Bantam, 1976. First published 1966.

Tuilier, André. *Histoire de l'Université de Paris et de la Sorbonne*. 2 vols. Paris: Nouvelle Librarie de France, 1994.

Ward, Martha. *Pissarro, Neo-Impressionism, and the Spaces of the Avant-Garde*. Chicago: University of Chicago Press, 1996.

———. "The Rhetoric of Independence and Innovation." In *The New Painting, Impressionism, 1874–1886: An Exhibition*. Seattle: University of Washington Press, 1986.

Watson, David Robin. *Georges Clemenceau: A Political Biography*. New York: David McKay, 1974.

Weber, Eugen. *France, Fin de Siècle*. Cambridge, Mass.: Belknap and Harvard University Press, 1986.

Weintraub, Stanley. *Whistler: A Biography*. Cambridge, Mass.: Da Capo, 2001. First published 1974.

Weisberg, Gabriel P., ed. *Montmartre and the Making of Mass Culture*. New Brunswick, N.J.: Rutgers University Press, 2001.

Wesseling, H. L. *Certain Ideas of France: Essays on French History and Civilization*. Westport, Conn.: Greenwood Press, 2002.

Whyte, George R. *The Dreyfus Affair: A Chronological History*. New York: Palgrave Macmillan, 2005.

Wildenstein, Daniel. *Claude Monet: Biographie et catalogue raisonné*. 5 vols. Lausanne and Paris, Bibliothèque des Arts, 1974–1991.

———. *Monet, or the Triumph of Impressionism*. Vol. 1. Translated by Chris Miller and Peter Snowdon. Cologne, Germany: Taschen/Wildenstein Institute, 1999.

Williams, Charles. *The Last Great Frenchman: A Life of General de Gaulle*. New York: Wiley, 1993.

Zola, Emile. *L'assommoir*. Translated by Leonard Tancock. Hammondsworth, UK: Penguin, 1970.

———. *The Belly of Paris*. Translated by Brian Nelson. New York: Oxford University Press, 2007.

———. *Correspondance*. Edited by B. H. Bakker. Montréal: Presses de l'Université de Montréal; Paris: Editions du Centre National de la Recherche Scientifique, 1978–.

———. *Germinal*. Translated by L. W. Tancock. Hammondsworth, UK, and Baltimore: Penguin, 1968.

———. *The Ladies' Paradise* (*Au bonheur des dames*). Introduction by Kristin Ross. Berkeley: University of California Press, 1992.

———. *Nana*. Translated by George Holden. Hammondsworth, UK: Penguin, 1972.

———. *L'oeuvre* (*The Masterpiece*). Edited by Ernest Alfred Vizetelly. London: Chatto & Windus, 1902.

~

Index

~

About the Author

Mary McAuliffe received a PhD in history from the University of Maryland. She has taught at several universities, lectured at the Smithsonian Institution, and published *Crisis on the Left: Cold War Politics and American Liberals*. For many years a regular contributor to *Paris Notes*, she has traveled extensively in France and recently published *Paris Discovered: Explorations in the City of Light*. She lives in New York City with her husband.